D0501880

EVENING SONG OF THINGS TO COME

The evening rides on crickets' song.
The stir of leaves includes its note
And summer seems to languish long,
Like dreams adrift inside a boat.

But listen, please, beyond this dream,
And hear between the croak of frogs,
Remember, all's not as it seems,
For creatures march from out the bog.

Come friends, the time is getting close.
You'll sense it rising if you're still.
I think I hear the goblin ghost.
I know I feel some ancient chill.

A foe is born of damp and dark,
And others, too, from long gone hills
Will enter stage to make their mark
With clever plans to bend our wills.

Enjoy this quiet summer night,
Tomorrow starts another tale,
Where tiger lilies have to fight
And chipmunk spies will land in jail.

For nothing is as it appears—
The bad along with good will thrive
And summer's warmth won't quiet fears,
As colder roots now come alive.

CAST OF CHARACTERS

Capiello, Jim: The younger Capiello boy, friends with Danvir Sharma
Capiello, Ricki: The older Capiello boy, who is friends with Steven Umberland
Cohan, Loretta: A neighborhood girl in Sara and Jam's class
Lynn: Steven Umberland's girlfriend
Poncho: The Capiellos' dog
Sanderson, Mrs: A neighbor
Sharma, Danvir: Known as Dan by his friends, Jamuna's older brother, Jim Capiello's friend
Sharma, Jamuna: Known as Jam by her friends, Sara's friend, Dan's sister
Sonya: A neighbor girl the same age as Sara and Jam
Umberland, Dr: Father of Sara and Steven
Umberland, Ms: Mother of Sara and Steven
Umberland, Sara: Lucinda's best friend
Umberland, Steven: Brother of Sara
Williams, Mrs: Sandy's mother
Williams, Sandy: Mrs. William's daughter

THE CREATURES

Apkin: Squirrel living in Sara's garden
Cep: Chipmunk living in the Glowing Tree
Cip: Chipmunk living in the Glowing Tree
Cobcaw: A city gull, Skitter's cousin
Ekle: Squirrel living in Sara's garden
Hool: Owl from the Glowing Tree
Owletta: Owl living near Sara's garden
Regata: Squirrel, mate of Apkin
Saralinda: Lucinda's daughter
Selena: Squirrel, mate of Ekle
Skitter: Cobcaw's cousin, an ocean gull
Tula: A gull and Skitter's wife

THE VINETROPE WORLD

Chantroute: The Glower and Healer of Vinetropeland
Chargons: Large wicked creatures from the ancient past
Fantella: A female, vinetrope scientist
Feylandia: A female, vinetrope composer
Glintel Fernroote: A male, vinetrope composer and musician
Jetro: A male vinetrope engineer
Kent Abo Roottroupe: A male vinetrope guide
Lucinda Vinetrope: The Master Rhymer
Vinkali: Small mischievous creatures who are ruled by chargons to do wicked things

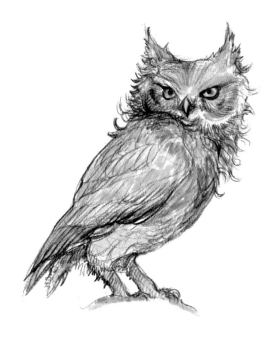

ACKNOWLEDGEMENTS

I want to first thank Diana Steel, for believing in the book from the beginning. She saw the first draft many years ago and often asked me if I was doing anything with it. As a publisher, she believed it had something special to offer children. Without her, this book would not be here today. And I want to give a big thanks to my publisher, Paul Latham, for picking up this project without a blink and believing in it.

I also want to give my thanks to James Smith, who has believed in this book for as long as Diana and who will help guide it out into the marketplace. His support has been instrumental in bringing this book to fruition. And all my appreciation to Mary Frances Albi, Director of Sales and Marketing for the US and John Brancati, General Manager for the US, for the all the work they are doing and will be doing to bring this book to the reader. Their guidance is instrumental in bringing this project full circle to the public. I credit my two wonderful editors, Gina Tsarouhas and Karen Tayleur for making this book shine. Gina saw the magic and with years of experience believed with some editing it would glow. Karen showed me just how to go about polishing and cutting when necessary so that it would shine. I can't thank them enough.

And, a huge thanks to Nicole Boehringer, who is responsible for the amazing graphic design and layout of this book. She too believed in its potential when she first saw it. Nikki has created a visually beautiful book that will delight readers of all ages as well as the children it was written for. She has enhanced its physical presence with her creative powers.

I was also fortunate to have the well-known cover designer, Michael Nelson, design the cover. It is magical. This brings me to my dear friend, the master artist and illustrator, Julie Bell. I can't thank her enough for these exquisite illustrations that have brought my tale to life. I was awestruck that she found the time to fit my project into her extremely full schedule. Julie was already a friend before she embarked on this project and she is the dearest of friends as we've concluded it, a testament on how

The VINETROPE
ADVENTURES

DEDICATION

I would like to dedicate this book
to my daughter Kara Lysandra Ross
who was the inspiration for the character Sara

And to my two wonderful granddaughters
Anna Catherine Colón and Kayleigh Hayden Colón

And in memory of our son Gregory Scott Ross
who was the inspiration for the character Steven

The VINETROPE
~ADVENTURES~

BY SHERRY LAZARUS ROSS

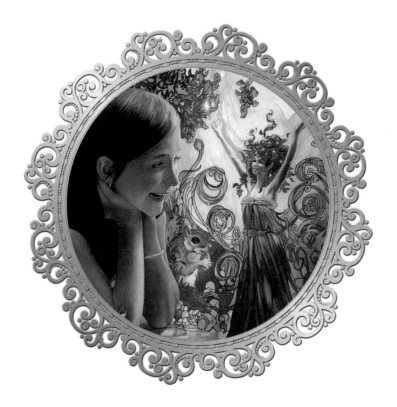

ILLUSTRATED BY JULIE BELL

~» BOOK ONE «~
RETURN OF THE VINETROPES

© 2017
World copyright reserved
ISBN: 978-1-85149-857-4

The right of Sherry L. Ross to be identified as author of this work
has been asserted by her in accordance with the Copyright, Designs and
Patents Act 1988

All rights reserved. No part of this publication may be reproduced, stored
in a retrieval system, or transmitted in any form or by any means electron-
ic, mechanical, or photocopying, recording or otherwise, without the prior
permission of the publisher.

British Library Cataloguing-in-Publication Data
A catalogue record for this book is available from the British Library

Front cover and spine design: Michael Nelson
(michael@michaelnelsondesign.com)

Illustrations © Julie Bell, except for those noted as follows:
Page 126: "Opening the Car Door" by Fred Ross
Page 330: "Owls Returning in a Snowstorm" by Sherry Ross

Printed in China for ACC Art Books Ltd, Woodbridge, Suffolk IP12 4SD, UK

CONTENTS

THE BIRTH OF LUCINDA VINETROPE

It is a beautiful, cool, moonlit night in early October and the moment is very still. Trailing around the trunk of an old pine tree grows a mysterious vine. It is not like other plant life in the area and it has grown late in the season. But what makes this vine most unusual is the one large, pale green, silky pod that lays on its side in the pine needles. If you know it is there, you might notice a very light glow coming from it. The glow pulses on and off with a heartbeat-like rhythm. Then it stops for a time. There, just then, the glow pulsed! There is a quick clicking noise, and then several small cracking sounds, quiet and easily missed. It is not a late summer cricket. It reminds you of the sound you hear in your own head when you crack open a pumpkin seed with your teeth. Two delicate hands emerge from a slit in the top of the pod. The hands grasp the edges and push against each side and the pod opens wide. Into the night air steps a most fantastical being. Lucinda Vinetrope is born. And she is wearing an exquisite pumpkin-colored dress.

"Where am I?" Lucinda whispers into the night. "Who am I? My name is Lucinda." She does know that.

She looks around and recognizes nothing. This isn't the world she expected to find. It is not even remotely like the place she has been dreaming about while developing in her growing chamber. Something is terribly wrong. Where are

her people? They should be here to greet her. Her broken pod turns brown, withering away as she watches. Even the long tangle of vines around the tree shrivels up, now that her life is not attached to it. There are no other pods in sight. She is now feeling frightened. Why is she all alone?

"This is definitely wrong," she thinks to herself. She sniffs the air and then puts her nose to the ground and sniffs the earth. "All wrong," she confirms. "This earth is too dry. It smells bitter and old. I'm sure it is supposed to smell moist and rich; bursting with life." She looks up into the pine tree and then all around her. "I don't recognize these plants. Where are the seedsong trees? They should be everywhere. And it is too quiet, even for night."

It takes a bit for what she knows and what she sees, smells, hears and feels to be understood at all. After all, she has just been born and so much would be new even if she were in the right place. That's when she notices the huge structure across the way and down a slope of land. It is so huge she can't quite believe what she is seeing. "Is that a chimney? Why, if that is a place in which someone lives, it would have to belong to a giant. But giants, as I see them, were never able to build anything that fancy. Well, still, it may very well be some kind of giant. And that means there is life here." This gives her a bit of comfort, but not much. She will need to be strong and get to the bottom of it all.

She can be strong. She would be strong for her people, so she must be strong for herself. She must, if she is to survive. Her fear subsides for a moment and she fills with a deep loneliness instead; an aching loneliness. She needs to be with her people to even be herself. And she's sure her people need her. It is frightening to recognize nothing; to be in a world that feels so alien. Her mind aches and her body aches. She

suddenly feels hungry but, more than hunger, she is overcome by complete exhaustion. She must sleep. She will deal with this in the morning after she rests. Maybe things will fall into place. Maybe her mind will feel clearer, work better.

"I must sleep," she says out loud. "In the morning I will be able to find food." Lucinda circles the tree and finds a little hollow between its roots. She pushes some pine needles into the hollow, climbs in and covers herself with some of them. In a second she is in a deep sleep.

SARA MAKES A DISCOVERY

Sara's school bus stopped in front of her house. She came down the bus steps, her heavy schoolbag on her back, and made her way along the walkway to her front door. Sara's house key was in the front pocket of the bag, so she reached behind, deftly unzipped the pocket and retrieved the key. She let herself in and dropped the schoolbag in the front hall by the steps.

Sara went straight to the den to feed her goldfish. Picking up the can of fish food, she flipped open the cover, and gave a shake into the tank. "Here you go, boys," she called out loud into the empty house. The three fish eagerly dove into the food and gave her no answer. Her dad had got them a year ago; she's not sure why and she hadn't even bothered to name them. But she did always make sure to feed them. They had to eat. They looked lonely swimming around and around in the little tank.

Next Sara went into the kitchen. On the fridge was a note from her dad: *please make salad and rake the leaves.* "Ugh," she grunted. Well, she didn't mind helping, but no one really cared if the leaves were raked and it wasn't like they would all sit down together for dinner. They almost never did anymore. Her dad, Dr. Umberland, the head scientist at Lazlan Laboratories, left early and often didn't get back till eight. She'd open a can of soup and be done with her dinner

before he even got back. And forget Steven, her 17-year-old brother—he had a life of his own which now included his girlfriend, Lynn. He didn't have much time for a 12-year-old sister. It hurt. They used to be so close. But everything was different now, wasn't it? Thirsty, she went to the kitchen sink, turned on the water and drank directly from the faucet, holding back her mid-length dark hair. Finished, she pushed her hair back behind her right ear with her forefinger, a habit she repeated often.

Sara returned to the hall, picked up her bag and headed up to her room. As she passed her dad's room she noted that it was messy and his clothes from the day before lay over the back of his desk chair. On the dresser top stood some of her mom's knick-knacks and personal items; a hairbrush, her perfume, and a sculpture of a unicorn. Sara had made the unicorn when she was little and painted it an uneven gold. It hurt to see her mother's things. The memories hurt. She didn't even like to go into the room. Her mom's stuff, what was still there, would be dusty and neglected. It made her feel sad and angry for some reason too. As she peered into Steven's room she noted how organized it was, unlike her dad's. Seeing his desk, with his archeology posters hanging above, she had another pang of nostalgia. Sara had spent many days sitting next to him at that desk learning how to use a computer. He was a wiz at anything technical and he was great with words too. He had been a natural teacher and patient by nature. Now he never had time. In fact, he would be gone all next summer on an archaeological dig, another of his "nerdy" passions. And then he would leave for college. She hated to think of that. It made her angry again.

Sara turned into her room and dropped her schoolbag on her bed. She had outgrown this room. It needed to be updated,

but she didn't have the heart to ask. That would cost money and her dad had other things on his mind. The room looked like it belonged to much younger child, with all her stuffed animals standing about on the shelves, her windowsills and her bed. It was getting a bit embarrassing, but she never had friends over anymore anyway. So what did it matter? She still loved her dragon, unicorn and furry red fox. She would never give them up; too many good memories of birthdays and Christmases. Sara stopped for a moment to look at herself in the dresser mirror. She had on her jean jacket, a light blue tee shirt and jeans. Her hair was clean, but could use a trim and her face was pale. She'd never thought much about whether she was pretty, but her mom had told her that she was many times. Her dad had too, but not in a long time. On her desk was the oldest computer in the house. Steven, of course, had a great laptop now. He worked at the drugstore three days after school—and Saturday and Sunday afternoons—and had saved up for it. Her dad said he would get Sara one when she turned thirteen. They were expensive.

And there were all her books on the shelf above the computer. That was her escape. She treasured her Narnia collection and her *Fairytales from Around the World*. She had her classics too, *Alice in Wonderland* and *Through the Looking Glass*, the OZ books and lots of modern fantasy novels. A recent edition lay on her end table next to her bed. Her mom had read to her all the time when she was little. Their house was old and creaky and that was good. It made the perfect setting for a great adventure. In so many of the really great fantasies about children there was an old house and often a special garden. Sara was quite certain that her house and garden were ideal for adventure. Why didn't some magical adventure ever happen to her? But this was enough daydreaming. She would

do her chores first, then her homework and read later. She had to set her own priorities now. And she didn't want to be a burden to her dad or Steven. Even if they didn't seem to be there for her, she would try and be there for them. Maybe that way they would notice her? So she *would* make a salad and rake some leaves.

Outside, and not even a day old, Lucinda was hard at work. She was feeling strong and energetic. She had to pull herself together and be practical. That was the plan. If she didn't function, she would certainly perish. In the morning she awoke so hungry her stomach hurt. She breakfasted on some ear-fungi she found growing on the pine tree. Then she went exploring. She soon found what she felt must be a walled-in garden; she had dreamt of such things. She went down a flight of steps to get to it and from above it looked like a sunken room. Inside this space there were flowerbeds around all four edges. Yes, it had to be a garden, but this one seemed unkempt and unloved, as though no one had tended to it for some time. But it did add further proof to her hypothesis that giants lived in the house up the hill.

Lucinda went down the steps and there, in the center of the northern wall, she discovered a flat rectangular piece of slate. It looked just like a door. She slid the flat stone open a crack and was delighted to find behind it a hollow space. Inside it was cozy and like a large room. It had a big, odd-looking root running along the back wall, which was useful as it offered built-in seating.

Since then, Lucinda had been hard at work all morning smoothing the ground into a presentable floor and had loosened and removed several large stones from the back wall that rose above the odd root. Now she began to dig upward, tunneling through the earth like a small burrowing animal. She was working her way up to the outside. This tunnel would be her chimney chute. It was not as impressive as the giant's but it would do the job. Tomorrow, she thought, she would mix up a batch of tar made from tree sap and collect small stones and pebbles to line the inside of the chute. That would make the chimney chute sturdy and fireproof. She wanted this job done first, before the winter freeze. It was important to prioritize.

Sara returned to the kitchen. One thing her dad never forgot was to get in groceries for the week. Sometimes she joined him and it felt good doing something normal together. But usually he shopped after work and came home with the groceries. She got all the salad makings out of the vegetable drawer, washed and tore the lettuce, and sliced up some red and green peppers, carrots and cucumbers. Sara tossed everything together in a bowl and placed it in the fridge, reserving eight slices of cucumber. It was time to feed herself.

Sara made her favorite: an opened-faced peanut butter and cucumber sandwich with the cucumber slices lined up neatly across the slice of bread in two rows of four. She ate the sandwich quickly, took another drink from the faucet, and headed for the back door.

The back door was in the laundry room off the kitchen. Here, in the corner, stood a broom, a rake and a snow shovel. Sara grabbed the rake and headed out the door, the old screen closing with a slow squeak. Her dark hair blew across her face as she stepped out into the cool October air and she instinctively swept a strand behind her right ear. Yes, Sara thought, as she headed out into the walled garden; she loved her house and garden, but this time of year made her sad. The memories were everywhere. Her mom had been an artist and had loved to paint outside in the garden, even on chilly days. She had also loved to take care of the garden and in the fall Sara would help with planting and raking. This time of year there would have been chrysanthemums blooming all around the edges and two big baskets of brightly colored gourds and Indian corn on either side of the stone steps. And her mom would have planted bulbs for the coming spring. Sharing this time outside with her mom had been special. They'd always had great talks.

It had been two years now since her mom had gone. What was *wrong* with her? Sara should want to rake the leaves, to keep her mom's garden beautiful, but it just made her too sad. She felt guilty at neglecting the garden and then, again, came that surprising surge of anger. Sara pushed the anger down and went right back to feeling sad. She had no safe place to go; no place where she could just feel plain good for a few minutes. Shouldn't it have gotten easier by now? She remembered a time when she'd often felt happy. Was she imagining that? A time when all four of them had talked, joked and laughed.

Sara stood the rake up in the northeast corner of the stone wall. Well, maybe, she thought, if I could just have a little magic in my life, I could make that rake stand up and come to life like the broom in *The Sorcerer's Apprentice.* This

brought a smile to her face. She looked in that moment like the imaginative, smart and pretty 12-year-old she was. Sara hoisted herself up on the wall and sat, her feet dangling over the edge. "Yes, I will command the rake to rake all by itself and then, with the right words and bit of magic dust, I'll turn the rake into ten dancing rakes!" Sara surveyed the scene in her mind, like a director directing a cast, watching the yard in her daydream get swept clean by ten magical rakes.

Right beneath Sara, Lucinda was still busy at work digging that tunnel. And she was still focused on the probability of giants and how that might work to her advantage. Maybe the giants up the hill could be of some help. She was also realizing some other interesting things about herself. She knew things; those dreams she had weren't exactly just dreams, they were memories! They included all kinds of information; in fact, the very history of her people. Even without her people here, she somehow knew all about them. It was like she had a built-in memory of much of her peoples' history. Just not where they were or what was happening to them now. These memories started somewhere in the past; but in these memories there were images of giants and other creatures. The images were clear, but not the words. The words that came to mind were goblins and elves. Were they real? She had other names for them in her head too, but the words goblin and elves came into her thoughts at the same time. It was as if she had a second language in her head that she wasn't used to using. She wasn't quite sure about all this.

Well, she continued her thoughts, from what I am seeing about giants, I believe they are probably approachable, but I will have to introduce myself cautiously. They are also rather stupid. That is why she was surprised by the ingenuity of this impressive house and garden. Things were obviously different

here than in her native home. Maybe she could do some work for these enhanced giants in exchange for some supplies? They knew what a chimney was. Yes, these were smarter giants than any of her memories showed her.

Lucinda had quickly learned another remarkable fact about herself. She was born a master rhymer. In fact, she was her people's Master Rhymer. It was instinctive. She had invented twenty or thirty funny and useful poems since her moment of birth. The poems comforted her, directed her work, and taught her things she needed to know. They also helped her remember what had just happened. And right now she was being told that giants were particularly fond of rhymes, especially when they were about giants. She would bargain with them for a rhyme. So as she finished her digging and neared the surface, she perfected her rhyme titled "Influencing Giants".

> *"Giants are known for*
> *Their kindness to others,*
> *They treat smaller creatures*
> *Like sisters and brothers.*
>
> *If you've got a problem*
> *Don't question a goblin*
> *A goblin will cheat you*
> *or even worse—eat you!*
>
> *But go to a giant,*
> *Just don't be defiant*
> *And I'm sure that you'll*
> *Get what you want!"*

With this, Lucinda burst into the sunlight, her fingers wiggling in the air—causing a shower of dirt to fall on her face and sending her into a coughing fit.

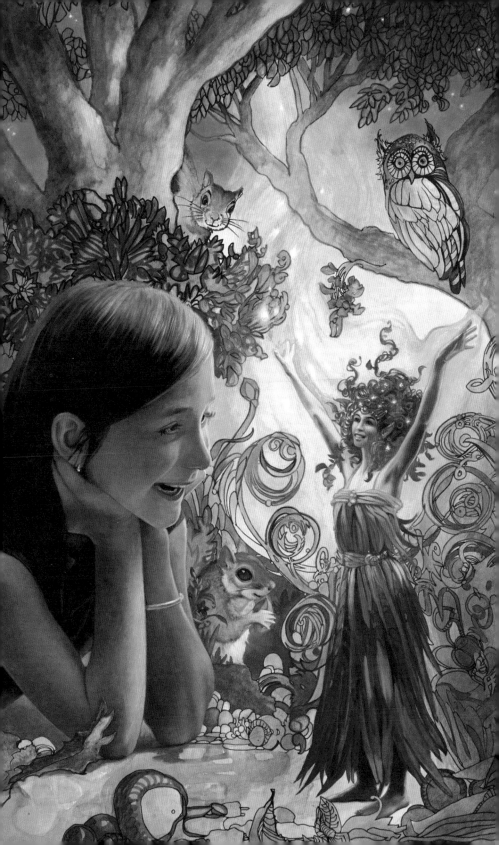

Startled from her daydream, Sara flung herself around on her hands and knees, and the two met face-to-face. Sara was speechless. The little being that met her gaze was beyond belief…beyond reason. And Lucinda, who had an inner visual image of what giants were supposed to look like, was not prepared for the real thing. The face that met her gaze was huge beyond huge and looked to be a different species of giant altogether. Sara's mouth dropped open and her eyes popped wide with alarm. Lucinda's eyes popped even wider, giving her an unintended fierce look…like a rabid rabbit.

"Please, do not eat me," pleaded Lucinda. "I will write you a very nice rhyme. Give me a chance!"

"Eat you?" said Sara, as though the words didn't mean anything. "You don't bite, do you?"

By then, Lucinda's quirky logic had set in and she began to laugh. Her laughter was so natural that it worked like a calming music and flowed right into Sara, who found herself laughing too. A huge, hearty laugh.

"Are you a child giant?" guessed Lucinda.

"No, I'm not a giant," Sara confirmed, still smiling, enchanted and bewildered. Was this *really* happening?

"Well, you look like a giant to me. A nicer kind, I am sure. In fact, you are even larger than my memory shows me."

"Well, I never used to be a giant. But looking at you, maybe I am!" said Sara.

"Well, maybe you are just not feeling too well, dear. I could try and find a taemare tree and make you some tae-bark tea and add in a little memory poem into the bargain. Maybe your memory is lost somewhere, in an arm or a leg, what with your being so big and all."

None of this conversation helped Sara to make any sense out of what was happening. She moved closer to the fresh

opening in the ground and peered down into the hole from which this strange creature had just emerged.

"This is my chimney chute," stated Lucinda nonchalantly, as if this bit of information would clarify everything. "You don't happen to have a pie pan you could part with? I could write you a memory poem in exchange for it. You'd have to write it down of course. Do you know how to write?"

"A pie pan? Yes, I can write," Sara tried to answer the two-part question, hoping she was handling the conversation satisfactorily.

"Then it's agreed!" said Lucinda excitedly. "This is going very well. You see, a giant's pie pan should make an excellent chimney cap for my chimney. Be back with the pan in ten minutes, and I'll have your memory poem ready. And don't forget," she added, a little worried. With that, she disappeared down the hole.

Sara was so flabbergasted that she just sat on the ground listening to the rumbling noises coming from out of the hole. She called, "Hello down there," just to make sure she hadn't daydreamed the whole thing. The little face popped up again.

"Did you get the pie pan already?"

"No, I didn't even go for it yet," said Sara.

"Oh, dear. Poor thing, did you forget?"

"No, not at all. I was just checking."

"Checking what?" asked Lucinda.

"Checking on the size," said Sara, trying to seem casual, moving her hands around the opening.

"A six-inch pan will do fine," said Lucinda.

"Okay, I'm going. Don't run away."

"Why ever would I run away? I live here now," confirmed Lucinda and she disappeared again, shaking her head sympathetically.

Sara ran into the house at full speed and began to clatter around in the lower kitchen cabinets, looking for the pie pans. She was pretty sure this is where her mom had kept them. She hadn't looked for them in ages. She pulled out a bunch of pots before she could get to the pans. She found one big pan and two smaller ones and the smallest definitely looked larger than six inches in diameter.

"Oh well, you'll have to do," she spoke to the smallest pan. She closed the cabinet door and tore out of the house. In a moment she was leaning over the hole, a little out of breath. "I've got the pan."

"Great! Just cover the hole with it and throw a few leaves on top to hide it. I'll punch a couple holes in it later and tie it in place with a pulley cord after I finish lining the chimney and making the ropes."

Sara covered the hole with the pan and scattered a few curled, brown leaves over the pan as instructed.

"Okay, come on down," called an instructive voice from.

Sara lifted the pie pan back up and called in, "I can't fit down here."

"No," laughed Lucinda, her voice loud again, coming up through the chute. "I mean come to my front door at the bottom of the wall below you. I have your memory poem ready."

Sara put the pie pan back in place and threw the leaves back on. Then she leaned over the wall. Her new neighbor was grinning up at her. Now that Sara was "adjusting", she realized the little being was actually rather human-looking and, yes, pretty. Her face was so small and her presence so huge, that how she actually looked hadn't registered. Sara's first impression had been that of a bizarre animated cartoon character! This incredulous being stood in front of the slate

stone that covered an opening in the wall. The little person waved at her to come down.

Sara dropped from the wall to the garden below.

"How do you like my house? There is even a front door. It is pretty heavy for me to push, so I will have to come up with some kind of pulley system for it. That will be trickier than the chimney cap."

"It's neat," said Sara, peeking in at the underground space. She was truly impressed at this being's energy and ingenuity.

"Let me introduce myself, as I now know better who I am. I am Lucinda Vinetrope of the ancient people of Vinetrope, one of a kind and uniquely me." Then she took a bow, raised her arms with a flourish into the air, and held out her hand.

Sara gently shook her slender fingers (which felt as soft as velvet) and gazed into the pretty elfish face which was framed by ample tresses of green leaf-like hair. No, they actually were leaves! Yes, green, like a growing plant. And yes, now that she was truly seeing what she was looking at, she could see that this little person was indeed quite appealing…beautiful actually. Her eyes were large and a fantastic emerald green.

"My name is Sara Umberland."

There was a glow emanating from the general area in which Lucinda stood. Sara assumed the sunlight streaming through the early autumn leaves was adding to the magic of this whole unbelievable situation.

"Umberland," repeated Lucinda, "a fine strong name. You are people of the mud lands, then?"

"I have no idea what you're talking about."

"Never mind, but I do truly appreciate the pan. It is an enormous help to me. I have had to start from complete zero. You have no idea. It is so frustrating. No tools, utensils, or familiar faces of friends, or even foe for that matter. Not a

single vinetrope in sight. It is such a strange land you have here. Where am I anyway?"

"Well, you're in the town of Pinewood, New Jersey, in a much, much larger place called a country, The United States."

"That, sadly, does not help me much. So this then is after the Great Freezing?"

"I don't know," said Sara.

"Well, we will work on these details later. Do not pressure yourself on my account. Not everyone has a gift for historical detail," Lucinda rambled on.

Sara could only nod.

"But some knowledge of history is very important," continued Lucinda. "You have to be able to place yourself in the larger history of giants. I can give you some rhymes for that too — that is, once I have the facts straightened out myself, which I can assure you I do not at this moment. Nothing much makes sense to me. And now, here is your poem in payment for the pan.

"If your arms are too big
And your legs are too long,
Your memories can drift
And get lost or go wrong.

But don't be discouraged,
It's not that you're dumb,
Perk up and get ready to
Learn and have fun.

Let the memories rise,
Let them flow, let them flow
If you let them come forth
They will know where to go.

Let them rise in your brain
I can promise good luck
Your reward will arrive
When they're no longer stuck!

Here's a tip from a girl
Who's a wee bit too small,
Your only shortcoming
Is that you're too tall!"

"How do you like it?" finished Lucinda, raising her arms in the air again as she finished.

"It doesn't make any sense," Sara answered honestly.

"Are you sure? You know, I have only been making these rhyming remedies for a short time and I have so many other things to do."

"No, it's good. It's funny. It rhymes. But I don't see what it's for."

"It is to help with your memory, dear. You had better get a writing stick and board and write it down."

"No one uses a stick or boards. I don't understand this at all."

"But my dear Sara, you have a bad memory. That is why I wrote you a memory poem to begin with."

"I have a great memory," stated Sara firmly, wanting to gain some control over these peculiar interactions.

"Now, now, do not be stubborn. How can I help you with your memory problem if you will not even admit that you have one? No one is perfect."

"But, Lucinda, I never said I have a memory problem."

"You most certainly did. Maybe you just do not remember."

"I do remember, and I never said it," said Sara.

"You distinctly told me that you could not remember if you

were a child giant or not. And that, my dear, is a memory problem!"

"I was joking."

"Joking?" asked Lucinda.

"Yes. I never met a person like you before. We don't have such small people here. Not till you. They only exist in fairy tales, which are make-believe. So when you asked if I was a giant, I felt like a giant compared to you. I didn't actually say I couldn't remember if I was a giant. That *would* be ridiculous!"

There was a moment of silence and then recognition appeared on Lucinda's face along with a spreading smile.

"I see, a joke. Yes, a joke! Well, I like jokes, you know. There is nothing better than a good joke. Most of my kind love jokes. Oh dear, I guess I got this all wrong?"

"Well, a little. It's been confusing for both of us. But you're right about the child part. I'm twelve."

"Twelve? Twelve what?"

"Twelve years."

"What are years? Your language is so different from ours."

"Well, like the seasons: spring, summer, fall and winter." Sara tried to think of a way to explain. "A full rotation of the Earth around the sun, twenty-four hours."

"Yes, yes, it is coming to me now. I have quite a lot of astrological information coming in since you brought up the word rotation. I'm still getting used to your language, so different than Vinetropese. Some words register instantly and others take a moment. I get pictures as well to help me. My translator is wonderful and as we speak it is gaining speed. So, by Earth you mean this world?"

Sara's eyes were bulging with renewed amazement. "You have a *translator* in your *brain*?"

There was more information coming from Lucinda than

Sara could handle at once. Everything required several answers or questions at the same time to keep up. What was a vinetrope anyway? Maybe this creature was actually a fairy and fairies were really called vinetropes? She had wished for a fantastic adventure!

"Yes, it appears I do; a translator and lots of information coming in all the time!" It was as if data was loading up into her mind and this process was confusing to Lucinda as well. "So am I right that you call this world Earth?"

"Yes."

"And by sun?" Lucinda pointed to the sun.

"Yes!"

"We call this world Aven and the sun is called the fieron. But it doesn't matter. I don't need to teach you my language. Twelve-years-old is an excellent age."

"How old are you?"

"I will be one Earth-rotation today at twelve o'clock midnight, well close enough, but it sounds more dramatic to say midnight. I guess you could call me a newborn!"

"That's not possible. Not even a day old? How can you be one day old and speak, know and do so much? You look at least 16. It's impossible!"

"No, it is not impossible. Although I guess I do speak too much and I am a bit bossy and maybe I do jump to conclusions. I will have to write myself some self-improvement poems."

"I don't understand."

"It is a joke," explained Lucinda.

Sara laughed. "No, I mean, I don't understand how you could have just been born."

"Well, you have to understand. I have been very con-fused by how different I have found everything. Nothing is as I expected it. It has taken my mind some time for the

memories, the history, to come forward, into focus. And more is coming in. I think being born in the wrong place has made it all the more difficult. For example, just now, it came to me what you mean by towns, countries and such. These are designated geological areas with boundaries based on groups of people. I can see maps in my mind. We are in a town called Pinewood in a larger area called a state, and so on." Lucinda raised her arms, palms up, to show she understood.

"Yes, that's right. That's exactly right," confirmed Sara.

"And in this short time I have learned some very startling facts about myself. Come inside and I will try to answer your questions. Just give me a hand with this door, will you?"

Sara and Lucinda pushed on the piece of slate together and slid it open wide enough for Sara to fit through. As they entered the little chamber, the whole space began to light up with a warm, pleasant, golden-orange glow. Sara noticed an odd root growth across the dirt ceiling that seemed to glow a bit. But it did not explain this much light. The air smelt pungent but sweet, a bit like warm tangerines and cinnamon. They slid the door shut with some difficulty and the light grew brighter. Sara looked around. She could just stand, bending over a bit, with her head brushing the ceiling. Now she really did feel like a giant…like Alice in Wonderland must have felt when she grew too big for the White Rabbit's house. The length of the room was about double her height. It had a dirt floor and not a thing in it except a few large stones and an exposed length of a pipe running along the floor. There was a large hole in the back wall with loose dirt and stones spilling out onto the pipe.

"I am sorry I have no rugs yet," Lucinda apologized.

"Rugs! I wasn't thinking about rugs."

"Well there will be some eventually."

It was cozy in here. Sara took off her jacket, laid it over a

piece of the pipe, and sat down on it. Lucinda sat down on a stone that protruded from the earth in front of the pipe and faced Sara.

"This old dead root makes a very good seat, doesn't it?"

"It's not a root," explained Sara. "It's just an old pipe."

Lucinda thought for a moment. "Yes, pipes might carry water or waste, I see that. I thought it was odd-looking for a root. I thought maybe it was so old it was petrified, like petrified wood."

It was then, after they were seated, that Sara realized where most of the light was coming from. It was from Lucinda herself.

"You glow!" said Sara.

"Yes, I am a Glower Vinetrope. In the dark we can get quite bright. We can control it; make ourselves glow brightly, dim down or turn off completely. That is part of what I want to explain."

With that she slowly dimmed herself and then turned off completely so that for a moment they were almost in complete darkness except for the faint glow coming from the roots on the ceiling. Then Lucinda turned her glow on again.

"It's wonderful," said Sara, completely delighted. She hadn't felt this enthusiastic in ages. Then she noticed the little bulb-like shapes in Lucinda's hair that blinked on and off. They looked much like flickering Christmas tree lights or fireflies in a summer evening. "In the summertime we have small bugs that fly and light up every few seconds. Just a little blink on and off; your hair reminds me of them. We call them fireflies."

"Really, how sad. They must be distant relatives that have grown completely stupid," said Lucinda.

They both laughed.

"Your glow is beautiful and your hair too; in fact everything

about you is wonderful. You look like a fairy!" said Sara.

"Thank you, I think. So let me see: a fairy is a mythical, magical creature from your legends and stories. Usually they are shown as pretty, mysterious, mystical and hidden from your kind...humans I believe?

"Yes, we're humans!" Sara could only make short statements, she was so overwhelmed by it all. "Yes, that's what fairies are!"

"Well, I'm definitely out of place here. Our people are called vinetropes. Even for vinetropes a Glower is special. Only Glower Vinetropes have the power of internal light."

"Where do you think they are; all the other vinetropes? Do you usually stay hidden from humans? Fairies are always hidden in all our fairy tales."

"Sara, in the few hours I have been here I have come to realize I must not be in my own time. There were no humans in my world. And there are no vinetropes here. Nor did my world look like this. But I don't know for sure how much time has passed. It all feels so complicated and hopeless."

Sara grew thoughtful and pushed her hair back. "Tell me what you know." She would stay calm, be helpful. This was more than an adventure. This felt important!

"Well, as my memories arrive and order themselves, I've learned, as a Glower, that I have stored in me the whole history of my people, the history of vinetropes. Glowers are either historians or healers, kind of like what you call doctors. In the recent memories I see a time of great cold when my seed and many others were sealed away and buried so that our people would hopefully survive the endless winter. My memories stop there. And I somehow got planted here, Sara, and now I am born. But I don't know how long ago it was that we sealed the seeds away. Maybe I'm the only seed to have survived?"

"Wait, wait, hold on. You came from a seed? You're a plant!"

"Of course I'm a plant. All intelligent life evolved from plants."

Sara was incredulous. "But we see it the other way around."

"What! You're an animal, Sara?"

"Yes, of course. I'm a human animal. We are part of the animal kingdom. This is the opposite of everything I've learned."

"This is mind-boggling!" said Lucinda.

"I guess we'll both have to look at things differently now."

"Yes, you are so right. But it feels absurd. Animals were just beasts in our time. Plant life had eons to evolve and we created such a civilization. But where is it?"

"I've never learned anything about it," said Sara. "My brother is really into archeology, and if there had ever been signs of vinetropes he would have talked about it. I can ask him, but I'm sure he would have shared it with me. A world of fairy-like beings! Let's face it. The whole human world would be talking about it."

"Then it must have been quite some time ago that our seeds were sealed away."

"Maybe you'll get more memories. Maybe everything hasn't come back yet. Wait a minute. Didn't you just say something about an endless winter?" asked Sara.

"Yes, that is where my memories end. Does that mean something? Yes, we were dying out. The world had turned cold, all life was dying. The sun was blotted out and our world began to die. That is why we came up with the idea of sealing and storing our seeds in many safe spots. So we might survive."

"Lucinda, that happened thousands of years ago. We call it the Ice Age. We learned about that in school and my brother told me about it, too. Your seed is from thousands of years ago."

"That is terrible news. How did I get here from thousands of years ago? I might be the last of my kind; one stray seed that made it and somehow got planted near your house. This must be what happened. This is not good news."

"You can't know for sure. It's way too soon to know that for a fact. I'll help you find out. I promise. You can count on me. I want to help you. Something very special is happening. It has to mean something special that a vinetrope is back in the world, and a Glower Vinetrope at that. I can just feel it."

"You do make me more hopeful. Sara, I am so happy I met you. You cannot know how lonely I have been feeling; lonely and angry too. Why is this happening to me?"

"I do understand. Oh, Lucinda, I know we were meant to meet and help each other. I've been feeling just the same way. My mom died two years ago and nothing feels right. My family is all changed. I have to be strong for my father. I know he is sad, too. It's kind of scary being with him; his smiles all seem fake to me. He has to work so hard. I don't want him to worry about me, but that makes me mad as well. Why isn't *he* worried about *me*!"

Sara dropped her head a moment, then brushed her hair behind her ear and continued. This was the first time she'd tried to explain to anyone what she was feeling.

"And my brother, Steven, is older and off spending a lot of time with his girlfriend and planning for college. He'll be gone next year. I have friends at school, but none of the kids in my class has had a mother or father die. I feel like they don't understand—can't understand, really. I don't want them to feel sorry for me either. So I never do anything with them after school. They just kind of leave me alone now. So I pretend that everything is normal, like it's just the same as before, but it's not."

Sara felt exhausted from her own outburst. Lucinda climbed into her lap.

"Oh Sara, how terrible this is for you. I am so sorry. I know what a mother is. You are too young to lose your mother. A Glower vinetrope is like a mother to her people. Without their history, they can't know who they really are or where they came from. And I have the information they need to know."

Lucinda's arms fluttered with emphasis and she reached up and patted Sara on her cheek.

"I am born differently than other vinetropes. I am born almost like what you call a *grown-up*. I can help my people right away. All Glowers are like this, born ready to be useful. If there are more vinetropes somewhere, they will need me. They would all be sprouting as babies from those ancient seeds we sealed so long ago; without Glowers to help they will not survive. You have lost your mother and I am a mother who has lost all her children. Yes, we were meant to meet. No wonder you can understand. You've lost so much and so have I. But we have each other now."

"This is all so amazing. I was longing for an adventure and here you are, right here in my own garden. And it's more than an adventure. It's serious. It's really urgent and we must figure it all out. I wonder if I'm dreaming?"

"That is what I have been thinking since I snapped off my stem last night. But now that we have met, Sara, I am sure it is really happening."

"And we'll help each other. We'll find out if there are more vinetropes somewhere. Maybe they aren't so far away. How exciting! We have so many legends about a time when little people existed in the world. And when I think of all the stories ever written, is it possible they are now coming true, that you are a fairy and I am a giant, an actual giant?"

"Let's not get ahead of ourselves. I've already seen how jumping to conclusions works!"

Sara smiled and Lucinda put her arms around Sara's neck.

"You poor child. This is a lot for you in one day, too."

Her hug, though small, was very reassuring.

"We will be there for each other," repeated Sara. "I don't feel alone for the first time in two years."

Now they were both quiet for a moment.

"Lucinda," Sara broke the silence, "you're born knowing almost everything you need to know to survive. How to take care of yourself—like a newborn grown-up! You're made to survive and to know the story of your people. You are a poet and mother at birth. You are here for a reason. I just know it. And if there are more vinetropes, we'll find them."

"Thank you, Sara. I'm learning quickly, and I do have a lot of information to work with, but when it comes to this world, as it is now, I am like a newborn myself. There are thousands of years since I was sealed and buried in the ice that I know nothing about. I will need all the help you can give."

"And I could sure use help figuring out my dad and Steven."

"I bet they are as sad as you, each in their own way. I actually know a lot about family life. I think. At least I have information about it. I would not be surprised at all if vinetropes and human families have many things in common."

"Me either, not after everything we've just said to each other."

Sara was thoughtful again. "And Lucinda, I think it's best if you stay out of sight as much as possible, from us human giants. You can't just pop up and talk to anyone, the way you did with me."

"I understand. Different beings respond differently. I am just realizing what a complicated history we vinetropes have.

What you say about humans was true amongst vinetropes as well. Well don't worry; I am a smart plant and I do get your point."

"And I'm a larger, but pretty smart animal."

They both laughed.

It was getting dark and the stars were coming out in the chill evening sky. Sara heard a car door slam. Her dad was home.

"Then I will see you soon?" asked Lucinda.

"Of course you will; as soon as I get back from school tomorrow. I'll find some stuff inside that might help you. We're best friends, real friends, Lucinda, more than friends."

"Yes! Friendship is highly valued by vinetropes. I'll try and have a friendship poem ready for you by the time you are back. And there are so many other things I can tell you about vinetropes. I am getting more information right now."

"You'll need to tell me everything. In those memories there should be other clues. We'll need to be like detectives."

"Yes, solving the mystery of vinetropes!"

Sara chuckled. "It's like you're reading my mind. You're amazing, Lucinda."

"I know," she confirmed. She smiled a glorious smile and made that characteristic flourish, raising her arms in the air. That meant her enthusiasm for life was up and running again. They slid the door open far enough for Sara to push through and step out into the garden.

Lucinda handed Sara her jacket. "And you are as amazing to me as I seem to be to you. I am counting on you to teach me all about this world of yours," she whispered through the crack in the door.

Sara had a lot of trouble holding in her excitement; should she tell her dad and brother about Lucinda …maybe just Steven? Lucinda and her world seemed to have as much to do with science as with magic. She thought Steven might be able to handle it. In fact, it might make a good way to get close to him again. But she decided not to tell either of them. This was between her and Lucinda at the moment. And besides, it was all so incredulous; even she couldn't quite grasp the truth of it. Had she actually sat with a living, breathing member of the "fairy world?"

Since she had stayed outside till it was dark, Sara actually wound up having dinner with her dad, while Steven was having dinner at Lynn's. Dr. Umberland looked tired and sad. Sara took note of this. Maybe she was not the only one still suffering. She told herself she would find a way to reach him and Steven too. Lucinda would surely have some insight. She kissed her dad goodnight on the cheek with tenderness. His smile, a genuine one, was worth everything.

"I'm heading up to bed, love you Dad."

"Love you too, Honey."

Once in bed, the day's events kept stirring in Sara's mind. Lucinda needed so many things. There must be stuff around home that would be useful for Lucinda.

What about a doll blanket? That would be useful.

What about food? What did she eat, anyway? I'll have to ask her tomorrow, thought Sara.

And clothes—Sara definitely had some old doll clothes in one of her trunks that would fit Lucinda.

Sara wondered what other special talents Lucinda had that she didn't know about yet. There were so many questions to ask. Sara wished she didn't have to go to school the next day.

It took a long time to quiet down. As sleep began to take over, Sara's thoughts became less sensible. Lucinda was sitting

at a spinning wheel and furniture was popping out of the wheel instead of cloth. Fruit was growing out of her vine-like hair. A grass rug was growing up under her feet with glowing mushrooms in it that looked like floor lamps.

As Sara slept, Lucinda sat outside, thinking. Her legs hung down into the opened chute, the pie pan pushed to one side. She looked up at the nearly full moon. It was now exactly twenty-four hours since she had first stepped into this moonlight. She was tired. She had been working almost since the second she was born.

Next to her were three large piles of small stones and pebbles that she had been gathering since sundown. She would push them down the chute and then call it a night.

The air was cool but pleasant. Although a few trees had begun to lose their leaves, many were still green. But here and there a few had begun their transformation into autumn glory.

The moon caught a bit of red, orange and gold along the treetops. The wind rustled the leaves.

It was at quiet moments like this, after a hard day's work, when the body is very tired, that a Master Rhymer writes the best poetry. Lucinda knew this. She could feel the poem growing inside her.

Then it came to her like water flowing from a jug and she poured it into the night air.

"Here is a new world
A world still unknown,
For most it is normal,

For me—a new home.
I look at all twig tips,
Each a life gone to sleep
It means winter's coming
But its life it will keep.
I'm just like a leaf bud
That's had its long sleep
And into this world
I've planted my feet.
And how will I change it?
For I know that I will.
And how will it change me?
For nothing stands still.
Oh world, you are ancient
Yet as new as each day,
I claim you as mine,
Till I'm done I will stay.
And between now and then
I will do what I can,
We'll both grow together
In this ancient new land."

Then she pushed the pebbles down the chute. Inside, the room was dusty from the fallen stones. She coughed a little, but the dust soon settled. The smell made her think of mud biscuits. She would bake some as soon as she got her fireplace working.

Lucinda looked at the pile of stones and had an idea. She made a few trips outside and gathered up several armfuls of dried leaves and then took them back inside. She shaped some of the stones into a lumpy rectangle against the wall and scattered the leaves over the top. Now she had a fluffy bed of leaves on top of a nice stone mattress...the perfect bed for a vinetrope.

Her body sank into the softness and curved into the harder bumps. This was her new world. What was it like? Did more vinetropes exist? What other creatures might live here? Would they be dangerous? Sara told her to worry about humans, not trust them all. Her recent memories about her own history were filled with untrustworthy beings. When the memory of chargons and vinkali came to her, she shuddered. She would tell Sara about them and ask her if they had such beings here, too. If there had been evil in the vinetropes' past, who was to say what evil might be here, in the present. There was so much to figure out. But fatigue took hold and, like Sara, Lucinda fell into a dream-filled sleep.

LUCINDA MEETS TWO FRIENDS
AND RECEIVES A CLUE

Lucinda woke up so hungry that her stomach hurt. She got up, brushed off the dried leaves from her pumpkin-colored dress and slipped out into the morning light. It was cold and drizzling, so she made her way up through the yard under the cover of a line of bushes till she was back at the pine tree where she had been born. She remembered the delicious crop of fungi that was growing on the tree. Sure enough, here it was, a moist stepladder of nourishment climbing up the north side. Some of the ears of fungi were as large as her head. She picked off three of the largest ears and tucked them into a huge pocket hidden in her dress. She knew the pockets were meant for gathering. She would plant the spores into one of the earthen walls in her home so that she could farm these delicious morsels all winter long. She would try to find other kinds of fungi and mushrooms to add to her in-house crop. Eventually she would add a variety of sprouts, berries and nuts. Now she eagerly snapped off a small ear and ate it. It took five more to satisfy her hunger.

As she ate, a roaring noise whooshed by and startled her. Between the trees she made out a large pathway and soon another roaring object went by. In a moment another one approached and this time she watched more carefully. There were humans inside this moving thing. It looked like a moving house. How wonderful, a moving house that could

take you places at great speeds. Remarkable! She wondered if vinetropes could create something like this for vinetropes.

Lucinda was sitting on a discarded broken branch in the nettles when she spotted two creatures on a slope of brown grass nearby. They were reddish-brown in color, had furry tails, and were about her size. They seemed very busy gathering little round objects and stuffing them into their mouths. This might be some other possible food source, thought Lucinda, and she needed to familiarize herself with other creatures in the area; determine who was friendly and who wasn't. She would check this out. The two creatures seemed intent on their work despite the drizzle. They would fill their cheeks, run up a tree for a moment, come back down and then start filling up their cheeks again. Sometimes they would dig a hole and bury a few. They must be gathering food for the winter, just like me, thought Lucinda. I'll try and talk to them. As she stood up to walk toward them, they noticed her. She stepped a little closer. They turned and ran halfway up the tree trunk, then stopped and looked back at her from a safe distance.

They are very nervous, aren't they? Lucinda thought. But I think I can speak their language. It is a simple enough tongue and it seems I have mastered it completely. I don't even sense my translator working.

"Greetings, friends," she called up to them. "You have no reason to be afraid of me."

"You look a bit strange," said the smaller and thinner of the two animals.

"And you look a bit strange to me. But I do envy your beautiful warm fur with the coming of winter."

"Thank you, it serves us well enough. My name is Ekle and this is my brother Apkin. He doesn't like to speak as much as me. And all this extra babbling we've been doing is kind of new to both of us, though I like it well enough."

Lucinda wondered what this meant. She could find out later. But introductions needed to be made first.

"I am glad to meet you both. My name is Lucinda Vinetrope and I come from a place far from here. But due to circumstances out of my control, I have come to live in this land of yours. It is all very strange and different to me."

This was close enough to the truth.

"We don't want to share our acorns," spoke the larger fellow, Apkin.

"Oh, they probably would not even agree with me," said Lucinda protectively. "I have no idea what acorns are."

"Please excuse my brother," continued Ekle with a whirl of his fluffy tail. "No manners. These are acorns," and from his mouth he dropped two of the round items Lucinda had noticed them collecting.

"They are from the oak tree."

"Seeds of the tree?" asked Lucinda.

"Yes. They are tasty and last well through the winter," he explained. "There is enough to share, unless you have a large family?"

"No, no family at all. It is just me."

"Good," said Apkin in a bit of a huff.

"Would you like to come to our home and get out of this drizzle? We were just going to take a break and have a few acorns. That is, if you can climb," invited Ekle.

"I can climb,
much like a vine,
but I haven't done it
in a very long time," answered Lucinda.

Of course, it was in squirrel rhyme, so that the squirrel brothers could enjoy it.

"Ah, a rhymer ... I'm certain I like a good rhyme," said Ekle, "at least now that I think about it. That's part of all this new

babbling and speaking that's come to us. Are you coming, then?"

This was quite a puzzle, thought Lucinda. She would get to its meaning. Reading between Ekle's words she decided it was safe to take them up on their invitation.

"I'm coming," she said, as her hands, arms and toes clung to the surface of the tree trunk.

The brothers made their way to the first branch and waited for her. By alternating her grip between her arms and feet, she was able to make her way up the trunk much like an inchworm does, but faster. She swung herself up onto the branch into a sitting position.

Ekle and Apkin nodded their approval. A good climber deserved respect, wherever she came from and however odd she looked. Right next to Lucinda, where the branch met the trunk, was an opening.

"Please enter our home," said Ekle. "Just climb in."

Lucinda peeked in and turned up her glow. She found a simple dry nest lined with nettles and bits of fur. Pleasant enough, she thought, and moved to the back corner next to a pile of acorns, to make room for her hosts. Ekle and Apkin entered.

"Ah, a Glower," said Ekle, impressed again.

"You know of Glowers? You've seen a Glower?" said Lucinda astounded.

"Oh yes, before the misfortune of our 'misplacement' there were odd stories about the coming of a new kind of creature. It was said that one of them was seen to glow, a Glower. These creatures supposedly lived beneath the earth and were building things. I didn't believe the stories. But then I met a Glower myself, Apkin too. It was real! It was right before our unwanted adventure."

"Really! Tell me, please. Did this Glower look like me?"

"Well, now that you mention it, there is quite a resemblance."

"Boy," said Apkin.

"What?" said Ekle. He was annoyed at his brother's interruption.

"Boy, boy, was a boy!"

"I think my brother might be right. That's surprising. This Glower was a male. I guess that's the difference. His face was thin, I would say, and he glowed blue/white, not an orange/yellow like you."

"Eyes were rounder," added Apkin.

"Yes, and he had a friend who played a pipe of some kind. A lovely music, it sounded like crickets and water and clouds moving."

"Beautiful!" Apkin agreed.

"You saw two of them? A musician and a Glower!"

A blue/white glow! This meant a Healer. Healers always glowed blue/white. And there was already a grown adult flute player?

"Where was it that you saw them? Can you take me there?"

"Too far," said Apkin in a rather flat voice. "Too far to get there." It was as if his language skills were not fully functional.

"Yes, much too far," agreed Ekle. "It was before the terrible misfortune that befell us."

"What misfortune?" Lucinda questioned, concentrating on this repeated reference. She had to contain her excitement. This could be helpful information.

"The barrel accident," explained Ekle. "You see, we used to live very far from here with our mates. We each had our own home in a grove of oak trees."

"It was a terrible accident," repeated Apkin with a bit more emotion in his voice.

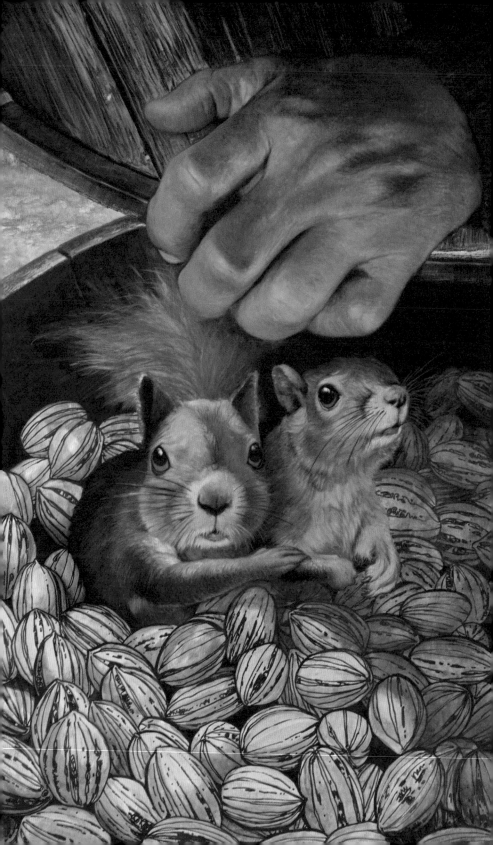

"We were gathering as usual, Apkin and I together, and we came across what we thought was a great find—a whole barrel of pecans. There were several of these barrels, just standing about. We thought, great luck, because the cover was off one of them. We jumped inside and filled our cheeks. We were going to jump out and get our mates so that we could empty the barrel out more quickly."

"Very bad plan," grumbled Apkin shaking his head.

"Just then," continued Ekle, "we heard human voices. Before we knew it a huge pail of nuts was dumped on top of us. Then the cover went down and everything went black."

"Terrible cover," Apkin affirmed.

"Then, almost immediately, we were loaded onto one of those fast moving human wagons; the kind that moves itself."

"I've seen them," confirmed Lucinda. "But I think one of the humans controls them somehow."

"Whatever," said Ekle, annoyed again at an interruption. "And then we were moving, fast, and we couldn't get out. We went on and on, far away from our mates, our home; our father's home. We just kept going until we got near here. A human took us down off the wagon and opened up the barrel to show another human the nuts. We jumped out and ran for our lives. Those humans were sure surprised!"

"How terrible for you," Lucinda sympathized.

"Yes!" the brothers said simultaneously.

"How long did you travel before you got out?" asked Lucinda, trying to get some idea of distance.

"Long, long time. Terrible dark time," said Apkin.

"A whole day's worth and I'm sure a night's worth, with stops on and off. One stop was very long and I'm sure that was a whole night. Everything got quiet and we just waited and waited. Then it started up again and it seemed forever," Ekle

tried to be more specific. "It was very hard to tell in the dark and it was frightening."

Lucinda could tell from his evaluation that Ekle was a thinker. "Yes, that sounds like it's far from here," agreed Lucinda, in a disappointed voice, "considering the speed of those wagons. Do you know what direction you were traveling?"

She didn't expect an useful answer.

"Don't know, too dark, too terrible," said Apkin.

"Well, let me think," said Ekle. "When we left home it was a pleasant enough day, but when we arrived here it was a bit on the chilly side, so maybe we were moving north." He seemed pleased with himself. "I know it gets colder earlier as you go north because my brother-in-law was from the north. He told us about it. He hitched a ride down on a long line of wagons with cows in them and started a new life. Also, when we got here, the trees had more color. That is the main point. So I'm pretty sure we were moving north."

My this Ekle could rattle on, thought Lucinda.

"We were scared, we had no nuts gathered, and no place to live, but now we do," said Apkin in his longest and most complicated sentence so far.

Ekle looked surprised at his brother's wordiness and then continued. "And we've had it confirmed from the other squirrels around here, who are gray and not red like us, that it does get a lot colder here in the winter than it did where we came from. My brother-in-law was telling the truth. And that worries me!" Ekle concluded with great force.

"That your brother-in-law tells the truth?" Lucinda laughed.

Ekle started to get mad and then smiled sheepishly. "I'm just worried about all this snow they talk about."

"I don't think I like it so cold." Apkin tightened his front paws against his chest.

"Then how long have you been here?" asked Lucinda.

"Oh, a couple weeks," said Ekle.

"That recently!" Lucinda was surprised.

"I miss my sweetheart," added Apkin.

"I understand," Lucinda risked patting his head sympathetically and he accepted the gesture quite easily. "It's all a bit of a shock for me right now, too. I've just arrived myself quite suddenly, and I also need to do much before the winter arrives."

"We'll help if we can," said Ekle in a friendly voice. "You can pat my head too."

She did. They were just adorable.

"Then tell me, please, whatever you know about this other Glower and his friend. If they are like me, then they are vinetropes. I'm a vinetrope. What did they say to you?"

"Didn't say much," continued Ekle. "Just said good day and the other one just said he was practicing his flute. He played that beautiful song for us and they left."

Lucinda had hoped for more but was thrilled to the core anyway. She was not alone! She was not the only vinetrope in this transformed world. Wait till she told Sara.

"And now that I think about it, that was another rumor," continued Ekle. "Our ability to talk to other animals began not long after the stories about the arrival of your kind. Vinetropes you say you are?"

"Yes, we are vinetropes.

"Yes, over many weeks, some of us began to talk to each other and realized we knew what we were saying between us; squirrels and chipmunks and such."

"And the owl," Apkin added in a low voice.

Lucinda didn't seem to hear this. "So then it was true, you began to talk to other animals?"

"Yes, I guess that does make it the truth."

"We are talking to you," Apkin added.

Lucinda nodded.

"And too much of it at times!" Ekle complained, but Lucinda wasn't sure he meant to criticize himself or his brother, who seemed to be catching on.

"So these stories must be true? There are other vinetropes."

"Well we just saw the two. But as I said, there was talk of many more, busy building under the ground near where we lived. There are patches of grass that they've done something to that became extra green. I saw these patches."

"Makes grass and plants healthier and stronger," Apkin added smoothly.

"Yes, that was the theory. Maybe that's true, too. I never put all these facts together till now. I can't imagine why not? It now seems so logical."

Apkin pointed his paw at Lucinda.

Lucinda laughed.

"Yes," Lucinda confirmed. "Vinetropes have always been able to give the gift of speech to those who have a hidden talent for it. I guess being near them, before the barrel accident, has given you both this gift."

"Then you are special, and can gift speech too," confirmed Ekle.

"And you're a Glower!" added Apkin, swirling his tail.

"And that must be even more special," noted Ekle.

"Why are you here?" asked Apkin.

A wise question and Ekle looked sharply at his brother for asking it.

"I was just going to ask the same thing."

"It seems, somehow, I've become separated from my people."

"And you need to be with them," concluded Ekle.

"And we need our mates!" finalized Apkin.

"Yes, boys, and we may be able to help each other. I will need to find a way to get to the place you call home. And when I do, you will come with me."

Ekle lifted both paws in the air. "That would be wonderful!"

Apkin somersaulted and banged into Ekle.

"But that will not be an easy task. We will need to meet and share many more stories until we can figure out where your home is. And then we have to figure out how to get there."

"We will," said Ekle. "Here, try an acorn." He was so grateful and hopeful and he wanted to show his appreciation. "You bite it like this," he demonstrated. "And then you eat out the meat from inside." And he demonstrated again.

Lucinda gave it a try and popped a piece into her mouth. To her delight it was delicious.

"These are terrific," she exclaimed.

"Too bad," said Apkin, and then he quickly dropped his head down in shame.

"I won't be greedy," assured Lucinda. "I'll gather a couple of piles about the size you've got here and use them in my mud biscuits to make them more nutritious."

"Oh, there's plenty," said Ekle graciously. "Don't mind my brother—he's a grumbler and always will be." He then laughed out loud quite jovially with a hearty squeak.

Apkin was still embarrassed. He apologized by offering another acorn to Lucinda with his front paws. It seemed the boys had a sense of humor and a sense of honor.

Lucinda joined them in a few more acorns and then decided it was time to get back to work. She could see that

their concentration on more serious considerations was wearing out. They would have to build endurance for this thing called thinking. But now they would be very motivated to think of anything that might help.

"I'm heading out now, but before I go, do you know where I might find some tall grasses? I need to weave a great deal of rope over the next few days," asked Lucinda.

"Oh, yes," said Ekle. "No problem—look in the yard next door. It is sunnier over there, like a field. Along the back wall you will find plenty of tall grass. They don't chop it down as carefully as some humans do," he explained.

"Strange habits," said Apkin.

"They're not dangerous, these humans?" Lucinda was curious to get their opinion.

"Well, usually they leave us alone. But you never can tell for sure," Ekle shrugged his shoulders. "They can go for months ignoring your existence and then suddenly they'll take an interest in you. They'll stand around watching you like they've got nothing better to do. Even feed you fancy nuts! And then, without any warning and for no reason I can ever figure out, they'll turn against you, setting traps. They've even gone as far as cutting down the trees. Be very careful in your dealings with humans. Keep out of their way, that's what I suggest."

"Keep away," repeated Apkin with a slow and gloomy shake of his head.

"The girl, Sara, is my friend," said Lucinda, thinking out loud.

"These humans do have some pretty strange ways," insisted Ekle.

"Keep away, it isn't safe," Apkin kept up the head shaking.

"It's up to you," said Ekle. You're a Glower, so I wouldn't tell you what to do. I'm just saying to be careful."

"Well, thank you for your advice. I have to be on my way now. I have so much work to do in my home. But I will tell you what. Would you like to join me tonight in my home for refreshments and a few good poems?"

"That would be very nice," said Ekle.

"I like that idea," said Apkin.

"But where is your home?" asked Ekle.

"Down in the lower garden at the north wall, behind the flat stone."

"That's a house?" said Ekle.

"It is now." Lucinda she fluttered her arms to emphasize this fact.

"Okay, we'll be there after sunset."

Lucinda headed to the sunny wall with all the grass, but on her way she picked up a few handfuls of acorns and put them in her convenient pockets.

Sara came home from school filled with expectation. She'd had trouble concentrating in class. Jamuna, a classmate who she had become friendly with just before her mom's death, caught up with her on the way out of class. She'd asked Sara what she was doing for Halloween. Everyone called Jamuna, "Jam" and she was a really nice girl. Her parents were from India, but Jam was born in the United States. Jam had a brother named Danvir, and he was nice too. Sara had not bothered going trick-or-treating since her mom had died. The last time, two years back, Jam had joined her, with two other girls, for the

evening. It had been fun. Sara didn't mean to be rude to Jam, but she just wanted to be with Lucinda. So she told Jam that she'd get back to her, that she had to get home right away for an appointment. Well, she wasn't lying, was she? She had an appointment with Lucinda.

The drizzling rain had stopped and although the sky was still gray, it was not dull and gloomy. Instead, the atmosphere had the charged excitement of a blustery autumn day. This was the kind of weather that made you think of things like what costume you wanted to wear for Halloween. So Sara understood why Jam might have been thinking about it, too. But why did Jam want to talk to her about it?

Despite the excitement of Lucinda and thinking of Halloween, the habit of sadness momentarily returned. Halloween made Sara remember all the great costumes her mom had made for her. Her mom had been playful and had a wonderful sense of humor that flowed through the whole family. That was the worst part; her father had lost his sense of humor. Steven still had his, but he saved it for Lynn and his friends. How could any of them be happy if her mom was dead? thought Sara. It didn't feel right. She felt guilty and angry that she had to feel guilty. But last night her dad had seemed so happy when she kissed him goodnight. She saw his mood lift. How long had it been since she had kissed him goodnight? Could her actions affect him? She had never thought about that before. And then she thought of Lucinda. Everything was going to change. She was sure. Lucinda needed her. And Lucinda understood her. She felt her own mood lift.

Sara let herself into the quiet house and ran upstairs to her bedroom to quickly find a few useful gifts for Lucinda. She went to her old wicker toy chest and started to rummage around. She discovered two suitable doll blankets from when

she was five or six. One blanket was a solid baby blue with satin edging. The other was a blue and green flannel plaid. Sara dumped her books out onto the bed and stuffed the doll blankets in. Her anticipation was too great to look for anything else. She made a brief stop to feed the fish and then she headed straight for Lucinda's front door.

"Lucinda," she called.

There was no answer.

"Lucinda." There still was no answer. I guess she's not home, maybe she never was, Sara thought. Then her whole body slumped.

"Is there something wrong?" asked a familiar voice.

Sara turned around to see Lucinda standing behind her with her arms full of long grass.

"You look like you've lost your best friend," teased Lucinda with a sweeping grin.

"I almost thought I did."

"Well here I am. Come in a minute, I have the most amazing news to tell you!"

They pushed inside and Lucinda turned up her glow. The entire room was filled with grass, reminding Sara of the fairy tale, *Rumpelstiltskin,* in which the king ordered the farmer's daughter to spin mountains of straw into gold. There was also a pungent smell that was new. It smelt like concentrated pinecones.

"What's all this for?" asked Sara.

"Grass for rope, pine tar to line the chimney chute. I will explain later. We have more important things to discuss now. Sit down."

Sara noticed a particularly fluffy pile of grass and sat.

"Ouch!" she yelled as she hit her bottom on what felt like rocks. Her schoolbag landed at her feet.

"What is this?"

"Oh, sorry, that is my bed. It is all covered up with grass."

"Your bed? It feels like a pile of stones!"

"It *is* a pile of stones. Vinetropes like a very firm and bumpy mattress."

"It's more than bumpy. It's lumpy and sharp. You don't like soft things?" asked Sara, settling herself into a more comfortable position.

"Well, yes and no. We do like to pile a nice layer of dried leaves and grass on top of the stones and then cover it with flintel cloth. If you had realized the bed was there and sat down more carefully, I think you would have found it pretty comfortable."

"That's okay, I'm pretty comfortable now," confirmed Sara, wiggling a little to show she was. She was ready to pull out the blankets, but Lucinda kept going.

"Sara, this is not the time for discussing how I make my bed." She sat on the bed next to Sara, arranging her dress around her legs, her bare feet sticking out.

"I have the most exciting news! I have made friends with two brothers, animals you call squirrels. These two live in that big oak tree in your side yard."

"You spoke to them?"

"Yes, squirrel talk, very easy for me. Let me tell you everything. The brothers call themselves Ekle and Apkin."

"They have names?"

"Yes. Ekle can speak with greater ease than Apkin, but Apkin kept getting better the more he spoke with me."

"What did they tell you? What's so exciting?"

"I am getting to the exciting part. They have met another Glower, a male, a Healer."

"What? That's amazing. Just since yesterday this happened?"

"This morning. And there was a musician vinetrope as well! He played a vinetrope pipe."

"A full-grown vinetrope?"

"Yes, a Glower, and a vinetrope who must have grown up from one of the sealed seeds. That is my logical conclusion. And if that is right, then these vinetropes have been here longer than I have. It could mean a lot more vinetropes, Glowers, adult vinetropes, babies, a whole colony!"

"That's fantastic! Oh, Lucinda, I'm so happy for you! I knew there had to be more vinetropes. So they're close by? When can we meet them? Where are they?"

"Well, that is the big problem." Lucinda explained her conversation with Ekle and Apkin, and the barrel "catastrophe". It got Sara laughing quite few times, despite the disappointment of not knowing where these boys came from.

"So wherever the squirrels came from is where the other vinetropes are. And I am sure that is where I came from, too. The brothers' history and mine are linked. It has to be. I'm a Glower and both of them have seen a Glower and all three of us are here in your backyard. I do not think that could be a coincidence. But it could be quite a distance to get to where the boys came from. And as yet we have no idea where 'there' is."

"We'll figure it out. We've got to. But this is great news. It means you're not alone, Lucinda—you're not the last of your kind. Yes! Fairies have returned!"

Sara picked Lucinda up and swirled her around and then put her back on the bed, sitting down again herself, much more gently this time.

"I hope so. I'll need to talk to the squirrels more. They may remember more than they think." Then Lucinda explained what she knew about the gift of speech. "They were getting better at it every minute I spent with them."

"So by being with vinetropes, animals can start to speak to each other?"

"Yes, by exposure to us directly or by living in the area in which vinetropes live. Language will flourish.

"All squirrels will talk now that vinetropes are here?" Sara was incredulous.

"No, no. Only some who have a knack for it. Other animals as well, it would seem by my logic."

"And this was true back way before the Ice Age? Creatures talked to each other?"

"Yes, we had many evolved plants that could speak. And to each other as well, if they took the time to learn the other's language. The plants today would never be able to make that leap. Sadly. I, of course, have a translator, so I don't need to learn other languages, the translator does the work for me."

Sara stood up and paced the room, hunched over a bit, as she digested all this information. She brushed the odd roots that were growing on the ceiling with her fingertips and slipped her hair back behind her ear.

"So there were many kinds of evolved plants back then? Enough that they could speak! Now, here, only humans talk, at least till now."

Lucinda had been following the pacing with her emerald eyes. It was a lot to explain to anyone. She pulled her knees up and folded her arms around them.

"Yes, we had what I believe you call *elves*. We called them felgins. And there were our giants, ginboks, and vinkali and chargons. But the old names don't matter and they weren't exactly like your legends anyway. It is the only way I can explain them to you, by comparison."

"And you all lived in peace? You were all friends?"

"Oh my goodness no! The felgins were friends, but vinkali and chargons were our enemies. They lived together and

the vinkali were ruled by the chargons. They were like bad children, those vinkali—a bit like goblins—and they seemed to belong to the chargons. And the chargons were terrible. I can't find a comparison in your language."

"You mean the chargons were evil?"

"Oh, yes. Chargons enslaved us many times throughout our history. They were much bigger than us. Bigger than you, Sara! They had a mist that came out of a horn on the top of their head, and that mist would paralyze us for a time. The vinkali would help with the gathering and throw us on carts pulled by slids—what you call lizards. They'd take us back to their homes in the swamp and make us slaves."

"We have a lot of slavery in our history, too."

Lucinda unfolded her arms and lifted them up while she emphasized her point.

"I'm not surprised that the good and bad would be in both our histories. Many of us died while we were enslaved by them."

"What did they make you do?"

"Everything! They are strong, mean and lazy. We built their homes, grew their food, cooked their meals. But what they really wanted most of all was vinetrope energy. What you call fuel."

"Vinetrope fuel?" Sara was beginning to see that the world of vinetropes did have many parallels to the human world.

"Yes, our fuel is much like controlled sunlight."

"Usable sunlight? Clean fuel? How can that be?"

"I believe your primitive plants use a weak version of our energy, or I should say a part of the process."

"It's called photosynthesis. My dad used to talk about it all the time and we learned about it in school. Plants give off oxygen as they live, which animals need and animals give off carbon dioxide as they breathe, which plants need."

"A mutually beneficial relationship. That's a good start," noted Lucinda.

"But that's not the way our fuel works. It's not naturally built into us. We use oil, gas and coal. We change it into electricity and that's how we heat or cool our homes, run our machinery, our cars, everything. But it also causes pollution, which means it makes the air and earth dirty. In fact it's the main project my dad's working on right now; trying to find a clean energy source for the world."

"Why would fuel make anything dirty?" Lucinda was genuinely taken aback at this ridiculous concept. "It's meant to keep everything healthy and growing!"

"Clean usable solar energy? That seems just as strange to me. But wonderful!"

Science and fantasy were merging more and more into the same thing for Sara. Lucinda's world was in the distant past. But it was starting to feel like it was in the distant future!

Sara sat down again. She was overwhelmed and excited. She pushed all her hair back with both hands behind both ears with force. This was a lot to think about. Clean energy, animals starting to talk. Where would this all lead?

"We didn't mean to make pollution," Sara explained. "We invented all these great things and then we found out afterwards about pollution."

"Great things like those moving wagons you control?"

"Drive, yes, the cars."

"I will call them cars. Wagons just stuck in my head for some reason."

"And there are also airplanes, jets," Sara added.

"Cars that can fly! Is that what my translator is telling me? Incredible! Well, you have got all these great things that have been invented. There has to be a way to create fuel that is clean.

It is a problem that needs to be solved. If I learn more, maybe I can help, or maybe my people can. Some vinetropes were like your father—scientists. But they worked on other things. Time will tell. But vinetrope fuel has always been clean. You see these roots on the ceiling?"

Lucinda waved her arms at the ceiling and Sara looked up.

"Yes, I keep meaning to ask you about them."

"Well, all I do is unhook my watering vine." Lucinda demonstrated by releasing a long green hose-like vine that was concealed in her hair. "And then I spray." She sprayed the ceiling in a fine mist of what looked like plain water. "And then the magic begins. The roots become alive with vinetrope energy and begin to change. Over time, they begin to perform many tasks. Try it yourself. Press here."

Sara took the vine in her hand and took note of where Lucinda pointed. There was a thick ring around the vine close to where it ended. She pressed and a fine mist of vinetrope fuel hit the ceiling.

"That's fun!"

"Yes, like watering your garden. The daily spraying changes the roots so that they can do different things. They change on a deep level. I think you use the word *code*. They are coded to work differently. In time they heat our homes in the cold by generating heat and they cool our homes when it's hot by releasing the heat back into the air. They give light and the strength can be controlled, just like a Glower does, but with a dimming knob grown in place so regular vinetropes can use it. Why, there were even vinetrope artists in the past who used the roots to create sculptures and beautiful artistic wall coverings on their walls. I have pictures in my mind of incredible architectural feats at the height of vinetrope civilization."

"My mom would have loved to hear about that!"

"She would have. Vinetropes loved to create beauty. But chargons wanted power. That's the main reason chargons enslaved us; for our fuel. And then, when they had us, they put us to work."

Sara stood and began to pace again.

"We have so many problems in our world and a lot of them are over fuel. I don't understand it all, but I know countries have fought over it. My dad feels clean energy would change the world. Make it better and safer."

"I agree. Energy should be a source of goodness. But it wasn't always in our time either. Chargons definitely did not put it to good use."

Sara now intentionally brushed her fingertips lightly across the roots. She examined them more closely. They gave off a pulsing glow of pastel colors. These roots were still pliable, some soft, but others were now bristle-like, with hairy points, like the fine hairs on a cactus. Others were so fine they looked thinner than a strand of hair. On closer examination, some looked like minuscule pipes.

"They are beautiful. They aren't very warm."

"That's because they are not mature. It takes a full season for the roots to be mature enough to heat a home or cool it. That is why I must have a fireplace ready for this coming winter. The roots will look very pretty in another week or two, long and graceful, but they will not be mature enough to do the job."

"And all this energy…it's completely clean!"

"Of course! It is food, we feed it to our babies."

"Really!"

"Yes, it is food and fuel."

"Do you know how it works?"

"I've never really thought about it. How do your lungs breathe? I'm sure there's an answer, at least a description of what is happening, but do you think about breathing or do you just breathe?"

"I'm beginning to think vinetropes are more advanced than humans."

"But we never had all the things you have, like your cars. Everything in our world was made from plant life or from natural rocks and stones. Maybe vinetrope fuel would not work for these new inventions of yours. I would need to learn a lot more about your world and maybe, if I find my people, there will be a way we can help. After all, this is our world now too, and we do not want it made dirty or ill or torn apart."

Sara sat again on the bed with no discomfort. It was becoming second nature, to sit on a vinetrope bed. She crossed her legs.

"And I'm also thinking that if everything in your civilization was made from plant life, nothing would be left to find! That's why no one has ever found any remains of vinetropes or felgens, chargons or vinkali. There is nothing to find!"

"You are so right! What a smart thought. You would only find the old bones of those poor or dreadful animals that did not make it."

"And that's just what we found! By dreadful, what do you mean?"

"Oh, I think you call them dinosaurs…or is it dragons? The two words are mixed up in my head."

"Wow, I wonder which Ice Age we're talking about? How far back do vinetropes go!"

"There's more than one?"

"Yes, Steven told me. He loves learning everything about how the earth evolved. So you lived when there were dinosaurs! Did any breathe fire?"

"Only the ones that flew."

"So there were dragons!"

"There were many dinosaurs. The slids, that pulled our carts, were the smallest of all. And we sure had to watch where we were going. That's one of the reasons our civilization was underground."

"Lucinda, I'm having a crazy thought. Crazier than any we've had so far."

"What?"

"You had all these other kinds of advanced plants, good and bad. If vinetropes are back, could that mean that vinkali and chargons could come back too?"

The two looked at each other with the same popping eyes that they had when they first met. But they were meant for this scary thought, not for each other. It was so quiet it felt like neither of them was breathing.

"I hope not!" Lucinda broke the silence.

"But is it possible?"

"Well, I only have a memory of us sealing our seeds to survive. I was a seed back then, not a living Glower participating in the final days. I do not have the details of every vinetrope and every living thing and just exactly what they did. I only have the general knowledge of what happened."

"So it could be possible?"

"It is not very likely, but I guess it is not impossible. We would not have intentionally told the chargons or vinkali what we were doing."

This was new and serious material to think about. They were trying to take this all in when they both heard a, "Pssst. Pssssst."

"What's that?" said Sara.

"Not sure."

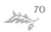

"Pssssssssssiiit!"

Then two reddish furry faces, a thin one on top of a round one, peeked through the crack in the door.

"Why it is Ekle and Apkin. Come in, boys."

The pair scurried in and stopped short, froze actually, when they saw Sara.

"Hi boys, I heard the good news!" Sara tried to show she was friendly.

"Start backing up slowly," said Ekle. Apkin listened to his brother for a change and began to move slowly backwards.

"What are you doing?" Ekle whispered to Lucinda. "I thought we warned you about humans. Now it's too late."

"Too late, poor Lucinda," added Apkin, shivering a bit with his tail out the door.

"Oh nonsense," said Lucinda. "Sara is a true friend. In fact, I even wrote her a friendship poem, although I haven't had a chance to tell it to her yet," as if that proved the point of Sara's trustworthiness.

"I don't know," continued Ekle. "She may be fine, but what about the others? Might draw their attention. Best not to associate with their kind at all."

Apkin just shook his head in disapproval.

To Sara, the conversation sounded like a lot of squeaking. She guessed they were using squirrel talk.

"What's going on?

"I told you, they do not trust humans at all."

Sara knelt down to converse with them and to assure them of her good intentions. They began to tremble more violently, and backed up a bit more. Only Apkin's head remained inside.

"We're just leaving," said Ekle.

"Wait," said Sara in her most cheerful voice. "Lucinda told me all about you. I love squirrels."

"Oh dear, this is bad, bad, bad!" said Apkin.

Sara misunderstood the squeaks to mean they were answering her and felt encouraged.

"You two are handsome boys. We don't have furry red squirrels around here, but then you're not from around here!"

"Terrible, terrible, terrible," said Apkin.

"You're making a mistake?" squeaked Ekle."

"Big teeth," said Apkin looking at Sara's smile and he trembled even more.

"They're shaking all over," said Sara, finally realizing how scared they were.

"Well, that's because they're terrified of you."

"Yikes. I'm sorry. Try and explain to them that I won't hurt them."

"I have. They are very angry at me and want to get out."

"I can't understand anything they're saying."

"That is because I'm speaking squirrel to them. Not English."

"Well tell them that I make a solemn vow never to tell anyone I've met them."

"I'll do my best." Lucinda passed on Sara's message.

Ekle acted indignant. "You don't know anything, Lucinda. You just got here. Didn't even know what acorns were, let alone squirrels. What do you know of humans? Did you know that sometimes humans eat squirrels? Did you know that?"

"Oh dear, oh dear, don't talk about it!" was all Apkin could say in response to his brother's tirade. His paws came up in front of his eyes.

"Really! I will ask her what she knows of this. Sara, they insist that humans eat squirrels."

"Oh no, no, not at all, no one in my family has ever eaten a squirrel. We eat a lot of chicken. But never squirrels."

"She swears she and her family never eat squirrels," explained Lucinda.

"That may be true," accepted Ekle, "but her parents could decide to poison us or cut down our trees at any moment. And all humans have eaten squirrel in the past. They have a cruel history. You can be certain that one of her ancestors ate squirrel!"

Although Ekle was assertive he didn't seem quite as scared. Nothing bad was actually happening. Apkin still backed out the door except for his head, but he had taken his paws off his eyes and was looking around Lucinda's home.

"What did they say?" asked Sara.

"They are just not accepting you yet. They have a rather long list of complaints about humans; a whole history it seems. But they are still here."

"I'm so sorry they feel this way. We need to work with each other."

"They are not going to change their minds right away. And even if they did, they would not let me see it just yet. They have a lot of pride."

Lucinda turned to the boys and spoke to them. "I understand you are nervous and trying to protect me. But you also showed me respect yesterday when we met." She then purposely turned up her glow to remind them who she was. "I won't give up my friendship with Sara. I know she is a dear friend. You will have to trust my decision."

"What's happening?" asked Sara.

"I told them that I would be your friend no matter how they felt; that they needed to respect my decision and trust me."

"Thank you, Lucinda. If you need to talk to them now, I'll leave if you think it's best."

"No, no, not at all. That would give the wrong message. I believe they will come around in time. They need to see that I am serious."

Ekle suddenly interjected, "Does this mean no poems tonight?"

Lucinda smiled and gave Sara a wink.

"No, Ekle, I will still be glad to visit with you this evening. But just know, there may be other times when you come visiting and Sara will be visiting too. You will have to be nice to her or leave."

Then, turning to Sara, "There is no need to worry, I think with time we can work this out."

Apkin spoke up. "What should we do? I like rhymes," said Apkin. "And you are a Glower. That is special." The squirrels both nodded with respectful resignation.

"Maybe we'll come and maybe we won't," said Ekle, not committing. "We'll think about it." A bit of false pride was setting in.

And then the brothers were gone.

"That's too bad."

"No reason to worry, Sara. They will come around. I can tell already. And if my gift of language keeps growing in them, they will eventually be able to talk to you and you to them. We just need to be together a bit more, all of us, and then all will go well."

"And if we understand what we're saying to each other, we will be able to trust each other more."

"Exactly! But that is because you can really trust each other; which brings us back to the chargons and vinkali. There will be no trust there if we are so unlucky to have that happen. It will not matter what we say."

"So you think I might be right? They could come back?"

"I am just saying we need to be prepared. We need to recognize it is a possibility. So much is happening, changing."

"Yes, squirrels talking, giving clues, a Glower and a musician vinetrope. The whole world of animals could start to speak! And clean energy! There's so much going on since just yesterday."

"We do not know yet where this is taking us. There may be a small group of vinetropes alive and if so, I will still need to get to them. We do not know for sure if vinetropes are returning in great numbers or if we can even survive in this world for a long time. We surely do not know about the chargons, vinkali, and all the others plants—that is just a theory, a possibility. And we are a ways off on discussing clean vinetrope energy for this world you humans have created."

"I know, we can't just hand you over to my dad and his team at the lab."

Lucinda nodded in agreement. It didn't need to be said. Who knows what would happen to her.

"I know my dad wouldn't hurt you."

Lucinda raised her arms halfway up, "But they might together, as a team of scientists, consider me for long term observation."

"Like a fancy lab rat."

Sara didn't like to think this of her dad and the other scientists, but she knew Lucinda had a point. It could mean so much for humanity, and they would consider that first.

"Don't worry. I won't tell anyone about you."

"Not yet. As I learn more and remember more I can see that, from now on, I will need to be a bit more careful with what I say to whom."

"I'm glad you didn't feel that way when you met me."

"I was just a newborn. I am so much more mature now."

They both laughed. Lucinda's hair flickered on and off and she sat with her arms around her folded knees again. She was thoughtful.

"What we need to focus on now is gathering more clues about where Ekle and Apkin came from. And I have to get my home ready for the winter, get my fireplace finished, and a pulley system in place to open and close this door. It is annoying to have to keep pushing it open and shut."

"The blankets!" Sara screamed and Lucinda fell backward on the bed as if a giant had blown her over.

"I'm sorry! I'm just excited to show you."

"Not a problem, just give me a little warning next time!"

Sara pulled out the two blankets from her schoolbag. "Here."

"Blankets, beautiful blankets! Thank you so much Sara."

She jumped right into Sara's lap, put her velvety arms around Sara's neck and gave the girl one of her little kisses as light as cotton candy. Sara grinned from ear to ear. It made her happy to make Lucinda happy. It was kind of like she had felt with her mom, but not exactly.

"This is more than I could have hoped for. They are wonderful over a bed of stones and grass. And they are as soft as flintel cloth." She rubbed a blanket on each cheek. "You see, I do like soft things."

"I wasn't sure if you used blankets. I might be able to get you some clothes too, if you could use some.

"That would be wonderful. I never, ever, could possibly have grown enough usable plants to weave cloth and sew clothing before winter. All I really need is a nightgown to sleep in and some kind of old work clothes. Shoes would

be great, too." She wiggled her bare feet to make the point. "Then I would only have to use my special birth clothes for entertaining and holidays."

"So your dress comes off. I was wondering about that."

Lucinda laughed.

"We Glowers are born with our best clothes on, you know. They're especially grown and custom-made for each one of us."

"It looks so beautiful on you."

The dress did seem perfect. The fabric was almost the same hue as Lucinda's skin, only darker, a rich pumpkin color with green leaf-like accents. There were golden threads woven throughout the dress, and feathery attachments, which gave the fabric the impression of being dusted with gold and feathers.

"I have a couple of dolls just about your size," continued Sara. "I haven't played with them in ages. I'm sure they can spare some clothes."

"Sara, you are such a good friend. And that reminds me. This would be the perfect time for me to recite your friendship poem.

"Yes, please!"

"Well, then, here it is," said Lucinda.

> *"When a friend is a friend*
> *Like you are to me,*
> *You see joy in their eyes*
> *When you do splendidly*
> *And you feel quite the same*
> *When they're doing grand,*
> *It makes you feel useful*
> *To give them a hand ...*
> *A slap on the back*

An encouraging phrase
Can keep you full charged
For several days and
Pull you right through
To the light at the end—
Well that's what I get
From Sara,
My friend."

Lucinda concluded with her joyful flourish of hands.

"I love it, Lucinda!"

"And now to work. I need to turn all this grass into rope so I can make those pulleys for the door and chimney cap. You can help me."

"Okay, teach me how and I'll tell you the story of *Rumpelstiltskin*.

They worked hard, laughed and revisited all they had discussed. By the time Sara was ready to leave, they had tarred and stoned the chimney chute, made enough rope from braided grass to attach the chimney cap, and got the first fire going in Lucinda's fireplace. By now it was nightfall.

"It's beautiful," said Sara, admiring their work and proud of her part in it.

"I could not have got it done this fast without you! Those big but clever fingers of yours can get so much done so much more quickly than mine," said Lucinda.

"And it was fun!"

They watched the flames crackle, both tired but content. For the moment, worrisome thoughts were put away. Sara was beginning to realize that being with Lucinda could be dead serious one minute and fun the next. Well, she thought, that's what life was, wasn't it? Tomorrow, if all went well, the squirrels

might talk to her! And who knew what else they might learn? The whole world seemed to be changing, certainly Sara's, now that Lucinda was in it.

4

LUCINDA IS INTRODUCED TO SOMEONE IMPORTANT

About an hour after Sara left, Lucinda was awakened by the sound of small squeaks. She must have dosed off. The fire had died down, but was still burning. Lucinda rubbed her eyes and sat up. It must be the Ekle and Apkin, she thought.

"Is that you, boys?" she called out.

"It's us," said Ekle in his familiar voice.

Lucinda was now wide awake and happy to have their company. Straightening out her dress, she called to them, "Come in."

With her back to the door, Lucinda added some twigs to the flames and stoked the fire.

"Smells good in here," said Ekle.

"Twigs and fresh pine tar," explained Lucinda.

"Good smell," approved Apkin.

When Lucinda turned, to her surprise, in came a third figure behind the boys.

"Lucinda, we brought a friend," said Ekle. "Someone we thought you should meet and someone who wants to meet you. This is Owletta. She knows a lot about the world. Owletta, this is Lucinda Vinetrope, Glower, and she makes up rhymes too."

"Welcome," said Lucinda graciously, even though she was quite taken by surprise.

"I am glad to meet you," said Owletta in a rich voice—a voice like a spring breeze riding through a hollow log. "I was quite excited when the boys told me about you, because we owls have legends about Glowers. My mother told me many of these stories. That was long ago. Of course the Glowers in her stories were always other owls."

"I am glad to meet you, too. You are the first owl I have met and I am pleased to hear that owls have legends, especially about Glowers. You speak with great beauty to your voice."

"Thank you. Yes, owls have a long history of passing down legends, though till now we could only share them with other owls. I have assumed all my life that Glowers were make-believe characters invented to instruct the young. I didn't know they really existed. Then Ekle and Apkin arrived in the neighborhood and we began to talk. I was lonely, though I didn't like to admit it myself. My mate had died the year before."

"I am so sorry," said Lucinda.

"Thank you. He took ill and didn't get better. And as I said, these boys arrived and made such a difference in my life. It is all so odd and unusual; owls and squirrels becoming friends. In any case, they told me that they had met a Glower this past summer and a musician too. Then yesterday Ekle told me of you. I had to come and meet you."

Why she speaks better than I do! thought Lucinda. That voice is enchanting.

"I am so glad you did," smiled Lucinda. "I am sure that there is much that I can learn from you. I believe the boys have caught you up on our shared dilemma. We need to find out just where they have traveled from. We must share what we know. Maybe your legends will hold a clue."

"I couldn't agree more. Your arrival is remarkable and must be noted and observed," said Owletta with assuredness. "But

it is the boys who have met another Glower, not me, I'm sorry to say."

"Please everyone, sit down," said Lucinda, fluttering her arms in an upward motion. The fire crackled invitingly. Owletta stationed herself in front of its warmth. Everyone took places on the pipe, Lucinda on her bed.

"You've made it cozy in here," noted Owletta.

"It's pretty," confirmed Ekle "and she did it in such a short time!"

"Very busy," said Apkin.

"As busy as a squirrel," Ekle joked.

Everyone laughed.

"I smell acorns," added Apkin.

"I do have some acorns here," offered Lucinda, "and a few ears of tree fruit—they look like ears. My first crop hasn't grown in yet. I am sorry I do not have much to offer. And I have no idea what owls eat."

"We're fine," said Ekle. "We had a big dinner."

"I only eat once a day," assured Owletta.

"I always like acorns," added Apkin.

"Help yourself, Apkin," Lucinda said with a smile and pointed to the little pile at the side of her bed.

"Now, Owletta, please tell me what your legends say about Glowers. This news excites my curiosity," said Lucinda enthusiastically.

Owletta had a lovely round face and her coloring was a mosaic blend of beige, brown, black and white feathers packed smooth and tight like feather tiles. Her most amazing features were her eyes. They were large and round, but what made them unusual was their color, or rather their colors: one was azure blue and the other was gold with little spots of green. She perched on the old pipe in front of the glowing fire.

"Well, as I said, the Glowers in our owl legends were always owls. They were great teachers and keepers of the history of owls. They also had the power to heal. I don't remember rhyming, per se, though we often did use rhyme in our legends. Now I don't know if it's possible that some of your kind appeared during the same period as the birth of owls. Maybe a couple of vinetropes here or there popping up as you just recently did, sprouting for a time, but never propagating enough to develop into a large population. That's my guess. It feels very probable to me that the occasional presence of your kind influenced us in some deep way. Your species must have overlapped with ours at some point and then disappeared again. That's my guess. It would have only been natural, then, for us to credit your good influence on us to the wisdom of some special owl—a Glower Owl."

"I do see what you are getting at," Lucinda picked up the thought. "Though most of our seeds were sealed in stone pods and frozen underground, maybe a few broke free and dislodged. In time, some may have surfaced and then were scattered, carried away by animals or blown by winds, sprouting on and off and into your early history, but never enough to return us in full force to the world."

This was a really good piece of thinking. Lucinda would remember to share it with Sara.

"Exactly," affirmed Owletta. "It is possible that climate or other geological circumstances in those earlier returns weren't favorable for your survival."

Ekle and Apkin's heads were going back and forth between the two, awed by all this complicated talking.

"Then why are you here now, Lucinda?" asked Ekle in his first truly thoughtful question.

"Yes, why?" repeated Apkin, just as serious. "Why have vinetropes come back now?"

Apkin put his paws out to the side, pads up, in a questioning gesture. Lucinda had to smile. Apkin and Ekle looked back and forth waiting for someone to come up with the answer.

"Maybe there is some special need in the world," suggested Owletta, "and a deeper but larger cluster of your seeds has emerged, and maybe this larger offering of seeds, whether by fate or fortune, has returned in a significant way. Though I would safely guess there is a purpose for your return. The boys told me that before they were swept away in the barrel, there were many stories going around in their neighborhood about others of your kind building a city underground. If this is true, and vinetropes have returned in numbers, they will surely change the world. Any species with Glowers in it would have great influence."

"The vinetropes have returned!" squeaked Ekle excitedly and he clapped his paws together.

"Maybe there's a danger, and that's why you're back," added Apkin, showing that he was thoughtfully following the conversation.

"Yes," picked up Owletta, "maybe some danger or need in the world has brought you back to us. After all, your kind has always been blessed with great teachers and healers."

"Oh my," said Lucinda in a bewildered tone. "That is an awful lot of responsibility! I am having enough trouble just figuring out how to make it through this first winter and how to get my door to crank open without so much trouble!" But in her heart she knew it might be true. Sara had told her of pollution and people fighting. Vinetropes might have solutions for this world's problems. "I must find my people, this is for sure, but to follow your logic, Owletta, even a few

vinetropes does not mean a vinetrope nation is in the making. It might just be a few odd seeds here and there, no different than you were suggesting a moment ago."

"I doubt that. The gossiping was too plentiful."

The boys nodded in agreement here.

"From what these brothers have told me, I feel quite certain, with the talk of digging a city under the ground, that there are more than two strolling vinetropes and you. But I wouldn't worry about solving the world's problems just yet," said Owletta in a philosophical but playful voice. "You are here and that is enough. If there is some special purpose, it will become known in time. For now, you are warmly welcomed by all of us."

Owletta's genuine welcome and her gracious nature warmed Lucinda's heart. She may sound a bit formal at times but she was a caring soul.

"Yes, yes," agreed Ekle and Apkin, showing Lucinda full respect after Owletta's explanations. "We're so happy you're here too," Ekle spoke for them both.

"But why do you have to be friends with that human child?" remembered Apkin.

"Is this true?" asked Owletta.

"Yes, there is a girl child, Sara, in the big house. She is very special to me and a very fine being." Lucinda was anxious as to where this might lead. But she told Owletta how much she admired Sara and about some of the important conversations they had had.

"You are a Glower and you must trust your instincts," Owletta was emphatic after listening. "If you consider her a friend, then she is trustworthy, I am sure, and you should continue your friendship."

The squirrels looked thoughtful.

"You look like her," said Apkin, much to everyone's surprise.

"Like who?" asked Lucinda.

"Like Sara, like humans," explained Apkin.

"You know what," said Owletta, "I believe Apkin's right. There is something about you that seems very human, your face and body, the way you walk and use your arms. You even wear clothes! That is human. But you have other qualities that seem more like us, the animal world," and she swept her wing in a general way. "The way you live in nature and can communicate so well with us."

"And to make it even stranger," added Lucinda, "I am actually a plant."

"Well then," continued Owletta, "you are part of the entire natural world!"

"Yes. That's it," cheered Apkin, "you're a bit of everything!" And he squeaked at his own wisdom.

"There is so much to think about," said Lucinda, with a touch of sadness in her voice, even though she was grateful for all these insights. She did feel overwhelmed.

"But now, my dear," said Owletta, "I think we have disturbed your sleep quite enough. It is time to be going and I have some hunting to do, a couple of mice to catch."

The squirrel brothers flinched.

"Never fear, my dear friends," reassured Owletta. "I dine on insects and mice; I no longer have any interest in squirrel for my dinner."

"What about the rhymes?" asked Apkin.

"We can enjoy Lucinda's rhyming talents another time. It is time for us to go. I have things to do and think about."

With that, Owletta waved her wing in a graceful arch as a farewell gesture and left. In a moment, a fluttering of wings was heard as she took to the air.

"We'll see you tomorrow," said Apkin, a little sadly. "Maybe then there'll be some time to hear you make a little rhyme!" Apkin chuckled at his own wit. This Apkin was going to be full of surprises.

"Of course," said Lucinda, grinning with delight, and she got up to see her remaining guests to the door.

"And maybe we will see Sara," said Ekle. Owletta's approval had changed their minds.

"That would be wonderful," said Lucinda.

The brothers gave a little nod and then were gone. Lucinda fluffed up the dried grass on her bed and laid out one of the blankets from Sara on top, the solid blue one. She lay down and pulled the plaid one over her and gave a little sigh of satisfaction. She thought, interesting, Apkin and Ekle do not trust humans, yet they are friends with an owl who used to eat squirrels. This is quite peculiar! And now, because of Owletta's approval, they seem okay with Sara. Things really do seem to be changing and not just for me. But she was too tired to work on this new puzzle.

Sara didn't get to see Lucinda till Saturday afternoon. Before Steven left for his job at the pharmacy he stopped by her room just after she had finished dressing and was heading out.

"Hey, Pumpkin," his pet name for her. "Dad said he'd like to take us and Lynn out for dinner tonight. He's home for a change. I thought that would great. Lynn does too. You should get to know her."

Where was this coming from? Was this for real?

"Really? Yeah, that would be great."

Well it would, wouldn't it? It was just that now it was a bit inconvenient. She thought the weekend would give her and Lucinda more time.

"Okay, great, I'll be back in time. I've got to get to the pharmacy now."

He gave her a kiss on the cheek and headed down the stairs.

And her dad, of all times, was not only home but sitting outside on the back patio. Since it was such a nice day, crisp but sunny, he had brought his laptop outside, facing the back garden. He joked with Sara that this was his chance for outdoor activity, because he rarely went outside anymore. He joked. He actually joked!

"Great day, isn't it! Nice and crisp. Thought I'd take a day off from the lab. Nothing crucial happening at the moment that my team can't handle."

"That's great, Dad. Steven said we're going out to dinner? Lynn too?"

"You like the idea?"

"Sure, of course."

Why was he so talkative today? It was very annoying. Then she remembered again how happy he seemed a couple nights back when she kissed him goodnight. Was he trying? Had she been trying? She felt guilty, but she needed to be with Lucinda.

"Okay, think of where you would like to eat. Maybe Italiannissimo's? You used to love that place."

"Is it still there?"

"It is, I checked."

"Okay, yes, that's great. Sure."

"Let's figure six o'clock."

Her dad smiled and then looked back down at his computer. Soon he was lost in work, home or not, and was Dr. Umberland once again.

Sara kept herself busy raking the leaves she hadn't raked before. Finally her dad got up to go in.

"Be ready at six!" he waved.

"I will."

When she was sure he wouldn't be coming out again Sara picked up her backpack, with a few more goodies in it, and went to Lucinda's door. Sara knew she was home because, from the corner of her eye, she had seen Lucinda's head, with its tangles of leaves, pop out a couple of times. The door slid open gracefully as Sara approached.

"That's terrific," said Sara as she came through and watched Lucinda crank the door shut again.

"Yes, I had a real find early this morning—wheels! I just had to unscrew them from some kind of hollow cart next door."

Sara checked them out. They looked like they were from a child's stroller or a wagon. Sara decided not to bother Lucinda about where she got them or to make her feel guilty.

"Your door works perfectly now," said Sara. "It's great." She cranked it opened and shut a couple times herself. and was impressed.

"Thank you. Now please sit down," Lucinda gestured. She was obviously excited, and took a seat on the pipe. Sara settled on the bed, now made with the plaid blanket on top and some lovely twigs and branches designed as a headboard.

"Wow, pretty!"

"I had time, waiting for you. Now no one can mistake it for anything but a bed. Wait till you hear what happened last night! I have more news. I have met an amazing owl called Owletta and she told me about owl legends with owl Glowers!"

"When? Where? Owls have legends?"

"It seems so. They have a sophisticated history. Ekle and Apkin brought her to me last night. She wanted to meet me

because of the Glower legends her mother used to tell her. Ekle and Apkin had mentioned to her about the Glower they saw near their old home. When they told her of me, she said she wanted to be introduced. Owletta feels my being here is an important sign."

"Has she seen Glowers too?"

"No, she is from here, so she was not able to offer any more clues on that account. But the idea of a Glower who holds knowledge or who can heal was not new to her." Lucinda then shared with Sara the whole conversation she'd had with Owletta and the brothers the night before.

"So now owls and squirrels are friends? I thought owls ate squirrels?" Sara was understandably surprised.

"Owletta has sworn to never eat squirrel again because of her friendship with Ekle and Apkin. They have been friends for only a relatively short time and can already speak as well to each other as you and I do. And she feels I am here for a purpose."

"She's right, Lucinda. Everything is changing, everything. And it's true, it all started after your arrival. There's so much more to your being here than we understand. This return is affecting everything. I would like to meet Owletta myself. She seems to know what she's talking about."

"You will. She is a wonderful owl and has the most wonderful way with words. She has completely won the affection of the squirrel brothers. And they respect her a great deal. She emphasized to them that they should respect my instincts on things. She said that if I believed that you, a human child, were trustworthy, then they should accept that."

"And do they?"

"Yes, and they want to meet with you again. They have completely come around."

"That's great news."

"But Owletta is also certain that my return carries a lot of responsibility with it as well."

"It does, Lucinda. How couldn't it? If the arrival of vinetropes is changing how animals think, gifting them speech, who knows what will happen next?"

"Yes, it means responsibility towards animals, humans, and vinetropes. It means figuring out a way to all live together. But from what I have seen of history, both yours and mine, that does not seem like it will be an easy task."

"It worries me, too."

"And we have not even taken into consideration the return of chargons and vinkali. It could be disastrous. I do not know if the world could handle that much change."

"So if they were to return to this world, they would be capable of real evil?" Sara was realizing the full implications as she spoke. She pushed her hair back a few times nervously.

"Yes, as I told you, they enslaved vinetropes. They are capable of murder and cruel behavior. And if they had captured any of us while we were putting our plan in motion— sealing our seeds for the future—they may have learned of it and decided to do the same."

"So there's a chance—you now believe there's a chance!"

"Unfortunately I do see a greater possibility than I did before. And if they do come back it would mean that any vinetropes near Ekle and Apkin's old home would be completely unprepared for their cruel arrival. I might be too late and it may have happened already. But I must get to them and tell them! If they do return, Sara, then my vinetropes would be completely helpless, caught totally by surprise. They don't know our history and they would not know to protect themselves from this evil. In fact, vinkali can be charming and

deceptive. They are good at luring their prey out for the chargons." Lucinda was becoming visibly agitated and her arms moved in rhythm to her anxiety.

"What do they look like? I'm scared to ask."

"I have a poem about them," she announced and raising her arms began to recite:

> *Chargons are tall with long legs and clawed feet,*
> *Their fur is quite coarse and they have wolf-like teeth.*
> *They stride on these legs which are segmented poles*
> *And take cover in swamps, in mud pools and sinkholes.*
>
> *And if you are a vinetrope, they will make you serve time*
> *Fueling their houses and working their mines,*
> *And building their cities and growing their food*
> *And sometimes they kill if they are in a bad mood.*
>
> *If they should return to this world here and now,*
> *They will try to enslave us, they surely know how.*
> *They use a strange mist that sprays from their horns*
> *It weakens all vinetropes and they must all be warned!*
>
> *The vinkali will help them and do what they say,*
> *We do not know their methods, not even today.*
> *But they plant them in wet lands and marshes and bogs*
> *Where they grow like your goblins while dining on frogs.*
>
> *There is no way of knowing what else they may do*
> *But it won't be for good, I know that to be true,*
> *We should fear for us all on this earth that we share,*
> *We must warn those we love; be alert, be prepared.*

They both were pensive for quite some time, lost in thought. Sara was the first to speak.

"So your chargons look like tall wolves and the vinkali are a lot like goblins?"

"It seems so."

"And they always come together?"

"Yes, there is some kind of mysterious relationship that vinetropes never understood."

"So that means if the chargons return, so will the vinkali."

"Exactly, they are connected."

"Then it's even more urgent that we find your people," said Sara with conviction.

"Yes, and if chargons have already returned, I won't be returning to my people to warn them. I will need to rescue them."

"If we can figure out where you need to go, I will try and get you there. If we could trust Steven, maybe he could even drive us." This crazy idea just came to her. Maybe it wasn't such a good one.

"That would be fantastic," said Lucinda.

"I don't know how he might take it."

"Well, we do not need to decide on that now. We should first get a better plan in place and know where we are going."

"In some ways it would be even easier if my dad knew." Sara was thinking of him and how sweet he was earlier. "But I don't see how we could ever tell him. You, talking animals, vinetrope energy…it would be his dream come true, in a way, but it might also fry his brains. And he couldn't tell his team about you."

"I think you are right. Steven is a better option."

"I know, but there'd be a lot of obstacles. We don't know how far we need to drive and I don't know how Steven could take me away for several days without my dad coming. I mean my brother's a teenager and just got his license!"

"I do see your point."

Sara knew it would be a very unlikely option to tell her dad, or even Steven. But she was feeling love for them. Not

quite so angry. And she was frustrated at how she was going to get Lucinda to her people once they had a plan. She kept coming back to her family.

"My dad was really trying to reach out to me this morning, and Steven too. I wonder what's changed?"

She told Lucinda about the way her dad looked when she kissed him and what had happened that morning.

"My dad's extremely responsible. Since Mom died he spends almost all of his time being the perfect scientist. When he wasn't a husband anymore, the father part got pretty thin. Steven, well, I don't blame him, he's way older and in a different place than me. But then, when I kissed my dad goodnight, it was like he woke up for a minute. And now he stayed home and wants us all to go out to dinner."

"Well, my dear friend, grief takes the joy out of us. It wasn't that easy to get you to smile either. You're a very serious person. But when you do smile, it's wonderful!"

"That's not true; I smiled within minutes of meeting you!"

"Well, you probably did. I was saying some pretty funny things! But you know what I mean," said Lucinda.

"I do," said Sara, and Lucinda snuggled next to her and tried to explain.

"I do have an understanding of grief, historical and personal. I feel and see much of the grief that is in vinetrope history as well as my own grief. I was born separated from my own kind and didn't know if I was the last vinetrope in the world. It was pretty devastating, and then you came along."

Sara's eyes were getting teary. She brushed at them.

"So I know something of loss on a personal level, not just from my historical memories, but from actual experience as well. I also know that your dad's work sounds important. And

I can tell you are both proud of him and have been angry with him. You seem less angry with Steven. Like you, he lost his mother too, and well, he is a teenager, a time when you might have found him less available anyway."

"You're right! It feels more like sadness with Steven, not anger. I understand him better than Dad and it's not really his job to be a parent to me, it's my dad's.

"Yes, and with your dad, if you've been silent about your sadness, maybe he hasn't seen your pain because he is so lost inside his own, and seeing yours would be even more painful. I'm not saying it was a good decision on his part. But I suspect this is what happened. And when you kissed him goodnight, like the old days, it made him aware that he was missing you. That maybe he wasn't there for you. I hope so."

"I hope so too."

"So keep an open mind. I think it is wonderful that you are all going out to dinner. It will be good for all of you."

"It's so helpful talking to you. I'm kind of looking forward to dinner now, even with Lynn."

"Good, and we will just keep our options open on how to get me and the boys to wherever we wind up going. A solution will present itself."

"I sure hope so."

"It will. And you should never give up on your brother and dad. I think you have a fine family."

"So we're back to the original plan," Sara continued. "We keep you a secret for the time being, but we try to locate your people. There's one big difference now; we know there could be chargons and vinkali."

"And that is a big difference," Lucinda emphasized. "If they have returned, we may have unintentionally brought your world a lot of pain and confusion."

"We have to stay calm," said Sara, trying to be mature about the troubling possibilities.

"We will keep busy and stay positive," added Lucinda.

"But it's hard!"

Lucinda got a sheepish smile. "Well maybe there is a distraction at hand. What's in your backpack? Any more presents?"

Sara got a smile instantly, "I almost forgot! Yes, I've more stuff for you," and she zipped open the main compartment and began to take things out. "This might cheer us up. I have some clothes, like I promised."

Sara pulled out two white nightgowns, two pairs of denim pull-on doll pants in blue, a dark red sweater, a royal blue blouse, a dark green flannel coat and a little dress in a brown flowery print that came with a white apron attached.

"This is great," said Lucinda, her smile radiating along with her glow. "They look like a perfect fit!"

"Yeah, I thought so, too. They're from an old doll of mine, she was about your height," explained Sara. "Oh, and wait, I almost forgot the best part." She pulled out a pair of long miniature black leather boots. Lucinda tried them on right away. Because they were made of soft, pliable, leather, they fitted like a glove on her feet.

"This is too good to be true!" Lucinda chirped and literally jumped for joy. "You have no idea how much this means to me."

She danced around and then she pulled off her golden-orange dress. Her body glowed with a light orange glow as she pulled on the pants and sweater and squealed with delight, dancing around some more. Sara was equally delighted to see Lucinda dressed in everyday clothes; jeans and a red sweater and little black boots.

"Well, do I look up-to-date?" she asked.

"Completely! You look very 'in', 'cool', completely up-to-date."

"Well, good, I would not want to look old-fashioned."

"You'll blend right in. No one will even notice you."

"That boring?"

They both laughed.

Sara was having so much fun.

"Now all you need is a hat, gloves and a scarf."

Sara pulled out more things; several white porcelain dishes with blue flowers on them. There were six cups and saucers, six dishes, and a teapot, kettle, creamer and sugar bowl. She had filled the sugar bowl with brown sugar and taped it shut. She now removed the tape and then took out the saucepan as well.

"They're beautiful," said Lucinda. She picked up each piece lovingly and looked them over. She dipped her finger in the sugar and took a lick. "Delicious," she approved. "Good for bark tea." She placed them carefully on the mantle over her fireplace. Sara had helped her shape it from the stones they used to finish the front and it was securely tarred in place with three wooden braces for added strength; a practical stone shelf. With all the dishes on the mantel, the room immediately felt homey, much like a human's.

Lucinda put the saucepan in the fireplace. It looked as big as a large soup kettle in the small opening. "Just perfect, I can make all my vegetable stews and soups in here and keep them simmering. It makes me hungry just thinking about it. In the old days we had root ovens. They got as hot as fire, but didn't leave any dirty ash like wood-burning does. We had vents to the outside that let out the steam, very efficient. We used an open fire too."

"A root oven, sounds like a mysterious way to cook."

"To us it was just the usual. I suppose it is like so many of the fantastic things in this world that probably seem ordinary to you. You cannot undo everything your people have created. It just needs some sensible adjustments…tweaking…like new ways of growing roots." Lucinda was thinking out loud, confirming what they had discussed. "I want to work on those solutions as well."

"Now, if you want to try something from our world that's really fantastic, try this." Sara handed Lucinda a bag of chocolate chip cookies.

"What do I do with it?"

"Open the bag and eat one of the round objects in it. We call them cookies."

Lucinda opened the bag and took out a cookie. It was nearly as big as her face. She took a bite and chewed. Her face began to glow so bright that it looked like it was on fire. Sara was afraid that she had unintentionally poisoned Lucinda.

"Are you all right?" she asked in alarm.

But Lucinda's smile should have been explanation enough.

"This is delicious beyond delicious! You call them cookies?"

"Yes, chocolate chip cookies. You see, these little brown pieces are the chocolate."

"They are fantastic. Here, have one."

Sara helped herself. "And here's a big can of fancy mixed nuts. I thought you might like to share them with Ekle and Apkin when they come by."

"How lovely of you!"

Lucinda then proceeded to fill the saucepan with vinetrope water and put it back up for boil. She had no need of a well. She made all the water she needed from herself! Sara busied herself adding more twig embellishments to the headboard

and Lucinda's bed became a work of rustic elegance. While they worked, Sara took note of how much the roots on the ceiling had grown. They hung in lovely iridescent tendrils, radiating a soft light and made the room festive and fairy-like. It was truly a magical environment.

An hour or so later they heard squeaks at the door and much to Sara's surprise the squeaks became mixed with words and then transformed into language!

"Lucinda, it's us, we've come for a visit," said Ekle.

Lucinda turned the well-oiled crank and the door slid open.

"Nice work!" said Ekle, and Apkin nodded. Then they saw Sara.

"Oh, is it a bad time?" asked Ekle.

"We can come back," added Apkin.

"Of course not," said Lucinda.

"Hi, boys," Sara spoke right up. "I'm so glad you came by."

The boys slowly approached and then sat down facing Sara, who was sitting on a stone to the left of the fire.

"I guess we're all talking to each other now," Lucinda noted.

"Yes," said Sara, "and I understand everything you're saying, boys."

"I understand human talk!" said Apkin with excitement and made the joyful swirl with his tail that would become his trademark.

"We were nervous about meeting you," admitted Ekle.

"And scared," said Apkin with honesty. "But we knew we had to."

"Sooner or later," added Ekle.

"Yes, orders from Owletta and the Glower here," Sara teased.

They all laughed.

"So, I'm not so scary after all?" she added.

"No, it's fun," said Apkin, and came a little closer.

"Yes, like a party," observed Ekle. "Whatever that is?"

"It's a human thing, a fun get-together with family and friends."

"Vinetropes have them too," noted Lucinda. "And there's usually food and drink."

"That's nice," said Apkin with enthusiasm.

Sara then broke off a little bit of cookie and gave it to Apkin. He took it in his paws and sniffed and touched it to his tongue. Then he nibbled it.

"It's good!" he said with surprise.

"Can I try a piece?" Ekle asked politely.

"Of course!"

"I think the tea should be ready," said Lucinda. "We can put out some acorns and cookies and some of those fancy nuts you brought."

"That's a great idea," said Apkin.

"So we're friends?" Ekle asked.

"We're friends," said Sara, "and we'll be the best of friends before too long."

"Look at all this fancy stuff," noted Apkin, looking at the dishes, pot and clothes, which were scattered on the bed along with Lucinda's birth dress.

"Yes," said Ekle. "It looks like human-type stuff. Your home is going to look very human when it's done," Ekle observed.

"But still pretty," Apkin added.

"And Lucinda, you look different. More like a human," said Ekle, looking back and forth between Sara and Lucinda.

"Yes, I took my birth dress off, to keep it safe. These clothes are better for work."

"Yes, that orange frilly thing looks very breakable," observed Ekle.

Apkin was helping himself to acorns, one in each paw.

"You are just the sweetest boys I've ever met," said Sara. Apkin dropped his head, feeling shy, and Ekle just said, "Thanks, you're the sweetest human I've ever met."

Soon they were all laughing and talking and helping Lucinda. Lucinda made the tea, but only Sara would drink it. The boys ate freely of the nuts and acorns and it was all quite festive. The boys fetched some more twigs for the fire. It was a successful first visit, and they kept the mood light and cheerful. The boys had been so fearful of meeting Sara that she didn't want to broach anything that might cause them anxiety. No talk of her father and brother, or of chargons and vinkali! There would be plenty of time for that, after they'd known each other longer and adjusted to the novelty of being able to talk to each other.

It was getting time for Sara to leave. She had to get cleaned up and ready to go out to dinner with her family. "This has turned into one of the best days ever," she shared with her new friends. And it was true, even with so much to worry about, it had still been splendid. She gave Lucinda a hug and patted the boys on the head and Lucinda cranked the door open for her as easily as a breeze.

"We thought we'd stay with you for a bit," said Ekle.

"Maybe a poem," said Apkin.

"I love stories, too," said Ekle. "You know, Owletta is great at them."

"Yes, she got us into it. Now we love stories."

"And, poems too," said Ekle, being tactful.

"Well, I don't have a story just now for you boys, but I do have a poem."

"Does it rhyme?" asked Apkin

"Of course!"

She lifted her arms and began.

"A fire's in the fireplace
The tea is in the pot
The squirrels eat quite daintily
For heaven's sake, why not.

The girl is eating biscuits
And the boys are eating nuts
A vinetrope is the hostess
And she loves to make a fuss.

We four are sharing tea time
And are chatting without fear
We love to tell good stories
And to shed a couple tears.

For two squirrels and a vinetrope
And a human can be friends
It is working out so nicely
It will likely be a trend!"

The boys applauded and Lucinda took a bow. She knew when to stop worrying and enjoy the moment. There would be plenty of time to worry. So much had happened, would happen and could happen! Good and, yes, bad. For now, she was happy.

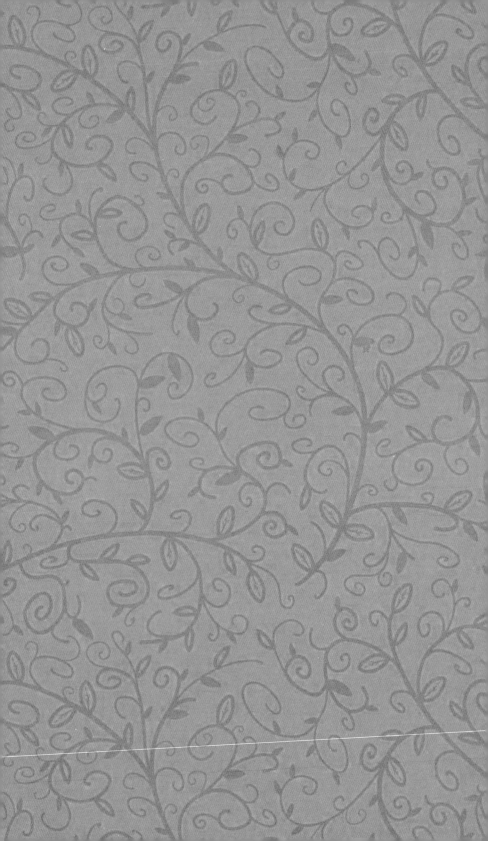

OWLETTA MAKES A BRAVE OFFER

Sunday was much like Saturday. Dr. Umberland stayed home and Lynn came by to be with them. They ordered dinner and ate together once again. Sara saw Lucinda hardly at all and the squirrels not at all. Sara was disoriented by so many changes in her daily routine and was pulled in two directions. But it was good to have time with her family and when she did have a few minutes with Lucinda, Lucinda encouraged her to take the opportunity to be with her family. Tomorrow would be school and work and Sara knew the routine would return to normal and allow her more time with her new friends.

Lucinda spent Sunday finishing the last touches on her home. She also finally got to plant the spores of the tree fungi she had collected on her walls. She had forgotten them in her dress pocket. There was also half a bag of chocolate chip cookies left and she wanted to make sure she had an ongoing supply of those, so she reserved three cookies from the bag, removed all the chocolate chips and planted them in the dirt wall. She was sure that the chocolate chips were seeds!

Then, early afternoon, Ekle and Apkin dropped by to tell Lucinda that Owletta had something important to discuss with her. She would be by later that night, after the moon was high, and the boys should be there too. Lucinda was excited to find out what Owletta had to say. She busied herself in

the evening making her home neat and festive. Her bed was made and she scattered holly berry branches, pine cones and milkweed pods along the mantle place.

The moon rose. It was a clear night and the stars were plentiful. Lucinda had her fire crackling and her home was more snug and comfy than the day before. Then she set the table with her dishes and a generous pile of chocolate chip cookies and acorns. She sat on her bed wearing her jeans and red sweater, with her legs crossed and her elbows on her knees. She had just picked up the plaid blanket and draped it over her shoulders when her guests arrived.

"We are here," called Owletta in her distinctive voice.

Lucinda cranked the door open.

"Splendid job," Owletta nodded in approval of the mechanical upgrade. "You're very clever with your human-like hands."

"Hey, look at all this," added Ekle as they came in.

"Come, sit down at the table. I brought some small logs in for better seating."

"This is very beautiful," said Owletta, and the brothers nodded. "Where did you get all these things?"

"Most of it's from Sara," Apkin explained.

"That's right," confirmed Lucinda. "Sara brought me these dishes and some new clothes and these delicious chocolate chip cookies. Please try some. The boys like them quite a bit."

Then she stood up and filled the teapot from the large kettle of boiling water. The bottom of the teapot was already prepared with dried lavender and dandelion leaves which she had tested and found safe to drink.

"The tea will be ready in a few minutes," said Lucinda.

"What's tea?" asked Owletta.

"Something human drink," Apkin made a guess.

"Well, actually...no," said Lucinda, "not just humans—vinetropes have made tea, all kinds, forever."

"But is Apkin right too?" asked Owletta. "Humans drink these hot drinks as well?"

"Yes, they do," said Lucinda.

"I was right," said Apkin.

"Well, you are all welcome to try some and see if you like it for yourselves."

Her guests nodded graciously at this point and looked around. They were impressed and Lucinda was enjoying being the hostess of her comfortable home. They settled in and Owletta spoke first.

"Let me get to the reason for this meeting. I've had a real brainstorm and I'm excited to tell you my plan."

"Please do," Lucinda encouraged as she poured tea. She added a bit of sugar to her tea then took her seat.

"Well, I'm going to take a trip for you down south and see what I can find out about this other Glower and the talk of vinetropes."

"Really? Would you really? That would be splendid. Fantastic! I am at loss of words." Lucinda could hardly believe it. "Are you heading that way for some reason?"

"No, no, it's something I want to do. Lucinda, there is a reason you are here. Imagine, Glowers, like in the tales my mother used to tell me. I must help you find your people. It will be an honor. I am convinced it is something I am meant to do, to find the other vinetropes."

"I can hardly believe you would do this for me. We have just met," said Lucinda. "Are you sure you want to make this journey? It could be a long one."

"I'm certain. I've given it a lot of thought."

"And she thinks a lot!" added Ekle.

Apkin chuckled and helped himself to some fancy nuts. "Umm, yummy!"

"Owletta, this is so wonderful. I thought I would have to wait till Sara and I could figure it all out and getting humans involved could be tricky. I had even had the thought that her family might be trusted and could take us in their car!"

"Not a good plan," Akin interrupted.

"Well, I had no idea how I would ever be able to travel the distance; to even start a search. But as an owl, you can fly! And you are so dignified, knowledgeable and you can communicate with other animals. You even speak squirrel talk! I am sure you can win the respect of other animals and ask questions and see if any of them know anything about a Glower or vinetropes. You will make the perfect scout!"

"I agree," said Owletta, dipping her beak in the tea without hesitation, as though she had been drinking tea all her life. "We just have to get me within a reasonable distance of the goal, and I can ask around. I believe I have a real chance of finding your people."

"And if you find them, I believe they would be willing to speak with you."

"I feel that way too," said Owletta, leaning over from her spot at the table to pat Lucinda gently on her shoulder with her wing tip.

"That's why I feel it is a job meant for me. In fact, I am beginning to speak the language of other birds as well, birds that migrate, who might have heard things or seen things. I will chatter with them on the way south. They would be going south too and might know something, or heard something, from before they came north. But you will still need to steer me in the right direction."

"True, we only know it is south of here by a substantial

distance. But we have no idea how far, or if it is southwest or any such details like that," said Lucinda.

"What about our mates?" asked Apkin, a cashew in his paw.

"Right," said Ekle, playing in the tea with the tips of his claws. "You should ask around for them too."

"What are their names?" Owletta questioned.

"Selena," said Ekle.

"Regata," squeaked Apkin. "Regata, my love."

"Well, it is simple then, "Owletta concluded. "I will ask for them by name and that will only bring me in closer to the destination!"

"Yes! Hurrah!" The boys jumped up and ran around the middle of the room in their excitement, leaping on and off the bed.

"Shall we continue?" asked Owletta in her commanding tone, but it felt like she might be smiling, for her was head cocked to the side watching them with amusement and her eyes twinkled.

The boys settled back in their seats and nodded.

"We know that the vinetropes will have hidden themselves well," assured Lucinda. "So it will take some detective work to find them—even if you are close by."

"And if a human helped you find them, they might not reveal themselves," Owletta added.

"Exactly, since I have no way to travel yet, if you find them, you will be my ambassador. And then at least we will know where they are, and how many there are!"

"And where our mates are," reminded Ekle.

"And you can prepare them for my arrival, Owletta. It will give me time to figure out how I will get there."

"How will we get there?" said Apkin, spinning an acorn on the table, but following everything. "We have to get home too."

"Yes, of course, Apkin. And then, when you return to us, Owletta, we will know just how far and long the journey is."

"So, how are we going to find out where were going?" Ekle stated the obvious in fluid words, lifting his two paws up and shrugging his shoulders, a gesture he seemed to enjoy.

"Yes," picked up Apkin. "I mean, we know we're going home, but where is home anyway?"

Everyone laughed. It was funny, but you had to hand it to Apkin, it was also completely true. They didn't know.

Ekle and Apkin leaned down into their teacups and lapped up a little tea. Apkin had copied Lucinda and put some sugar in his as well. There was a trail of crumbs across the table. The boys looked up at Lucinda and waited for her to give an answer.

But before Lucinda could focus her mind on that, she realized she had another task she had to ask of Owletta.

"There is something I have not told you about," she stated frankly, lifting her arms to the side, her fingers spread wide, as though asking to be understood. "And I hope you won't be mad. Everything has been happening so quickly and it just did not come up. I mean, I had no idea you would make this offer, Owletta, and I have only really come to realize the facts myself."

"Enough," said Owletta. "Just tell us what it is!"

The boys' eyes widened.

"You must warn the vinetropes, if you find them, that the chargons and vinkall may be back too."

"What are chargons and vinkali?" Owletta fluttered her feathers.

"They must be bad," Apkin deducted from Lucinda's tone.

And then Lucinda had to give a full explanation of the unfortunate possibility of these evil creatures returning to the

world. She told them about the history of her people and what role the chargons and vinkalI had played.

Owletta was angry. "Why haven't you mentioned this till now?"

"Are Selena and Regata in danger?" asked Ekle.

"I am sorry, everyone, truly. I have been putting this together piece by piece. Sara and I have only just realized this possibility. And this is only our second meeting, Owletta. I had no idea you would be making such a generous offer; that you would want to become this involved."

Ekle and Apkin, for a change, were speechless.

"And boys, I was going to tell you when we all met next ... and this is it."

"This is a very crucial piece of information," said Owletta. "It means this journey is now even more important for me to make!"

"Yes," said Ekle.

"You have to warn the girls, too," Apkin nodded vigorously.

"So you will still go? You are not too angry with me?"

"Of course I will go. It's not your fault. I was just taken aback by the gravity of these new facts. If this is the case, we may all be needed at some point in the future to defend our world against these creatures. Of course I will help. This has become more than a challenging quest; this has become a mission of urgency. I'm more certain than ever that I was meant to be a part of this. What should I tell this Glower if I find him? What do your vinetropes need to know?"

"You tell them as much of the history as I have told you and you tell them to watch carefully. They must have guards on duty watching all day and night. The chargons would easily raid a small community and take them back to their territory and enslave them. They need to know about the chargons'

horns and the spray, that it will knock a vinetrope unconscious. They also need to know that the chargons use the vinkali to trick vinetropes. Vinkali are clever, about the same size as a vinetrope and they will pretend to be friendly, like an odd-looking neighbor, and then lure their victim away."

"Then I will pass this message on."

"And let's hope it isn't needed or you aren't too late."

"And you'll tell our mates?" asked Ekle, raising up his paws in a questioning gesture.

"Will the spray knock out my Regata?" asked Apkin, pushing his paws tightly together.

"I would not think so, boys, but I'm not sure. We can only take precautions," Lucinda tried to reassure the boys, but frankly she didn't know how chargons might react to the animals of modern earth.

"But I must be honest with everyone," she continued. "I have no way of truly knowing what chargons and vinkali might do. If they come across a talking squirrel, they might enslave it."

The boys began to tremble. Apkin's teacup shook so much the tea splashed over the edge.

"I really do not want to scare you, but this is how chargons are. They would surely make use of the spray from their horns, as it is part of what they are; then they would see the results. And if they came across a civilization that had heated homes and root ovens, they would want to have those things

for themselves and would enslave those who knew how to build them. It never occurs to them to figure out how to do it themselves."

Lucinda looked sad, but she knew she had to tell the truth. "The chargons and vinkali are bad, maybe evil. Their methods are always wrong. Something is wrong with them."

Owletta raised both wings and gave her right wing a wide sweep to draw attention to what she was about to say. "Lucinda, boys, I make a solemn vow to do everything within my power to complete these tasks, to protect my friends and to warn those who need to know of the possibility of evil coming their way. It is the least I can do."

"Please, keep our girls safe," begged Ekle.

Lucinda patted both the squirrels' heads. "My people will do everything they can to help your girls. And remember, we do not really know if they will return at all. That even a few vinetropes have been born after eons of time is miracle enough. You must stay calm and save your strength for what is needed here at the moment. And I need your help to figure out where we are even going!"

The boys tried to smile and lapped more slowly at their tea, until Apkin realized he had none in his cup. It had all spilled out from his trembling. Lucinda refilled their cups.

"Now, Ekle, Apkin, can you think of anything else that might help?"

"We'll try and remember what we can," said Ekle.

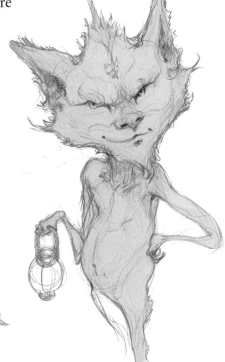

Apkin had regained some composure and he sat at his place with his paws on the table. "Haw, Haw," he said.

"What are you haw hawing about?" asked Ekle. "It's time to be serious,"

"Haw, Haw," repeated Apkin. "It's the Haw."

"I don't know what you're going on about," said Ekle, getting annoyed. "Can't you do any better than haw? I thought you were improving with words!"

"Now don't get so angry with your brother," said Lucinda in a soothing voice. "He's under a lot of stress."

"Yes, let's keep calm," chimed in Owletta. "Maybe Apkin is working hard at remembering something and it's slowing down his speech. He doesn't have quite your easy knack for it, Ekle, be patient."

Apkin became excited. "Yes, I remember, the water, the big long water. Remember Ekle? Our tree was near the water!"

"Yes, that's true. Our tree was near a river."

"That's grand!" said Owletta. "Now we're onto something. You lived near a river!"

"Yes, we lived near a river. But I don't know what river," said Ekle. "We squirrels simply called it the Water Path."

"That's fine," said Lucinda. "It's a clue. Just keep talking. Remember whatever you can."

"Haw," said Apkin again in a calm voice that contained a touch of disdain. Then easily, as if he'd been saying it correctly all along, "Haw River, we live on the Haw River."

He tapped his paws on the tabletop, quite pleased with himself.

"The Haw River," repeated Ekle. "Sounds familiar."

"Farmers said Haw all the time," continued Apkin. "Up the Haw, down the Haw River. Haw, Haw, Haw. I remember them using those words now."

"This is just the clue we have been looking for, Apkin," said Lucinda. "I think we are all guilty of underestimating you. You have your own unique way of learning and explaining yourself. If only we had a map. Sara may have one."

"I know of maps," said Owletta. "Owls were fine mapmakers thousands of years ago. Now we only keep small maps in our heads and don't travel so far."

"Vinetropes were wonderful mapmakers, too," Lucinda confirmed.

"I have a feeling I've seen a book of maps somewhere; now that I'm remembering about them. I could easily follow one if I could get my wing tips on the right one. Now that I read, it will be easy."

"You read?" said Lucinda.

"Yes, don't you?"

"I do. Vinetropes read and write. But Owletta, this is remarkable. In this short amount of time, you've gained the ability to read!"

"Yes. I think I've always had a knack for it. And, Lucinda, I believe you have brought it out in me. I am sure of it."

"I know I can give the gift of speech, but I did not know about the ability to read! If it is true, I have no idea how I did it. It was not a conscious plan."

"Maybe we'll be able to read some day too," added Ekle. "We spend a lot of time with you." Apkin nodded in agreement.

"Ekle," said Owletta, remembering something, "when you told me the barrel story, you complained that something was pricking your foot all the way up here in the barrel," said Owletta.

"Yes, that's right," said Ekle. "It started to bother me the morning before the accident, then during the barrel ride it got more bothersome, and when we got out, I limped about

for a couple days. I kept licking it and then finally it stopped bothering me."

"What does a vinetrope seed look like, Lucinda?" asked Owletta.

"Well, it is as clear as pure water, very small, and has little spikes on it that can easily hook onto moss, or earth, or fur. Fur!"

"That's it!" said Ekle. "Lucinda, your seed traveled up here in my paw! You were stuck in me the whole time we were locked in the barrel. And before! You were stuck in my foot, between my toes."

"That's how you got here," confirmed Owletta. "Your seed came up with the boys. All three of you came up here by accident together!"

"Then you are part of the unfortunate barrel accident, Lucinda!" Apkin realized with pleasure, lifting his paws in the air. "That means we already knew you before we met you!"

"And," continued Owletta, "that explains why your language skills are so advanced, Ekle. You had vinetrope energy plugged right into your foot!"

"And it even explains why I sprouted so late in the season and grew so fast. I was kept warm in your paw for several days before I went into the ground. So when I did fall into the dirt, I was ready to open and take root. And since we Glowers grow quickly, in only days, I still had time to finish growing before the weather turned too cold."

"If I knew it was you, I wouldn't have complained so much," said Ekle. They all laughed.

"And now back to the map!" said Owletta, "I know I've seen a map somewhere. Wait a minute, the humans who live with Sara, I saw a woman looking at maps in their car. This was quite some time back. Most the time these humans look

at little boxes that light up. But in the past I observed a woman using a map. Yes, they keep it in their car."

"That must have been Sara's mother. I wonder if it is still in the car?" Lucinda questioned.

"Well, we could give it a try. I just wish we knew what our location is called."

"We do. Sara told me the first time we met that she lived in Pinewood, New Jersey."

"Perfect!" said Owletta, raising her wings and knocking Ekle off his log by accident. He rolled a bit across the floor and shook his head.

"I'm so sorry! My wings are somewhat large for this space."

"That's fine, I like rolling," said Ekle.

Apkin chuckled into his cup.

"I'm glad you're okay. So then, all we need to do is find out where the Haw River is on the map in relationship to Pinewood, New Jersey and I can fly there. Once I get to the Haw, I will make my way along the river and ask the local owls and birds and animals if they've had any sightings of glowing creatures that fit your description, Lucinda. Since I speak Squirrel, I can ask the squirrel population as well."

Ekle piped right up. "And use our mates' names too, Regata and Selena."

"Yes, Regata and Selena," repeated Owletta, to make a mental note.

"Okay, then what are we waiting for, we should go see if there is a map," Lucinda stated the obvious.

"Do you think the car is locked?" asked Apkin.

"Let's go find out," said Ekle.

"They rarely lock the car doors," Owletta seemed to know this from observation. "They drive it into the garage and then

come out and shut the garage door. They use some other kind of box, press it, and the door closes."

"How will we get the door open?" asked Apkin.

"We have paws and wings. Only you have hands, Lucinda."

"And they're very small," noted Ekle.

"Easily solved," said Lucinda. "We can bring some of my braided rope along, tie it around the door handle and then we will all pull!"

"Then, let us be off," said Owletta.

The friends slipped out into the night. Lucinda had two long strands of her homemade rope gathered around her arm. She turned her glow off completely, so crossing the driveway would not draw attention. Luckily, there was enough moonlight to show the way. Owletta flew directly to the garage and waited while the other three climbed the steps from the garden onto the driveway and then to the garage.

The garage door was shut, but it was built into a small hill and there was easy access through a small window on the hill side. They mounted the hill to the window and luckily found it was opened a crack. Lucinda pushed up on the window and the boys slipped through the crack and pushed up from inside, sitting on the inside ledge. Working together they opened wide enough for Owletta to fit through.

It was a steep drop into the garage. Lucinda hooked her rope around the window lock and lowered herself down. The squirrels scampered down the rope effortlessly, leaping onto a variety of different objects piled up under the window. They were down before Lucinda reached the floor. Owletta flew in and landed on the car's roof.

They all gathered by the car door on the front passenger side.

"I can just barely reach the handle on my tippy toes. You were right, boys," confirmed Lucinda. "This will need a joint effort."

She turned up her glow so everyone could see more clearly.

"Okay, Owletta, I have an idea. Take the end of this rope and fly back up onto the hood."

Owletta did as she was instructed. She sat on the hood with the end of the rope in her beak.

"Now, edge your way closer till you are directly over the door handle. Then see if you can drop the rope through the opening in the handle. It will be like threading a needle."

"What's a needle?" asked Apkin.

"Never mind," said Lucinda. "Just lower it slowly, the opening between the handle and the side of the door is pretty generous."

Owletta grasped the rope with one claw and slowly lowered it down the side of the door using her beak to assist in the process. It went through on the first try.

"Now keep hold of your end, Owletta, and come on down."

Owletta secured the rope firmly in her beak and flew down to the garage floor.

"Great job!" congratulated Lucinda.

The squirrels leaped around with excitement.

Lucinda took hold of Owletta's end and tied a knot around the handle, then wrapped a length around her waist, allowing a long piece of remaining rope to drop to the floor.

"The handle works like a lever," Lucinda analyzed. "It has a hinge, so when we pull, we have to pull towards the hinge, to get the right leverage. Okay, all take hold of this rope behind me, pull towards the right side of the handle, and pull like your lives depend on it!"

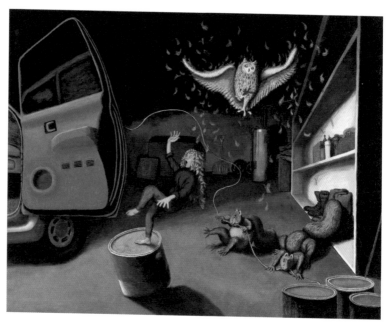

Lucinda took hold and positioned herself so that the rope lay snug against the hinge with her hands gripping tight. The brothers each grabbed a piece with their teeth and front claws and Owletta took the end piece in her beak.

"At the count of three, pull," ordered Lucinda. "One, two, three, PULL!"

The four friends held firm and pulled with all their might. The door did not open.

"Okay. We must try again. And put more pressure to the right. One, two, three, PULL!"

No luck.

"I think it is not working because we are still not getting enough leverage against the handle to click it open," said Lucinda. She thought a moment. "Humans are higher up when they pull on the handle. We need to pull from a higher position."

"Let's stand on these small barrels, suggested Ekle as both Ekle and Apkin circled around three paint cans stored along the side of the garage wall.

"Great idea, give me a hand."

One of the cans was wider and taller than the others and looked like it might give them the height they needed. With all four pushing, they were able to slide the can directly under the door's handle. Lucinda positioned herself again.

"Here," she said, throwing the length of slack rope behind again. "Ready," she cried, "One, two, three, pull—"

The door flew open, tossing Lucinda to the ground and toppling the can. The squirrels rolled onto the floor, and Owletta paddled the air, feathers flying, as the rope gave way.

"We did it!" shouted Lucinda joyfully, getting to her feet.

"Shhhh!" said Owletta.

They all climbed into the car and began to look around. A little light had come on automatically so Lucinda didn't need to turn up her glow.

"Where's the map?" asked Apkin.

"It's here somewhere," whispered Owletta.

"Was it a book of some sort?" questioned Lucinda.

"Yes, a pretty big one."

"Here's something," said Ekle and he tapped on an object in the side door pocket of the front passenger seat.

"Look at that wheel," said Apkin. "This must be where the driver sits."

Lucinda took hold of the book with both hands, but couldn't pull it out of the pocket.

"Give me a hand," she said to Ekle.

He took hold with his teeth and front claws and together they were able to pull the book out and lay it on the seat. It

was a large red book, bigger than Ekle's body, and its cover now displayed a few fresh teeth and claw marks.

"What does it say?" asked Apkin as he and Owletta joined them in the front.

"Let me see," said Lucinda, placing herself in front of the book.

"It says, *Road Atlas,*" read Owletta.

"That's it!" cried Ekle. "It also says *Maps of the States* right on the cover."

"Which means, obviously, that you can read," added Owletta, not as surprised as one would think.

"Yes! I can! I can read! Look what you've done to me Lucinda. I can read human! Help! I mean, I'm fine. Now what do we do?" asked Ekle.

"Open it up," said Apkin.

"Yes, of course," said Lucinda. "Okay. I know we are in an area called New Jersey. It is a state, part of a larger country. Sara mentioned that to me when we first met. And we are also in a smaller area, a town called Pinewood. We need to go south from there. What would be most useful would be to see a big picture of the whole country and see where Pinewood is located. Then we will know where we are right now." She was thinking out loud again.

"Yes, Pinewood is our starting point. Look in the front of the book," suggested Owletta. "It makes sense they would place the map of the whole country there."

Lucinda flipped through a number of pages with writing on them. Then, sure enough, there was a map of the whole country. The United States, as Sara had explained.

"Are we on the east side or the west side or in the middle?" questioned Owletta.

"I have no idea." Lucinda moved her finger around the map.

"Well, here are the words New Jersey," said Ekle, pointing with his right front paw.

"So that means we're on the east side of the country, close to this huge body of water called The Atlantic Ocean," Owletta read. "It is near this large city called New York."

"These words with the names of towns are very tiny!" Ekle complained.

"And so many of them," added Apkin, trying to be useful. It seemed he couldn't read, at least not yet.

"You're right," Lucinda wiggled her fingers with impatience. "It is very hard to find the one small word Pinewood on this map of the whole country. I doubt they are even able to fit all the towns into this tiny little space."

"States," Apkin lifted his paws in another moment of brilliance. "This is a book of the states with lots of maps."

"You're so right, Apkin." Owletta understood what Apkin was getting at. "Let's go to the map that just shows us New Jersey. Then all the towns will show up better and be easier to read."

So Lucinda began to flip through with Ekle helping until they found the big map of New Jersey. "Here it is!"

They all searched carefully while Apkin helped to hold the pages down, one paw on each page.

"Pinewood!" screeched Olwetta, losing her composure for the first time any of them had seen. She pointed to the name with her wing tip.

"Yes, we are here, wonderful. This is our starting point," Lucinda emphasized.

"But I don't see us," Apkin said in a serious voice.

"Why of course not!" Ekle threw his paws up in exasperation. "They don't show every person and animal in the town on a map!"

Apkin burst into laughter and rolled his eyes. "I'm just joking. You sure must think I'm stupid."

Ekle just shook his head. Lucinda and Owletta weren't paying any attention.

"So," continued Owletta, "we need to move down very slowly, state by state going south, until we find the Haw River."

"Let's go back to the big map and see what states are south of us and in what order." Lucinda flipped back to the map of the whole country and Apkin sat on the west side of the map and pressed his paws down on the east. "Right under New Jersey is Delaware, Maryland, a place called Washington D.C., Virginia, North Carolina, South Carolina, Georgia."

"From what the boys told us about the trip up here in the barrel, and by the mileage indicator here at the bottom of the page, I don't think it could be much further than Georgia," estimated Owletta.

"Then we will start with the map of Delaware first, look very carefully for the Haw River and then move down to the next state until we find the Haw," Lucinda concluded with a flutter of her fingers.

"I think I can help," said Apkin, "if you just show me what the words Haw River look like."

"I am sorry, Apkin, there is nothing I can write it down on for you just now," Lucinda explained.

"Okay, I'll just keep holding down the pages."

"Now let's get to work," said Ekle. "The Haw River must be in one of those places ... states."

"Oh, and everyone, rivers look like blue squiggly lines, not like the towns," Owletta remembered to point out.

"Then I can help find the rivers," said Apkin, thrilled. "I can find blue lines easily!"

"Great. You can make sure we don't miss any," Lucinda smiled and patted him on the head.

They took their time looking at all rivers along the coast, moving south state by state. They checked every square inch of it. Ekle and Apkin both pointed to the rivers and Lucinda and Owletta took turns reading the names. They still hadn't found it after intently studying Virginia. Lucinda then moved to the map of North Carolina and read, "Pee Dee River, Cape Fear River, South River, Neuse River, Haw River—Haw River!"

"Haw River!" everyone yelled in unison.

"Shhh!" said Owletta again, but she had screeched the loudest and everyone laughed, including her. They all leaned in to take a good look.

"The Haw River is west of this large city called Raleigh," Lucinda observed.

"This is actually doable. I can find it," said Owletta with confidence, raising her wings and swiping Ekle by accident.

"Watch it," Ekle got angry.

"Sorry, Ekle. I'm just excited. I now have a picture in my head of the direction and distance I must fly. It is a long flight, but I will do it in stages. This place called Raleigh, not that far from the Haw."

Owletta tapped her head. "It's inland, but I think the easiest way not to get lost is to start out heading east from here and find the big water called the Atlantic Ocean. I will fly to New York City. I can't miss it. That will bring me to the ocean and then I will follow the coastline south."

"You need some clues to let you know when you have gone south far enough, when to turn inland to Raleigh," Lucinda realized, running her fingers over the map, looking for landmarks that might help.

"I can read human road signs, which is a big help," Owletta reminded them. "And most of the trip will be south along the coast. If I follow a human road going south, at one point it will say when I'm close to Raleigh." She lifted one wing, the one not next to Ekle, and pointed again to Raleigh.

"And take a look at some of these other cities north of Raleigh, Owletta," suggested Lucinda. "It will let you know if you are getting closer." She pointed to a list of them for Owletta to remember.

"When I find Raleigh, I will turn westward toward the Haw River. Look here, there is a lake I will cross over before I get to the Haw," she pointed carefully with her wing tip, calmer now. "That's good to remember. I will know I'm going the right way."

"And the map ends here," Lucinda said, tapping the words Haw River, west of the lake.

"There's a lot of river to cover. That's where my investigating skills will come into play. I will ask a lot of questions of the birds and animals in the area. Someone will have seen something, I am sure."

"So you really think you can find your way there?"

"Yes, I'm feeling very good about it. I will give it my best, I can assure you."

"We can't ask for anything more," said Lucinda.

"Selena", "Regata", the boys called out.

"We're coming said Ekle.

"Wait for me," squeaked Apkin.

"When would you leave?" Lucinda asked the important question.

"Why, tonight."

"Tonight!" all three voices rang out.

"Yes, why not? I've made my mind up, I have the map in my head and night is the best time for travel. In fact tonight is the best of all times."

Lucinda put her arms around Owletta's neck and gave her a hug. "Thank you," was all she could say. Her appreciation was beyond expression. The squirrels ran around and around her until she felt dizzy. "Please boys, that's enough, I feel I'm going to lose my balance."

It was time to head back. They were able to get the Road Atlas back into the door pocket and pushed the car door shut. But they left the paint can where it had fallen. Lucinda picked up her braided rope and Owletta took the end of one piece and secured it to the window crank and Lucinda and the boys climbed up and out. Owletta joined them and the four friends went back to Lucinda's home to feast a bit more and to celebrate, to give encouragement and to say their farewells to Owletta.

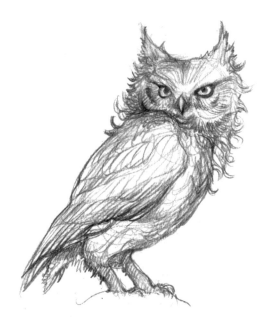

"It is like we are making our own legend," Owletta announced after they were all seated again at the table.

"And we are part of it, too," said Ekle, putting his arm around his brother. Apkin smiled and looked up at his brother with affection.

"I didn't know it quite so well until tonight, but now I am sure this is all meant to be. I am as sure of it as I am that you are all my friends. And Sara will help us make it all come true. She is a most important part of this legend," said Lucinda.

"I have not even met her yet," Owletta realized.

"I know. And now I will ask one last favor. Tell my people that there is a human child, Sara, who will play an important part in our new history. I want them to be prepared to meet her. In fact, we may even need to travel in her family's car. It might be the only way."

"And trust more humans?" Owletta asked, shaking her head.

"I'm not getting in a car," added Ekle, getting indignant.

"It might be fun?" said Apkin.

"Please, Owletta, just tell them about Sara. I know it is important."

"Alright, I will. I guess it t is a small enough request to add to this great adventure."

"Thank you! I feel so hopeful my friends, that I have a poem for you," said Lucinda.

> *"Tonight is the night*
> *We have made a great plan,*
> *So stick out your paws*
> *Your wing tips and hands,*
>
> *And shake on the promise*
> *To do all that we can*

To insure the success of
This daring new plan.

It is risky and wild,
It has never been done!
Which adds to the challenge,
And we are the ones.

So what if we tremble
Not sure of success?
Tonight lift these teacups
This day we are blessed!

To this tale we add Sara
A child with a gift
She will help with the healing
And the mending of rifts.

We will all work together
Till this tale is full told
Though we need to be careful
We must also be bold."

With that, the little group cheered and everyone, for the moment, seemed as merry as at a holiday feast. The cookies disappeared, a second pot of tea was prepared, and stories were told. None of these friends knew where life was taking them for sure at this moment. What was sure was that everything was changing and the world was not the world it used to be. This had presented a brand new kind of future. They had become part of a new story. And Sara had a very big role in it. In fact, the best and strangest stories were yet to be made!

6

TIME TO SNEAK INSIDE

The day after Owletta's departure brought an opportunity. Of course Sara didn't know yet that Owletta had left. In fact, they hadn't even met yet. But when Sara got home from school, her first surprise of the day was that her dad was already home and so was Steven. She found them upstairs in her dad's bedroom and Dr. Umberland was packing a carry-on bag, flung open on his bed.

Her father explained that there was a science convention in Chicago that he had been asked to lecture at.

"We are exploring the potential use of microbes as a process of environmental cleanup," he said.

This was another part of Dr. Umberland's work—clean energy and cleaning up what was already polluted was connected and her dad cared about both. Dr. Umberland had known about the lecture for some time, but had arranged for his most senior assistant to go instead of him. Then, at the last minute, he decided that he should go himself. This was too important.

Dr. Umberland had explained the basic idea to his family before. "Imagine—a natural and safe system that could be put into effect to breakdown toxins, using safe microbes!"

The idea was based in some ways on the way bodies burned calories. The microbes, in a sense, would eat the biodegradable waste and then burn themselves up in the process.

In any case, her dad was now presenting the lecture and had to leave almost immediately if he were to make it to Chicago in time. Sara was to stay home with Steven. Dr. Umberland would be gone two nights.

"You should do something fun with you sister," he suggested, as he threw a shirt into his carry-on.

"You mean like nighttime white-water rafting?" Steven teased.

"Sounds like fun," said Sara. "How about nighttime sky-diving?"

"Even better. How about skydiving into white water at night?"

They all started laughing and Sara found herself marveling in disbelief at the happy sound.

"Well, you'll probably have to settle for a movie," Steven patted her on the back.

"Is Lynn coming?"

"Anything wrong with that?" Steven frowned.

"No, I like Lynn a lot. It's fun getting to know her. You never used to bring her home before. That's why I was asking."

"Yeah, I'll ask her. She likes you too."

"That's great," said Dr. Umberland. "In fact we all have to spend more time together. And you could ask a friend over too, Sara. It's been a long time I think, hasn't it?"

He was vaguely aware of this. Being at the lab all day for two years, often on the weekends as well, he'd lost track of Sara's social life, or whether she even had one. These concerns had just begun to enter his consciousness, and it made him feel uncomfortable and sad.

"I might give Jamuna Sharma a call," Sara answered her dad.

"That's Danvir's sister, isn't it?" asked Steven. "I've met Dan a few times when I was tutoring at the middle schools'

summer computer program last year. He's pretty cool. A techy like me."

"Yes, he's a year older than Jam. Everyone calls them Dan and Jam. They're really nice. In fact Jam was just asking me about Halloween." Sara pretended to make more of their quick chat than had actually happened.

"Well that would be good, too," said Dr. Umberland. "You went out with her last year didn't you?"

"No, actually that was two years ago, before mom died."

"You didn't go trick-or-treating last year?"

"No, I didn't really feel like it." Sara dropped her head, pushing her hair behind her ears, sad and embarrassed for her dad.

Dr. Umberland dropped his socks into the bag and looked up like he was wide awake for the first time in a while. He reached for Sara and gave her a hug.

"I guess I've been kind of not here," he came right out with it and there were tears in his eyes.

It was almost too much for Sara. It seemed everything was changing in the few days that Lucinda had arrived in her life.

"Well let's make certain you go this year," he said tenderly.

She smiled. "I will. I'll ask Jam if she wants to go with me."

"Great!"

"Hey, maybe I'll come along too," Steven chimed in. "We haven't done much together either and next year I'll be at college. I'd like to see the old town done up for Halloween again."

"And we could stay out real late if you came with us!" Sara was feeling happy and actually looking forward to calling Jam now.

Dr. Umberland looked proudly back and forth between his two children. Their mom would have been so proud of them

too. "You're both so responsible. You've never given me any trouble or reason to worry."

Sara felt bad for him. She knew he was feeling guilty. It made her sad and she felt protective of him. That was surprising! Feelings were so changeable and complicated, weren't they?

"Yeah, Dad, and don't worry about anything now. We'll be fine," added Steven. "It's just two nights. In fact, take a week. Have some fun. I can handle things."

"Well, not this time." Dr. Umberland smiled. "Maybe I'll take you up on that one day, kids. I left all the contact information by the phone in the kitchen and I'll have my cell phone on me at all times. And here's some cash." He handed Steven some money. "Jim's pizza has my credit card, and they'll deliver."

"We know," both Sara and Steven said in unison.

"The cab will be here any minute. Which jacket do you think I should take for the lecture?" he asked, holding up two possibilities. "The tweedy one or the solid navy?"

"Tweedy," the kids answered in unison again.

"More nerdy," said Steven. "Works with the data better, Dad."

They all laughed again.

"Okay, I'm packed. Where did I put my briefcase?"

"It's downstairs by the front door," reminded Steven, "all ready to go."

"That's right."

They heard the cab honk. The tweed jacket was folded and thrown into the carry-on bag. Dr. Umberland zipped the bag shut, and they all headed down the stairs.

"Okay, kids, I'm off. Wish me luck. This is a big one. I think it's good I'm going—I haven't lectured since you mom passed."

"You'll do fine," said Sara and kissed her dad goodbye.

He gave them both a hug and in a moment the cab pulled away and Steven and Sara were alone in the center hall.

"Don't get mad," said Steven in preparation for his next sentence, "but I've got restaurant reservations for Lynn and me tonight and tickets for a show at the Westhouse Theater. I got them weeks ago and only have the two tickets. I didn't know that Dad was going to be away tonight."

Fantastic, thought Sara. I'll bring Lucinda inside to see the house! "No problem," she said calmly to her brother. "Don't feel bad at all. I'll be fine. Have fun."

"I'll be back by ten. I promise."

"Okay, good."

"You can order from Jim's if you want and tomorrow Lynn and I will come back here right after school and spend the whole afternoon and evening with you."

This was getting way too good to be true; it was overkill. It was interfering with her time with Lucinda. "That will be wonderful," she found herself saying anyway and then gave Steven a hug. She loved her brother.

"Okay, I've l got to get ready and be out of here in a half hour. It's an hour drive to the theater and we're catching dinner first."

Steven rushed upstairs, a happy young man, Sara thought to herself. A half hour later, he was back down in some fresh clothes with a wrapped gift in his hands.

"You look very handsome!" Sara critiqued.

"Thanks!" he grinned, and in a moment he was in the family car and gone.

Sara had an idea. She took a brown shopping bag out of the broom closet, grabbed her jacket and went outside. She raced around and in short order had the bag half-filled with pinecones. She and her mom used to collect pinecones all the

time and decorate them for Christmas. Lucinda could jump in and hide under the cones and Sara could easily transport her back and forth. Maybe Lucinda could sleep over! How cool was that! Steven wouldn't know. She would ask Jam over another night; but this was not the time. Then she hurried to Lucinda.

"Where were you and why were you rushing around the yard?" Lucinda asked dramatically. She was standing outside her door. "I thought you would be here right after school and I have a lot to tell you."

"Don't scold! It took me a while. I had to wait to say good-bye to my dad and Steven. Dad's off to a science conference for two nights and Steven's on a date with Lynn. We have the house to ourselves."

"You mean your house?"

"Yup. Don't you think it's about time I brought you inside?"

"Fantastic! I have always wanted to see how giants live." Lucinda smiled. "And I have some exciting news for you."

"What? More happened?"

"Yes, it certainly did. Owletta has left to find my people for me. She is on a search and discover mission. She left last night. And while she is looking she will look for the boys' mates as well. And on top of that, if she finds the other vinetropes, she will be able to give them a warning about chargons and vinkali from me."

Sara stood speechless.

"And she can tell them of the mist that comes from their horns and even some of our history; as much as I had time to tell her. I have also told her to tell the Glower, and any other vinetropes, all about you, Sara. I want you to meet them and be part of all our plans."

"All this happened since last night? I haven't even met Owletta."

"I know, Owletta said the same thing."

"Last night? She's left already? How does she know where she's going? I can't believe she's gone. This all happened since I saw you yesterday?"

Sara was feeling so many emotions, strangely jealous of the squirrels and this mysterious owl. And she was angry that such a big step had been taken without her. She had been on a roller coaster of feelings all day with her family; it was mostly good, but it had thrown her emotionally. This made her mad. The most important thing happening in her life and she'd been left out!

"I had planned to check maps for you on the Internet, show you my computer," Sara continued, shoving her hair behind her ears.

"What's a computer?"

"And my cell phone. I don't know why I didn't think of that before. It was in my backpack. We could have searched for maps together. And you've got to see how it works. The way your built-in memory works reminds me of a computer. Why did you decide all this without me?"

"Slow down! Why are you angry?" said Lucinda.

"I feel so left out. And I could have been a real help. Maybe Owletta is going the wrong way! You should have checked with me first."

"Calm down, my dear. I am sorry you feel left out. I can see why you might feel that way. But you are not left out. You are a major part of this whole plan. And I told them so. Let me tell you how it happened."

Lucinda explained how Apkin remembered the Haw River; that they had lived on the Haw River. She knew that they were

in Pinewood, New Jersey in the country called the United States. Sara had told her that in their very first conversation. So they had a starting point and a general ending point. All they needed was a map.

"That's my point. We could have used my cell phone, computer, googled it."

"Well these tools you speak of may be wonderful. They are obviously very modern and not in my historical memory. But it appears we did very well despite them in the old-fashioned way. We found a map in your car and we knew how to use it. And it is too late, she is gone."

Sara sighed with disappointment, but was beginning to accept the situation. "And you're sure you got it right?"

"Yes, I am. Owletta knows where she's going...the basic location at least. And where she's going, in the end, will be off any map we could possibly find or on this thing you call a computer. Once she gets to the general area, it will take detective skills and good communication to find this village. It will be well hidden. Owletta can use her speaking skills to ask questions of animals and birds in the region and get clues, maybe meet someone who has spotted the other Glower. I have faith in her ability to do this for me. It makes sense to find my people first, know for sure if and where they are. Then we can figure out how to get me there."

Then Lucinda explained it all in full detail: Owletta and Ekle being able to read, how her seed came up with the boys when they got locked in the barrel...stuck in Ekle's foot. "That's why Ekle is so good at language."

"That is amazing," Sara sighed again, taking it all in. "So much has happened. I still wish I'd been there. I was going to check out where pecans most likely grow south of here and stuff like that, but you did this all on your own."

"That is right, me and two squirrels and an owl."

"It's like we're all becoming more like each other."

"I know."

"I mean reading maps, figuring all this out."

"I know. It's all very thrilling."

"I'm still jealous," Sara said again, but this time without the anger. "I should have been there," she repeated for the fourth or fifth time.

"You were there in spirit. We are all in this together, Sara. Please do not feel left out. You need to understand, Owletta is perfect for the job and she can fly. When you meet her, you will understand even better. Her power of language is very strong and beautiful and I'm sure other birds and animals will trust her. And if she finds the vinetropes, they will trust her too. Owletta is our best bet at making contact. It should be her to make it first, if not yet me. She is the perfect ambassador."

"I understand. I do. It just took me by surprise. And it will give you time to learn about us, so when you finally get to your people, you'll know a lot more about how things are."

"That is exactly right. And it will also give us time to figure out a way to get us there. Maybe in one of those cars."

"That's going to be hard to do."

"I know, but not impossible. I'm here, and that should be impossible."

Sara smiled. She was feeling better and tried to explain why she was so sensitive. "So much has happened and now my dad and Steven are acting all interested in me," she said.

Then she shared everything that had happened with her family that day.

"This is a good thing," assured Lucinda.

"I know, it's just too much."

"It has been too much for all of us!"

"Well, let's not waste time out here when we can go inside. Hop into this bag."

Lucinda peeked in. "Pine cones?"

"Yes, I thought it would be a good way to transport you around after Steven gets back, if you decide to sleep over."

"A sleepover? I am not quite sure about that."

"Okay, we'll see, after you've been inside for a while. But if you do stay over, you can duck under the cones and hide and I can carry you back out that way."

"Nice," said Lucinda, sniffing the cones and hopping in.

Sara opened the back door that led directly into the kitchen and placed the bag on the floor.

"Okay, the coast is clear."

Lucinda jumped out onto the earth-colored tile floor. The newness of everything put all other concerns on the back burner for the moment. This was going to be a big experience!

"Wow, everything is so big. I feel dizzy. Look at this floor. How did you get your dirt so even and clean and shiny?"

"It's not dirt. It's tile, kind of like baked earth, but tougher. It's ceramic—glass-like and colored like earth," Sara tried to explain.

Lucinda sat down and stroked the floor with her hand.

"Beautiful. It is something like polished stone. We used that a lot, but mostly our floors were covered with moss or rugs we weaved from grass and other plants. This is very attractive and practical. I bet it keeps the bugs and worms out."

"Yes, it does. Mom, despite her love of nature, would have had a fit with a living floor. But I think Dad would like it. He'd probably have us all studying it and taking notes on the life cycles of indoor fauna and flora."

Lucinda laughed. "And what are all these wooden doors?" she asked, looking up and down.

"Those are cabinets for storage." Sara opened a door to demonstrate.

"Of course, I know what cabinets are. We had them too, but they mostly stayed opened, you call them shelves. Yes, we had a lot of shelves. We did have doors too, for our main doors in and out of our homes. Those were made of wood…often from the Seed Song tree. They were called Seed Song trees because when the wind blew through them they made a sound like beautiful music in the distance. It was mysterious, even to us. They were plentiful and were easy for our carpenters to work with. The wood made wonderful musical instruments as well." Lucinda was rambling, lost in historical memories.

"Sounds wonderful."

"We also had movable doors in-between rooms, I think you call screens,—yes, they were screens. But these doors are so huge."

Sara lifted Lucinda to her shoulder and took her around the kitchen. She opened the kitchen cabinets, so she could look inside at the huge dishes and supplies; she showed her the refrigerator, oven, microwave, dishwasher, and sink.

"I love this running well you call a sink. How efficient and a better design than a simple well. We can use our own self-made water, but for larger jobs, like bathing and washing we did dig wells."

"How do you bath now?"

"Oh, Glowers don't need to bath. We self-clean all the time because of all the clean energy constantly coming from us."

"That's crazy!"

"No, it is another kind of normal; but regular vinetropes bath. And we all like to swim. I could fill this sink and use it as

a small swimming pond. I cannot believe the size of these pots. You could cook for three vinetropes in this one," she laughed. She pointed to a pasta pot in the drainer. "This pot would probably hold enough food for thirty vinetropes."

Sara took her from room to room and everything was a marvel to Lucinda. She noticed Sara's mom's paintings right away. One beautiful painting hung over the fireplace in the living room.

"This is one of your mom's paintings isn't it?" asked Lucinda.

"Yes, she did that one three springs before she got sick. It's me in the garden, from the back."

"It's beautiful. I can tell it's you, even though I can't see your face."

The painting was of the lower garden, looking out from just about where Lucinda's front door was located. The easel must have been set up in front of the wall. The garden was splendid. It was in full June bloom and you could see it was tended to with love. Sara was twirling in the center of the garden on the grass and her gesture was full of joy and energy. You could tell, even though her face was turned away, that she was happy in that moment.

The painting was vibrant and used both realistic and impressionistic techniques to create the effect. Where the sunlight passed through the branches the sense of light was almost blinding, making Lucinda's eyes avert away and back to the image of the spinning girl. It breathed with life.

"It's very special for me," said Sara. "I spent a lot of time with Mom while she painted that piece. She kept having me twirl and then, with my body twisted and my arms out, I held the pose as long as I could. Both feet are on the ground, but it gives the feeling that I'm about to spin again."

"It is truly splendid," confirmed Lucinda.

Lucinda had to see everything. When they got to the toilet she was puzzled.

"This seems a little low for a human sink, too small for a human bathtub, now that I am used to your scale of things. Do you use it for some kind of recreation?"

Sara giggled and then explained.

"By the way Lucinda, how do vinetropes handle it?"

"Well, my friend, since you ask, I can tell you that all our waste is recyclable material. It is close to being what you call topsoil, but it is a bit strong to keep indoors right in our homes."

They both giggled this time.

"We have another chamber nearby to 'deposit' it in," Lucinda continued. "In short order, it becomes the best topsoil there is and we use it in farming. Vinetropes farmed indoors in ancient times. Our roots provided the sunlight."

"Wow! So you use what we would call an outhouse. And it's also your compost heap. Very interesting." Sara laughed.

"I think you have a bit of the scientist in you, Sara, like your dad. You are curious about everything. Well, that is a lot like me, too."

"I guess so," Sara chuckled. "So where is your outhouse?"

"It's further down at the far end of the wall near the end of the garden. I found another smaller hollow there and made a tunnel to it."

"Good plan," said Sara.

By now they had made it upstairs and into Sara's room. Sara plopped Lucinda on her bed with its pink bedspread, the same one she'd had since she was six.

"My room's a bit childish," Sara explained defensively. "We've never gotten around to changing it since Mom died. We'd just talked about doing it when Mom got sick..."

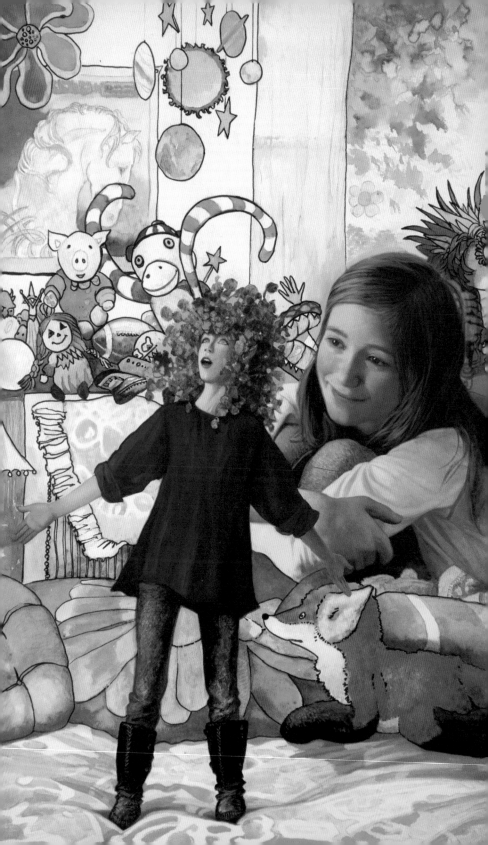

Sara frowned, but then brightened once more. "But I have so much more to show you—my computer, television, music. I'll order out for dinner. I'm sure we can find something on the menu you'll love."

"We are going to have a splendid time. But sit here first next to me on this royal bed of yours."

Sara took off her shoes and sat cross-legged facing Lucinda. Her room displayed a large collection of toys and stuffed animals in many shapes, colors and sizes. The unicorn poster still hung on the wall and scattered across her shelves and window sill there sat a menagerie of other toys … rabbits, a horse, rag dolls, puzzles and games. The room, of course, boasted the large bed they were on and the bay window with a view. On her pink bedspread was the toy fox Sara's mom had given her when she was nine— a year before she died. Lucinda stood in the middle of the bed, turning around and around like a music box ballerina, taking it all in.

"Your room is so artistic!" remarked Lucinda. She seemed dazzled by the size and array of colors and shapes. "I have never seen anything like this."

"Of course, you haven't," Sara chuckled.

"You never told me you collected sculpture," continued Lucinda, as she petted the toy fox that was as big as she was. "I never could have imagined there could be so many sculptures in one place. Did your mom make any of these?" She gave the fox another pat on its head.

"Oh, that's not sculpture."

"It must be! All these three-dimensional creatures all over your room!"

"They're just toys."

"Pretty fancy toys," said Lucinda, impressed. "This is quite a huge sleeping chamber for one person! Even for a human child."

"I know, I guess I'm lucky. Our three bedrooms are all pretty large."

Lucinda jumped off the bed and approached a green creature perched on the wicker toy trunk under the window.

"This guy looks just like an ezack."

"What's an ezack?" asked Sara.

"Well, like the dinosaurs we discussed, but ezaks could fly and breathe fire. Dragons, yes, we discussed dragons already."

"This is a toy dragon! So dragons actually looked like this?"

Lucinda handed Sara the dragon and hopped back on the bed. "Oh yes, and there were other huge birds that could fly in my time, huge like the dinosaurs; but they were not dragons, they were large and not very bright animals. Dragons were smart and they were plant life like us. We rode them occasionally."

"Plants! Dragons were plants? This is too much!"

"Of course, they were intelligent. And they were part of our legends."

"Ours too. Could they come back?"

"I doubt it. But who knows. Some vinetropes may have sealed dragon seeds in pods, feeling sorry for them. My history tells me the basic events that happened. It does not tell me every single thing that every vinetrope ever did on a personal basis! So there are many things I cannot possibly know. I am most worried about the vinkali and chargons returning because their lives crossed ours all the time and they very well may have copied our methods of survival."

Sara looked long at the dragon but her mind was elsewhere for a moment.

"It's too much to think about now. That dragons existed. Imagine if they came back—"

"It is a lot to think about."

"I'm going to rename this guy Ezack," said Sara, patting his head. "It's my new word for dragon!" Sara laughed. "And it's good to know that vinetropes have legends as well. That's a very human-like trait."

"It is true. We all like stories. And legends have a bit of truth in them too, that is why they last."

"Actually, we have lots of movies about legends, all kinds of adventure stories brought to life. We have funny movies too."

"I would love to see one of these movies."

"Okay, we'll choose something to watch later. You'll tell me what you think of it. If we pick one about dinosaurs you can tell me if what we imagined them to look like is anything like the way you remember them. It must be such a different world that you remember."

Lucinda stood up again and twirled around on the bed. "Sara, here in your house I feel like I have left one strange new world, the world outside, and arrived now in another! And both are nothing like the world of vinetropes." She jumped off the bed and went to the bay window. Climbing up on the trunk with games stacked on top, she was able to get up on the windowsill. "I love these windows; how they let you look out, but keep you protected from the weather."

"You didn't have windows?"

"Well, we had root roofs. They were in the main rooms closest to the surface. When the weather was good, a part of the roof made only of roots, would pull back like a curtain and open and let in air and sunlight."

"Like a skylight, but open," Sara suggested.

"Yes, the weave of the roots would contract, revealing the outside. Then it would close again when we wanted it to. This glass is especially beautiful, though. Vinetrope seeds are clear like this, like glass."

Just then Sara's cell phone binged from her bedside table. It was Steven texting, checking in with her. Sara texted back, "… fine … ordering from Jim's … doing homework."

"OK … heading into the theater/I'll text again when on the way home," answered Steven.

Sara pressed end and put the cell phone back on the bedside table.

"That's the little boxes of light that Owletta said she saw humans using all the time! Is that a computer?"

"Yes, it has a computer in it. Here, let me show you. It's called a cell phone."

Sara slid it open and began to explain. Before long Lucinda was engrossed and checking out maps, getting side-tracked by a hundred things that caught her interest, and learning faster than Sara thought "humanly" possible.

"This is outrageously fantastic! I see why it would have been so helpful with planning Owletta's journey. I am learning so much more about this world. I have a good geographical feel for the whole area, here where you live, and how big it is and what grows here. I have even gathered a few good ideas for potential food sources that I never would have thought of without this device. This is great!"

"You're unbelievable. You seem more at home on my cell phone than me!" said Sara.

"I wish I could plug myself in somehow and just upload all the information that might be useful."

"So I am right. There is a part of you that works like a computer!"

"Yes, I think the way I store information in my body works something like this."

"You mean your brain," corrected Sara.

"Well, I think the part of my brain that stores information

is all over my body. My brain, in my head, is what puts the information to use. And it is me, Lucinda, the living me, that feels, experiences and makes decisions. And I am unique and more than all my information. Just like you, Sara."

"This is too complicated." Sara tossed Ezack on the bed. "I'm confused."

"Well, me too. I just wish I could connect to this cell phone somehow."

"Well, here, come over to my computer at my desk. Maybe you can hook up to some outlet here."

Sara lifted Lucinda up and placed her on the desk.

"Let's get you started."

Lucinda sat and was soon enthralled and deeply engaged. She learned so quickly. After ten minutes or so of studying, Lucinda did a surprising thing. She took a tendril of her vine-like hair and plugged a strand directly into the computer. While Sara watched, Lucinda seemed to be surfing the net and uploading at the same time. She absorbed as much knowledge as she could at a rapid pace. Her body lit up and dimmed and then lit up again. She seemed in her element. She was smiling and humming and talking to herself all at the same time. Sara took out her schoolbooks and did some homework while she waited for Lucinda to finish.

An hour later, as she continued to work, Lucinda began to speak. "It seems my long-term memories, the ones I was born with that tell me the history of my people, work a lot like a computer. They are stored all over my body, I was right about that. When I was born, this information took a while to upload to my brain. I've been reading about how computers work, how code works, programming … it all makes sense to me. I've read up on human biology, human history and some current events, energy sources, cold fusion."

"You've done all this in the past hour?"

"Yes," she affirmed. "I can absorb from many sites at the same time and organize the information. Then I can read through it again later when I'm not connected. It is all stored, as I said, all over my body. It seems the cellular structure of my body is made of a cellulose network that works much like the crystalline network used in programming computers."

"Unbelievable! I've learned about cellulose," said Sara, getting up and pacing around the room. "So your body is kind of like a celery stick?"

Lucinda laughed. "Yes, in a way, but it is as complex as a human's nervous system, filled with activity, all moving about with vinetrope energy making everything connect and making me a living being. And our clean energy seems to be a form of photosynthesis that uses cold fusion. I'm learning so much about how my own body works."

"So you're not a computer?"

"No, I'm a living being like you. But it seems a vinetrope can hold a tremendous amount of information, way more than humans, because we can store that information everywhere. It then needs to go to the brain, in my head, like in a human's, to be put to use. But just because we can store more information, does not mean we are incapable of making mistakes. We need real life experiences, living in the world, to know what to do with the information we have. That is just like a human being."

"I think I know what you're saying." Sara picked up on the thought process. "You make mistakes like humans do, even though you can store more data more quickly than we can. And that making mistakes for all of us is part of learning and living."

"Exactly!"

"But you're learning so fast," Sara threw her hands up in

amazement and pushed at her hair. It was beyond belief. "Lucinda, it takes a person, I mean a human person, months, maybe years, to learn as much as you just learned. And probably a human couldn't hold as much information in their brain if they tried a whole lifetime."

"Yes, I can learn rapidly and from many places at one time by connecting to the Internet. But remember, in the ancient time of vinetropes, when we were a vast civilization, there were no computers. This will be new for vinetropes, too. We did not have access to this much knowledge. You humans invented computers, the Internet, your own ways of storing, like the iCloud. So it is a strange surprise to find out that vinetropes, so much more ancient than humans, are better made to make use of this human tool than humans are."

"It's more than surprising or strange. It's phenomenal. And I think a bit scary. I'm worried people—humans—might feel frightened about this if they knew."

"They would. I am sure of that. But vinetropes, if we all can do this, can help solve so many of the problems in this world; just not the problem of human nature. And not all vinetropes are perfect. But I do think we are more civilized. So we will have a responsibility to help this world if we are truly coming back."

"How can you help us all and protect yourselves?" This was a huge problem, and Sara understood it.

"There may be a way of getting solutions to your world without your world knowing about us. The best way of solving would be to let humans think that they came up with the solutions themselves."

"I get that. But how? I mean my dad would be the perfect person to get the information to. But then he'd know about you."

"Who knows, maybe he can be trusted. Or maybe there is some other way. But right now I need to store, store, store and learn, learn learn. I will need quite a few sessions over the next few weeks to absorb everything that will be useful. I think, if we are careful, you can just sneak me in from time to time. And during the school week I could have two or three hours to work every afternoon."

Sara came back and sat down on the bed. "You're right. I don't think it will be hard to get you in and out."

"And by the time Owletta gets back, I will have so much knowledge. Why I think vinetropes can create their own computers, cell phones, ways to travel! We might be able to program roots to do new things . . . like put up a force field to protect us from chargons."

"That would be incredible!"

"It would be the first time we had a really powerful way to protect ourselves. Wow, I think I had better take a break, I suddenly feel exhausted." Lucinda unhooked herself from the computer. "I need time to integrate all this information and make better sense of it. My body will do that for me while I rest."

"I agree. You were glowing like crazy on and off. I was beginning to get worried you'd short yourself out."

Lucinda laughed. Sara picked her up, carried her back to the bed, and sat down next to her. She loved these conversations with her new friend. She really had to think hard.

"Let's hope Owletta can complete her mission," said Lucinda, yawning and rubbing her eyes. "When I am with my people maybe I will be able to figure out how we came to be back in the world."

"And how they wound up in North Carolina and you didn't!"

"Yes, this will be another piece of detective work." Lucinda yawned again. "You know what, Sara? I suddenly feel what I think you call starved. Really hungry!"

"Me too! Time to order dinner!" Sara got the menu off the nightstand and handed it to Lucinda. "Here, look over the delivery menu. I thought you might like one of the vegetable wraps. I'm going to get a small pizza with mushrooms and cheese. You can try it, but I don't know if you can digest cheese. You do eat all vegetables?"

"Just the non-intelligent kind. But I do not eat animals."

"Well that's a relief, to all of us."

They both laughed.

"I had better stick with the vegetable wrap. What is it wrapped in?"

"Just another kind of vegetable, it's made thin, round and flat. They roll the veggie in it."

"I think I will stay with that. I don't want to spend the next two days making compost."

They both burst out laughing. Sara placed the order and was happy to see Lucinda was unwinding from her computer session. And she was unwinding too. They were having fun. They really needed to have some fun.

"Okay, ready for a movie?"

"I sure am," confirmed Lucinda.

Sara opened two cabinet doors in a piece of furniture across from her bed. She had managed to talk her dad into a TV in her room. Her mom wouldn't have approved. So when they got a new flat-screen, she inherited the old one. Her dad might have been feeling guilty about being gone so much. Steven just watched everything on his laptop anyway.

"This is it, a TV," said Sara. She tried to prepare Lucinda before turning it on.

"I get the idea," said Lucinda, "from my time on the computer. This will be like watching legends and stories come to life. Let it roll!"

"I think I'll find that old movie 'Jurassic Park' first, to test out the dinosaur thing. There's a newer one, but I really like this version. I think you'll like the story. Then maybe we can watch something newer."

"Maybe something about outer space?"

"You like stories about outer space?"

"I have no idea. I was just studying about it on the computer before."

"Okay, well let's get going on the 'Jurassic Park.'"

The movie began and Lucinda was entranced. The swiftly changing images and movement were easy for her to grasp after being on the Internet. The natural story line took over, and her mind quickly adapted to this new process of visual storytelling. She cuddled up to Sara and at the exciting spots clutched onto Sara's arm. "Yikes! Wow! Uh-oh!" she called out at the right moments.

"This is a thrilling way to tell a story," she confirmed. "Of course you have got a lot of stuff wrong about dinosaurs, but that does not stop it from being exciting. Very imaginative!"

"What do we have wrong?" questioned Sara, putting the movie on hold.

"Oh, please, why are you stopping it at such an exciting moment?"

"Please!"

"Okay. Well, they were much bigger, but then we are smaller than you. So I am not sure about that. And the colors of the plants are all wrong. They were more reddish."

"Well, this is supposed to be happening now," reminded Sara. "They only brought the dinosaurs back."

"Oh yes, that is right. Well then, you have the dinosaurs down pretty well. But I see you did not bring back anyone from the 'moving plant kingdom', no vinetropes at all," she chuckled.

"I guess that's yet to happen!"

"The shape of the dinosaurs and their colors are excellently done. But these raptors, as you call them, they were not as fierce as you make them out to be. We just kept our distance when we were out and about. It was those long neck plant eaters that were the vicious ones."

Sara cracked-up. "Well, that makes sense."

Just then, the doorbell rang. The food had arrived. Sara went downstairs for it and returned with a tray holding a couple slices of pizza, a veggie wrap, with salad on the side, and two bottles of water. Lucinda tried the pizza, despite her gastrointestinal worries, and loved it except for the cheese. Sara helped her peel off the cheese. The wrap was a big hit, but one wrap was nearly half the weight and size of Lucinda herself. So Sara cut off a one-inch round and Lucinda "pigged-out".

While they ate, they finished watching the movie. When that was done they watched another movie and then the late news, to give Lucinda a taste of current events, which she had already delved into a little on the computer. She already had a grasp of war, nuclear weapons, global unrest, terrorism, hunger and many of the ills of the world. This was very disturbing to her. But there was war, hunger and slavery in vinetrope time, so it wasn't a complete shock, though the weapons and extent of their destruction was beyond what she knew of.

She was also complimentary of the creative pursuits of humans in the arts and sciences and could see that humans

were also capable of goodness, compassion and empathy. Lucinda seemed to get it all—the big picture of life. As distressed as she was by what she was absorbing, she stayed true to her nature and remained basically positive. She proved again to be an exceptional being. Finally, Sara noticed Lucinda begin to droop. She had never seen her truly exhausted before.

"Maybe this is enough for one day," Sara suggested.

"No, wait," Lucinda waved her off. "Listen, they are talking about the convention that your dad spoke at today."

And indeed they were. The reporter briefly mentioned Dr. Umberland's team and their work and showed her dad at the podium talking for a moment, but not what he was saying. The report was over in a minute.

"And there's all that to figure out yet, too. But to tell the truth, Sara, I am finally exhausted. I can actually say I must stop and go to sleep in this lovely room of yours, or I will drop!"

"Then we'll call it a night," and Sara gave Lucinda a hug and received a feathery kiss.

Sara went to the bathroom and when she returned she couldn't find Lucinda. She looked under the bed but she wasn't there. She had a moment's panic.

Then Lucinda whispered, "I am over here." She had climbed into an old doll cradle that still remained in the corner and had pulled up the blankets.

"Cozy in here!" said Lucinda. "But it could use a few stones. This will be my first sleepover! That is what you call it?

"It is."

They both giggled and Sara turned out the lights.

Sara was able to sneak Lucinda in almost every day over the next week. It was just as Lucinda had predicted, an easy task. If Steven passed them in the hall, he never questioned the shopping bag with pinecones or the school bag slung over Sara's shoulder. What was there to question? It was a snap. They would discuss many of the things Lucinda learned from her computer sessions. It was all working well. But despite the comfort level of coming and going, Lucinda usually preferred to return to her home in the garden each night: to her comfy stone bed, her fireplace, and her visits from Ekle and Apkin. And Sara often spent time in Lucinda's home, too, visiting and planning with the brothers.

They had so many questions.

If Owletta finds the vinetropes, what is their world like? How many are there? And once they know just where to deliver Lucinda and the boys, how will they get them there? Could they trust Steven to drive them? How would they do that without Dr. Umberland knowing? Could they trust him? Should Lucinda give him a sample of vinetrope energy to start tests on? How would he keep it a secret even if he wanted to? Were chargons and vinkali already back? Were they too late?

Everything rested on Owletta's journey, on what was happening with Owletta…

OWLETTA'S JOURNEY PART 1

The night that Owletta embarked on her journey was clear, cool and perfect for travel. She circled over the yard several times, making a mental note of all the clues she and her friends had discussed. First, find the city called New York near the great Atlantic Ocean. These were clear marks on the map. Then turn right and head south along the coast toward North Carolina. Once there, find the city called Raleigh, then move inland, west to the Haw River. Her skills with languages gave her added confidence. She could swoop down from time to time and read the signs humans liked to use. With her great eyesight she would have no trouble in locating signs along the way. All these thoughts buzzed in her head.

Owletta hadn't taken a long trip like this in ages. Once she and her mate Ashbah had found each other, they had settled down. And when he had died, she hadn't the energy to move anywhere else, or the desire to find a new mate. She hoped her wings were still strong enough for this demanding kind of trip. If necessary she would begin her journey by taking shorter flights until she built up her wing strength.

She thought about Lucinda. She remembered the legends of the Glowers and the memories sparked her excitement. Maybe someday she would be part of a legend that others would tell. *Owletta's Journey*, she thought. That sounds good. She knew she was doing something important. This was an historic

mission. She understood that things were changing and that she was part of that change. What it all meant was not yet clear. But in thinking about the necessity of this trip, she felt her confidence rise and, with that, she pumped the air and lifted herself higher into the night.

Owletta looked below and above, got her bearings and headed east. When she reached the great water she would take a rest before turning south. She had become content to stay at home, but as she worked the air with her wings and looked out over the earth, she felt a sudden rush of energy. This was wonderful! Was it possible she was younger than she remembered? If her mate hadn't died, was it possible she would still be laying eggs?

She followed the path of lights that people used at night when they traveled in their cars. When lit up, it was rather pretty. These roads were wide and plentiful in the area and she knew, from the map, that many headed east toward the coast. She now understood that cars were a form of transportation. After another moment of circling, she chose a wide and busy path, one on which quite a few cars were still traveling. It would lead her directly to the big city and the ocean, she was sure. Even though she was invigorated, she expected her wings would probably ache after the first night out.

Owletta approached the vast city sooner than she thought and the night sky was so brightened by the lights that it took away the stars.

"Follow the moon to the silver-black sea, then make a right turn to Haw River Valley," she hummed into the air.

She was starting to rhyme like Lucinda. She felt amused and chuckled to herself. The skyline swiftly became a reality. As she crossed a river she found herself maneuvering carefully through a maze of huge buildings, a forest of brick and steel. Many windows were lit up with human light.

Owletta flew between what seemed an endless sea of human made structures. Some were so huge and rose up so quickly, she only narrowly missed their edges. How many humans lived here all stacked up on top of each other? It was mind-boggling. She continued to fly east. She had passed over two rivers, but hadn't found the ocean.

She continued flying but, finally, just as she felt her strength was giving out, she approached an area where everything grew darker and more deserted and the buildings were not so tall. She glided and dipped over this patch of buildings. Owletta preferred the smaller homes of humans to the gigantic city buildings. The smaller homes were made mostly of wood and felt familiar. She knew of owls that lived in the higher parts of wooden houses. Maybe owls lived in these buildings too? She didn't know. She wondered why the other buildings were so lit up and filled with people and these buildings were not as high and so dark.

Then it appeared: the big water, the great silver-black sea, the Atlantic Ocean. In the daytime it had a different color, in fact many colors, depending on the weather. How did she know this? She had lived by the sea a long time ago, when she was a young hatchling, with her parents. Yes, she had forgotten that! But the memory had now come back. Was her mind changing in the way it worked? Seeing the ocean made her feel both sad and happy at the same time. How strange.

Owletta settled on top of one of the darkened buildings to rest a moment and just look. The building had a huge flat roof that seemed to go on for acres like a baked and blackened field. She would rest awhile and enjoy the water. It had been so long since she had seen it.

Yes, there had been a terrible storm, a long time ago, when she was just beginning to hunt for herself. The ocean had become the enemy, a danger, something to fear, and in its maddening fury it had destroyed the beach where they lived.

It pounded against the homes and trees that humans lived in along the beach. Their home was in a nest, up high. The tree swayed wildly. She was so afraid. She had been in the nest waiting for her parents to return. They never did.

"Nice night, Mate! Caw!" said a shrill voice next to her.

Owletta was bolted out of her memories. She jumped around and faced a strong, muscular but battered-looking gull.

"I didn't hear you land," said Owletta, extremely startled.

"I know, Mate, quite surprising, caw, for an owl. You owls hear a thing before it's happened. Learn to listen like an owl, my dad used to say to me."

"I must have been deep in thought," answered Owletta. "Not a good instinct when traveling."

"It's not! Caw. Not used to being on your guard, caw, like us city birds, are you? Not from around here, are you, Mate?"

"No. But not from so far away, either."

"But there's a long way to go, right, Mate?"

"You're very observant," said Owletta. "May I ask your name?"

"It's Cobcaw, caw, Cobcaw the Watcher."

"And you watch well," she paid a compliment. "My name is Owletta—Owletta the Thoughtful," she teased back. But she had to be honest with herself; her vanity liked the sound of it.

"In the city, Mate, one must hear in the now and think on the wing," screeched Cobcaw, in his excitable voice.

"I'm fortunate you are friendly company, then, and not an enemy."

"How right! Caw! And how is it that you speak seagull, Mate? I thought you'd turn and fly when I spoke up."

"It seems to be a talent of mine, speaking with others. In fact, this talent seems to be growing all the time."

Cobcaw tilted his head and looked Owletta up and down.

"Tell me, are you hungry, Mate?" asked the gull.

"Yes, now that you mention it. Quite!"

"I'll be your host tonight, caw. I know a place to find fish. In return, will you tell me your story, Mate? It must be a good one, caw, if you speak seagull."

"I will gladly tell you. But then I must continue on my journey. I want to be well past the city lights before dawn, though I seem to have passed the forest of tall buildings already. I need to follow the coast south."

"You have come too far east, Mate, if you want to follow the coast. You are out on the Island, caw. You'll need to turn southwest for a ways, then you'll see the line of the mainland, caw, with the water to the left of it. But we can discuss all this later, Mate. Follow me."

Cobcaw glided off the roof and swooped down to the right. Owletta followed. The gull made several turns, mostly to the left, but still heading east, directly to the water's edge. All the while they were gradually descending. Finally they rested on a small roof that was very close to the water; close enough that Owletta could hear the water lapping. From the roof she could see many ships docked. Some had tall parts that reached into the sky like the huge bare bones of an ancient bird. Some looked like the big silent buildings of humans, but in the water, floating, with windows, a few lit, with round-shaped chimneys. Owletta settled down next to Cobcaw and took in the view.

"Very impressive," said Owletta to her host.

"It's home to me, Mate."

"Where are we?"

"This is a fish-eating building. In the daytime many humans come here to eat fish. Come on, Mate, we'll go down in the back. No one is here now. Caw, I always find fish. There are mice as well, if you're interested."

Owletta followed. Soon they found themselves in a back alley with many large trash cans lined up along the side of the

building. Cobcaw was adept at getting off a couple of the loose lids with his beak. "Here's some great fish, Mate, from today's menu," he happily announced. They could smell it right away. Between them they picked out and accumulated a large, partly-eaten pile for feasting. There was quite a variety, some soft fish and some in shells. Owletta's favorite was the small fish humans called sardines.

"Plentiful, isn't it, Mate?" said Cobcaw.

"Yes, and it is quite delicious. I've never dined out like this before," said Owletta, making a short bow and sweeping her wings in appreciation.

They enjoyed their dinner and continued to converse.

"It's very pleasant to be talking to another bird," said Owletta, popping another sardine in her mouth, "even though I am so fond of Ekle and Apkin."

"Who are Ekle and Apkin, Mate?" asked Cobcaw as he tossed a fish bone away.

"Squirrels. They are my two and only best friends since my Mate Ashbah died."

"Squirrels? CAW!" Cobcaw was incredulous. "I thought that owls ate squirrels."

"Oh, I used to, but since I became friends with Apkin and Ekle, I wouldn't dream of it. I made a solemn vow to them I would never eat squirrel again. They'd have nothing to do with me if I did. It bothers them enough that I eat mice. It's strange, though, Cobcaw, because we've only been friends a short while, yet it feels like I've known those boys forever."

"Mate, you are the strangest owl I have ever met. But my dad always said owls were eccentric. Caw. Owls made him nervous, but he was respectful too. So owls make me curious, Mate. That's why I decided to speak to you. And now we are sharing dinner, caw, and talking and you're telling me your best friends are squirrels, Mate?"

"It is a bit odd, I have to agree. I've never run across such a friendship in any of the owl legends or lessons from my childhood, that is, of owls and squirrels living together in friendship, or of gulls and owls chatting." Owletta continued cautiously, eating another sardine. "When my mate died, I was very lonely. So when the boys arrived, both speaking owl, they made me laugh and we became friends."

Cobcaw tossed another fish skeleton behind him and asked, "Mate, they could talk owl? That's even weirder than you talking seagull! Caw."

"Yes, it felt peculiar at first," said Owletta, dropping a sardine as she continued her train of thought. "Ekle was especially good with my language. He could talk to me quite well from the first. Anyway, those squirrels made home seem like home again, even though it wasn't *their* home, so a little modification in my diet seemed worth it."

"Mind-dashing, Mate!" Cobcaw screeched.

"Yes, well, with time, I began to speak their language even better than they spoke mine. Then, before long, it felt like we were talking the same language." Owletta was now feeling free enough to tell Cobcaw more. Something told her it was safe to do so. "You see," she continued, "it all happened so slowly and naturally that none of us thought of it as that unusual till very recently . . . until Lucinda came into our lives. That's when we realized that it was Lucinda's arrival that was causing all the changes. She gives the gift of languages."

"Lucinda, who's she, Mate? Who are you talking . . . CAW! Watch out!" Cobcaw suddenly shrieked, flapping his wings.

Owletta looked up and saw five angry, aggressive-looking cats surrounding them. They were hissing and moving in toward the pile of fish, trying to intimidate the birds. Owletta thought maybe she could talk to them; offer to share. She'd always gotten on fine with cats.

"Hi there boys, girls, no need…" But her speech seemed to push them into action instead of reason. They began to move in for an attack. Cobcaw shrieked again, "Caw, caw, caw," and jumped around, flapping and screaming. Owletta opened her wings wide, making powerful flaps in attempt to frighten them away, but in that instant the biggest of the hissing creatures leaped nearly straight up and landed on her back, making her scream. The cat bit her on the back of her neck while it dug claws into her shoulder. Owletta howled and then flung her wings out instinctively. She was powerful and with a half twist and great force she flipped the animal off and onto the ground with a crash. It lay stunned, but the others dashed forward again and made for the fish pile, hissing the whole time. Owletta stood back, in pain, but ready to fight if necessary.

Then the stunned cat got up and looked crazed and angrier than ever. It leaped forward making ready to attack again. By this time, Cobcaw had taken to the air and was at a good height above them. He dove down bravely and struck the cat on its back with his beak. The crazed cat howled and took off down the alley and the others followed it, disappearing into the night.

"Are you all right, Mate?" asked Cobcaw, shaken.

"I think so, but it hurts where that mad cat bit me." Owletta was shaken too.

"Let me check," cawed Cobcaw. "Yes, some blood where its teeth went in and claw marks. It looks painful, Mate. You've lost a few feathers."

"Was that really a cat?" asked Owletta, turning her head from side to side and flapping her wings to see if all was working properly. "I've seen many cats in my life, but none have ever tried to attack me before. Maybe smaller birds, but never me! Some were rather nice."

"I expect the cats that you're talking about are well fed by humans. These are wild, caw, and not the sort you're used to."

"No doubt they were hungry, but that crazed one did seem especially aggressive. Maybe she's the leader and considers this her territory."

"It's mine too. Caw. They know that. But that cat was different. I've never had an attack like that before, Mate; some growling and hissing when we cross paths, but this was mean! Caw, So sorry, Mate! I hope there wasn't something wrong with her."

"I hope not too." Owletta flexed her wings and tried to put the discomfort out of her mind. "It stings, but I am sure it will be fine by morning. It's been a long day and I should probably not push on further."

"Good idea, Mate. I was going to suggest that myself, caw. Let's get you back to my place where it's safe. Rest is the best plan and I feel responsible. You can tell me more of your story, caw, after we're settled in. Do you think you can fly, Mate?"

"I think so. We'll know soon enough. Lead the way."

Again Owletta played follow-the-leader and she managed to get airborne with some pain but no apparent lessening of wing power. Fortunately they didn't have far to go and in ten minutes they entered Cobcaw's nest, hidden in the roof of a factory facing the water. Owletta caught a glimpse sky through an opening in the roof. Cobcaw explained that he too was alone. His mate had been killed by a truck not far from where they had just had their dinner. That was three seasons ago. Owletta sympathized.

As they relaxed, Cobcaw asked that she tell her whole story.

"You were telling me about a Lucinda, Mate," Cobcaw reminded her. "First the squirrels, caw, and then this Lucinda."

So Owletta explained the reason she was traveling. She told about Lucinda returning from the ancient past and of

the history of vinetropes, the human child, Sara, and even the possibility of the wicked creatures called chargons and vinkali. She ended with the fact that it was now her job to find the city of vinetropes being built under the earth, as well as Ekle and Apkin's mates.

"And Lucinda has so many powers, I guess you would call them that," Owletta continued. "She has the gift of giving speech to other animals, she has power over roots, gets them to do things for her, and she's a Glower, she glows!"

"Wait," said Cobcaw. "A Glower, you say, Mate? She glows?" He tapped the tip of his wing to his head. "I have a cousin down the coast—Skitter is his name, caw. Last time I saw him, he rattled on about a creature that glowed. Thought he was fooling with me or had gotten drunk on a puddle of beer, but maybe he was onto something, caw?"

"He saw a Glower? What did he tell you?"

"Said there was talk of a creature that looked a bit like a human, but was smaller, caw, more our size and that it gave off a glow. There was also talk of digging and building … might be that city you mentioned, Mate."

"So he didn't actually see one for himself?"

"No, just rumors, first from his wife—who's from further south. I thought he was pulling my talons, joking around with me; he's always one to play a prank on you, caw." Cobcaw laughed. "That's Skitter for you, Mate. But he kept going on about it. Said another two gulls mentioned these Glowers after his wife. Now, from what you say, it seems he was onto something, caw."

"How long ago was this?"

"Oh, late winter? Early spring? There was a bit of snow melting. It takes time for chatter to move up the coast, Mate. Skit and I only see each other a couple times a year. Caw, he's got a family now, further south. He hasn't been up this way of

late, Mate. But he said the rumors started south of him, where his wife comes from. Caw,

"Cobcaw, this adds credibility to what I'm telling you, doesn't it? Do you believe these rumors now?"

"I guess I have to, Mate, don't I? I don't like the idea of these chargons and vinkali, and a city of vinetropes makes me nervous too! Caw, even though they sound like good mates … When things change too quickly it can be dangerous, caw. All these new creatures, will they want power? Will they harm us, Mate?"

"Vinetropes, no, never. I'm sure. They would never do harm."

"But, Mate, it seems to me it's their coming, caw, that started all this. If all you've said is true, it's happening because of vinetropes," he screeched, getting excited.

"But nothing bad is intended." Owletta raised her voice and lifted her wing to make the point in defense of the vinetropes. "Ow, that hurt!" The pain interrupted the conversation. "My neck is really bothering me." She lowered her wing carefully.

"Sorry, Mate."

"Vinetropes have so much to offer the world," Owletta continued, moving her head carefully from side to side, testing her neck. "And whatever has been set into motion, especially anything bad, will require the help of vinetropes to make it all come out right!"

"I see your point, Mate. If this is already happening, caw, it can't be stopped. And vinetropes are the answer, Mate, we need them!"

The two birds sat quietly for a moment, contemplating, each lost in their own thoughts. Then Cobcaw spoke.

"Owletta, my mate, I have decided to help you with your search. Caw! I'm now part of this story. I will take you to Skitter and we'll go from there. We'll follow the chatter back to where it started, using your mental map and the gulls' gossip. Caw,

we'll find this Glower, these vinetropes. We'll do it together, Mate."

"Cobcaw, I am very grateful to you. This is a wonderful plan and, furthermore, I will appreciate the company."

"Rest here in my nest, my friend. I must tell a few gulls that I am off, caw, so they won't worry about me. I will be back well before dawn and then we will leave."

"Yes, that sounds perfect. I'm quite tired. Actually I'm exhausted, and my neck and back does hurt. Take your time. I want to sleep awhile."

Cobcaw stretched his wings and prepared to leave.

"Cobcaw?" Owletta called out.

"Yes, Mate?"

"Have you ever heard of an owl and a seagull becoming good friends?"

Cobcaw stood shaking his head. "No, never, caw, but that doesn't mean it can't happen, Mate."

"You're absolutely right," confirmed Owletta. "It doesn't."

Cobcaw left. Every muscle in Owletta's body hurt, and the pain in her neck—especially where the cat had sunk its teeth—was troubling her. Her shoulder felt sore and stiff as well and her whole back throbbed. But Owletta was so tired she fell asleep despite the pain. The night was more than half over when Cobcaw returned.

"Owletta, Mate, are you okay? CAW! Owletta?" Cobcaw was standing over her and gently nudging her with his head.

"What? Yes … where am I?" was her first response. She was uncomfortable and disoriented.

"You're here in my home, Mate. I'm Cobcaw, remember? You're here on the Island, on your way to find the Glower? I'm coming with you … caw, caw."

"Yes, yes, of course, Cobcaw. I was just so tired … what with the trip here and the cat biting me."

"I know. You had me worried there for a while, Mate. I've been trying to wake you for a few minutes.

"No, no…I'm okay, I think. Just give me a second." She wiggled her feet and moved about a bit, stretched her wings, and moved her neck.

"Here, let me look at the bite, Mate," suggested Cobcaw. He checked the back of her neck and the claw marks lower down. "Your neck looks swollen, red. How does it feel?" Cobcaw didn't like the look of it.

"It's throbbing, but I think I'm feeling stronger after that rest. I seem intact. Are we going then?"

"Yes, I'm ready if you are, Mate. Cleaner air, away from the city, may do you some good. Do you think you can make it?"

"I'll give it a try."

"We can certainly wait, caw."

"No. I'd like to get started."

So they headed out. They made a sweep out over the water and turned southward, then moved southwest toward the mainland. Owletta's wings did continue to ache, but she got into a rhythm and they had a pleasant current of air blowing in the right direction, taking some of the strain off her wings. They flew the rest of the night and into the morning, resting now and then to catch their breath. Owletta was beginning to feel chilled and very tired again. The throbbing was becoming hard to ignore.

"I'm not sure if I made the right decision. Don't know if I can go on much longer," Owletta called out to Cobcaw, who was flying alongside her.

"If you can push an hour more, Mate, we'll be at Skitter's nest. He's got a large safe nest, caw. I don't know what else to do."

"Let's stop for just a moment, a short rest, and then I'll try and push on."

"Are you hungry, Mate?"

"No, my stomach feels off, actually."

They landed on a gnarled tree that was twisted and thick with tangled branches and twigs filled with clumps of dried ivy. "This will do," said Owletta. "I can hide in here unseen and take a short nap."

"Okay, Mate, I think I'll find something to eat and I'll be back as soon as I can. Caw!"

Owletta found a swirl of drying vines deep inside the tree, closer to the trunk, and tucked herself inside. She went right to sleep. But it was a restless sleep and she kept waking, feeling chilled and in pain, then falling asleep again.

Cobcaw knew Owletta was in trouble. He observed that the bite mark on her neck was swelling more and with that chill she was showing signs of a fever. But he didn't want to add fear to Owletta's condition. There was no chance Owletta would be able to fly the distance to Skitter's nest. Cobcaw was going to have to go to Skitter's on his own and come back with help. Somehow they would have to get Owletta to safety where she could be looked after.

About an hour later, Cobcaw was at Skitter's front door. The gull family's nest was in a deep rocky crevice on a low cliff that overlooked the ocean. The nest opened up into a substantial space after you entered it. Rather than the shallow nests that most gulls prefer, this was quite an ample living space. Fifteen gulls could fit comfortably! It was impressive. Tula, Skitter's mate, greeted Cobcaw as he entered.

"Cobcaw, what a surprise! Welcome, welcome, Luv!" She danced about and pecked him lightly on his head affectionately. She was a long, thin gull and full of energy. "Skitter and the kids will be so glad to see you, Cob. He is out with the kids, getting some breakfast." She waved her wing toward the opening through which he had just entered.

"I've got a problem, Tula. Caw! I'm going to need Skitter's help now! And any of your neighbors who may be willing to chip in."

Just then Skitter entered with a fish in his beak. The kids were still out and about with friends. He tossed the food into the nest. "Cobcaw, great to see you, old Coz! What's wrong, you look terrible?"

"He needs our help, Luv, he was just going to explain it to me," said Tula.

"Here, Coz, eat this," said Skitter. "You look like you need it." He bent over and picked up the fish he'd just thrown down. "Here, you look terrible, Cob. Eat some, then tell me about it."

So Cobcaw ate a bit and between bites told the story, a shortened version, just enough, so he could get his cousin to understand why he was helping an owl.

"Cob, you see now, it is true about these sightings. Did you hear that, Tula?" he called to his wife.

"Yes, Luv, about the creature that glows and the city being made under the ground. I told you Skit, this is real!"

"You see Coz, I didn't believe Tula at first myself. I bet you thought I was playing a prank on you, didn't you? Well you believe me now, don't you?"

"Yes, I do. Caw, I most certainly do, Skit. But that's the least of it now. I need you to help me save Owletta's life."

"Of course! I'll gather some friends and go to the seaside town closest to here, Coz. We'll look through the garbage," said Skitter, hatching a plan, as though he knew just what to do. "We'll find a sheet of fabric or plastic, Coz, something that the humans have thrown away that can be used as a portable nest. I think if five or six of us work together, we can lift this owl in a sling and bring her here. We'll have to fly lower than I'd like, but it's the only way."

"Thank you, Skitter. Thank you! What a good idea, Mate."

Skitter headed out just as Skoot, Picket and Ditta, the gull teens, arrived back.

"Cob, it's you," said Skoot.

"Hi super-Coz," screeched Picket and Ditta slapped Cobcaw's wing tip with hers.

"My, you have all grown!" commented Cobcaw. "You will be leaving the nest by next spring at this rate!"

"They probably will," acknowledged Tula.

The gulls visited for a bit, way longer than made Cobcaw comfortable. Finally Skitter returned with help. Four large gulls were waiting on the beach below and they were standing on a large, heavy-duty garbage liner that they had picked up behind some shops in a nearby town. It was a thick clear plastic and seemed very sturdy. The wind was up a bit now and they were keeping it in place by standing on it.

"Okay, Cob, we're ready to head out, Coz. Lead the way."

"They know the story? Caw?"

"They do, Coz, enough to be very curious and excited to help this Owletta of yours. It didn't take much explaining. They're good friends." Skitter quickly shoved a couple of pieces of food into his mouth and then motioned with his wing to exit the nest.

Cobcaw and Skitter glided down to the other gulls and exchanged a few words. Then the gulls pierced several holes, two sets at a time, into the plastic trash liner with their beaks, all around the edges. When pierced, it created a plastic strip between each set of holes, creating a plastic "handle" to hold onto. They each took hold of a handle with their beaks. When they had a firm grip, they lifted off, circling over the beach. They practiced awhile in unison, getting used to flying and holding onto the plastic liner. This was the first gull-ambulance in history. As they moved closer together the plastic dropped

and folded in the middle, creating a sling. Owletta would need to climb into the sling for the ride.

Cob rose first and took the lead to show them the way, with Skitter at the back of the ambulance. It was nearly an hour's flight, and they had to adjust their flight pattern and their speed and height in relationship to the wind. The wind would sometimes whip into the folded plastic, making it harder to handle.

Fortunately, as they moved inland a bit, the wind died down. Coming back would present its own set of problems, but the weight of Owletta would keep the bag from flapping out of control. It was their endurance that would matter on the trip back. Could they fly high enough to sustain the weight and how much slower would they have to fly?

The sky began to darken as they approached the tree Owletta had taken refuge in. A storm seemed to be brewing out over the water, and that was not a good thing for their task. Cobcaw entered the tree first and pushed into the tangle of dried vines.

"Owletta, it's me, Mate, Cobcaw. Are you okay?" He nudged her with the side of his head. Owletta stirred and made a moaning sound. "Owletta, caw, can you hear me, Mate?"

"I'm sleeping a long time," said Owletta, in a weak voice.

"Yes," said Cob, "you're sick, Mate, and feverish from the bite. I've come with help to get you to Skitter's nest."

"I can stay here until the Glower comes, Cobcaw. Let's stay! He'll be here soon!" Owletta was agitated and not making sense. "I can hear the music, can't you? Some kind of mysterious piping, beautiful isn't it? The squirrel boys have made a boat. Sara helped. Lucinda can steer it. That's it, Cob; we'll stay here until they come with the boat. Leave me be. Just leave me be." She was delirious. There was no point arguing

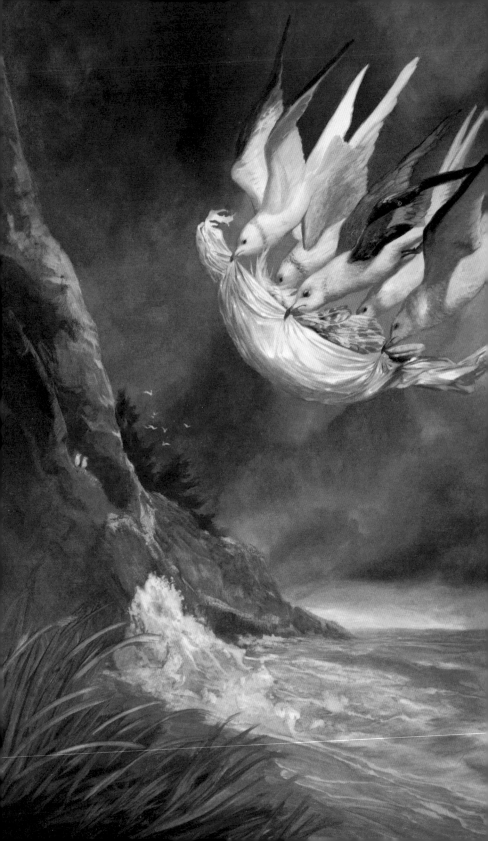

with her. Instead, Cobcaw worked *with* her hallucinations, not against them.

"You're right, my good girl. Caw. I have the boat here now that will take us. Lucinda arranged the whole thing. Clever, this vinetrope! Caw! You just have to let me help you onto the boat and then we'll be on our way."

Owletta seemed to calm and nodded in agreement.

Cobcaw explained the situation to the others and they flew into the tree, pulled the plastic in after them and spread it out in front of Owletta, keeping it straight by resting it across a network of small branches. The gulls then took hold of the corners, once again. Cob roused Owletta and encouraged her to step onto the plastic bag.

"Now, Mate, you just have to get into this boat. Let's go, a step at a time, we're almost there."

"What kind of boat is this? It feels slippery and cold," Owletta complained, as she put her feet onto the plastic.

"Yes, yes, it is, caw, but don't let that worry you, Mate. It's some new kind of waterproof stuff that girl Sara got for the boat. Human made. Caw! Lucinda gave it her approval."

"Okay, that makes sense. I wish I wasn't so cold."

"It's the fever. Now there we go; we're right where we need to be. You just settle down now. That's it, Mate. I need to go up front and help with the steering. Caw, Lucinda knows the way."

"I'm so tired,"

"You just go to sleep and before you know it, Mate, we'll be there. You'll feel us floating through the water in no time. Caw."

"That will be wonderful!" Owletta seemed asleep again, wheezing a bit and making little odd noises.

"Okay, Mates," announced Cobcaw, "let's take her away!"

Cobcaw then took a place on the ambulance, making the crew five for departure. Skitter was already out and above, waiting to lead the way back to his home.

"One, two, three, takeoff," Cobcaw mumbled, and they pulled out of the tree, dipping a bit precariously at first, and then lifting into the air. Between the five gulls, well positioned around the tarp, they moved up and out at a good height and speed. But the wind was also beginning to pick up, and in the wrong direction now. This was not going to be an easy trip.

"Hope no one notices us," Skitter called back to them. But his words were blown away. It was a real struggle to make any progress. The storm was gaining strength and they were getting very weary. The gulls landed land four times, as dangerous as that was, to rest. They guided Owletta down slowly in her plastic sling and dropped behind some rocks to get out of the wind and incoming rain, which was beginning to get heavy. They rested just long enough to catch their breaths and to take turns to shake out their wings. Owletta was not making any sense at all, but she didn't try to get out or get away. She seemed to believe she was in a boat and on her way to complete her mission.

Finally, Skitter's cliff was in sight, just as the rain began to come down in torrents. Skitter flew ahead and into his nest to let Tula know they had arrived. He then flew out again and sat on the edge of a rock that protruded from the entry to the nest. He waved to the incoming ambulance. Tula came out to watch. Then Cobcaw dropped away, to make their entry size smaller, and the sling dropped down with the loss of wing power. But they were going to need to be lower anyway, to make the entrance. The remaining four birds were exhausted and they had to use their last bit of strength to fold the sling in tighter and aim themselves level to the nest's opening. They closed the plastic together over Owletta, enfolding her like a pearl in a clam shell. Then they made their first attempt at entering and poor Frit hit the left side of the entrance and dropped his corner. He gave a cry and dropped back out,

circling in the storm. Skitter jumped on, just in time, catching the corner as Owletta began to slide out.

They made a second try, and flew straight for the opening. This time it worked. They came through the narrow opening with little room to spare and landed in a pile of feathers and feet onto the floor of the nest, releasing the plastic and Owletta at the same time. Everyone was moving and twisting and checking themselves out at once. The Skitter kids were yipping and squeaking all at the same time and Tula was running from one bird to the other checking for injuries. Owletta was helped into the back corner of the nest which had been prepared for her with extra grasses and loose feathers.

"Have we arrived?" she kept asking, and everyone reassured her that they most certainly had. Cobcaw thanked everyone all around. Frit came in for a moment too. He was bruised, but fortunately nothing was broken. It was a downpour, but the wind had subsided for the moment. In short order, the exhausted neighbors said their farewells and quickly headed home in the rain, happy that they had only a short way to travel and a warm nest to go to, and satisfied that they had done something that no birds had ever done before; they had joined forces and bravely rescued another bird!

Owletta was very sick indeed. The wound from the cat's bite was infected and now so was her blood. Tula bathed the wound with her saliva, but the sickness had already spread and she would either live or die. Cobcaw, Skitter and Tula took turns at Owletta's side. Only time would tell if she would make it.

8

TRICK OR TREAT

t had been three weeks since Owletta left and she was on everyone's mind, but they knew that three weeks was probably not enough time to make the trip and return. And if Owletta found the city of vinetropes, she would need to spend some time with them. So they kept up their visits and Lucinda kept up her computer sessions. By now Lucinda, Sara and the boys were old friends; a shared mission made their friendship deepen more quickly than would usually be the case. And Steven and Lynn did spend more time with Sara. Dr. Umberland still worked long hours, but he made an effort to be home for dinner twice a week and began to take off Sundays.

Now it was only two days until Halloween. This year Sara was going trick-or-treating, for sure. Sara had an idea. If she concealed Lucinda in her trick-or-treat bag, Lucinda could come along. That would be super fun! They had gotten away with concealing her up till now, so it would be as easy as cake with a trick-or-treat bag required as part of the holiday dress code. She would run this idea by Lucinda. When she arrived at Lucinda's, Ekle and Apkin were waiting there too, sitting on their haunches. They bobbed their heads up and down in greeting.

"Hello, boys."

"Hi," said Apkin.

"What's up?" asked Ekle.

"I have something fun to discuss with Lucinda."

Lucinda arrived smiling, carrying a bouquet of dried plants for seasoning the soups and stews she was now cooking, which included natural ingredients she had discovered from her computer searches.

"This should be good stuff to cook with," Lucinda explained "My computer lessons have been invaluable. I've got dried wild chives, dried oregano from a neighbor's garden and some interesting tubers that are good for vinetropes to eat." Lucinda drew a few out of her pocket to show Sara and the boys.

"Those are daffodil bulbs and lily tubers," Sara realized. She and her mom had planted so many. "But don't worry; no one will notice a few missing."

"Good! I can really use them."

They went inside Lucinda's house. Lucinda piled her supplies on the table and began to fuss with the fire and prepare for tea. The boys helped themselves to the ever present pile of acorns as well as nuts that Sara happily provided.

Sara sat down on one of the stumps at the table, facing out into the room, while Lucinda put the kettle on the fire and pushed her hair behind her ear. "Lucinda, I want to make you an offer," she proposed as she rubbed the brothers behind their ears the way you would a pet cat. Apkin rolled over on his back and practically smiled, waiting for a belly rub, which she provided. "This Friday," she continued, "is Halloween. How would you like to go trick-or-treating with me?"

"Of course," agreed Lucinda. "I would love to! What do we do, exactly?"

"We go out at night, dressed in costumes, to our neighbors' homes and say 'trick-or-treat' and if they're home, they give us candy. Very little kids do it during the day. But we older kids wait till dark to go out ... much more fun and spooky.

"Spooky? asked Apkin.

"Yes, and usually, if people are home and have candy, they let you know with a lit jack-o-lantern. You bring a bag along and try to load it up with as much candy as possible. Lucinda you could travel in my trick-or-treat bag!"

"What's a costume?" asked Ekle.

"Oh, well, it's a disguise—so no one knows who you are. It can be funny or scary. Scary costumes are better because Halloween is supposed to be the night of the dead … the night when the dead come back and walk the earth."

"Yikes. This sounds weird," said Ekle.

"I don't like getting scared," added Apkin.

"Don't worry, it's tons of fun, boys. And a little spookiness makes it more exciting."

"What is a jack-o-lantern?" asked Lucinda.

"You clean out a pumpkin, a big one is better, and then you carve a face in it, all the way through so the shapes are opened like holes, right into the hollowed pumpkin. When that's done, you light a candle and put it inside the pumpkin, or you can use one of those flameless battery candles or glow sticks. Then the face makes a lovely orange glow."

"It sounds a bit like me!" laughed Lucinda.

"Yes," laughed Sara, "but not pretty like you."

The squirrels seemed amused at this.

"You'll love seeing the different jack-o-lanterns," said Sara. "Some people get very creative with their carving. Their pumpkins are like little works of art. And they decorate their homes to look spooky … with skeletons and ghosts and monsters in the yard and on their porches."

The squirrels' eyes widened at Sara's descriptions.

"And you get to see everyone in their costumes, walking around," Sara continued. "You'll probably get some chocolate, like in the chocolate chip cookies you love."

"So they hand out chocolate? It sounds magical."

"Yes. Whole bars sometimes. A lot of parents actually don't like the candy part so much."

"I am ready to go!" Lucinda raised her arms and wiggled her fingers in enthusiasm. "This waiting for Owletta is getting on my nerves, if I am honest. This will be a great distraction."

"And I've just decided on my costume," Sara continued. "I'm going to make it myself. I'll be a giant jack-o-lantern and I'll make my costume glow with glow sticks hanging inside of it."

"Well in that case," said Lucinda, raising her arms again, "I will put on my birth dress and glow and we'll match!"

Everyone laughed.

"But you better not let anyone see you," Sara added.

"Of course not!"

The boys didn't know quite what to make of it.

"And my most super idea is the glow sticks. When it's time to go out I'll just snap the sticks and they'll be hanging inside my costume and the orange fabric will light up. It'll be great. I plan to be a very fat pumpkin, so I have to figure out how to make the fabric stick out like a pumpkin."

Apkin shook his head in disapproval and Ekle began to scold. "Lucinda, you'll be out among so many people, mostly kids. I've seen this thing Sara calls Halloween. I never knew exactly what it was, but now I know why the kids are always checking their bags. And they look into each other's bags as well. They may want to check in Sara's bag and they would see you."

"You are worrying too much, boys. Sara and I will make sure no one discovers me. You can run in the bushes and on the branches and watch us, if you want."

"Okay," agreed Ekle, "Maybe we should and keep an eye on things … just in case you need help."

"Can we have costumes too?" asked Apkin.

"Don't be ridiculous," said Ekle. "We have too much dignity for that!"

"Okay, I'm going to get started on my costume," said Sara. "You want to help me, Lucinda?"

"Yes, of course."

"We'll stay here and keep an eye on the fire," Ekle suggested.

"And have a few more nuts," Apkin added.

Before they knew it, Halloween had arrived. Sara struggled with the construction of her costume, but she had learned more from her mom than she had realized and was pretty pleased with the results. Lucinda's help turned out to be mostly moral support. It was fortunate that the old doll clothes had worked out so well for her. If Lucinda had needed to make her own clothes, they would have looked terrible. But Sara didn't mind, in fact she found it comforting that Lucinda was not good at everything!

Two things changed on Halloween that altered the plans. It was getting dark and Sara and Steven were both grabbing a snack in the kitchen. Sara was using a glass for her drink, not drinking directly from the faucet in front of her brother. And then, much to her surprise, he reminded her that he was coming along.

"It'll be fun," he continued, waving his sandwich at her. "Next year I'll be gone over Halloween."

"Yeah, you'll be going to a college Halloween party instead," Sara crunched on a carrot stick.

"I know, hard to believe. I'm going to one tomorrow night with Lynn, at the Capiellos'. Rickie is having his friends over Saturday because there's too much commotion at his house on Halloween and he always helps out."

The Capiellos went all out on Halloween. Rickie was their eldest, in Steven's class, and Jim, the younger brother, was a year ahead of Sara. They were also known as the wealthiest family in town and didn't hold back on the decorating or the "treats". They turned the front yard into a graveyard with lights, sound effects—a full theatrical event. And every year there was a surprise attraction, something new and alarming. No one in town missed the Capiello's on Halloween! It was a town tradition.

"I can't wait to see the Capiello's place. I haven't seen it in two years," Sara realized feeling enthusiastic.

"Well, it gets bigger and wackier every year."

"It'll be fun. I'm glad you're coming," Sara gave her brother a hug. She would just have to make sure Lucinda was very careful.

"And maybe you'll let me share in some of your bounty?" he teased.

"Okay, I'll give you all that sour gooey stuff that you like and I don't."

"I like the other stuff too," he protested.

"Well, we'll sort it all out after we get back. Pour it out on the rug and negotiate like in the old days."

"Sounds good, a lot fairer than when you were four or five. Some of that candy you shared with me back then was kind of wet, like it had been chewed on."

"It had! That's how I knew I didn't like it and that you could have it."

They both laughed.

It would work. She would have Lucinda and Steven with her at the same time. Lucinda would just need to be extra careful. This would be fun.

Just then the second thing happened. Sara's cell phone rang. She got it out of her pocket and slid it open.

"Hello?"

"Hi Sara, it's Jam.

She had forgotten to call Jam back about Halloween, like she'd promised!

"Hi, Jam!" she almost shouted. "Are you going trick-or-treating tonight?" Sara didn't know what else to say.

"Yes! I'm heading out in about an hour. Want to join me? I'm just by myself and that's not much fun."

Jam's honesty touched Sara. Maybe Jam was lonely too? Jam had always seemed like she wanted to be friends. Something suddenly clicked, and Sara wanted Jam to come along.

"That would be great. I wasn't going to go out, but then my brother Steven said he would join me." She altered the facts a bit; embarrassed she hadn't called Jam back.

"That's even better. Your brother is cute and so nice. My brother Dan really liked him a lot when he was in computer camp last summer. And if Steven's along, my parents won't mind if I stay out late. What's your costume?"

"I'm a jack-o-lantern. I made the costume myself."

"I can't wait to see it. I'm wearing one of my mom's saris from when she was my age. It's so pretty. I'll be an Indian princess, I guess."

"That sounds beautiful."

"And Dan told me not to miss the Capiello's home. He and Jim Capiello are best friends, so he's seen it already. In fact, he helped out. It's supposed to be outrageous this year and extra spooky."

"We'll definitely not miss it then. Why don't we meet here at seven? Come down the driveway and Steven and I will be up by the garage."

"Perfect. I'll be there. I'm so happy we're going together."

They hung up.

"That was Jamuna," explained Sara. "Jam, she's coming with us. Is that okay?"

"I guessed that. Of course, she's a great kid. I'm glad you'll have a friend along."

"She thinks you're cute."

"Well I am, aren't I?"

"I guess so, I never really thought about it," Sara laughed.

"And I'm keeping you both out late, I assume?"

"Yes, you are. I'd better get ready. I want to test the glow sticks in my costume."

"I can't wait to see it. And you both better be prepared. I might give you an unexpected scare of my own. That could make the night more fun for me."

"You'd better not," she said and Steven chased her upstairs pretending to be Frankenstein's monster, both of them laughing. It almost felt like the old days.

Sara closed her bedroom door and quickly got into her costume. She had to get over to Lucinda's now and warn her that Steven and Jam were coming along. Jam would arrive in half an hour. She came back down and Steven was still in the kitchen, on his cell phone, talking to Lynn who was babysitting that night.

"Wow! That's fantastic," Steven called out.

"Wait till you see it with the glow sticks lit up! I'm going to head out early and try it out."

"Okay, I'll be out in a bit." Steven continued his conversation with Lynn.

Sara picked up her trick-or-treat bag from the kitchen table, two paper shopping bags stapled together, and went into the front hall. By the front door, on the hall table, was an old wooden bowl her mom always put the candy in. Her dad had picked up chocolate bars, with and without almonds, and small boxes of pretzels, and Sara had put them in the

bowl herself that morning. If her dad made it home in time, he could hand out the candy. She dropped four chocolate bars into the bag, two of each kind and a couple of boxes of pretzels. Then she went back to the kitchen and put in a kitchen towel and a flashlight. The towel would give Lucinda a place to duck under in an emergency. With the glow from her costume she probably wouldn't need one. But there was no harm in bringing one along.

As she went out the back door she discovered that her pumpkin costume was so wide she could hardly get through the door gap. She pushed together all the netting she had stitched and layered to the inside of the costume to give it its shape, and by holding it all in she just made it through. Sara had thirty glow sticks hanging on strings of different lengths, sewn around the neckline. They were hanging outside the costume, ready to go. As she came out the door, she stopped a moment, pulled out the glow sticks and broke and shook them until they began to emit their phosphorescent light. She then dropped them back down into her costume and they lit up the thin gauzy orange fabric she had used, making it light up a bright orange. The effect was great!

"Lucinda, we're just about ready to leave. Are you ready? We've got company joining us tonight so we need to go over some stuff before they get here." She was at Lucinda's door.

"Yes, I am so excited! What kind of company? Come on in a minute."

"I can't fit. My costume is too wide."

"Too wide? I can't wait to see this!"

201

Lucinda slipped out in her beautiful birthday dress, looked up at Sara and laughed so hard that her glow went out of control for a moment and lit up the whole corner of the garden.

"Watch it! You look like the New York skyline!" warned Sara.

"Okay, okay, I have just never seen anything so funny before. If you looked like this when I first met you, I would have fled so fast my vines would have dried out before I turned the corner."

She was still laughing, but she brought her glow back down.

"Pay attention! Steven is coming with us and a really nice girl from school, Jamuna. Now here's the trick-or-treat bag," instructed Sara, "jump in before my brother and Jam show up."

"I am so pleased to get a look at Steven," said Lucinda with a mischievous lift to her voice. She climbed in. "And who is Jam?"

"Jam's the girl I told you about, didn't I? Her name is Jamuna, but everyone calls her Jam. Her parents are from India? I figured we're so good at hiding you now, it shouldn't be a problem."

"It will be fine. I think it is nice that you have a human friend. I hope she won't replace me."

"No, of course not. Don't get jealous on me now." Sara frowned. But when she looked into the bag, Lucinda was looking up with a smile on her face.

"This will add more excitement to the evening!" Lucinda moved the towel and candies around in the bag and pushed the flashlight into the mix at the bottom and sat on it.

"You can use the kitchen towel to hide under if it's necessary. Please keep that in mind."

"You sure seem bossy tonight, Sara Umberland!" Lucinda looked up into Sara's face, which was painted green.

Lucinda started to giggle.

"I'm just serious about your being careful. You don't seem to be taking it seriously," said Sara.

"I am. But this is supposed to be a fun night, I thought. I am in a good mood. Is that so wrong? It has been very stressful, waiting to hear from Owletta. I thought we might all just have some fun."

"I guess I'm just a little nervous with both Steven and Jam joining us. Just watch your glow. That gleam in your eye is making me more nervous."

"Don't be such a worrywart. You were the one who invited me, remember?" said Lucinda.

"Yes, and I hope it was a good idea."

"It was, and your costume is absolutely spectacular! That's why I have been laughing so much."

"Oh, thanks. It did come out good, didn't it?"

"What's this?" Lucinda interrupted. She held up a box of pretzels in one hand and a candy bar in the other. "Chocolate," she read out loud and immediately ripped off the wrapper and took a bite. "Yum! Umm. Really good!" she kept commenting on every bite.

"Don't get yourself sick on this stuff and for heaven's sake, eat more quietly!" Sara complained. "It sounds like a nest of mice in there."

"Well pardon me! I had no idea that you had become my mother!" Lucinda giggled again.

The back door opened and slammed. "Cover up!" Sara whispered.

"Let's get going," Steven announced.

At that same moment, Jam showed up on the driveway.

"Hi Sara, hi Steve," she announced.

Steven was zipping up his jacket and coming towards her.

"I'm ready," Sara managed a smile and tried to calm down. She picked up her bag too quickly and Lucinda tumbled over giving her an annoyed look. "Sorry!" whispered Sara.

With that she headed up the steps and onto the driveway where Steven and Jam had converged.

"Wow," said Jam. "Your pumpkin costume is fantastic and hilarious! Where did you get the idea for hanging the glow sticks inside?"

"Well, a lot of people are now using them in their jack-o-lanterns instead of candles. I guess it just came to me from that."

"It really works! It's the best pumpkin costume I've ever seen." Jam was honestly impressed and it pleased Sara.

"Thanks! And your sari is just beautiful," Sara returned the compliment. "It's so elegant. I love all the greens and the deep pinks!"

"Thanks. It was my mom's, so it's a bit old-fashioned, which makes it feel more like a costume, and the embroidery is really fine. My grandmother embroidered it."

"It's all hand embroidered? Wow! With all those mirrors sewn in, it must be heavy."

"A bit, but not really."

"It is beautiful," agreed Steven, "but if we're done with the fashion documentary, can we head out?"

The girls laughed and the three of them cut across the lawn, through a patch of woods, and out into Hilltop Way. They made a right on Hilltop, walked about 200 feet and made a left onto Rennselear Road.

"I thought we'd hit Rennselear first," explained Steven, "We know half the people who live there."

"And the Capiello's house is on Rennselear!" reminded Jam with a laugh.

"And we don't want to miss that!" Steven confirmed.

Lucinda gave a little squeak of excitement, but no one heard. Within five minutes they were at the front door of the Sandersons' home. Three jack-o-lanterns greeted them along

the walkway, one for each of the three children who lived here. On the front porch was something quite unusual—the largest jack-o-lantern the kids had ever seen. It was made from the kind of pumpkins used for displays at roadside stands. It probably weighed more than 300 pounds. But this jack-o-lantern was especially unique because it wasn't carved into a face, it was carved into a house with a front door and many little windows all lit up with candles inside. It had its own little glowing jack-o-lantern by its front door.

"Hey, this is fantastic," acknowledged Steven.

"It's wonderful," agreed Sara. "Really magical!"

Jam rang the doorbell. They heard footsteps running around and voices. So someone was home

Just then Sara felt some movement in the bag and more concerning she heard a ripping sound. As they stood waiting at the door, Sara looked down at the bag and to her shock saw two of Lucinda's fingers poking right through the bag to the outside. Then the fingers quickly pulled back in. Lucinda winked up at her and placed her eyes against the two holes she had just punched through the paper.

Oh well, thought Sara. I guess there's not much point in her coming along if she can't see anything.

Then the door flew open and there stood the two youngest of the Sanderson kids—two and three years old—with Mrs. Sanderson.

"Trick-or-treat," said Sara and Jam simultaneously. The three-year-old dropped a bag of potato chips into each of their bags and smiled.

"Thank you," they both chirped and Sara heard a little more ripping of the bag.

"That's quite a pumpkin house," commented Steven. "It's so creative. I bet you'll start a trend with it, Mrs. Sanderson. Next year every kid in town is going to want one of these instead of

a traditional face." Steven was good with words and good at socializing with adults.

"Yes, it's beautiful," said Sara.

"And I love the small jack-o-lantern at the side of the door," added Jam. "It's charming," she concluded in an adult-like manner.

"Thank you, my husband is the one who carved it," Mrs. Sanderson explained. The two-year-old clung to her leg.

"Well, pass on the compliment," said Steven.

"I will," and she closed the door.

Sara peeked into the bag again as they headed back to the street. Lucinda was eating a pretzel stick. It looked like magic wand in her hand. She gave another wink.

"Oh dear, I'm in trouble," said Sara under her breath.

"What's the trouble?" asked Steven who was a little in front of her. Jam was lagging behind, still looking at the jack-o-lantern house, and hadn't caught up.

"Nothing," answered Sara, "I just said I'm glad it's double."

"What's double?"

"My trick-or-treat bag. I made it extra sturdy. Two paper bags stapled together."

"Oh? Planning on a huge haul this year?" Steven laughed.

As they approached Sonya's house, Lucinda's glow brightened. Sara reached her hand in and wagged her finger. Lucinda turned right off and then lifted her shoulders up and down with an "I'm sorry" expression on her face. They reached the door a moment later. Sonya was in Sara and Jam's class. She had a sheet ghost hanging from the front porch and a lot of fake spiderwebs all around the door with several handfuls of plastic spiders thrown into the webs for effect. There was one nice traditional jack-o-lantern glowing to the right of the door. Sara rang the bell. She hoped Sonya would be out, because, knowing Sonya, she'd want to go through

Sara and Jam's bags immediately to see what they'd gotten so far. Sonya opened the door.

"Hi Sara, how did you do so far?" She leaned right over to look in the bag.

Sara pulled back and put her own hand in the bag and pulled out a chocolate almond bar to distract her.

"Here. I brought you one from my house. No one's home at my place now. You're our second stop, we don't have anything yet."

"Oh. Thanks. Hi Jam," Sonya added. "I'm going out again in a few minutes, but I've already got a full bag."

"No kidding? This early?" asked Jam, fiddling with a plastic spider that had come loose.

"Yup, my Gram picked me up after school and took me around near where she lives. All her friends spoiled me and gave me handfuls of stuff. My bag was loaded in no time."

"And now you're going out on the evening shift," teased Steven.

"Yup! Oh here Sara, Jam… my mom made these big popcorn balls to hand out to the kids in our class. I'll throw in one for you, Steven. How come you're taking your sister and Jam around? Do they still need babysitting?" she giggled. Sonya was known for her sarcasm. She tossed two large popcorn balls wrapped in orange cellophane into Sara's bag and one into Jam's.

"No, they're babysitting me," Steve tossed back. "I begged Sara to let me tag along with them. This is my last time around the old town before going off to college next year."

"That's cool. I like your costumes," she added. "Hey, what's that glowing in there?" Sonya questioned.

The bag seemed to quiver with light.

"Glowing? Where?" answered Sara, knowing full well what it was!

"In your trick-or-treat bag. It's lit up."

"Oh, that's a flashlight I brought along. It must have got turned on."

Lucinda turned herself off as Sara put her hand in the bag.

"We'd better get going or we won't even get one bag full this year," said Sara as she quickly spun around and headed down the steps, with Jam right beside her. Steven gave a little bow to Sonya and turned as well.

They passed a group of kids coming from the other direction; two Count Draculas, a werewolf, a vampire and a scary clown.

"Don't miss the Capiellos' house," recommended the shorter of the two Draculas.

The next two houses were dark, so they moved on. They had success with the rest of the houses on the block, moving back and forth crossing the street and alternating between homes. They were now close to the end of the block. The next would be Loretta's Cohen's, another classmate, and the activity and noise level greatly increased as they approached. Spooky music was being pumped into the air. That made sense, since Loretta lived next door to the Capiello's house. The loudspeakers at the Capiello's home were pounding out mournful noises, frightening howls underneath the pulsing throb of a heartbeat.

The length of Loretta's walkway was lined on either side with small illuminated bags, orange in color. And each bag had sand in it to weigh it down. Fireless candles and glow-sticks had been placed in the bags and they were held secure in the sand. The bags gave off a friendly orange glow and the walkway was inviting.

Loretta had two jack-o-lanterns on her front porch and both wore witches' hats. The front door had a huge six-foot cardboard witch taped onto it to match the theme.

Sara rang the bell and Loretta opened the door. She looked like Dorothy in the Wizard of Oz, except for her blue denim jacket with the red plaid lining and her cell phone sticking out of the upper front pocket.

"Can I go with you guys?" she asked Sara and Jam before even saying hello.

"Fine by me," said Steven. Sara turned and made a face at her brother. She'd been a loner for the last two years and Loretta wasn't the first on her list to spend time with. Well, that wasn't nice to think, but with Lucinda in the trick-or-treat bag, Loretta was just more person to worry about and she could be annoying. But to give Lucinda her credit, she was pretty much behaving herself now.

"Mom," Loretta called back into her house. "I'm going around with Jamuna and Sara and her older brother Steven."

"Okay," answered her mom coming downstairs and stopping at the opened door. "Thanks, Steven. I'm glad someone is going to be keeping an eye on them," said Mrs. Cohen. "I really hate this holiday. I don't know how they came up with it. I'm glad, at least, that we just keep it to the homes around here. Really, all this holiday does is make the kids sick on candy and the parents sick with worry. About how long do you expect to be out?" she added.

"Till about ten I guess? It's a Friday. Don't worry, Mrs. Cohen. I'll have them back safe and not sick on candy."

"Thanks, Steven. I haven't seen you in quite a while. I believe Justin was two years ahead of you?"

"Yes, I graduate high school this coming spring. Thought I'd go around with my sister for old time's sake. I'm getting a little sentimental as I'm getting older," he jested.

Mrs. Cohen laughed. "Yes, that happens as you age." They both laughed.

"How is Justin?"

"He's doing well, started his junior year."

Loretta was getting impatient. She picked up the picnic basket from off the hall bench. It had a brown stuffed toy poodle sticking out of it, to represent Dorothy's dog Toto, and would double as her trick-or-treat basket.

"I'm ready," she said, stepping out and closing the front door right on her mom.

"I'll get sick if I feel like it," she muttered to Steven and walked with him back toward the street. Loretta was always in a state of rebellion, especially with her mom.

Sara quickly peered in at Lucinda who simply smiled graciously up at her and then put her eyes back on the two holes punched in the bag. Jam was at Sara's side a moment later with Loretta and Steven in front. A group of kids came up the walkway on their way to Loretta's.

"Don't miss the Capiellos' house," a Ninja Turtle told them as they passed by.

"We always get a ton of kids at our house," explained Loretta. "It's because we're right next to the Capiellos. We don't even try to compete. If we did we'd have to start digging up our front lawn in July to have a fighting chance."

Steven laughed. Loretta might be going through a rude stage, but she did have a sense of humor. She'd probably turn out just fine. They waited as Jam and Sara caught up.

"Well, we're just about there!" announced Steven.

"Let's go see what it's all about!" Jam spoke for them all.

"We'll have to wait in a long line," explained Loretta, nodding to the street in front of her house. "It happened last year too."

Sure enough, a line had formed along the curb in that short time, everyone waiting their turn at the Capiellos. And it was

growing. By the time they got in line it was backed up past Loretta's house.

"Of course I've seen the set-up already," Loretta admitted, "but it's always special at night, with the sound effects and the lights. It's pretty cool."

As they moved closer they observed an electric blue glow illuminating all the Capiello trees, the eerie light spilling into the neighbors' yards. Mr. Capiello, with Rickie and Jim helping, had spent hours getting this lighting just right, Jam explained. Her brother Dan had helped out a few times. The spooky glow made the floating sheets hanging everywhere in the trees look like real spirits.

"And Mr. Capiello always has that last minute surprise!" reminded Jam. "Dan knows what it is, but he wouldn't tell me."

"We'll know shortly!" The excitement had taken Sara's mind off Lucinda's proximity to the crowd.

The line moved slowly and seemed to be taking forever. Poncho, the Capiello's dog, was overly excited and raced around between everyone, getting a lot of attention, but not any supervision. The participants who were done with the "Capiello Event" moved past them, thinning back out into the dark, and they didn't give the surprise away. Adults were hanging around with lidded cups of coffee and, as they would soon see, Mrs. Capiello had set up a long table on their front lawn between two gravestones, loaded with plates of doughnuts and cookies and two restaurant-size coffee pots— one with coffee and another with hot water for tea. There were stacks of Styrofoam cups, teabags, cream and sweeteners, the works. The smell of coffee and baked goods was everywhere. It had become a neighborhood party. While they waited they were bombarded by continuous mournful sounds coming from the speakers. From time to time these sounds changed

from chains clanking, to howls, or that reliably unnerving steady beat of an anxious heart.

Finally, a full twenty minutes since they left Loretta's, they arrived at the front of the Capiello home. And here the line came to a complete standstill, people just waiting their turn. Whatever it was, was taking time! The yard was again an elaborate graveyard and this year it was more extensive than ever. The graves had spooky details like the mangled rubber hand coming out of the dirt and the full-size skeleton leaning against a gravestone holding a bottle of whiskey in one hand and a glowing lantern in the other. There was even a human skeleton walking a skeleton dog! Each scene was lit by a spotlight to add to the drama. And as well as the supernatural glow of blue, there was the occasional glitter of red, the eyes of a demon. It seemed that Mr. Capiello had outdone himself!

Poncho came running over and Steven bent down to pet and roughhouse with him a bit. At that moment, Jam saw her brother Danvir out the front with Jim Capiello, talking to people. Both boys were nice looking. Dan had shiny dark hair and eyes like his sister, neatly cut and Jim's hair was wavy, unruly and blonde.

"Hey, Dan. Hi, Jim," Jam called out. "I'm here with my friends, Sara and Steven."

"And Loretta," added Loretta.

Jim and Dan stepped over.

"Hi, Sis. Hi, Sara," he said a bit shyly, smiling. "That's an amazing costume you have!"

"She made it," said Jam.

"Wow! It's great! Funny and very clever!"

"Thanks, Dan."

Dan nodded to Loretta. "Hi, Dorothy."

Jim said hi to the girls too. "Your dress is pretty, Jam."

"Thanks!" she smiled and felt happy that he noticed.

Steven turned from Poncho and stepped forward and shook Dan's hand. "How's it going Dan? Good to see you. You too, Jim." He shook Jim's hand. "It seems the Capiellos have tipped the scales this year, Jim. Your dad should rent this set out to Hollywood."

"I know. I'm afraid what will happen when he retires and has more time on his hands."

They all laughed.

Poncho, feeling ignored, ran off elsewhere looking for attention.

"So what's the scoop?" asked Loretta, feeling a bit neglected.

Jim explained with Dan's help as the line moved forward.

"You see the coffin on the porch?" asked Dan.

Everyone nodded.

Jim took over. "Well, in order to get your treat, you've got to go up and knock on the coffin three times. Then it opens and something gives you a key. Then you've got to use the key to open the front door!"

"You're kidding?" said Sara and Jam in unison. Loretta just stood spellbound at the prospect.

"Pretty intense," confirmed Steven. Poncho had returned for some more fun and Steven gave him a couple pats.

"No, I'm not kidding. Then you have to let yourself into the house, one person at a time. That's why it's taking so long. Dad didn't think that part out too well."

"What happens next?" asked Loretta.

"You find out when you get inside!"

"That's awesome!" said Jam.

"And spooky," added Sara, pushing her hair back.

"When you come out," Dan continued the explanation, "you knock again and give back the key."

"No wonder we're not moving," laughed Steven.

"Like I said, my dad didn't think this out so well."

"But it's really worth the wait," added Dan, smiling at Sara. She smiled back. "I'm excited to do it. It's a great idea. Jam said you helped with everything."

Dan nodded with pride.

Finally the line moved and they were nearly at the start of the front walkway. There were six or seven kids ahead of them.

"We've got to get back," said Jim, "and help out."

Dan nodded in agreement.

The boys took a position down the walkway near the porch steps, so they could encourage the trick-or-treaters and remind them to return the key when they came out. Rickie, Jim's older brother, was giving the kids in front of them the directions. Steven had gone over to say hello to Rickie and was now helping out.

The old oak tree that graced the Capiello's front yard had an impressive spread of branches, and from them hung an army of fluttering ghosts and twisting skeletons, swaying in the evening breeze. And sure enough, there on the front porch stood a coffin. Everyone was delighted. Sara, Jam and Loretta looked on. It would be their turn soon.

Just then the front door banged shut and out came a child carrying a helium balloon shaped like a ghost. He knocked on the coffin door and it creaked open. They couldn't see too well from where they stood, but they watched as the child handed back the key to whoever was inside. The coffin quickly shut.

"Can I go first?" asked Loretta.

"Okay," said Jam. She got behind Loretta and Sara took her place behind Jam. They waited and the next child in line walked up to the coffin and knocked three times. The coffin opened with fake mechanical creaking. From where they stood they made out a tall man in a black cape swirled around

his body and nothing coming out of the dark collar. It was the headless horseman! In his left hand he held a glowing jack-o-lantern with red-lit eyes and in his right hand he held the key which he offered silently to the child. The child, dressed as the Easter Bunny, took the key, and the lid closed. The bunny then turned, walked along the cobweb-draped porch, and stopped at front of the door. He then got his courage and quickly used the key and went inside. In one seemingly long minute, bang went the door and out came the Easter Bunny looking calm, carrying his reward; but on second thought, he decided to add some the drama, so he screamed, and in a pretend panic, rushed right past the coffin.

"Don't forget to return the key," said Jim, grinning. The bunny returned to the coffin and returned the key.

This ritual of waiting and personalizing the experience with a performance was now an important part of the fun. A couple of the kids screamed and pretended to faint. One claimed dramatically, as she came out, that it was so horrible inside you shouldn't do it. You would never want to have that memory. It was Loretta's turn next and Sara felt a shuffle in her treat bag.

"Hey, what are you doing in there?" she whispered a bit too loud.

"I do not want to miss this!" Lucinda wiggled her fingers and pulled in close to the holes.

"What's who doing in where?" questioned Jam, hearing Sara's whisper, but not Lucinda's answer.

"I said I wonder what they're really doing in there."

Loretta climbed the front steps and knocked on the coffin three times, got the key and went in. She came out crawling on her hands and knees, throwing a rubber bat out onto the porch. "I'm okay. But I think something made me lose consciousness. How long have I been gone?"

Everyone in earshot laughed and Jam said. "Twenty minutes, but no one was willing to go in and find you." Jim and Dan cracked up.

Loretta got up, retrieved the bat and threw it at Jam. Then they both started laughing and Loretta took it back and threw it in her bag. Everyone was having a good time.

Jam was next. She came out acting dazed, holding a huge family size chocolate bar. All she said was, "That was really weird! I think I'm going to need to see a therapist."

Now it was Sara's turn. She climbed the front steps and got the key from the headless horseman. He said, "Hi Sara, glad to see you out this year," and she recognized the voice. It was Mr. Capiello.

"Thanks Mr. Capiello. This is just terrific, what you've done here. The whole town loves it!"

He patted her head with his free hand and no head of his own. Smiling, she marched along the porch and just as she approached the front door she heard more ripping and Lucinda's whole head popped out of a slit in the bag, facing the door.

Lucinda looked up and said, "No worries, I am going right back in, see?" And she pulled herself back in.

"Please, Lucinda, be careful, I don't want you falling out of the bag!"

"No chance, I know what I am doing."

Sara put the key in the lock and turned it. The door clicked open and she stepped inside. All the bulbs in the impressive hall chandelier had been changed to blue, and they flickered and sent strange shadows into the corners; emitting just enough twilight to show off the cobwebs, spiders, bats and skeletons that thickly draped the hallway and staircase. Then, a dark shadow on the staircase stood up and moved down the steps towards her. A frightful witch in a ragged but elaborate

witch's costume emerged out of the darkness and into the eerie hall light. She stopped under the chandelier and faced Sara.

"Hello, my dear. I'm assuming you are a brave little girl if you have ventured this far for a simple treat," said a crackling and sorrowful voice that sounded a lot like Mrs. Capiello with a sore throat.

The witch suddenly noticed something.

"And what's this little creature you have watching me from your bag, my dear?" Lucinda was still sticking out! It was obvious by the witch's calm that she thought Lucinda was a toy of some kind. She leaned forward and petted Lucinda on the head. Thank goodness Lucinda was quick thinking and remained motionless with a fixed expression on her face. And she was glowing.

"Just a weird old doll I have. She lights up," added Sara. "I thought she would look good with my glowing pumpkin outfit." That was quick thinking on her part!

"Well, she certainly does, very clever," said Mrs. Capiello. Before she could pat Lucinda again, Sara turned the bag casually around, pretending to look at things. That was close!

"And now you must choose your prize." The witch pointed to three black kettles. One was filled with large bags of chips and candy bars. Another had Halloween-themed helium balloons floating up from the kettle on weighted ribbons and the middle, third kettle appeared to have nothing in it at all.

"You can help yourself, my dear," continued the witch. "The kettle that appears empty has paper notes in it. You take a higher risk if you pick from there, for the note may say that you win nothing at all, or it may offer you an even better prize!"

Sara would have been enjoying all this immensely if it weren't for her concern about Lucinda. Well, she would just make her choice quick and get out of this situation as fast as

possible. She set her bag down a moment and bent over the kettle with the balloons.

Just then Poncho came from nowhere, went to the bag and sniffed right into Lucinda's face, which was sticking out again.

"Hey, Poncho, leave my bag alone," Sara ordered.

With that, Poncho grabbed the handles of the bag with his teeth and ran to the front door, which was now somehow ajar, she must not have clicked it shut! He pushed with his nose, the bag dangling from his mouth, and was out the door before Sara could stop him. The witch now spoke in her normal voice, "Just give me the key, Honey, and then go after him." So Sara handed her the key and took off after Poncho.

Poncho tore past Jam, with Lucinda's face still hanging out. But Lucinda pulled herself back instantly. The crazy dog made a quick turn and shot out back, away from the crowd.

"Help!" screamed Sara as she tore down the steps. Everyone laughed, assuming it was her turn to play terrified.

"Stop Poncho! He's got my bag," she screamed again, coming down the walkway. She was more terrified for Lucinda's safety than about her being discovered!

At first Steven also thought Sara was screaming to be dramatic. But out of the corner of his eye he saw Poncho race around back with the bag in his mouth, half dragging it on the ground. What Sara was yelling registered.

"My bag," she called again passing him.

Steven took off after Poncho, outstripping Sara and tearing ahead. He tore around the back of the house and followed Poncho into the border of trees and bushes that grew between the Capiello's house and Loretta's.

"Poncho, you stop right now. Poncho! Come here, boy. Come on, fella. Where are you?"

That's when he spotted Sara's bag abandoned on the ground, glowing. Poncho was gone, probably out the front

again. Steven went to the bag, catching his breath. He figured the glow must be coming from the flashlight Sara had in her bag. It must have gotten knocked on again during the bumpy ride. Then he heard it—the little voice.

"Help, help! Get me out of here. I am so dizzy. I think I am going to throw up. What a ride! Thank goodness it's stopped. Sara, where are you?"

And just as Steven came up alongside the bag, a little pear-shaped face, glowing as bright as a jack-o-lantern, peered out of the bag at him; then it fell back inside. Steven gasped and stood there speechless. What had he just seen? Dare he look? But he had to look, he had to find out, so he peeked into the bag.

"Oh, Steven, I am glad it is you, though it would have been better if it was Sara," spoke the creature out of breath. "That was a close one! You had better pick up this bag before that crazed animal comes back or a crowd of humans show up! Do not just stand there young man, doing nothing. You act like you have never seen a vinetrope before!" Then, wiggling her fingers in the air, she smiled a smile that Steven would never forget as long as he lived.

Steven was speechless and motionless and Lucinda had to get him functioning.

"Sara has told me so many nice things about you and I was really hoping we would meet," she continued. "Of course, I would have chosen better circumstances. But that is how it has happened and so here were are. Now you just need to pick me up and we will sort this all out later." She waved her arms again, in her usual manner.

Steven was struck silent but he could move and so he did as he was told. It was just in time. When he turned around with the bag in his hand, several kids had caught up and Sara, Jam

and Loretta were in the lead. Jam tripped, got up and dusted herself off and the three girls approached Steven breathless.

"I've got the bag," Steven gained his speech back on seeing Sara. "Everything's fine. It didn't even rip much. See?" He held the bag up for everyone to look at. The kids who had gathered, seeing that there was no harm done, lost interest and turned back to pick up wherever they had left off on their evening's adventures.

"Here's your bag, Sara," and he handed it back to his sister, very gently.

Sara's small green face, with the glow sticks from her costume lighting her complexion in a weird phosphorescent way, looked as pale as a green ghost, even though she was a pumpkin. She carefully took the bag and looked inside. There sat Lucinda as cozy as could be, surrounded by broken bags of candy and scattered candy corn. She gave her shoulders a shrug and made a gesture, like, "Oh well, that's life," and pulled the kitchen towel over herself. Sara had no idea what to think.

"Everything okay?" asked Jim coming up to them with Dan right behind.

"Its fine," said Steven. "No harm done."

"It's only candy anyway," added Sara, pushing her hair back, "I don't know why I got so upset." She suddenly felt embarrassed, especially in front of Dan. She'd acted like candy was the most important thing in her life. So uncool!

"Poncho is a pretty hyper fella," Jim explained.

"And all the people tonight must have pushed him over the edge," added Dan.

"Well, I was kind of worried he'd get into the chocolate," Sara thought on her feet. That made sense!

"That's right, chocolate's really bad for dogs," Jam confirmed. Then she checked her mom's sari to make sure it hadn't got torn.

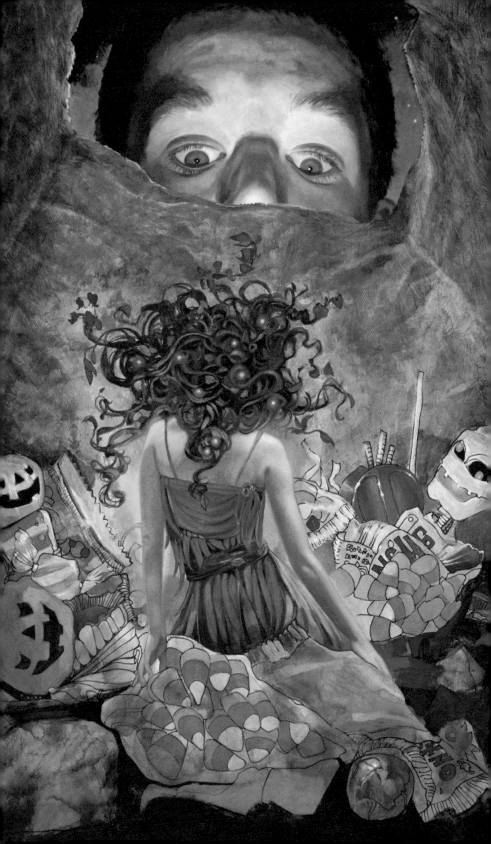

"I hope your dress is okay," said Jim.

"It seems to be. I guess it wasn't the best thing to wear on Halloween.

"Okay," Steven spoke up, looking a bit drained. "I suggest we get going if we don't want to miss out on the rest of the night. And I'm feeling kind of tired already."

This worried Sara. Steven was usually full of energy and he did look a bit off. Brother and sister exchanged looks, but Sara couldn't tell for sure what the look meant; had he seen Lucinda or not? He must have. It would have to wait till Jam and Loretta weren't with them anymore. When Sara checked in again on Lucinda, she had pulled the towel completely over herself. That wasn't a good sign either. But they continued on their trick-or-treat route as planned. Steven did cut it short by half an hour because he had a headache and they dropped Loretta off at her house grumbling. Jam said her goodbyes next, as she lived close to Sara and they could pass right by her place if they circled around from the other direction. The girls promised they would call each other in the morning.

When Sara and Steven got back to their house, Sara headed down the garden steps into the lower garden.

"Why are you going that way?" asked Steven.

"I'm just taking the long way around. I hate to see this great night come to an end!" This excuse didn't seem so clever. "It was exciting with Poncho? Wasn't it?" Oops!

"It sure was. I guess your little friend got the biggest thrill of all. Dropping her off somewhere by any chance?"

"You saw her!"

"A vinetrope, I believe she said? But we weren't properly introduced. It was a crisis bonding situation."

By now Steven had followed Sara down into the lower garden and was standing next to her near Lucinda's front door.

"Oh for Heaven's sake," said Lucinda hopping out of the bag with a chocolate bar in her hand. "You have seen me. Here I am. Lucinda Vinetrope. We have got a lot to catch you up on, Steven." Sara dropped the bag on the ground.

"Seeing is not the problem; the problem is being able to believe in what I'm seeing," Steven concluded, holding his arms out to the side.

"And what about your hearing?" teased Lucinda. "Is that giving you trouble too? Well, never mind about that. I talk a lot, you will soon find out, and your hearing is just fine. And so are your eyes. I guess what you really need now is one of my poems. A believing-in-what-you're-seeing-and-hearing poem would be very helpful. What do you think, Sara?"

"Yes, very useful," agreed Sara, nodding a bit too much with what she was sure was a stupid expression. "Lucinda is a great poet," she added, trying to be helpful.

"I'm ready," interrupted Lucinda.

"Ready?" said Steven.

"With the poem."

"Now?"

"She's fast at this stuff," Sara offered, as an explanation.

Lucinda lifted her arms and then folded them behind her back and recited her poem.

"If what you see
Is just not there,
Like seven moons
Up in the air,
That means you are in trouble.
But if a friend says,
'See that kite?
Look way up high
So shiny bright

With wavy stripes
All gold and white?'
And sure enough
When you look up
You see this kite just fine,
Then all is great
This proves your state:
No trouble with your mind.
It may be true
That sometimes two
Can play the fool,
If someone's out
To trick you,
But most the time
If what you see
Is also seen
By two or three,
It means you know it's there;
Even if it's seven moons
Floating in the air!"

Lucinda took a bow. Steven, despite everything, found himself laughing.

"That was very funny," he acknowledged.

"And very true!" said Jam.

She was looking down at them from the top of the wall near Lucinda's pie-panned chimney.

"Jam!" everyone, including Lucinda, called out in unison.

The moonlight light shimmered on Jam's long dark hair and caught the colors of her beautiful sari, the small mirrors embroidered in the fabric twinkling.

Jam came down the steps and joined them. "I saw the fairy lady sticking out of the bag as Poncho ran past me," she said

excitedly. "At first I thought I had imagined it. But then knew I hadn't. I followed you back here because I was trying to get the courage to ask you, Sara, if she's real. And she is! A real fairy!"

They were speechless and Lucinda was the first to speak.

"We have a lot to catch you two up on, Steven, Jam. Can we trust you both to keep our secret?"

"Yes, one hundred percent! I'm in, completely, and I'm totally trustworthy!" said Jam without hesitation.

Lucinda broke out laughing.

"Jam, you are going to catch up fast."

"Steven?"

"I don't even believe it yet myself, so yes, I'm not telling anyone."

"Thank you, Jam and Steven. You see, Sara, everything will be okay. I knew your brother would understand, and now Jam does too. Everything will be just fine. But I am utterly exhausted and my ears are ringing from all that tossing around—unless you three hear the ringing, as well?"

"No ringing," said Steven.

"Then I will call it a night. We will figure it all out tomorrow, Sara. Goodnight Steven, it was nice to finally meet you. Goodnight Jam, I am glad Sara has you for a friend."

And with that, Lucinda bowed and slipped inside her house. Steven and Jam and even Sara stood speechless as Lucinda's door shut.

A CATASTROPHE,
A SHOCK AND A LOSS

teven, Sara and Jam were still standing outside Lucinda's door. "She lives in there?" asked Steven.

"Yes, I'm sure she'll show you tomorrow," confirmed Sara, pushing at her hair and picking up her trick-or-treat bag.

"I've come to the conclusion," Steven continued, "that there are only three possible explanations for what is happening to me: one, I'm accepting the unbelievable; two, I'm going nuts; or three, I'm having hallucinations due to some major accident I can't remember because I have a head trauma. Was I in an accident?" he asked in all seriousness.

Jam laughed and the mirrors glittered. "You're so funny Steven. I'm thrilled. I've always believed there were 'wee-folk' out there hiding from us. I've had dreams about them my whole life, and they looked a lot like Lucinda. Oh Sara, this is going to be a great adventure. I can't wait to know everything! Can I come by tomorrow? I will never tell a soul. I swear. It would ruin everything—everything I want to be a part of!"

"Of course," Sara nodded eagerly. The two girls smiled happily at each other.

"So she lives in there," Steven repeated in a voice that was beginning to sound very tired.

"Of course she does," answered Jam, taking over for Sara. "We just saw her go in and close the door! You saw her yourself, Steve. Can't you tell it's the perfect-looking fairy house? It blends right in; would fool everyone. It's an obvious choice."

Now Sara was getting worried about Jam. She was accepting too easily! Maybe this was a different kind of shock; just saying yes to everything because it was too much? But, no, Jam seemed fine. It was obvious that her brother, being older, was having much more trouble with the idea.

"It's quite nice inside," explained Sara, trying to make it all seem ordinary. "I helped her out with a few things. She's made a fireplace, and I brought some blankets for her bed, doll dishes from my old stuff. It's cozy. The squirrel brothers and Owletta come to visit, but of course Owletta is away just now on an important mission—"

Oops… she'd gone too far.

Steven threw his hands up nowhere in particular, a useless motion. "Sara, I can't deal with this right now. I'm just too bushed," he said, waving his right hand and then rubbing his forehead a lot, like in a badly acted movie. His mind was closing down.

Jam was grinning and jumping from one foot to the other in her excitement, her long hair bouncing to the rhythm. "Do they talk?" she asked in all seriousness. "I mean the squirrels? I'm sure they must talk." Jam was too much. This was all going to be a piece of cake for Jam.

Just then, Dr. Umberland's car pulled onto the driveway.

"Okay, I'll be by tomorrow morning," assured Jam. "You can tell me everything then!"

"I will," promised Sara and the girls hugged.

"Hi, Dr. Umberland," Jam called out as she ran past him.

"Hello, Jam!" he called back, carrying a shopping bag. "Love your sari!"

Steven and Sara waved to their dad and met him at the back door.

"I'm so glad you all went out together," he smiled. "Looks

like you had fun. Sorry I'm late. I picked up some Chinese food, if you aren't full on candy already," he laughed.

"Nope," said Sara, "didn't eat a single piece."

It was the morning after Halloween. Steven woke up convinced that he'd dreamt the "Lucinda incident". He was groggy and having trouble waking up. Halloween night was a bit of a blur. Frankly, that's the way he wanted it. He was content to be back in the real world. "That was so weird yesterday," he said to himself. "I almost believe it happened."

Pleased that he had his dad's car for the day, he got up to ready himself for a nice ride in the country with Lynn. He'd bring back some apple cider and maybe an apple pie for Sunday. Now, with his dad home on Sundays, the family had dinner together. He was glad Lynn hadn't gone out with them last night. Whew! And they had Rickie's party to go to tonight, back at the Capiello's. Yup, it was going to be a nice relaxing weekend, he assured himself.

Then Sara knocked on the door and knocked him right back into Never Neverland.

"This is going to be a great day," she announced cheerfully, hoping the right attitude would keep this simple.

"Yup … I got the car."

"I don't mean that. I mean we're going to go over everything about Lucinda. Jam will be here later. It's so great to be able to share this with you and Jam. I feel terrific. It's such a relief not to be the only human knowing about all this stuff. It's a lot of responsibility, Steven, you can't imagine."

"Are you saying it actually happened?" he said, still foggy-minded. "Hold on, Sis. I've got to use the bathroom … take a shower … wake up. It's too much. Give me a few minutes." He wanted to shut this down, but he could see he wasn't going to be able to.

"Sure, but hurry up!"

Steven grabbed some clothes and went into the bathroom and turned the shower on. "I'll meet you downstairs for breakfast in twenty and then you can hit me with the whole Lucinda thing again." Hadn't he heard something about talking squirrels? An owl? Or was that Jam's idea? He shut the door.

When Steven got downstairs, Sara was already dressed and sitting at the table. She had forked an entire waffle, and was waving it around as she talked, periodically dipping it into the syrup. Her mouth looked sticky. Steven poured himself a glass of orange juice and collapsed onto the chair with an "Okay, how much sloppier can you get?"

"Don't give me that look," said Sara. "I don't eat this way in front of anyone but you and Dad. Consider it a privilege, a sign of trust, which is what we need a lot of now. And anyway, we have more important things to discuss."

When did Sara begin to sound like the older sibling? he thought.

"Yes," she continued, with the waffle half-eaten and still waving on the fork, "you saw Lucinda and you'll see her again soon enough. I can tell you want this to go away, but it won't. She's here, as real as you and me, and I've already been out to visit her this morning. She's expecting all three of us soon. I'm glad Dad's not here."

Dr. Umberland had gone to the lab that day with a colleague, leaving Steven the car.

"All right," said Steven. "Let's have it. I can tell this is going to be the strangest day of my life, last night being the strangest night."

"The strangest, maybe, but not the worst," added Sara.

"That was when Mom died."

"Yes." She put the waffle down and grew sad.

They were both quiet for a few moments, lost in their own thoughts.

"Yeah," said Steven, "it's just as well that Dad's at the lab today, with all this going on. But he seems a bit better lately, doesn't he? I mean he's trying, and he's had Sundays with us three times now."

"Then you've noticed it too? That he hasn't been around much since Mom died?"

"Of course I do, Sara. I guess he misses Mom a lot. But I miss her too and I miss him! I wish he'd found a better way to deal with it."

"Me too! Why didn't we ever share this before?" Sara pushed her hair back with both hands and rubbed at her eyes.

"Oh, Sara what a jerk I've been. *I* haven't been there for *you* either! I'm your older brother, I should have seen this. I'm so sorry. Wow, how could I be so selfish? I'm an idiot."

"No, you're not an idiot. You've been sad too, and dealing with it in your own way. Lucinda taught me that. I'm just happy that you're back!" Sara jumped up and they hugged. Steven's eyes were a bit watery.

"And Lucinda helped you with all this?"

Sara nodded and she sat back down. "Yup! She did. I miss Mom so much, Steven. It still hurts. But having Lucinda has helped in so many ways."

"I guess it's been a little easier for me," he reflected. "I'm older, leaving for college next September. I have Lynn and good friends. But I should have been thinking about you, too.

Dad has been so distant. It must be so hard for you, Sis. But he seems a little better, doesn't he?"

"He does. Maybe it's because Lucinda is here. She has all kinds of special talents."

"Well, if she got you to forgive me, I guess I'll have to give her a chance."

"You will—when you know everything, you'll see that it's strange, yes, but wonderful too, and exciting and the biggest challenge you could imagine. Maybe scary too, if all of it happens, so we need to discuss it. And that will make it an even bigger responsibility."

"Okay, Sis, shoot away."

Just then they heard knocking at the back door. Sara got up and it was Jam, of course. They hugged and Sara brought her inside.

"You want a waffle?"

"I'm good, just finished breakfast."

"I was just going to tell Steven the whole story."

"Perfect, then I'm just in time. Tell us!"

So she did. Sara explained absolutely everything from start to finish; including the part about chargons and vinkali.

"And when Owletta gets back, if she's found the vinetropes in North Carolina, we'll have to help Lucinda and the boys get there."

They listened, spellbound, like children entranced by a fantastic story; but a story that was supposedly true. Steven was respectful, but still skeptical and held his tongue. Jam piped up from time to time with comments such as, "I knew it," or "This is really happening! The fairies are back!"

"Well, we better get going." Sara took a deep breath. "Lucinda will be expecting us. I'm worn out from explaining all that. Lucinda can take over for me," she laughed, "and I'm sure Ekle and Apkin will have something to add."

"Okay," said Steven. "I just have to call Lynn up and make an excuse. We were going out for a drive today. I just have to tell her I can't today and that I'll pick her up tonight for the party at Rickie's."

"Thanks, Steven."

"No problem, Sis. You need me today."

"And so does Lucinda."

Steven made the call and the kids grabbed their jackets and stepped out into the fresh morning air. Lucinda was outside, sweeping away some leaves that had blown up in front of her door.

"Hi Steven, Sara, Jam," she called out. She still wore her birth dress as she had decided it would be good to be in full "uniform" when she met Steven and Jam for the first time officially.

"Hi, Lucinda," Sara called back.

Steven actually found himself rubbing his eyes like in the expression "he thought he was dreaming so he rubbed his eyes". Lucinda held her unusual hand out to Steven. Steven bent down and gave it a little shake. It felt real … a little cooler than a human's hand, a bit like peach fuzz, but definitely solid. Jam shook her hand too.

"You're so pretty, Lucinda! Now that I can really see you!"

"Thank you, Jam!"

"And your dress is right out of a fairytale. Sara told us that you are born with your dress on!"

"Yes, it is special. We Glowers do get some extra perks when we are born. How are you doing there, Steven? I could pinch you," she said, giving his hand a bit of a squeeze. "Or maybe you need me to recite the 'believing and seeing' poem again?"

"No, that's okay, Lucinda. I mean the poem was sensationally funny, but I think I'll just have to find my own way into all of this."

"You seem just fine, Jam," added Lucinda with a grin and a flourish of her hands.

"Well, truthfully, I always knew this would happen," Jam explained. Her long dark hair was tied in a ponytail today and swung when she talked, as lively as Jam's personality. "I've had dreams about a world of little people all my life, and frankly, talking animals too. I used to tell my parents about it all the time. They thought it was cute when I was little. But I don't think they'd be so happy to hear about it now. I'm too old for that. But that doesn't stop me from having those dreams."

"What exactly do you dream?" asked Lucinda, very intrigued. They all were! Steven started to pace as he listened. He felt the need to move around.

"Well, in my dreams, it's kind of like we're in a jungle. Everything is lush and thick and moist and the leaves are a deep red, burgundy I guess you'd say. I'm little, like the people, like I'm one of them. We're always busy building things and working and thinking of ways to protect ourselves from something scary… other beings that want to hurt us. Also, sometimes it seems like dinosaurs are in the dream and we all hide underground, like running to a bomb shelter! It's weird, I admit, but the dreams feel so real. And Lucinda, the people look a lot like you do. I'm not kidding. When I saw you, it really was like seeing a dream come true."

"This just gets wilder and wilder," confirmed Sara.

"It does, indeed," said Lucinda. "It is as if you had visions of the world of vinetropes from eons ago! Jam, it is as if you were transported back to a time when vinetropes walked this world and called it their own. How could you possibly know?"

"It's a piece of the puzzle," said Sara. "Maybe Jam's been preprogrammed with some extra knowledge as well! And it comes to her in her dreams!"

"That is an incredible thought," said Lucinda, finding this revelation of Jam's dreams to be important. "You could be right, Sara. A human version of what I can do."

"Yes!" said Jam, her ponytail jumping as she nodded. "It means I'm supposed to be a part of this."

The girls grabbed hands and jumped up and down.

"I always knew I wanted to be your friend, Sara. After your mom died I tried, but I could tell you wanted to be left alone. It wasn't the right time. I felt sad for you, but I didn't want to be pushy. But I sensed we would be friends someday."

"And now we are," Sara smiled. They squeezed hands. "And you're meant to help with all of this!"

Ekle and Apkin heard the chatter and came down the garden steps. Earlier that morning Lucinda had filled them in on what had happened, as they hadn't come along trick-or-treating the night before. Steven stopped his pacing. The brothers gave a little bow in greeting.

"This must be Ekle and Apkin," said Steven. He was surprised at how normal his own voice sounded.

"Yes, it's us," they seemed to say. "I'm Ekle." "I'm Apkin." They swirled their tails. Was he hearing that?

"Hi, boys," said Jam. "I'm Jam."

"Yes," said Ekle, "we were listening to you talk about your dreams."

"You're one of us, for sure," said Apkin. "We were right above you, spying," he blurted out.

"You guys are sneaky, aren't you?" observed Steven.

"Had to see if you two seemed dangerous," explained Apkin, without any apparent embarrassment.

They all laughed.

"Are you going to help us get to North Carolina?" Ekle asked Steven.

"You drive a car," Apkin added. "That's why we're asking."

"Let's give Steven a chance to take this all in boys," Lucinda suggested. "Remember how hard it was for you at first, to talk to Sara."

"It's true," Ekle acknowledged. "We were very scared about all of this," he lifted his paws.

"Still are, if chargons and vinkali come back," Apkin pulled his paws in tight.

"Well, Steven needs some time. And until Owletta gets back, we are not going anywhere."

"Yes, please, give me some time! I only got my driver's license this year. Don't know if you'd even want to drive with me," he joked.

"We would," said Apkin.

"We have to get back to our mates somehow," said Ekle, lifting his shoulders.

The girls were now sitting on the steps.

Apkin climbed right onto Jam's lap and gave a pleading look. "You can pet me," he implored, which Jam promptly did.

"So we're really all talking to each other?" Steven asked for clarity.

"We are," confirmed everyone in unison, nodding and laughing.

Ekle came down and squeezed himself in between the girls and Sara gave him some attention too, scratching his neck while he lifted his chin.

"Let Steven and Jam see your home, Lucinda," suggested Sara.

"Good idea," Lucinda cranked her door open. Jam got up and the two peeked inside, Jam first.

"It's perfect! Just the home for a fairy," Jam exclaimed. "So these are the roots Sara was talking about. They're beautiful!

They remind me of what the Aurora Borealis is supposed to look like!"

Then Steven looked in. "Wow, it's really nice in here! These roots are awesome!" Seeing all the little homey touches made him feel a bit more grounded. Lucinda, then, was really rather normal, just as his sister suggested. "I guess you really do exist, Lucinda!" Everyone laughed at this. "And the squirrels are really laughing, aren't they?" Steven looked from Jam to Sara. "I'm not imagining this? Squirrels laugh!" Then he laughed even harder because of this and so did Ekle and Apkin.

"We laugh!" confirmed Ekle, holding his sides.

"A lot more than I thought," Apkin added, falling down.

"They do!" confirmed Lucinda.

That made them all laugh even harder until Sara and Jam were rolling in the leaves and Steven was holding his sides. The squirrels copied the girls and began to roll in the leaves too, and Lucinda stood with her hands on her hips and grinned her grin, shaking her head back and forth in amusement. This laughing fit seemed to help all of them and Steven began to feel like he might fit right into this new world after all.

When they regained their composure they settled down again, the girls on the steps with Lucinda in Sara's lap, the boys scurrying around of the grass, finding a few acorns. Steven sat on the wall, quietly reflecting on all that had transpired. Then Apkin darted forward and peered up at Lucinda.

"What's in your hair?" he asked in his worried voice.

"Is there something in my hair?" asked Lucinda.

Steven jumped down and the three children took a look. They didn't know what Apkin was seeing.

"What are we looking for?" asked Steven. For Steven, everything about Lucinda was still new. He realized, as he observed her more closely, that the girls were right, she was

very pretty. Her small size, coupled with her large personality, was disarming. It took concentration to actually see what she looked like.

"I don't see anything," said Jam. "But you sure are pretty, Lucinda." She seemed to be reading Steven's thoughts.

"Who cares about that," Apkin was impatient, as always. He pointed with his right paw. "There, there, in her hair."

"Check my hair here on the left side and find out what he means. Apkin is usually right about such things."

Sara noticed that Lucinda's hair seemed thicker than usual.

"Wow, you sure have a lot of vine-hair!" she observed.

"Yes, it has grown quite a bit. I have noticed that myself."

Sara also noticed that her face looked a little different too. Maybe a little older? Well, vinetrope Glowers did mature quickly. Then her fingers touched something warm and knobby and she jumped back.

"What is it?" Lucinda asked, alarmed.

Sara parted the vines and looked closer.

"Lucinda, there are two green blobs growing right out of your head, on stems, on the left side. They're about the size of olives and they're quite warm!"

"Yes," conferred Steven. "I see them now."

"Me too," said Jam. "They're glowing."

The boys moved in closer as well.

"But these knobs aren't blinking like the other globes in your hair," Steven observed.

Apkin and Ekle each had a paw on Lucinda's knees as she sat in Sara's lap.

"Really? I can't believe this! It is unbelievable," Lucinda exclaimed. "My historical memory banks are now telling me it is possible, but I never considered it! No wonder my hair is thicker! No wonder I have been tired recently! I fell right to

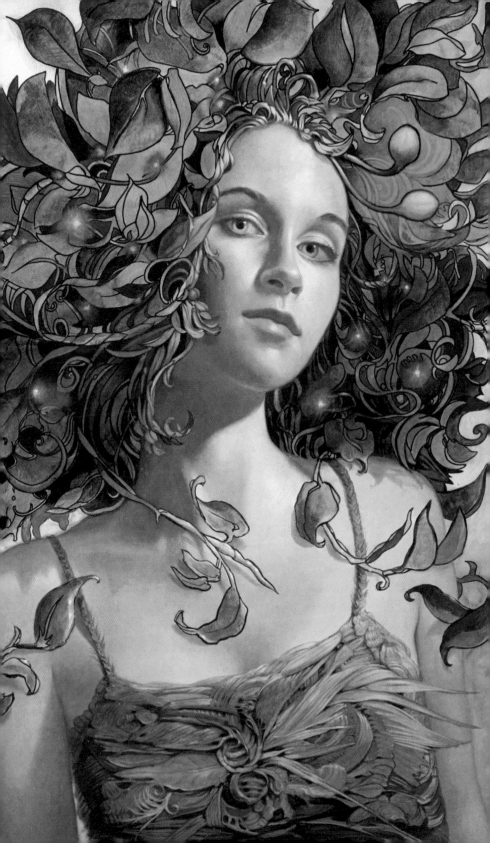

sleep after that whole episode with Poncho last night. Usually I would be wide awake after something like that. What a shock!"

"Oh, Lucinda," wailed Sara. "Is it serious? Are you going to die?" The idea of lumps suddenly appearing brought back her worst fears. Could Lucinda be dying? Could she be losing Lucinda too?

"Oh for heaven's sake, no. It means I am having babies, twins to be exact. I am having two little vinetropes of my very own!" and she reached up to pat the warm green knobs, smiling from ear to ear.

"Babies!" everyone cried out in amazement. Congratulations came spontaneously and everyone had to have a good look at this start of new life.

"Lucinda, you're going to be a mother," was all Sara could say.

"This is so wonderful!" said Jam.

"They have a faint glow," observed Apkin, "but not blinking."

"This means they will both be Glowers," said Lucinda, obviously delighted.

Steven, a bit more like his usual inquisitive self, had some questions. "How is this possible, Lucinda? I thought vinetropes grew from seeds planted in the ground, then pods developed. And you don't even have a husband."

"A good question, Steven, this is a rare event, indeed. Only in times of great emergency can this happen, and only to a female Glower. Why it is so rare, it is like a footnote in our history! I am just seeing it now! A birth like this, right off the mother Glower, ensures the birth of additional Glowers in a time of need. It also means that the mother Glower can move about with her babies attached to her. They can move away from a place that may have become dangerous. So this must be a needy time for the vinetrope world. And I will be able to bring two more Glowers into it!"

"So what you're saying," picked up Steven, "is that you've basically self-pollinated!"

"Yes, I suppose so!"

"Awesome!" said Apkin, using a new word.

"I don't know what pollinating means," Ekle shrugged his shoulders, but it sounds great!"

"It's awesome!" said Apkin, "I don't know what it means either but I know you're having two babies, and that's just awesome. I like that word a lot. Where did I learn it?"

"Who knows," said Ekle. "You've got your own way, that's for sure."

They all chuckled.

"But I thought Glowers were always born full adult size," Sara questioned, "like you were, Lucinda."

"Yes, usually we are. Just not in this case. When the world is short on Glowers this is a way to make sure that there are more. My babies will be born small, the rarest of all vinetropes, tiny Glowers, but they will grow very quickly. Faster than you can imagine!"

"How fast?" asked Jam.

"It takes about two months for the baby to grow in the pod and then only another twelve weeks from the time of birth for the tiny Glower to reach full size!"

Everyone was flabbergasted, except the squirrels who didn't find it surprising at all.

"That's normal for squirrels," announced Ekle, "about twelve weeks."

"Well, I guess tiny Glowers are a lot like squirrels," Apkin concluded, holding his tail up proudly with his paws up at his sides.

Lucinda patted his head. "Yes they are."

"There's a lot to understand about vinetropes," said Sara.

"And I'm sure a lot more to learn," added Jam, her ponytail swinging as she nodded her head.

"I'm so happy, everyone. I have all of you to help me, Owletta will find my people, and now I will have two babies, two Glowers to bring when I arrive!"

"And we'll be there for you, no matter what," assured Sara and the others, each in their own way. Ekle and Apkin rested their chins on Lucinda's lap and she patted their heads. Apkin gazed up at her and sighed.

"I am so fortunate to have you all for friends. Really, more than friends—you're my family," said Lucinda.

"We're a family," Sara agreed.

"A brand new kind of family!" added Apkin.

"And Selena and Regata will join us," Ekle added, to Apkin's joy.

"And I guess I'm a member too?" asked Steven, not sure.

"Of course!" everyone shouted.

"All I can say," Steven admitted, "is it's pretty hard to tell what's normal for vinetropes, or not. From the human point of view, it's all pretty rare."

Everyone agreed it was confusing and wonderful. The boys were so ecstatic; they were not able to remain quiet for long. They left Lucinda's lap and began running in circles, stopping to put their paws back up on Lucinda's lap now and then. Sara noted that the pods would be ready to open not long before Christmas. Jam thought that was perfect timing since they'd all be getting out of school and would have more time to be with Lucinda. Steven was debating with Sara whether to tell their dad or not. How else would they get Lucinda and the boys to North Carolina? They would have to use the car. There was so much to consider. But first, they would have to wait for Owletta's return.

Right in the middle of their joy, a terrible thing happened. And it happened so quickly, no one had time to think. There

was a sudden shadow, a screech, and then two claws had a hold of Lucinda by the back of her dress and hair and took off with her into the trees, heading into the sky. It was a huge hawk and it seemed to think Lucinda was its lunch.

"Do something! Do something!" screamed Sara in terror.

But they were all helpless and stood there staring as if frozen to the spot. In a few seconds, Lucinda was a dot in the sky, heading east.

The squirrels ran back and forth making squeaking noises of panic. Ekle ran up a maple tree and pointed in the direction he had seen the hawk take Lucinda. Sara noted that it was in the direction of the grammar school.

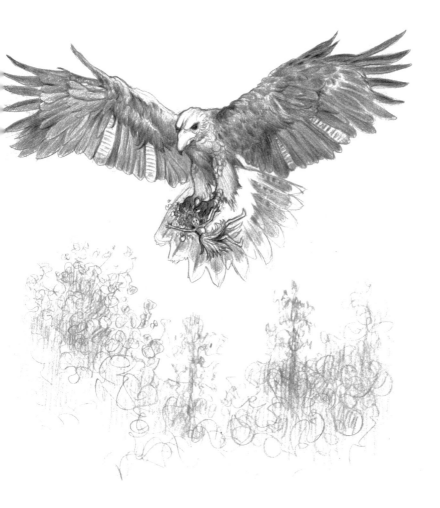

"Let's get in the car and head that way," said Steven. "All we can do now is try and find her and hope she isn't hurt."

"Or killed," Sara gave a sob.

"Let's just get in the car," finalized Steven.

Ekle came down the tree and joined them, shaking his head. Apkin looked miserable and Ekle looked angry. Jam picked up Apkin and Sara grabbed Ekle. They ran to the car and got in the back. Steven had the keys out of his pocket and got into the driver's seat. Soon he was backing out of the garage. In truth, he had no idea where to look. He would just start down Hilltop Lane going east toward the school, which seemed to be the direction the hawk was flying.

"We'll find her," was all Sara could say to comfort herself and everyone else. She patted Ekle's head and tried to comfort him, rocking back and forth. Jam did the same with Apkin, who kept pushing his paws onto his eyes, as though he wanted cry. Sara felt cold and frightened and Jam kept saying, "I should have seen this coming," which no one understood. A day that had started out happy was turning out so badly.

"I'm heading toward the grammar school," Steven called out. "It's the right direction and there's a pretty big track of woods behind the school."

"I hope he doesn't try and eat her," Jam began to cry quietly, her shoulders shaking.

"Don't say that!" screamed Ekle.

Apkin began to shake as well and kept pressing on his eyes.

"They have to stop somewhere," said Steven, "and if he thinks she's food, he's got to stop to eat." He was being very blunt.

"Stop!" Ekle screamed again and Apkin buried his face in Jam's lap.

Ekle was mad and jumped onto the divider between the two front seats. He looked up at Steven and then lifted his right paw

and pointed to the right. "Make another right here," he stated in a voice as clear as a radio announcer's. "When I saw them from the top of the maple tree, the hawk had shifted his direction, going more southeast than east. You'd better turn."

Steven made a right onto Taylor Road. "That could still be by the grammar school, near the parking lot. The woods start behind the lot and go back quite a ways."

"Let's open all the windows," suggested Sara, opening hers. "She might be calling for help, if she fell. She's a fighter, so I'm sure she would struggle to get away."

"Or use her brains," said Jam, "something that hawk doesn't have!" and before she could do it, Apkin reached over and pressed the button on their side and opened that window too. Then Apkin closed the window, opened it, closed it. "Apkin," shouted Jam and Sara at the same time. "Stop it!"

Apkin opened it again right away. "Sorry, just practicing," he said sheepishly.

As they drove slowly down the street, they observed and listened for any unusual sounds.

Ekle came onto the front seat and he opened his window as well. He stood on his hind legs looking out, stretching his body, his nose just making it over the bottom of the opened window. Apkin did the same from Jam's lap and had a better view. They continued down Taylor Road, in the direction of the school.

"Maybe we shouldn't be in the car at all," said Sara, feeling another wave of panic. "She's got to be somewhere—in someone's backyard. Not right along a street like this."

"Let's try and stay calm," said Steven. "The bird was moving at a fast clip. I still say it makes sense to head to the woods. There's actually a lot of wildlife living there. It could be his home. We'll be there in two minutes."

"When we get to the school," said Jam, "we'll get out and start a search. I hope there aren't a lot of kids there now, or a football game going on."

"Well, we might actually need a search party if we don't find her very soon," Steven admitted. "We may have no choice."

"Don't even go there," said Sara.

Taylor Road ended at the school parking lot. The field was to the left and the woods began right in front of them and continued around the edge of the sports field. The lot was empty and so was the school field. To their right, along Taylor Road, were several homes, their front yards facing the street. The last home on the street, closest to the school, had a sewer in front of it.

"Look, there, orange!" shouted Apkin, almost falling out the window.

Sara spotted it too. "There, in front of the sewer!" she shouted with fear and excitement. They all jumped out and headed for the sewer.

"It's Lucinda's dress. It's the skirt from her birth dress." Sara was both excited and terrified. She picked it up. "I'd know this material anywhere." She stood looking at it as though she expected it to talk.

"Well, this could be a good sign. Maybe she struggled free and ripped right out of her dress," suggested Steven.

"And fell to the ground," said Jam. "She might be lying around somewhere nearby."

"Hurt or dead!" Sara allowed her worst fears to materialize.

Apkin started to cry, there is no other way to describe it. His body shuddered and he kept pressing and pressing his paws to his eyes. Ekle gave him a quick slap, not violent, but sharp. "Snap out of it Apkin! Stop acting like a human! We have to search!" That slap snapped Sara back into focus too and they all composed themselves.

"Let's start a full search right here," Steven advised.

"The first thing we should do is look down the sewer," suggested Jam.

They all agreed.

"We could use a flashlight," said Sara.

"Dad has one in the glove compartment," remembered Steven.

Sara tucked the piece of dress into her jacket pocket, went to the car and returned with the flashlight.

Steven searched the sewer with the light, but Lucinda wasn't anywhere in view.

Ekle and Apkin took off. Using their skills as tree climbers, they headed into the tree tops. It was possible Lucinda was stuck up in a tree somewhere and they could survey the whole area from this height. The kids let the boys to do their own thing, not really knowing what they were up to.

Steven, Sara and Jam stepped over the sewer and onto the grass. If Lucinda had fallen as the dress ripped, she might have sought shelter behind this house. It was very quiet everywhere and no one was outside.

"It's kind of spooky, how quiet it is around here," said Sara.

"Yeah, you'd think there would be more activity. It practically feels abandoned here," Steven observed, "and these are pretty nice homes."

"Maybe they're all running errands?" Sara suggested. "It's Saturday."

"The bigger the house, the quieter it seems," added Jam.

They crossed the front lawn, walked around the dark house, and had just approached a covered swimming pool in the back yard when they heard a commotion. There was the rustling of branches and twigs overhead. They looked up.

"It's Ekle and Apkin, I'm sure," said Sara. Ekle appeared on the grass in front of them. He chattered wildly and incoher-

ently, as though he had forgotten how to talk, and then turned and ran to the edge of the woods that continued at the back of the property. "We're coming," called Steven.

Ekle waited till Sara, Jam and Steven caught up. Then the little squirrel scampered down a leaf-strewn path that cut through the woods and let out onto the next street. The path was covered in gold and brown leaves and the children followed quickly. As they tore down the path after Ekle, Sara looked up through the charcoal branches into the autumn blue sky and said a prayer. "God, please let Lucinda be alright."

When they reached the street they found Apkin waiting for them.

"In here!" said Ekle.

Apkin was surprisingly calm, standing next to another sewer. As soon as the kids looked in they knew why, because they saw the glow.

"It's Lucinda!" gasped Sara.

"She's okay," added Apkin. "I found her!"

"It's me," called the familiar and wonderful voice.

"Are you okay?" they all blurted out.

"Yes, but my right ankle hurts and I am having trouble getting out."

Sara spotted her in the light of her own glow. Lucinda looked bedraggled, but her voice sounded strong.

"I've got an idea," said Steven. "I just need to get something from the car. I'll be right back."

He turned and ran back down the path.

"Just hold on there, we'll get you out," reassured Sara.

"Steven knows what to do," said Jam.

"I'm so glad you found me," Lucinda began.

"We found you," said Ekle.

"Yes, you did, boys. You are wonderful! But you all have been looking for me, I'm sure."

"We sure have," said Sara, pushing her hair back with both hands to emphasize their efforts. "We were terrified! All of us!"

"And we had some ideas," Jam wanted to set that straight.

"I think I would have found a way out eventually, but right now I am too exhausted and my ankle aches. How did you find me?"

Sara quickly explained their drive over and the discovery of Lucinda's skirt by the sewer.

"Lucky it is a bright material and caught your attention," noted Lucinda. "On the other hand, I might not have caught Mr. Hawk's attention in another color, who knows?"

Steven returned at that moment a length of rope.

"You can tell us the whole story later," he said to Lucinda. "But let's get you out of there first."

"I am all for that!" said Lucinda.

Steven tied a large knot at one end of the rope and dropped it into the sewer.

"Hold on and I'll pull you up."

"Good plan, Steven."

Lucinda's arms were strong for her size. She slid over to the rope, crossed her legs over the knot, keeping the injured foot on top, and gave the rope a yank.

"Okay, here we go."

Steven pulled her up, slowly, being careful and as she reached the opening in the sewer, he carefully lifted her into his arms. Everyone gathered around. Apkin got up on his hind legs and put his paws on Steven's pants.

"I can't see her," he complained.

"Can you move your foot?" asked Steven.

Lucinda wiggled it. "Yes, it's twisted though. I'll wrap it when I get home and soak it with warm vinetrope water. The energy will help it heal fast. And I can use some rest."

"We were so worried," and Sara gave her a little kiss as Lucinda sat in her brother's arms.

"What happened?" asked Steven.

"I think Mr. Hawk had quite a scare himself. When he grabbed me I started to glow like mad, pure instinct, and I yelled at him in hawk talk as fast as I could. I was not sure if I had it down quite right, but I did my best and ordered him to put me down, as gently as possible. I have no idea what he thought I was, but my talking startled him. He lost hold of my hair and had me by my dress."

Here Lucinda went to smooth her skirt. But it wasn't there. She was wearing white pantaloons under her birth dress! They were tattered and dirty with little white ruffles at the bottom.

She continued, "Then he swooped low, almost to the ground. He might have been planning to put me down gently, but my skirt it ripped and I fell. I was lucky he was close to the ground by then or I might have been killed!"

Her hands flew up in an excited flutter and she wiggled her tiny fingers. "Well, I saw the sewer and I did not want to take any chances. I was not positive he had understood me, so I dove right into the sewer and out of sight. Unfortunately, I did not land all that gracefully. That is when I hurt my ankle." Here she moved her foot and a pained looked passed momentarily over her face.

"That Mr. Hawk peered in at me, but he did not seem to know what he wanted to do about me and he was not able to talk to me. He just seemed confused. With him standing there, peering in, I had no intention of climbing out. So I limped away, underground, along the sewer line for quite some time."

"And that's how you wound up in *this* sewer," Steven concluded.

"Yes, when I saw the light coming in above me, I realized I must have made my way to the next sewer. I tried to climb

out but I was not able to. My ankle hurt too much. You know the rest."

"Well, that explains it," said Sara.

"But how did the boys find you?" questioned Jam.

"Apkin and I saw a glow coming from the sewer," said Ekle. "We ran through the trees to the next street, and then we saw a glow turning on and off."

"It flashed from the darkness!" explained Apkin, with poetic strength.

"Yes, I was flashing my glow on and off like a beacon or an SOS signal. I hoped you would see. I knew you would be looking."

"And we saw her first," Apkin was happy to announce.

"And she was calling out," added Ekle.

"Yes, I knew I had to give a yell once in a while, in the hope you would pass by."

"Well," said Steven, adjusting Lucinda in his arm, "I think we'd better get you home."

Steven cradled her gently and they headed back, through the woods, past the pool and back to the car. When they arrived, Sara took off her jacket and laid it on the back seat and Steven settled Lucinda onto it. Both girls got in, and Apkin joined them. He had to see Lucinda up close to make sure she was really okay. Ekle wanted to sit in the front seat with his new pal, Steven.

That's when Apkin noticed it ... the loss. One of the lovely green buds in Lucinda's hair was missing and there was a small gash on the side of her head.

"It's gone!" Apkin squeaked. He covered his eyes, and began to tremble. "This is terrible."

Sara and Jam immediately realized what he was saying. Steven turned around from the driver's seat and Ekle was now facing back on the seat divider.

"Oh no," Sara cried, her eyes widening. "It's gone, one is gone!"

"What is it?" asked Lucinda, but she had instinctively guessed and reached for her hair, finding what she feared. "My bud, my baby, one broke off! It is gone!" Lucinda wailed.

For the first time, Sara saw Lucinda cry in torrents. Her little body shook with grief.

"This is so terrible," said Sara. "We'll find your bud, won't we everyone? We'll search until we find it, just like we searched for you."

Sara was now crying too and so was Jam and everyone was trying to comfort Lucinda.

"There is no use," said Lucinda, wiping her face. "Once the bud is broken off it dies and withers almost instantly. It was too new. There is no point in even looking. We would find nothing. Thank goodness this other little darling is still attached and safe. I could have lost them both!"

Now there was a hushed silence. Everyone understood there was nothing to say. Lucinda would need time. Steven drove them back and carried Lucinda to her home.

"Are you sure you want to be alone?" asked Sara. "I could take you up to my room."

"No, no, Sara, just let me have some time. I need to be by myself."

Steven handed Lucinda to Jam and cranked open the door. He took Lucinda back and climbed inside, almost filling up the room. He then placed Lucinda gently on her bed. Ekle and Apkin squeezed in for a moment and took a place on either side of her.

Lucinda looked tired and muddy, but even in her torn dress, with white and old-fashioned pantaloons sticking out, she managed to look dignified. Sara and Jam peered in and

with a squirrel guarding her on either side Sara thought she looked like a broken-hearted elfin princess.

"I better get some bandages," thought Sara out loud. While she ran to the house to get some, Steven gave Lucinda a kiss on her head, letting Jam inside. Jam stared at all the colorful hanging roots with amazement while they waited. Sara returned quickly with a strip of gauze and gently wound it around Lucinda's ankle. Lucinda took her watering vine out and soaked it with vinetrope energy. Then Jam pulled the covers up over her.

"Would you like something to eat?" asked Sara softly.

"No, thank you," said Lucinda, closing her eyes. "I am not hungry. I have enough internal energy to go on for a long time without eating. But you could light a little fire for me. I just need to be alone for a time."

Steven heard her request and said he would do it. So the girls gave her a little kiss and stepped out and Steven climbed back inside and got a fire going.

"We'll keep a watch all night," said Ekle.

Apkin made sure the pie pan was in the "up" position.

"If she needs anything, we'll get it for her," assured Apkin.

The children watched as the two squirrels cranked the door shut and took positions outside, like faithful guards.

Brother and sister and their new friend Jam all walked back to the Umberlands' home. They didn't say much, but they were a comfort to each other. They were there for each other, good times and bad, and they all knew it.

MORE SURPRISES ALL ROUND

ara, Steven and Jam sat around the kitchen table. It was early afternoon. The whole event with the hawk had taken about two hours, so they decided to spend some time together while they let Lucinda rest. If anything seemed wrong, the brothers would come and get them in an instant. Steven had postponed his drive with Lynn till Sunday morning and the party at Rickie Capiello's didn't start till seven that night. He'd pick Lynn up on the way. This gave the three of them time to talk. Pretzels, glasses of water, cheese sticks and some fruit sat on the table in front of them.

"I knew something bad was coming," said Jam. "But I didn't know what. I feel terrible. I should have known."

"You said that before," remembered Sara. "What does that even mean?"

"How could any of this be your fault?" Steven was puzzled too.

"It's my dreams. They tell me things, like about the vinetropes when I was little. But they tell me other things too. Unfortunately not in a way that's easy to understand. They come in riddles or symbols. It's frustrating."

"What are you talking about?" asked Steven, taking out a cheese stick.

"My dreams! Remember? I told you I've had dreams all my life about fairy people in a jungle. And there were dinosaurs, too!"

"You really had dreams like that?" Steven's eyebrows lifted.

"Yes, repeating dreams. I'm never joking around when I talk about my dreams. And I dreamed about those other creatures too … the not such nice ones."

"So they could be chargons and vinkali?" Sara was following her logic.

"Exactly!"

"And these little people looked like Lucinda? I can tell you're a very imaginative person, so your dreams might be super imaginative," Steven was trying cover up his doubts with a compliment.

He wasn't fooling Jam. "Steven, it's more than imagination. Please believe me! With everything Lucinda's told us about vinetropes, dinosaurs and chargons, you just have to believe me. How could I have dreamt about all this stuff when I was only six?"

"Maybe I just don't really understand what you're saying," Steven tried to defend his skepticism.

Sara had an idea. "Give us an example. That will help."

"Okay, you're right, let's take this morning, then. I dreamed that I was growing a cherry tomato plant that I was proud of. The plant was in a large orange pot and very full and beautiful. The tomatoes were so red and rich and the leaves were very green, a thick green vine and everything was kind of glowing."

"That kind of reminds me of Lucinda," Sara caught on.

"Exactly! But I didn't realize that the plant could mean Lucinda until the hawk came and took off with her."

Steven and Sara both nodded their heads.

"Go on," said Steven.

"In the dream, I knew the tomatoes were ripe and I took a basket and went out onto the patio to pick them to share with my family. But when I got outside, all the tomatoes were gone.

At first I thought an animal must have eaten them, maybe a squirrel. But when I looked on the ground, I realized they had all withered and fallen off. There were a hundred little dried balls on the ground that looked like raisins or currants, shriveled and dead. And then all the leaves fell off too!"

"How strange!" Steven was getting it, but it was making him uncomfortable.

"And I see what you mean," said Sara. "The withered tomatoes and leaves might symbolize Lucinda's lost baby."

"Yes, exactly," said Jam, brightening up even though it was a sad subject. "Remember, Lucinda even said that if a Glower's baby breaks off early it just shrivels up into almost nothing and can't be saved. So you see what I mean by my dream coming true."

"It was a prediction!" finalized Sara, pushing at her hair, her eyes wide in wonder.

"Yes, and it was in a disguise," Jam pointed out. "When I had the dream, none of us knew Lucinda was going to have babies, not even Lucinda!"

"That's amazing," Steven had to admit. "It does seem like it's more than just coincidence. But I guess you could just be trying to make the things in the dream match what happened. It was an upsetting day and the dream had things about it that could be made to fit into what happened."

He gave a small nod, as if he were convincing himself. "It's kind of like pushing pieces into a puzzle that look like they fit, but don't quite if you look closer." Steven was older, with more set ways and it was scary to have your sense of what was possible questioned. He was just trying to be logical and grounded in facts.

"You sound like my parents," Jam said in an accusing tone. "They never believe me either. They don't want to. That's why

I never talk about it with them anymore. It seems to make them upset, like you seem to be Steven."

"I don't think I'm upset." But he was a little and he knew it.

"I don't think you are being fully honest with yourself," Jam replied. "Sometimes Dan listens to me, but I'm not sure if he's just being nice. It's safer, I've decided, not to tell anyone. And I haven't, not till today." She looked down at the table, like there was nothing else to be said.

Jam was clearly upset and Sara felt upset too. She saw it both ways—Sara's and Stevens. But this dream was just one example. What were some other examples of dreams that came true that made her so certain?

"Maybe this is a gift you can develop," Sara encouraged Jam. "What other dreams have you had? I really want to know."

"Yes," Steven picked right up. He didn't like making Jam feel rejected and upset. "I want to believe what you're telling us, it would be incredible if it's true. I mean, look, I just helped rescue a vinetrope today, a fairy! So who's to say what is and what isn't true! I'm not that sure about a lot of things right now myself!"

This made Jam feel better and she smiled. "Thanks Steven. I've thought about this so many times and sometimes I wish I never had these dreams. I keep it to myself and it makes me feel weird and alone, you have no idea. But then it happens again. I have a dream and it comes true."

She fiddled with the glass in front of her. "I think you're right Sara. If I could just figure out how to use the dreams in time, maybe that would make me feel better. If I had figured out this morning's dream, we could have been on the lookout for danger and seen the hawk in time."

"You can't be mad at yourself about that," Steven assured her, getting up and beginning to pace back and forth in front

of the kitchen table, thinking it all through. "How do your parents actually react when you tell them? What have you told them? Give us some more examples."

"My parents! I haven't shared any of this with them since I was ten. It scares them too much."

"And you've shown them how the dreams match up to things that happen?" Steven stopped pacing and rested his hands on the back of his chair, facing the girls.

"Of course, many times, that's what scares them most! I've been having these special dreams on and off since I was three or four years old. I knew when my grandma, grandpa and Uncle Ajit were going to die. And they all still lived in India!"

Here Jam pulled her ponytail forward and then flipped it back. "I would have a dream; a dream that felt very real. In one my grandma came to say good-bye. In another my grandpa came to say he was going on a long trip and would see me in another world someday, in a better world. My Uncle Ajit was sitting on a bench in a garden. He was already dead and told me so! He told me that he was fine and he was happy where he was. When I woke, I just knew they were going to die or had died." She turned her hands, palms up, as if to say, so you see what I'm saying.

She looked from Sara to Steven, "So I told my parents these dreams. In each one, a day or two later, my parents would get a call that whoever I had dreamed about had died and they'd have to make plans to leave for India. I know it really scared them!"

It was Jam's turn to get up. She took her glass and filled it with water from the sink and took a drink. Then she turned back and looked at her two new friends. They could see the sadness in her eyes. Jam was always so cheerful, so full of life and joy, but she had been keeping a secret, and under all that

energy she too was feeling alone and different from the other kids, a lot like Sara had been feeling since her mom died.

Sara got up and gave Jam a hug. "Jam, I believe you. And I know just how you feel. When our mom died, I felt like I had something that made me different than most of the other kids and I felt like I couldn't talk about it with anyone. I could tell it made them nervous, kind of scared, just like you're saying about your dreams."

"Yes! I knew it, Sara. I knew you were feeling a lot like me. That's why I wanted to be your friend."

"Well, we are friends now, the best of friends!"

"I don't know why it has to scare everyone." Jam ran her ponytail through her fingers again and sat down with her glass of water. They all sat down. "I just sometimes have dreams that come true. I don't know why everyone has to be so upset about it. I just want to figure it out myself and I have no one to go to."

"Maybe Lucinda can help you," said Sara.

"I know—that's what I'm hoping."

Steven tapped his fingers on the table. "I believe you, Jam. We're all going to try and help you out with this." He smiled and rested his hand on her shoulder for a moment.

Jam's face lit up and filled with all the energy and animation that they had come to know her for. "Thanks! You don't know how much that means to me."

Sara was smiling too. She was happy to bring her friend comfort, especially on a day with so much drama and loss. "You're meant to be part of this whole thing, whatever it is, and maybe your dreams will help us all out. We'll have to tell Lucinda more about them when she's feeling better."

"Yes," agreed Steven, grabbing a cheese stick and pulling back the wrapper. He waved it in the air, like Sara with her

waffle, but not as sloppy. "You two are both meant to be a part of it. I feel like I fell into this story by accident."

"No, Steven." Sara picked up an apple. "We really need your help and I know Lucinda wanted to meet you."

The three kids spent the day getting to know each other even better. They joked, and were often serious, going over all the details of everything that had happened so far. By early evening, they decided they should check in on Lucinda, even if only for a few minutes. They hadn't heard anything from the squirrels or her.

When they arrived at Lucinda's front door, they were pleased to see Lucinda up and about. She was favoring the ankle, but was getting around, sweeping up in front of her door. Ekle and Apkin were nearby playing tag. Jam was the first to notice that Lucinda's dress was completely repaired and cleaned. How was that possible?

"Your dress it's all fixed!" popped out of Jam's mouth before anything else.

"Yes, Jam, it has grown back."

"It grew back?"

Sara found herself, half-consciously, reaching into her pocket for the torn skirt she had put there. There was nothing inside but a bit of dust! She took a pinch in her fingers; it glowed. And when she dropped it, it scattered like fairy dust.

"Yes, birth outfits repair or replace themselves as needed," Lucinda said matter-of-factly. "As we get fatter, thinner or older, they adjust in size."

Everyone looked at each other, but didn't say anything more on the subject. More important questions needed to be asked.

"How are you doing?" Sara asked Lucinda, gently. "I see you're limping. I'm not surprised."

"I am keeping myself busy. The ankle hurts a bit, but I can tell it will heal quickly. I just have to favor it. I was planning to stop by a little later."

"There's no reason to explain yourself." Steven didn't want Lucinda to have to explain anything. "You've been through a lot and had a big loss."

Ekle and Apkin came over and joined the group.

"Thank you Steven—everyone—losing the baby is disappointing. But I am alive, I have this other bud to think of, so I am counting my blessings right now. In another couple of weeks I will begin to feel her move around in her pod. I have to stay well for her and for the future." She sat her broom, a stick with dried grass tied on, up against the door. "How are you three doing?" Lucinda returned the question.

It seemed like the right time to tell Lucinda more about Jam's dreams. The boys were listening intently. Lucinda was not surprised. When Jam had mentioned dreams about vinetrope-like creatures in a time of the dinosaurs, she knew that Jam had to have a gift. And she agreed whole-heartedly that it would be important for Jam to share these unusual dreams, the ones that seemed to predict things. Lucinda called them "lucid" dreams.

"Lucid means clear, understandable and it can also mean bright or luminous, like my name!" Lucinda revealed. For Lucinda, it was an easy concept to believe in.

"Jam," she explained, as everyone listened, "my body holds the entire basic history of vinetropes. You seem to have some of this same ancient knowledge. My body can store huge quantities of information in the present as well, for example, anything I learn or study on the computer. That part of me works like an organic hard drive." She threw her arms up to emphasize this fact. "With all this complicated information, the

living, thinking, feeling, 'me' can predict how we might use that information in the future. For some people, these predictions come in dreams, when we are the most open to using and connecting all this information in creative ways. It is not surprising that some of those predictions will come true. They are the logical outcomes of using the information creatively."

"I dream mostly about Regata and food," Apkin shared.

Ekle waved his paws, "Go on Lucinda, this is interesting."

Lucinda patted Apkin's head and smiled at Ekle. "Why should it be so difficult to believe, Jam, that you have some way of storing the most likely outcomes of the future, or at least some parts of the future? You have a lot of information to work with in your mind. And dreams can sort through it all and make discoveries."

The kids had to think about this one. Steven really liked the idea. "So, as we live, many possibilities present themselves, and many outcomes, but when we make certain decisions, those outcomes become more finalized. And that reduces the number of potential outcomes."

"That is right, Steven, that is just what I mean."

"So maybe some of Jam's dreams, the 'lucid' ones, predict the most likely outcomes of our ongoing history, of everyone's history put together, the things that will very likely happen in this world because of the decisions that we're all making right now?"

"And Jam, when she's sleeping, is somehow connected to all of us and has the use of greater quantities of information," Lucinda concluded, picking up her broom and tossing it into her house.

"That's a bit confusing," laughed Jam, her sparkle back. "But it makes it all seem more normal, at least normal for me. And it feels like a gift, the way you put it, not a curse."

"It is! And Jam, you will get better at interpreting your dreams, if you believe in them."

"And if you do," said Steven, getting very excited, "it means you might be able to figure out what your dreams mean in advance and share with us, and that means we might all have some influence over the future!"

"Yes," Lucinda confirmed, "if we can use Jam's dreams wisely, we might be able to do just that. It might give us an advantage when one is needed."

"You mean if I can figure out what my dreams mean, we might be able to change the future?"

Now Sara was pacing like her brother, and getting excited, "That's exactly what she means! You see, Jam, I knew Lucinda would understand your gift. And now we all do."

"At least better than we did before," Jam laughed and her ponytail danced.

"It is a bit over my head," admitted Ekle.

"It kind of makes me tired," added Apkin, rubbing his eyes.

"We all have our gifts," Lucinda assured them, "and they will all be needed, before this adventure we have begun is finished. I saw these gifts in each of you soon after we met."

"What gifts did you see?" asked Sara, brushing her hair away from her face.

Steven and Jam sat on the steps and Sara took a seat in the grass facing them. Lucinda stood in the middle, with all attention on her. The boys had to run around a bit. It was in their nature.

"Well, all three of you are basically good, trustworthy, loyal and ready to work, to do what it takes. You know there is something bigger than you going on. I do believe you all share that knowledge, even if you have not fully realized it yet. And it takes courage, you know, to recognize that. Also, you each

have your own individual and unique strengths, though they have not been fully tested."

"What are they?" asked Sara.

"Well, Jam, as we have discovered, has the gift of prophecy through dreams. She can glimpse into the future. When she fully believes in herself, she will amaze us."

Everyone looked at Jam. She was beaming and a bit embarrassed at the same time.

"And Steven, I can see that you have a strong desire to protect. You are a defender. I see it in your feelings for your sister, and also in how you helped rescue me out of the sewer. Also, you are skeptical and use logic well. You will not be easily fooled."

"And me?" asked Sara, a little nervous, wondering what Lucinda saw in her.

"Sara, my dear Sara, you have a great capacity for love and understanding, and also the gift of being able to communicate your understanding. It is what you humans call empathy. You will make a great ambassador someday."

"An ambassador? For whom? You mean like Owletta is doing for you?"

"For all of us, Sara," affirmed Lucinda, raising her arms slowly and then reaching out to her. Sara held Lucinda's little hands in hers. "You will have the skills to negotiate between vinetropes, humans, animals, maybe even with the chargons and vinkali. Who knows? That will take some courage. You have the capacity to communicate wisely with everyone."

"So this is a prediction?" Jam pointed out.

They all laughed nervously.

"Yes, in a sense it is, but in a different way than your dreams. If vinetropes have actually returned, I know what needs to be done. I know what all your potentials are and what they may

be needed for, all three of you, to make things right. For this world will need guidance, if it is truly changing in the way it seems to be."

Ekle and Apkin had both curled up on Jam's lap. But they were listening quietly.

"And our weaknesses?" questioned Steven, needing to know them in order to know better how to defend against them.

"Your weaknesses are the usual ones, the ones we all share: self-doubt, fear, losing faith in what is true and in what needs to be done when the time comes. That will be the challenge for all of us."

"How will we know what needs to be done?" asked Sara. Lucinda hopped on her lap and faced the others.

"Sometimes we won't know until it is right on top of us, already happening. And then we will have no choice but to figure it out. Some things we can prepare for. We will help each other and we will have help from others we have not yet met," Lucinda tried to explain.

"I don't understand all of this," interjected Ekle, lifting his head. "What about me?" he asked.

"And me?" Apkin joined right in.

"Boys, you are still growing, changing. Not all squirrels, or all animals for that matter, will be able to make such a huge internal transformation. So you will be ambassadors, too. You will be able to bring the squirrel world to our aid, if it is needed, and it very well may be."

The brothers nodded proudly.

"In fact, in the beginning, you will be trusted by some of the animal world even before Sara. You boys will pave the way. Ekle, you will be able to rally support, win trust, even make speeches that inspire your kind, and Apkin, you will speak well too, but your special skill will be in spotting important details that everyone else has not yet noticed."

"I'll be very afraid," admitted Apkin.

"Me too," acknowledged Ekle.

"But you will both do it. That I am sure of," said Lucinda.

"This conversation has turned serious," confirmed Steven, folding his hands in front of him, a frown on his face. "I feel like I've known you all for such a long time, and the squirrels too. Listening to you, and talking with you boys seems so natural. It's so weird and so normal. Was it Halloween just yesterday? Is that possible? It's not been the same world since then. Not for me."

"I told you, Steven." Sara got up, placed Lucinda on the grass gently, then walked over to her brother and gave him a hug, sitting down next to him. "I told you everything is changing; that meeting Lucinda would change everything."

"So much has happened," Lucinda agreed. "I was almost eaten by a hawk and I've lost a baby! I feel like I was a child on Halloween compared to now."

"If I had only told you about my tomato dream, it might have helped," worried Jam again.

"No, Jam. Never go there," Lucinda said firmly. "And it is no longer a burden you carry alone."

"Too many things are happening," confirmed Apkin. "I need a rest!"

The way he said it made everyone laugh.

"And some good things have happened, too," added Ekle. "Steven and Jam are our friends now. We can help each other."

"And we still can have some fun and eat good-tasting things," added Apkin, glad to be cheerful again. "In fact, I'm kind of hungry right now."

Everyone laughed again.

"You just ate before we got here!" Ekle complained.

"But I never eat too much at once," Apkin replied, implying Ekle did.

The squirrels jumped up and chased each other around.

"And we'll find our mates," said Ekle, remembering more good things. "Owletta will find them, I just know it."

"My darling," stated Apkin sighing. "How I miss her."

"That's so sweet, Apkin," said Sara, scratching his favorite place behind his ears. He squinted and smiled.

"What about me?" Ekle questioned again, but for attention this time. Jam picked him up and gave him a kiss on the top of his head.

"And you are still going to have a baby," added Sara.

"That's something to be very thankful for," added Steven.

"I am so grateful I didn't lose both. I wrote a poem about my feelings. It is different than the others. Would you like to hear it?"

"Of course!" everyone called out.

Lucinda climbed on Sara's shoulder and sat down. "Okay then," she said.

"In the summer,
Deep summer,
I forget and just live,
Time, it stands still
And the land, it just gives.
But then comes a moment,
I am pulled from my dreams,
When ripe is too ripe,
Life is not what it seemed.
In the fall
Comes an ending,
It has fire and style,
The decay is all hidden
In color and guile.
The electric excitement

Lasts but a short while
 And like a smart squirrel
I collect my nut pile.
In the depth of the winter
In a night with no moon,
Comes a coldness and darkness
I know will end soon,
And yet for the moment
I feel chilled by some doom;
And words of kind comfort
Will not lessen the gloom.
In the spring there is pain
In the burst of each bud,
There is beauty as life
Flows up from the mud.
Together—sweet sadness
Is spring's second name,
A wound and a healing,
And a chance for great change."

Ekle was again gazing up at Lucinda with admiration and Apkin was crying a little. He did love a good cry these days.

"That was beautiful," said Steven. "I think it says what you're feeling just perfectly."

"I hope so."

"It does," said Sara. "And the poem is also comforting. Your baby will be born and by the spring you might be reunited with your people."

"Yes," said Jam. "By then I'm sure we'll have heard good news from Owletta."

"And if she's found the vinetropes..."

"What good news?" asked Dr. Umberland, coming up suddenly behind them, "and what the heck is a vinetrope?"

"I'm a vinetrope!" announced Lucinda, from Sara's shoulder.

"Too many things are happening," said Apkin, and he fainted.

"Apkin, are you all right?" asked Sara and ran over and picked him up, stroking his sides.

Dr. Umberland stared at these "happenings" with a bewitched and not-too-healthy look on his face.

"We'll explain everything," said Sara coming up to her dad with Apkin in her arms and Lucinda holding onto her neck. Apkin started to wake up, but when he opened his eyes he was met by the man's bewildered expression and fainted again. Meanwhile, Lucinda jumped onto Steven's shoulder, so she could be closer to the tall man's face, presumably to make it easier to talk to him.

"Hi, I'm over here!" she waved to him, not sure he'd actually seen her; he had such a dazed expression on his face.

Dr. Umberland looked back and forth between the unconscious squirrel, and the "whatever-it-was", and seemed to get wobbly on his feet. Steven leaned up against his dad to

offer him support, bringing Lucinda in even closer. Dr. Umberland shaded his eyes with his hand and said, "I'm not feeling too well."

"It'll all be fine," Jam reassured him.

He nodded to her and gave a peculiar smile.

"Let's get everyone inside," suggested Steven, guiding his dad back

toward the house. Lucinda was sitting comfortably on Steven's shoulder, one arm around his neck now and the other holding on to the collar of his jacket.

Sara, at a complete loss, simply followed her brother, still carrying Apkin. Jam followed her and Ekle was right behind. Jam picked him up to move faster. Just then Lynn showed up. Her parents were on their way out for the evening and had dropped her off since she was going with Steven to Rickie's party. Lynn came running over when she saw Steven helping his dad into the house.

"What happened?" She was worried about Dr. Umberland, who definitely didn't look well. When she reached them she saw Lucinda perched on Steven's shoulder. Lynn screamed. Lucinda screamed. Steven's dad screamed. Sara screamed and Apkin jumped from her arms and ran under a bush. Jam stood still, speechless. Then, finally, Steven started laughing and Lucinda started laughing, but then Lynn fainted with Sara and Jam able to break her fall just in time so she didn't get hurt.

"I think we will have to start this all over again," said Lucinda, but she wasn't sure anyone was listening.

Lynn began to wake up and Steven and Sara managed to get both her and Dr. Umberland into the house. Lucinda was still on Steven's shoulder and Apkin came out of the bush. He was rejuvenated and even seemed to be enjoying the excitement. Now, he thought, maybe they could get the whole car thing worked out before Owletta even got back. The two squirrels followed right on in through the opened back door like they'd been in a human's house many times before. In truth, everyone was so overwhelmed by the suddenness of this introduction, that nobody's responses seemed quite right. Somebody had to do something and, not too surprisingly, Lucinda took the lead.

"I think it would be wise if we all went and sat down in that nice living room of yours," said Lucinda calmly. "We could have something to drink and maybe eat some of those chocolate chip cookies while we talk," she added with practicality, nodding in Sara's direction.

"A good idea," picked up Steven. He turned with Lucinda still on his shoulder and headed to the living room. Everyone just followed behind him without protest. Lynn and Dr. Umberland were in shock and they walked like robots. In a few moments, everyone was seated in the living room. Lucinda took a pillow off the couch and placed it on the coffee table. She carefully hoisted herself onto the pillow and sat, crossed-legged, favoring her swollen ankle. She was facing Steven and the two new initiates who were in a row next to each other on the couch, Steven in the middle. Ekle and Apkin took a chair to the left.

Apkin, who had an innate love for comfort and pretty things, began sliding the pads of his front feet back and forth over the chair's fabric and enjoying the texture. It was velvety. "Very nice," he whispered to his brother.

Sara and Jam ran to the kitchen together and came back a moment later with a platter of chocolate chip cookies and some bottles of water, then placed them on the coffee table next to Lucinda. They took their places on a love seat across from Ekle and Apkin. Lucinda picked up a cookie and began to eat. Between bites, she spoke.

"Now everyone, just relax. I know this, or I should say *I*, may come as a shock. Let me tell you the whole story from the beginning. You do not have to say a thing. Just listen."

"Hold on a minute, Lucinda, let me start first," said Steven. "I'll just get it going. Yeah, okay, Lynn, Dad, it's not as weird as it seems." He was squashed between them on the couch and

he turned from one to the other. "I just found out about all this yesterday, myself! But look, I'm doing great!"

He threw his hands up to demonstrate his "greatness" and hit Lynn in the face.

"Ow!" she yelled.

Ekle and Apkin looked at each other.

"Sorry, sorry, Hon! You okay?" Steven patted Lynn's shoulder. She nodded, glazed over again.

"Well, where was I?"

"You weren't anywhere yet," said Ekle.

Apkin laughed. Sara, Jam and even Lucinda were speechless.

"You were saying how well you were doing since you met me, only yesterday," Lucinda thought she would help out.

"Yes! The first time I met Lucinda—I mean you," he turned to Lucinda, "I just went blank. That was yesterday? Wasn't it?" He looked questioningly around.

The squirrels bobbed their heads up and down. Dr. Umberland noticed and quickly turned away.

"Thanks, boys, time does seem to be acting strange," Steven continued. "I mean it is weird, this whole thing," he started to lift his arms again, but then thought better of it.

"What I'm trying to say is the weirdness gets better; I mean feels more normal, pretty quickly. Why now it seems no weirder to be talking to Lucinda or the squirrels than it does to be talking to my friends Rickie or Jim. Well, actually, it sometimes is pretty weird to talking to Jim. But that's beside the point." He checked his arms. "You'll find in no time that weird is alright and actually quite good."

Dr. Umberland's and Lynn's expressions were still blank. Steven gave up and took a cookie.

"As I was saying," continued Lucinda, "it is probably best if I try and explain. Watching and listening to me talk might

be helpful. Steven is very new at this, and doing splendidly, I might add, and although what he says is actually true, it does not make any sense when you first hear it."

Sara, Ekle and Apkin laughed a little. Jam took a sip of water. Lynn and Dr. Umberland sat patiently waiting for it all to go away. Actually, Dr. Umberland looked a bit worse. He had heard the squirrels laughing, which was very disturbing to him. Lynn, well, she could only actually hear the sound of Lucinda's voice because she hadn't had much exposure to a vinetrope, whereas Dr. Umberland, without being aware of it, had acquired some of the language benefits, since Lucinda had been regularly sneaking into the house and even sleeping over.

"Those two squirrels sitting on my living room chair?" he asked. "Did they just laugh?"

At least he was talking, thought Steven.

"Yes," confirmed Ekle, "we were laughing. That's very good, Dr. Umberland. I was laughing because I couldn't help it. Everything is getting so confusing. There doesn't seem to be anything else to do but laugh. I couldn't say why Apkin was laughing for sure. But I'd guess it was for the same reason."

"Nice seat you have here," added Apkin politely, giving the chair a pat. "Very soft and pretty." He smiled reassuringly.

Dr. Umberland remained quiet, but you could tell he had heard them.

Lynn could tell that everyone else was acting as if the squirrels were talking. She thought for a moment it might all be a joke on her, a cruel one, but they seemed so earnest. She started to swoon again and laid her head back on the sofa's huge pillow right behind her. Dr. Umberland got a kind of crooked smile on his face as though he was trying to participate in the squirrel's humor; a humor beyond comprehension, in fact, beyond all concepts of reality.

"Okay, enough," said Lucinda, throwing her arms up and wiggling her fingers. "Now, please, just try and listen! This is how it happened. I was born in your yard not too long ago on a beautiful moonlit night. I grew on a vine in a large pod. As you can see, I am intelligent. In fact, I am an intelligent plant. My kind of being comes from earth's long-distant past. We thrived in great numbers before the Ice Age, which Ice Age we are not sure." Lucinda sighed, took a breath and then a sip of water.

There was no response from the listeners, so she kept going. "My seed survived through time, along, we hope, with others of my kind, under the ice and snow. Somehow, we think, some of our seeds surfaced in recent months and got transported to North Carolina. We have not figured out that part yet. Well, there is a lot to figure out!"

Lucinda leaned over and patted Sara on her knee. "Sara, my Dear, would you mind getting some pecans or walnuts, for the boys, and maybe a cup of tea?" Lucinda interrupted herself. "This is going to take a very long time, and tea is always so soothing."

Sara jumped up, and Jam followed, glad for something to do during this awkward time. They went to the kitchen and returned with a bag of mixed nuts, a pot of brewing tea, and some mugs...one doll-sized, that Sara had already reserved for Lucinda's visits.

Lucinda poured some and took a sip. "Now where was I? Oh yes, the night of my birth. Dear me, we have a long way to go. I had better get on with it."

And so Lucinda did all the talking and her power of language did its work in time. It both mesmerized and relaxed the newcomers. The veil of shock began to lift and her voice worked its wonders in different ways on each of them. The

story she told, though incredible, began to make some sense. It had a kind of logic to it.

For adults, this was harder, because they had years of seeing reality a certain way that needed to be broken down. It was a great undertaking for Dr. Umberland. But to give him credit, he was also a creative scientist, so his inquisitive mind was being stimulated by Lucinda's persistence, the interesting data and larger-than-life personality. She spoke of clean energy! It came from a vine-like hose in her hair? This was something to understand! And as Lucinda layered facts upon facts, it did begin to make a kind of sense. He wanted to know more, to comprehend this little being, maybe to study her. He was making good progress. At least he was remaining conscious.

Poor Lynn! Even though she was younger, and might have been expected to adjust more quickly, she didn't. In fact, she ignored Lucinda and the squirrels and seemed to believe they were all having a normal conversation with each other about school and cars and the latest Smart phones. So when she spoke, it made no sense and had no bearing on anything that was happening. Steven was wondering if he should take her home and then hope she would just forget about the whole thing. He'd never bring it up again. He put his arm around her and Lynn put her head on his shoulder, closed her eyes and fell asleep. He didn't know what to do.

Apkin opened the bag of mixed nuts and offered some to Ekle, but he wasn't hungry. Apkin ate a few; he ate when he was nervous. During this whole period, a couple hours at least, almost no one spoke but Lucinda. Sara and Jam and Steven added support from time to time and affirmed what

she was saying. Ekle and Apkin grew bored and tired. After all, explaining this whole mess wasn't their job, was it? Well maybe, when it came time to explain it someday to other squirrels, but not to humans, thank goodness! They fell asleep on the comfortable chair with a few nuts scattered between them.

Near the end of Lucinda's explanation, Dr. Umberland seemed to grasp the gist of the story and he was beginning to ask more pointed questions. He was feeling almost, well, invigorated. And strange as it was, Lucinda's magic must have worked on Lynn, who woke up and seemed in better spirits and more accepting of the situation. She looked right at Lucinda and said, "So she's still here! I guess I must have fallen asleep. You'll have to explain this whole thing to me all over again, Steven, but not now, maybe tomorrow. Are we going to Rickie's party?"

Was she kidding? thought Steven. Well, maybe this was a good sign. Maybe they should go to the party, like nothing had happened, and he'd see what she was like on Sunday, when he picked her up to go out for a ride.

"That's a good idea," approved Steven, jumping at the opportunity to help her out. "I think we should!"

"That's great," Lynn smiled with extreme relief. She nodded to Lucinda, but she still wasn't acknowledging the squirrels. She said her goodbyes and they left.

Dr. Umberland and the girls escorted Lucinda back to her home. Ekle and Apkin said they'd stay with her all night, but she said she was fine. She'd had the longest day of her short life and would sleep well.

Dr. Umberland remembering the end of the tale just told, realized that Lucinda had lost one of her baby vinetropes just that day. He gave his condolences. "I'm sorry for your loss,

Lucinda." He peeked inside her home for a moment. It was astounding. Were these the "programed" roots she had told about? Clean energy, a chemical process of some kind? They had to be. "I'd like to study your habitat, if possible, at some point," said Dr. Umberland. It was the first thing he'd said all afternoon that sounded completely like him.

"Oh, have no worry about that, Dr. Umberland. You will study it eventually. But that is for another day."

Over the next three weeks, they did all adjust. Lucinda became a regular part of their family life. And so did Lynn and Jam. The two girls visited Lucinda after school almost every day. Everyone understood the importance of remaining silent about Lucinda's existence. In fact, they weren't sure there would ever be a good time to talk about it, although they knew that human awareness of vinetropes could be forced upon them in the future. Ekle and Apkin came by regularly, too. It was now a strange and complex family, but really quite "human" in many ways and definitely a happier one.

The squirrels were amazed at the way humans lived and they were given free range to explore, which they did constantly. Steven cut a little trap door in the back door and installed a flap so the boys could have easy access. In fact, Lucinda could fit through it as well. Her ankle was completely healed and she was hopping about with her usual ease and grace.

Everyone learned to play card games and Monopoly, though Ekle and Apkin weren't very good and usually folded fast. Sara, Lucinda, Steven, Jam and Lynn took turns reading

stories out loud. There was also time for some computer games. And Lucinda worked on her computer every day. Dr. Umberland found an extra laptop at the lab and had it refurbished just for her!

The squirrels loved story time, but didn't much like movies. Maybe their eyes weren't designed to translate the visual stimulus into a recognizable experience. Whatever the reason, it bored them. Lucinda loved movies. But maybe that was because her eyes worked like human eyes.

Some nights Lucinda even slept over. But most of the time, she preferred her own home, which she said suited a vinetrope better than the grand scale of human dwellings. It was, after all, her natural habitat. Only on very cold nights would she sometimes give in so she wouldn't have to keep tending her fireplace all night: with the baby growing in hair she needed her sleep.

There were often serious conversations. They speculated on how and why all this was happening and what would happen if chargons and vinkali returned to Earth. They played out various scenarios and tested each other on their responses. But until they knew the facts, they couldn't plan fully. Jam shared any dreams that might seem useful, but she wasn't having "lucid" ones.

And best of all, Dr. Umberland had agreed to drive them all to North Carolina if Owletta came back with good news. He only wanted a chance to study some of those vinetrope roots. Lucinda said that hers weren't mature enough yet to be useful. The process broke down as soon as you cut them. But finally, she came to trust him enough and she filled several vials of her vinetrope water for him.

"Dr. Umberland," said Lucinda, "I think you will find this very useful for your work."

"I'm excited to get started. But if I have a breakthrough, you should receive the credit along with my team."

"You have no choice but to keep me out of it. My ego does not need the recognition. I would rather be safe and keep all investigation into my people out of the picture. Scientists and news reporters would all be running to North Carolina if a vinetrope city is really being built, and it gets out that we exist. And if they know, our freedom would be gone. I know human history fairly well by now. And it is not all that different from the history of my ancient world."

"You're right, I won't let that happen."

"And if we find my people, and there is a city, their root system will be much more advanced than mine. I will get you a large variety of those roots to work with."

They agreed. He would start this work quietly, by himself. If Owletta found the vinetropes and they made the actual trip to North Carolina, he would have many more specimens to work with. He could tell his team that he'd made a chance discovery of the glowing roots in a forest on their family vacation, and in studying the roots realized they had great potential.

"Now, it all depends on Owletta's return," said Dr. Umberland.

"It has been a month now." Lucinda was beginning to worry.

"I haven't had any dreams that might help," said Jam, her shiny, nearly black hair, hanging over her shoulders.

"Is a month really that long?" questioned Steven. "I mean it's a long flight for a bird, and you said she hadn't flown in a long time. Also, even if she's made it there, it might take time to win the vinetropes' trust and even get to speak with them."

"That makes sense," said Sara. "You said she might have to act like an ambassador and win their trust. That could take time."

"I suppose you are all right. It may be a bit soon to get too worried. I guess I am just impatient for news." Lucinda lifted her shoulders and fluttered her fingertips.

So the big question remained. What had happened to Owletta?

11

OWLETTA'S JOURNEY
PART 2

Five days after being rescued by the seagulls, Owletta's fever broke. She would live, but would need time to gain her strength back. That meant that the whole time the Umberland family, Lucinda, Jam and the squirrels were getting to know each other, waiting for her to return, Owletta was recuperating.

It was a sunny autumn day and Owletta woke and blinked her eyes. She had been sleeping on and off continuously for days and eating what was brought to her by Cobcaw, Skitter and Tula. This time, as she lifted her head, she felt fully awake for the first time since the fever had taken hold of her. It was time to get up and test her flying strength.

"How long was I sleeping this time, Cob?"

"A few hours, Mate. You want something to eat? Caw?"

"Yes, thank you. But I think today, Cob, I should get up, work my wings, maybe try a short flight. I've been gone too long and haven't even made it to North Carolina yet. I need to get back to my mission."

"Our mission, Mate. Remember? We've been doing some research while you've been resting up, and we have a plan that will make it easier for you, caw, and quicker to get there, Mate."

"What's the plan?"

"We're going to take a train, Mate!"

Skitter had been the one to notice the trains. He observed them moving quickly across the countryside and saw humans in the windows and sometimes animals in open cars. This was interesting. He had just never paid much attention to them before. What if these cars went where *they* needed to go, to find the vinetropes? They could get there so much faster and Owletta wouldn't have to fly the whole distance. So he followed a train inland till it stopped.

Here there was a building and a platform to let more people on and off. He knew a bit of human talk by now and these places were called stations. With a bit of research, which meant overhearing human conversations, he determined that there were trains going south to Raleigh! The very place Owletta said they needed to get to first! It meant a flight by wing to the station, but for most of the trip, they could then be passengers. They just had to know what train to get on.

Owletta began to get out each day and practice flying. Finally she was strong enough for a decent length flight, one long enough to take her to the train station to figure out which train to take. She could read, after all, and there were schedules on the station's wall and on pieces of paper. Skitter had determined that.

Skitter decided to join Owletta and Cobcaw on the trip to the Haw River. They were worried as to how it would actually be to ride a train, but if they had rescued Owletta in a raging storm, they guessed they could manage a train. Skitter had to argued a bit with Tula, but she finally gave in. "I guess this is important," she agreed. "You go then, Luv, but please be very careful. Good-bye, Owletta, I wish you all the best! Take care of my Cob!" Owletta thanked Tula for all her help and said her farewells to the gull teens, whom by now were calling her Aunt Owletta.

Finally, it was time. So, on a clear, late November morning, the four friends headed out. They took to the sky and headed west. The temperature was pleasant—crisp but not very cold. It was actually warmer than when Owletta had left Lucinda's on the night of the car break-in. That seemed such a long time ago. How were they all doing? She wondered if they were worried about her. There hadn't really been any estimate on time, on how long it might take for her to complete this mission. So maybe they were worried and maybe they weren't. The three birds flew over moist-looking lowlands with clusters of trees, empty of their leaves. The general impression below was brown, gray, black and wet.

"How are you doing, Mate?" asked Cobcaw, coming up alongside Owletta.

"I'm fine, Cob. I'm really fine," she called out happily.

"Fantastic!" Cob rejoiced. "We've got this under control, mates."

Owletta gave a wing's up, and Skitter, getting the gist of it, saluted them both with a quick tip of his wing to his head, dropping down a bit and then rising again, level with his friends.

By late afternoon they had crossed a wide river.

"Here's the river I had to cross," Skitter, who had made the trip before, called back to them. "That means we're three quarters of the way there!"

"Great! Caw!" said Cob, nodding enthusiastically, his beak going up and down. "We're making good time, Mates. Caw. And you're doing extremely well," he said to Owletta who was at his side.

"Thank you, Cob, but I hope we get there soon. I will need to rest," Owletta acknowledged.

As afternoon turned to dusk, the friends, came into a town.

"Here's the station!" Skitter gestured with his wing.

They approached the station, a low-lying building that seemed deserted at the moment, and circled around. The three birds landed on the roof, settling down on the edge of the main roof. Right below them was a lower roof, running the length of the building. It created a porch-like structure protecting waiting passengers from the weather. They had no idea what the inside of the station looked like, but this lower roof was held up by fourteen columns that came close to the edge of the platform where the travelers got on and off the train. Skitter explained this all to Cob and Owletta.

Determining that no one was around, Owletta flew down to the platform and walked its length, looking for posters or signs on the outside wall of the station. She didn't find what she was looking for but fortune was on her side. On the ground, near a garbage can, lay a brochure. On examination, it was exactly what she wanted—a train schedule. There were departures from here to Raleigh two times a day, in the morning and afternoon. And even better, they were very direct, with only two stops. She memorized their numbers and suspected the train would probably say "Raleigh" somewhere on it as well. This was great news.

She then smelled a scent of fish coming from the garbage can. She called to her friends and together they located half a tuna fish sandwich wrapped in a paper bag as well as other edible tidbits. So they had their evening meal. It was decided they would take the morning train, as they had already missed the afternoon one. There was nothing to do now but get some rest. They would get to the station ahead of schedule and wait till the train pulled in and stopped. Owletta would check and make sure it was the right one. Then they would fly down to the end of the train, away from the bustle of the station, and settle themselves in-between the last two cars. Their plans

made, the three friends found a tree not far from the station and settled in for the night.

The sound of an early morning train whistle woke them.

"I hope we haven't overslept," worried Owletta.

"No Mate, we're fine. Caw. It's the crack of dawn. I guess some of these humans get up as early as us! Caw!"

Their train wasn't due in for another hour. Excited to be on their way, they looped about and landed on the station's roof to wait. No people, in their frantic human activity, seemed to notice the birds' perched over them. Finally the train arrived. Owletta swooped over to verify it was the right one and, when a human called out, "Hey, James, look at that beautiful owl!", Owletta made her way back to her waiting friends.

"This is it! The train to Raleigh!" she confirmed.

The birds flew away from the station and down to the end of the train, which was quite a distance down on the tracks. They chose the last two cars to investigate. Landing on some chains, the friends discovered that the cars were connected in a variety of ways. There was a coupling bar and heavy chains linking the two cars together. There were also electrical cables inside rubber piping that ran from one car to the next, connecting the electricity needed for lighting and other functions. To the birds, these were simply hoses, some that felt warm when they landed on them, probably something to do with the heating system, Owletta intelligently guessed. The hoses were actually quite comfortable and insulated.

"I think we should hold on to the chains with our claws," Owletta suggested, trying them out. "These hoses don't give us much to grip onto."

"If we stay close to the wall of train, between the cars, it will cut down on the wind blasting us," Skitter added.

"Good idea, Mate," agreed Cob.

"I'm nervous," admitted Skitter.

"I'm terrified!" announced Cobcaw. "I hope we know what we're doing, Mates!"

"Well, if any of you want to back out, now's the time," Owletta nodded her head and gave a partial lift to her right wing. "I'm stuck with this ride, whether I like it or not. I won't blame you for changing your mind."

"We're both coming," said Skitter.

"Yes, Mates, I wouldn't miss it! Caw! It just helps to complain," said Cobcaw.

So they took their positions and waited. Fifteen minutes later the train blew its whistle and not too long after that they began to move. The birds' expressions were priceless, but they were too engrossed with their own emotions to look at each other and there was no one there to see them.

They held on, stiff with tension. As they gained speed, and nothing bad happened, they began to relax. They nodded at each other in companionship and relief, but it was hard to talk over the noise of the train and the wind. Their claws were strong and were built to grip for long periods of time. Despite their successful adaption to hitching a ride on a train, they were glad when they came to the first stop.

"We can stretch our wings and feet for a few minutes," suggested Owletta.

"Yes, thank goodness, Mates. My claws are so tight they feel like they can't let go. Caw!" said Cobcaw.

"When we hear the whistle," Skitter screeched. "We'd better get back and take our positions."

They took a short flight around the end of the train to stretch and relax and then landed back between the cars, to wait. They were too nervous to fly too far away. It was then that Cob noticed something.

"Hey look, Mates, there's a door into this last car. It's opened a crack. Caw. Maybe we could squeeze inside for a more comfortable ride, Mates?"

"We might get locked in," Skitter worried.

"Let's check it out," Owletta said entering.

The others followed and Owletta made sure the lock was fixed in the open position so that it could not come down and lock them in when the train started up again.

"This is great! We can ride in here easily. I made sure the door won't lock. There is nothing to worry about."

The whistle blew and soon after the train began to move. So the three friends settled in to chat in the comfort and safety of the car. Time passed quickly and soon they were pulling into the station at Raleigh. As they came to a complete stop, they took to the air. They flew over a stretch of grass and headed for a small wood nearby. From the top of a tree they could see the city of Raleigh and decided to roost and hunt for food. They would rest an hour and then head out that afternoon, in the direction of the Haw River. Owletta had the map in her head and knew in which direction to fly. But the map ended at the Haw. That was as close as she could get them by her memory of the map.

Rested and fed, Owletta, Cobcaw and Skitter took to the air. They circled out over the city, made a U-turn and headed inland, going further west. Owletta led the way and soon they approached a body of water. It was not a river; it was a lake and Owletta remembered a lake from the car map. Lucinda had pointed it out. It was small on the map, but this liquid span of water went on for quite some time. It was beautiful and it meant they were going in the right direction. Now they passed over farmland and patches of wood and at last, a river was in sight. It had to be the Haw! The late afternoon

light shimmered on the water's surface, making it glisten like a satin ribbon. There was a sense of peacefulness below that made Owletta feel quiet inside, despite the uncertainties of what lay ahead.

"Let's drop down a bit," suggested Owletta and she did, Skitter and Cobcaw following her cue. "That's better. We can see the river's edge more clearly this way."

There were tracts of woodland along the river and suddenly a remarkable red beechnut tree, that boasted an amazing spread of branches, came into view. They were all drawn to it. And no wonder, for it was glowing sweetly in the rising moon. Yes, this tree was glowing! That had to mean something. That had to mean vinetropes.

Owletta swooped lower, heading for the tree. "Let's stop here and determine what it means."

As they settled into the branches, there was a commotion. Several animals squeaked at them angrily, and much to Owletta's surprise, a large male owl spoke up in a commanding voice, from somewhere overhead.

"May I ask what you a*rre* doing here?" He rolled his r's and it sounded a bit like a soft growl. "You make a most unusual and unexpected pa*rr*ty at the end of a day, so I think we a*rre* owed an explanation."

Owletta turned to her friends.

"Let me try and do the explaining. I may have more success in communicating with this owl gentleman, who seems to be the protector of the tree."

Owletta flew to a higher branch, closer to the male owl, and allowed herself to be seen.

"Please, sir, excuse our unannounced arrival, but we are on a long and important journey with no idea of where to take rest. The beauty of this tree called out to our tired wings and

we were drawn to it in our weariness. We mean no harm to you or any of the tree's inhabitants."

The male owl seemed pleased with Owletta's formal and attractive language. "You need not be in such a hurry. We arre a welcoming enough group, and enjoy the company of guests when proper intrroductions have been made."

"This is completely understandable," agreed Owletta. "Let me then introduce myself and my friends and tell you our tale."

"Please, Grracious Lady, your language is almost as lovely as you arre yourself, and I would be honored to hear your story and meet your frriends."

Owletta felt her feathers ruffle. She was a bit embarrassed by the compliment, but also pleased. He was a handsome fellow and as good at speaking as she was.

"You are very kind. My name is Owletta and I come from the north. I live northwest of the huge human city called New York in the region once known to us owls as Dogwood Forest, until a plague killed all the dogwoods. I live in a lovely old oak, nearly as old as your beech. It is an ancient oak that goes back to a time before the human town in which it grows was built."

"This sounds like a fine home and you have trraveled far, then. No wonder you arre weary."

"Indeed, we are. Let me introduce my two gull friends whom I've met in travel." She called to her friends to join them and they did.

"They are helping me in my mission. In fact, these two gulls have saved my life. This gull's name is Cobcaw The Watcher (she remembered their first meeting) and his cousin is Skitter of the Great Eastern Cliffs, (she made this up)." The gulls nodded politely, Skitter with a puzzled look on his face.

But Owletta knew it was important amongst owls to make these introductions formal, even if you didn't talk like this forever.

"I am pleased to meet you all. My name is Hool Beechum and this is my much beloved home. You arre welcome to rrest and take rrefreshment here. We gladly welcome you. Let me introduce Cip and Cep the chipmunks and this is Selena squirrel."

"Selena squirrel!" hooted Owletta so loud that nearly everyone jumped off their branches and the tree rustled madly with scattering life.

"Selena, did you lose your mate to the mischief of humans and a pecan barrel, and is his name Ekle?"

"Ekle! Ekle! Do you know my dear Ekle? Is he alive! Is Apkin!"

"Yes my dear, alive and well and looking for you and Regata," assured Owletta. "You and Regata are part of my mission. Where is Regata?" she asked.

"Regata spends much time at the old tree where we all lived before. She feels she should stay there as much as possible in case Ekle and Apkin return. Hool was kind enough to ask us to live in his beautiful tree. Regata is so sad, but she always winds up here at night. I like to keep myself busy. It helps me cope better and Hool has us working on many useful projects."

"Then here too is an owl who has befriended squirrels!" remarked Owletta.

"How amazing! You arre friends with Selena's and Rregata's mates?" Hool lifted his shoulders and his eyes grew wider, if that was possible. "Relationships arre changing between animals!" He swept his impressive wings open to their full width to make his point, showing them to their best advantage.

"This has to be more than a coincidence, your arrival. It seems we arre already linked to the same history. You must tell us everrything!"

So once again Owletta told the tale, at least a good part of it, while Cip and Cep brought refreshments. She told them about Lucinda and that she, Owletta, was her ambassador. Lucinda, a Glower who knew the whole history of vinetropes.

"She was from a seed sealed away for safety from a disaster in ancient past. She had survived and was separated from all the other seeds that had been sealed this same way. They had been a great civilization once, before the world was anything like it Is now."

Hool nodded. "We know very well of vinetropes and Glowers too, but not of this surprrising history. This is very crrucial information. And this Lucinda is of grreat interest to me. But first finish your tale. Then I will tell you ourrs."

So she told them about Sara, who she herself hadn't yet met, but who Lucinda believed in with all her heart, and of course she told them how she had befriended Ekle and Apkin and now Cobcaw and Skitter. She even told how Cobcaw and Skitter rescued her in a raging storm while she was delirious with fever.

Everyone was mesmerized by the story. Selena was beside herself with joy. In short order it was as if they had all known each other for a long time. Besides Cep and Cip there were other squirrels, chipmunks, sparrows, woodpeckers and two raccoons. Selena then excused herself. She said she had to tell Regata the good news immediately. They would both return soon.

Owletta hadn't told them everything. She didn't mention the chargons and vinkali. She would, probably first tell Hool, but not until she had some questions answered. She and the

gulls still knew nothing much of Hool or his friends or what they had to do with vinetropes.

"We have many things in common, Owletta," said Hool in his rumbly voice. "I can't help but wonder if we we*rr*e meant to meet."

"This may be true, but right now you know a lot more about us than we do about you. Please, Hool, tell us what you know about vinetropes and their activities."

"Well, when I first came to this beech t*rr*ee, many years ago, it didn't glow. That was befo*rr*e the vinet*rr*opes a*rr*ived, a couple of yea*rr*s back now. I wanted to avoid meeting any vinet*rr*opes, especially the one that glows blue, Chant*rr*oute. They wo*rr*ied me and so did that glowing."

"Chantroute, you know his name!" Owletta was excited to hear.

"Yes, that's what I'm getting to. This g*rr*eat old tree began to die. Several vinet*rr*opes, including Chant*rr*oute, came to me and said they could save the t*rr*ee. They wanted nothing for their help. They only asked we not sp*rr*ead rumors about them. I was happy to oblige. I'm not the gossiping type, nor are any of my f*rr*iends here in the Beechnut t*rr*ee. So they sp*rr*ayed my t*rr*ee everyday with their special water."

"Yes, I know a bit about that," said Owletta.

"And not only did my trree surrrvive, it's never been so full and beautiful."

"It is beautiful, Mate," nodded Cobcaw.

Skitter patted the branch with his wing respectfully.

"In fact they sprrayed it too much and it began to glow," Hool raised his wings again sweeping across the branches. "They are worrried now it will bring too much attention. But I'm glad it brrought you," he added, bowing to Owletta.

Owletta smiled and nodded back. "Yes, it is the glow that pulled us in."

"Since then," Hool continued, "we have become friends. They have asked my advice on issues that come up with other animals. I have gone to conferrences and to council meetings."

"You've actually had meetings with them!"

"Yes, many times. I've been to their Councils on nine occasions. Their Glower and Healer, Chantrroute as I said, sought me out. They are hoping to grrow a full vinetrrope nation. They have all the members of their community but one. They need a Master Rhymer, a Glower who is also always the vinetrope historrian!"

"You mean Lucinda!" Owletta threw her wings around Hool and gave him a hug. Well that wasn't being very formal. But she was so happy she couldn't help herself.

Hool fluttered his feathers and smiled for the first time.

"Of courrse, my dear Owletta. I realized that right away when you told us about her. I knew you had to mean the Glower they've been hoping for. They have one other young Glower, born six months ago, but she is not a Rrhymer or Historrian either. She is a Healer, like Chantrroute. So they still can't make sense of who they rreally arre or where they came from. It is like a kind of deep forgetfulness; an amnesia.

And it makes life harrd for them; despite all their effort, work and building skills, which I might add, is rremarkable!"

Hool obviously felt for them and understood these vinetropes well. "You see, therre is something missing and they don't feel right." He tapped his wing on the branch. "They live in the prresent, surrviving, but know nothing about their past. Only Chantroute knows a bit of historry; and only when it comes to medical facts and how to trreat Illnesses. This knowledge is built into him."

"Yes, all of Lucinda's knowledge of history is built into her too. She was born knowing it."

"Exactly, Chantrroute explained this to me. And that's how he knows they arre missing their historian. Having their historian is part of their survival."

"And they must all realize they can't remember a past!"

"They do. And it makes them feel lost. What you just told me today about their historry is more than they could have imagined. It will help them immensely." Hool opened his wings again. "Why, they werre extinct! They came from thousands of years ago! And somehow theirr seeds, sealed for safety so many eons ago, have surrvived. Just knowing that will bring them strrength!"

"I can do more than that," added Owletta. I can bring Lucinda to them. I can return her to her people."

It was Hool's turn to hug Owletta, much to his own surprise. "That would be wonderrrful! You arre like an angel from heaven!"

Cobcaw and Skitter nodded at each other knowingly and smiled. A few other residents tittered and made little giggling noises.

"Love birds!" Cep whispered.

Then Hool he tapped his head and said quietly, "I wonder how she got separated from her people, your Lucinda?"

"We all do, especially Lucinda," Owletta nodded, bringing the tips of her wings together thoughtfully. "And why was she born less than two months ago and these vinetropes you know have been here for two years building a city!"

"That is a verry puzzling question," Hool agreed.

Skitter and Cobcaw had been quiet for quite some time.

"Caw, tell him about the chargons and vinkali, Mate," urged Cobcaw. It was true; it was time to tell about this worrisome part of vinetrope history. So Owletta did and they all listened intently.

"I must arrrange a meeting immediately," said Hool. "I will leave now!"

"Yes, please Hool, the sooner the better," Owletta agreed, "and tell them that Lucinda, their Glower, Rhymer, Historian, is alive and well. She will be here as soon as she can. And she wants me to warn them of the chargons and vinkali, since they would have no way of knowing about them. Tell them that I will meet with them tonight and tell them everything. And then I will return and get Lucinda and bring her home!"

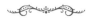

Owletta, Cobcaw and Skitter fell into a deep sleep.

It must have been about an hour later when Hool alighted in the beech tree.

"Owletta, I'm back."

Owletta awoke, feeling completely rested.

"I feel wonderful!"

"It's the glowing trree. It heals our bodies too."

"What did they say?" was her next question.

"The vine*trr*opes are overjoyed at your a*rrr*ival, Owletta, and want to meet you as soon as possible, tonight! I've already told them eve*rr*ything you have told me … *rr*ight down to the cha*rr*gons and vinkali. But they want to hear everything from you and more."

"That's wonderful!"

"But only you can come," Hool said sternly. "They a*rr*e very cautious."

"I don't like being left out!" said Skitter, who had woken up. "I came all this way. I have a right see them too."

"That's just the point," said Hool. "They a*rr*e not interested in satisfying everyone's cu*rr*iosity. It is not your *rr*ight! They're p*rr*otecting themselves, you know," he concluded with irritation.

"Well, I didn't mean it quite like that. It came out wrong," explained Skitter. "I guess I understand. I'm just disappointed."

"I understand, Mates," said Cobcaw, shaking his head and waking up. "Wow! Caw! That was a good rest."

"It's only right that I go alone, my friends," said Owletta. "After all, I am Lucinda's messenger. It is my responsibility to meet with them first."

"Those are the ve*rr*y words spoken by Chant*rr*oute Wayforth," explained Hool.

"Chantroute Wayforth," repeated Owletta. "When do we leave, Hool?"

"*Rr*ight now! Follow me to Vinet*rr*opeland!"

Hool swooped out into the night and Owletta followed, feeling strong and well. They crossed over the woods and back towards the river. Owletta praised the land below and Hool graciously accepted her compliments, obviously proud of his native countryside. The night air was pleasant against their wings and the land was quiet below, unlike summer, when insects make their racket in the night.

Soon they caught glimpses of the golden liquid road, called the Haw River, glittering here and there, between the trees, ahead of them.

"The *rr*iver is cleaning up," commented Hool. "It's gets cleaner eve*rr*y month. The humans c*rr*edit it all to themselves, but it's the vinetropes who have made this happen."

Owletta flew at his side and admired it all. Hool descended and she followed.

Now the land took on a rich, velvety quality that felt intense and lush in the creamy moonlight. Owletta observed that they were over a green elliptical strip of land with scattered trees. This green area was evenly green, a spring green, young and bright.

"It's so green! It looks like summer down below. Are we here? Everything feels so soft and deep and dreamy!" commented Owletta, dropping a bit further.

"Yes, the front ent*rr*ance is just ahead," explained Hool. "What you see below is g*rr*owing over the very center of their unde*rr*ground city."

"You can almost feel the life underneath," said Owletta. "It's as though the grass and plants and trees are twice as alive as usual."

"Exactly!"

"What about humans? They truly haven't noticed yet?"

"Not *rr*eally," said Hool. "We are far away from any town. But it is su*rr*prising and fo*rr*tunate they haven't been discovered. Maybe vinetrope energy p*rr*otects them in some way? The more I learn about vinetropes, the more I *rr*ealize what wonders they a*rr*e capable of."

They made the final descent.

Hool landed and ran a bit, flapping his wings. Owletta landed next, more gracefully. The grass and moss felt as soft and cushion-like as it looked.

"The grass feels warm!" Owletta was surprised.

"It's the *rr*oot system at work underneath," said Hool. "The vinetropes explained it to me. The tempe*rr*ature is always kept comfortable inside."

"This is so exciting. I can't wait to see what a mature root system is like."

"Then let's p*rr*esent ourselves."

Hool approached a tangle of vines that fell from the branches of a giant weeping willow. The vines spilled over the front of a circular stone embedded in the bottom of the tree's trunk. The willow branches rustled in the night breeze and Hool caught a few tendrils of the vine with his wing tip and pulled them away to the side. The stone door was now fully revealed.

Hool leaned forward and spoke into a hole in the stone. His gentle growl rumbled through, into the depths of Vinetropeland.

"Hool here, at the Willow Hollow, bringing the foretold messenger," he called. It was an intercom system of some kind and his voice echoed down behind the stone and into a space that sounded like a deep well.

There was a familiar cranking of wheels that sounded to Owletta a lot like Lucinda's front door opening. Then a wonderful glow emerged around their feet, and as the door slid open to its full capacity, the opening created a perfect circle. The glow from inside filled the circle and for a moment it seemed that the autumn moon had been held captive under the earth and was now ready to escape. In fact, the light was so bright it blinded them.

"Let me dim that down," said a friendly voice.

When their eyes adjusted, they beheld a thin but agile figure standing in a golden tunnel. Owletta could see it had

the silhouette of a vinetrope, a male vinetrope. He took a step forward and stood before them.

"Welcome," said his smiling face. "How are you Hool? You must be Owletta! Please, come in!"

His friendly voice put Owletta at ease and they stepped into the tunnel.

Owletta looked face to face at her first male vinetrope; her first vinetrope at all, besides Lucinda. His skin was a medium cinnamon brown and his features were more angular than Lucinda's.

"I am Klent Abo Roottroupe, your guide," he announced.

"Hello Klent, may I introduce Owletta. She is Lucinda Vinetrrope's messenger."

Owletta and Klent bowed a little to each other.

"We're so happy that you're here, Owletta, with news of our missing Glower! Chantroute has arranged for a Moonglad Feast, to celebrate your arrival. Nearly everyone is busy preparing as we speak. Everyone is wide awake with excitement, even the children!"

"I am very honored and thrilled," said Owletta. "This has been an adventure of a lifetime for me."

"Follow me, please. We will go directly to the banquet hall in the center of town. It's about a fifteen-minute walk," said Klent, closing the door and then stepping quickly down the tunnel in front of them. Owletta looked around. The tunnel was much higher than Klent and the owls, maybe five feet, but it was not very wide. Everywhere the tunnel glowed lightly, a soft yellow, and the walls, ceiling and floor was completely covered in root fuzz. It was this fuzz that gave off the glow.

Klent Rootroupe was dressed in a rather plain brown outfit with loose-fitting pants and shirt and brown boots. As he led the way, Owletta noticed a subtle pattern of mushrooms on

the back of his shirt that shimmered slightly depending how the light hit the fabric. The tunnel began a slow descent and then it widened considerably—it was now about eight feet high and six feet wide. Owletta and Hool walked side by side behind Klent. In a moment they met another vinetrope coming their way.

"Hi, Jetro," said Klent.

"Hi, Klent, Hool, I was sent to guard at the front entrance," he explained. Jetro was taller than Klent, had light blue skin and wore an outfit similar to Klent's, but in a deep purple. "You must be Owletta," he gave a little bow. "Hool told us about the chargons and vinkali. We know this warning comes from our Master Rhymer, so we take it seriously. I'm very happy to meet you and so glad you're here."

"I'm delighted to meet you, too, Jetro."

"I'd better get to my post so you can get on," said Jetro. "I'll see you both later and catch up on everything that's said when I'm off duty. Have a good visit, Owletta."

"Thank you."

Hool nodded and waved his wing.

They continued on their way and, as they walked, Owletta was overwhelmed by the beauty. The root network overhead and down the walls was now more advanced. It was made of millions of gently glowing strands, each as delicate as silk thread. Instead of just hanging down, like in Lucinda's little home, these roots were woven into dense and wonderful patterns, covering everything.

The designs changed every twenty feet or so. This created the impression of passing from one section to another, almost like a room, and each section was decorated with a different pattern: leaves, flowers, paisleys, geometric designs and different colors, some blue, green, lavender, yellow and pink, all

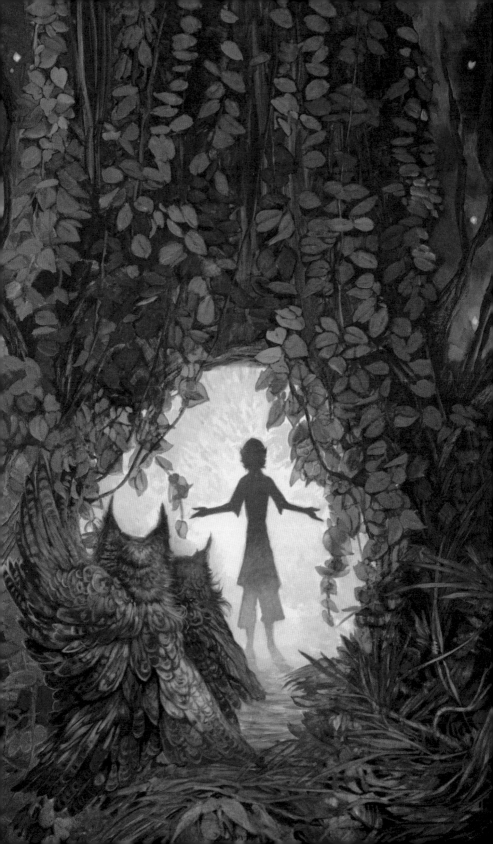

made from roots. Some shimmered with multi-colored effects—much like LED lights—and pulsed lightly.

"It's trruly rremarkable, isn't it?" said Hool, impressed all over again each time he came.

"This is so beautiful it's hard to believe!" Owletta agreed, stopping and turning around to peer at the walls to see the patterns more closely.

The tunnel soon expanded into an impressive hallway. The patterns became denser and thicker the further in they traveled, so that some of the designs looked like carvings, three or four inches deep, of animals and vines and even vinetrope faces! All made from artistically controlled roots. At this point they passed doors and windows in the walls, but they were all closed.

"What are these windows and doors?" Owletta asked Klent who had stopped to wait for them.

"Homes—different homes," explained Klent quickly, "they are back doors."

Next was a section with a pattern of snowflakes, all white and blue, from floor to ceiling. These roots had become a covering of delicately embroidered lace; like an intricate lacey tablecloth. The "embroidery" became especially thick in the middle of each section, glowing at the center and hanging down into the hallway. Further on, these lacey hangings thickened and became vinetrope chandeliers with glowing bulbs and pulsing globes of light! It was magnificent.

"Owletta," said Hool, taking her wing in his. "Everry time I visit, their city is more advanced than the time before. And the closer you get to the center, the more advanced it becomes. I'm neverr sure what I will find next!"

"I can't imagine what joy this will bring Lucinda. It will be like her dream come true! They seem to have outdone humankind in what they have accomplished!"

"I know. It feels the way I imagine heaven might look!"

As they approached the center of the city, the walls no longer glowed; instead the root chandeliers became larger and the main sources of light. They hung like clusters of white grapes or floating globes that pulsed like little suns. The walls and floors were now covered in emerald green moss. Flowers and herbs sprinkled the moss and as they crushed it with their feet, a delicious herby scent was released and filled the air. There seemed to be vents in the walls that led directly to the outside, and fresh breezes reached them as they passed. The walls boasted an abundance of plants, vegetables, berries, herbs and mushrooms.

"There's more growing here every time I come," said Hool, stopping to examine a cluster of red berries and popping one in his beak.

They came to a stop as Klent explained.

"It's the city's food farm, and it has really taken off. We grow most of what we eat right on the walls. Chanroute knows how to test and discover what is safe to eat and then we plant the seeds or spores in the moss, on the walls." He then pointed to the chandeliers, while the mushroom pattern on his clothes caught the light and shimmered. "The lighting, those globes and bulbs, give all our crops the proper light they need, as if they got it from the sun, and of course we water the walls every day with vinetrope water. We have mushrooms, and vegetables and all kinds of herbs, ready to be picked!"

"It is spectacularly beautiful in here, Klent," stated Owletta. "Lucinda will be delighted when she sees what you've accomplished. Her home is still in its early stages, quite simple, though homey and charming in its own way."

"Well, we are a growing community here and have many vinetropes with artistic talents working all the time on the roots. And it seems, from Hool's account, we've been in the world

much longer than Lucinda has! You know, the roots also have the practical value of keeping the earth from crumbling in on us," Klent rambled on. "It creates a very sturdy and nearly impenetrable fabric, thin but incredibly strong."

"I know," said Hool. "Even though I've been here many times, it never ceases to amaze me. When I first came, the root system wasn't complete and I had two guides to lead the way. They came with root lanterns."

They began to walk again.

"Why aren't there any vinetropes about?" Owletta asked Klent. "I was expecting to see vinetropes everywhere."

"We're only two hundred and three vinetropes in all, and they're all gathered right now at the town center to meet you Owletta!"

"I'm honored," said Owletta, feeling a bit overwhelmed.

"Yes, we're a small group, but we're growing. We've re-emerged into several flourishing families. We've got the Vinetropes, that's Lucinda's line, the Rootroupes like myself and Chantroute Wayforth our healer, then the Vineroots, the Fernfels, the Vineferns, the Fernroots, the Rootfels and the Ferntroupes! But we're all vinetropes," finished Klent Abo.

Owletta felt her head spinning.

"Those are all the different family names, but as I said, we're all vinetropes. You'll see." He then gestured with his arms held high and stepped to the side.

At that moment the hall opened into an immense dome-shaped room about eighty feet in diameter and twenty feet high. There were at least forty elaborate wooden front doors in an array of colors all around the circular room. Giant globes of light floated in the air. And under the globes a crowd was gathered by a beautiful fountain; a tremendous fountain that sprayed water out of crystal clear trumpet-shaped flowers,

splashing into several root made tiers. As Hool, Owletta and Klent Abo entered, the crowd cheered at the top of their lungs.

"Hurray for the messenger! Hurray for Owletta!"

"Thank you, thank you," said Owletta. "This is an amazing day for me. I'm almost bewildered beyond words at the sight of your beautiful town and your warm welcome."

Again a cheer went up on all sides.

Owletta looked around at all the faces and sizes. It seemed vinetropes came in many colors and shapes and each face was unique and yet definitely belonged to a vinetrope. There was a rainbow of skin shades, from the cinnamon of Klent Abo to dark walnut, deep burnt-orange and the lighter pumpkin peach of Lucinda. There were even shades of green and blue! And all their hair, whether short or long, was made up of leaves, burgundy red or shades of green. Some heads of hair were tightly packed and others loose and flowing, but the strands all grew as vines right out of their heads.

"Welcome," said the slender figure of a young male vinetrope dressed in blue. "And may the stars be witness to the joyous message that you bring." He stepped forward, bowed and raised his arms upward.

Owletta and Hool followed the direction of his arms, and as they looked up into the domed ceiling, they observed eighteen large windows slide open, like the inner lid of a cat's eye, revealing the autumn night sky, twinkling with stars. Owletta gasped and so did Hool, who had not seen this latest mechanical invention. The glowing globes hovered and roamed the air, mysterious moons powered by vinetrope energy. It was all so magical. A cool night breeze filled the room with a delicious spicy fragrance.

"Cool air is good for parties and dancing and feasting!" emphasized this young man. He blue tunic was simple but

elegant, and he had light blue skin that matched his clothes. What's more, his skin began to glow a wonderful electric blue. He then offered Owletta his hand. "I am the Glower Chantroute Wayforth, the Master Healer of my people, and our good friend Hool has informed me that you bring us the greatest news possible."

Owletta picked up this cue and stepped into the center of the room to speak, lifting her wings before starting and turning fully around once, looking at all their faces, before she began. She hadn't planned what she was going to say, but somehow she knew it when the time came.

"Indeed I do have great news! A most amazing being was born from the ground near my northern home. She is smart, industrious and cheerful by nature and possesses three extraordinary qualities. One: she glows at will." The crowd cheered. "Two: she makes up the most wonderful rhymes." With this, the roar of the joyous vinetropes was almost deafening. "And three: she knows the history of the vinetrope race!"

With that, Owletta was lifted into the air to the tune of a wonderful song and the vinetropes paraded her all around the circular space, while clusters of young vinetropes and their parents cheered from the sidelines. Owletta was finally placed down by the fountain next to Hool, and back in front of Chantroute Wayforth, who was grinning from ear to ear, very much like Lucinda.

"Let the Moonglad Feast begin!" proclaimed Chantroute. The air filled with the watery music of wooden flutes and lovely singing as merry vinetropes busied themselves in every direction. Tables and chairs were quickly set up and the front doors of many homes opened to reveal the smell of delicious preparations. All the while was the splashing of the water in

the giant fountain. Chantroute signaled to Hool and Owletta to sit down at one such table. Mugs and bowls of herb-scented drinks were placed before them, as well as plates piled high with something that looked like golden pancakes.

"Help yourselves," said Chantroute. "These river cakes are nutritious and tasty to most animal life, at least to my knowledge. From what I've studied of the animal life around here, this food will hopefully be satisfying to owls. We've cultivated new plants that should satisfy both your body and your taste buds. And sip freely from your drink bowls my owl friends!" His handsome young face was beaming with joy. "Eat and drink first, my good friends," he continued. "Please rest and when you're ready, Owletta, we would be honored if you would tell us the whole story from the beginning in your own words."

When she was ready, Owletta's voice carried well. They had a simple system of voice projection set up at her table. It seemed to consist of a large megaphone connected to some kind of underground piping that then came up out of the walls at intervals around the room, vibrating and enhancing sound like a speaker system. It projected her lovely clear voice. In this way all the vinetropes could hear her speak.

Owletta kept Chantroute and the crowd spellbound with the full story of Lucinda, Sara, the squirrel brothers and herself. She continued with the story of her journey, meeting Cobcaw, Skitter and everything that happened afterwards, from her illness to their continued trip down south, the train, and coming to the Glowing Tree where she then met Hool.

And even though Hool had explained much of the story, they all wanted to hear it again from Owletta. They asked her many questions about Lucinda, and she answered them as well as she could. This gave her a chance to tell them as much of

the history of vinetropes as she knew. Of course, Owletta had no idea of how much Lucinda had learned from her computer sessions, or that she was having a baby, a tiny Glower, or that Steven and Dr. Umberland would be able to drive Lucinda back to her people once she returned. But she told them what she knew, which was so much more than they had known. They were very grateful.

The celebration continued into the night with a private discussion between Chantroute, Owletta, Hool and the Council of Seven, all sitting at the same table. It was now that they discussed in greater detail the worry of vinkali and chargons and the history of chargons enslaving vinetropes. As of yet, there were no signs of these creatures returning, but they needed to take precautions based on Lucinda's advice. If it took Lucinda's seed so much longer to sprout, who was to say it couldn't happen with chargons and vinkali?

Then she told them of Sara, a human child who Lucinda had affection for. Lucinda seemed to think she was important to the future of vinetropes. Owletta was worried about humans and wanted the Council's opinion on Lucinda's friendship with Sara.

Owletta laid her wing tips on the table and leaned forward, "Lucinda may want to bring Sara to meet you; if there can be a way. She said we will need Sara's help, maybe her family's too, to bring Lucinda back to you. They could bring her and Apkin and Ekle back here in their car, once I return and tell them of your city."

"That worries me," said Hool, raising his forehead in disapproval. "I don't like the idea and I'm worried for your safety as well, Owletta."

Chantroute was wary of humans too, precisely because they seemed such a developed civilization. He frowned and

shook his head slowly. "I see humans as competitors with us. They have an advanced civilization. I don't understand their motives or what their response would be to other intelligent beings as advanced as vinetropes."

Hool nodded in agreement and so did the Council.

"Also, the damage to some of the earth and flora that I've observed seems to be a result of a variety of human activities. This adds to my concerns. I have told everyone that I thought it best to keep their distance from humans."

"But Lucinda is very certain of Sara's importance," Owletta repeated.

"Well, if Lucinda trusts this girl child named Sara, and she arrives with her, I suppose I will have to consider meeting her and deciding for myself. But tell Lucinda that Sara, and only Sara, can accompany her into our city."

Everyone agreed this was a good plan. And so it was finalized that night that Owletta would return to get Lucinda but if Sara came with her family, only Sara would be allowed to actually enter the vinetrope world.

The rest of the night was devoted to music and dance and the sharing of stories, layering their understanding and trust of one another. The music lifted their spirits and everyone took turns dancing, Owletta and Hool among them.

As they swirled around the dance floor, Hool whispered into Owletta's ear, "We may be part of an historical event, but the most wonderful event for me, Owletta, my dear, is that we have met, for I know I am completely in love with you!"

Owletta was thrilled to her heart. "And I know I love you too, Hool. From the moment we met. My mate died so long ago, and I never thought I would feel this way again."

They wrapped their wings around each other for a moment. The night's merriment continued and before long it turned

into a double celebration, for somewhere in the midst of the merriment, Owletta and Hool announced their engagement. Cheers and toasts were made to Owletta and Hool and the vinetropes insisted on helping them with their wedding plans. Many more songs were sung and dances danced deep into the night. Finally the owls said their goodbyes. Owletta promised she would bring Lucinda to them as soon as possible.

Back at the glowing beech tree, Owletta and Hool found everyone asleep. They took their place in the nook of the tree and leaned into each other, happy in their closeness.

"My dear Hool," said Owletta, "you understand we will need to put our personal joys aside for a while. I will need to make the trip back north to get Lucinda and bring her here. I must fulfill this mission first."

"I understand," said Hool, "I do, but with one small change in plans."

"What's that?"

"I'm coming with you."

12

OWLETTA'S RETURN
AND A BABY IS BORN

It was December tenth: nearly two months since Owletta's departure and only two weeks till Christmas. Everyone was concerned for Owletta's safety and they had already decided to head out to North Carolina over the winter break to see if they could find Owletta, the vinetropes and the squirrels' mates on their own. This made sense as it was school break.

When they reached the Haw River, Lucinda and Ekle and Apkin would need to set out on their own to investigate the whereabouts of vinetropes and determine if they even existed. At least there was a good chance they boys would find Selena and Regata. Lucinda was feeling guilty that she had let Owletta go.

"I should have made her wait till she met you, Sara. And if she had waited till now, we could have all gone together. She would be safe now, not hurt or dead!" Lucinda was driving herself crazy with worry.

"You have to stop doing this to yourself," said Sara. "You had no way of knowing if or when my dad and Steven would ever have been able to help you."

"But you were so mad at me, Sara, and rightfully so."

"Only for not waiting a day till I could meet her and help with the directions," Sara pushed at her hair, "because I felt left out and could have helped with that. But I'm sure I would have then let her go with my blessings. Remember, she wanted to go very much!"

"It is what it is," added Ekle, lifting his paws, getting philosophical in recent days.

"We can only hope for the best," said Dr. Umberland. "We'll head out the day after Christmas and just hope for the best."

Jamuna had one of her vivid dreams. In her dream she was a crow. It was snowing hard and she was flying directly into the storm over a large stretch of woodland. The branches broke unexpectedly through the fast falling flakes, black and sharp. Startled, she was afraid they would scratch her, cut her or throw her to the ground. But, no, she regained her bearings, and, lifting herself higher, she found herself looking down once again onto the landscape. The wood was a black blur against the ground, the ground now covered in deep snow. Suddenly a hole in the ground tore open out of this whiteness.

It was a tunnel and from the tunnel emerged a speeding train. She was flying right over it now, going in the opposite direction. The train moved swiftly on a path that ran through the forest, right down its middle. She then saw it wasn't a path, but railroad tracks. The train passed under her. She reversed her course and followed the train. The snow and wind, moving with her, whipped her along, till she caught up. Soon she was hovering over the train. With the wind helping, she could fly as fast as the speeding train! She could keep up with it. It all seemed perfectly natural. Looking up and into the distance, she made out a familiar sight. It was the skyline of New York city. That's when she woke up.

Jam sat straight up in bed. She looked at her clock. It was 6:00 am! What day was it? Yes, it was Friday. She opened her blinds partway to look outside. It was snowing, pretty hard. She knew what the dream meant! Owletta was returning. She was flying home in the snow, as straight as a speeding train! She would be here soon, in fact today! She had to call Sara. She took her cell phone off the night table, unplugged it from the charger and called. It rang several times and went to voice mail. She called again.

"Hello?" said Sara.

"Have you looked outside?" said Jamuna.

"No, I'm just getting up. My blinds are down."

"Well, look!"

Sara pulled up the closest shade. It was snowing. "It's snowing," she observed, groggy and annoyed that she had been woken up before she had to be. "What's up? Did they cancel school?"

"No, but that's not the point."

"Well, if it was cancelled, it would be," said Sara.

"Never mind that, I had a dream."

"You mean one of your special ones?"

"Yes, please listen." Jam told Sara the dream.

"That is strange. You really think it means she's coming back?"

"It means Owletta is almost here. She's coming with the snow! I was flying in the dream. I was a bird. I was her!"

"Yes, Jam. I can see how it might be that." Sara sat up and hung her legs over the side of the bed. "But it might just mean that it's snowing and you were thinking of her and sensed the snow at the same time."

"No, Sara, you promised not to do this. I'm telling you that it was one of *those* dreams. She's coming."

"You're right, Jam. I'm sorry. I'm just waking up. Let me focus on what you just described. The way you were flying in the dream, so fast, like a speeding train, it must mean she'll be here pretty soon. She's in a rush, now that she's coming. It sounded a little dangerous, too." Sara was fully awake now.

"Yes, you're absolutely right, something about falling through branches. I was almost knocked out of the sky by the trees. The trees came up so unexpectedly. What I know for sure is that she'll be here soon; most likely today. And with that sense of danger, we'd better be on the lookout for her, in case she needs our help."

By now Sara was out of bed and heading to the bathroom.

"Jam, I'm going to get dressed and go downstairs and tell Dad and Steven. Then I'll head out and tell Lucinda. She can inform the boys. We can discuss everything later at school the first chance we get."

"Agreed."

They clicked off.

No one was down yet when Sara got to the kitchen. She turned the coffee on, threw some boxes of cereal on the table, put on her coat and ran out back. She had to tell Lucinda immediately and then she'd come back in and tell her dad and Steven over a quick breakfast.

"Lucinda, open up. I've got news."

"What is up?" Lucinda sounded groggy, too. "Wow, look at this snow! It is snowing," she said as she stepped out. "I have read about snow, quite recently, but I have never seen it! I feel a poem coming on just watching it." She stepped outside and twirled around. "Cold! Beautiful!"

"Forget the poem, it's cold, I'll come inside a minute. And you'll need your coat and one of those sweaters I gave you when you come out again, and a hat and scarf."

"Yikes, and my boots!" Lucinda was barefoot and hopping back and forth now.

They both went inside. The fire was almost out and Lucinda quickly got it going again. "I had to get up and stoke it twice last night," she explained. "I guess the temperature really dropped. I will come over to your place after breakfast."

"Maybe you should consider moving in with us for the winter." Sara realized that this was the only thing that made sense. "Your baby will be here soon."

"You might be right. I do not think I really knew what cold felt like. I cannot risk the fire going out during the night with the baby here," and she patted her pod, now large, warm and getting close to birth time.

"Thank goodness you agree. Listen, I've got some big news."

"What?"

"Jam had one of her dreams, the kind that tells her stuff."

"A lucid dream?"

"Yes." And Sara told her.

"That is fantastic! Then this could be it. I will tell the boys as soon as I get dressed. We'll keep a lookout for Owletta all day. I hope she is not hurt or lost in the snow."

"Me too—that's what worries me."

"I hope the weather doesn't get worse. I will have to leave most of the scouting up to the boys. I cannot risk the baby's pod outside in the cold to that much exposure. But I will check with the boys frequently and keep my fire going. If Owletta returns, she will come here first."

"Okay, and wear your hat over the pod. I'm going to tell Dad and Steven and then I have to go to school. Even though it's snowing, school isn't cancelled."

"Okay, Sara. I will keep you updated and see you later."

Sara gave Lucinda a little hug. "Your pod looks pretty plump," she teased.

"Yup, it is getting close."

Sara slipped back out and returned to the kitchen. Steven and Dr. Umberland were already there, eating cereal.

"I saw you outside," said Dr. Umberland. "How's Lucinda? Does she love the snow?"

"Yup, but I have something more important to talk about."

"Make it quick," said Steven. "I've got to get out of here. I've got an exam in Spanish this morning."

Sara told them the dream.

"Well," said Steven, "this will show us if these dreams of hers are for real."

"I think they are," said Sara. "I have a strong feeling about this."

"I'll check in from the lab later today, after school," said Dr. Umberland. "And call me if Owletta shows up!"

"I will."

"I'll come straight back after school," said Steven. "I can help keep a look out with Lynn."

"Thanks! Let's hope this is it. What we've been waiting for."

With that, the family put their cereal bowls in the sink, and headed out.

Owletta and Hool got off the train in Newark, New Jersey, and rose up into the falling snow. It was cold. Now that they knew how to ride trains, it made sense for them to use one for the trip back. So they chose a train that got them as close to their

destination as they were able to figure out: Newark Station. They were on the last stretch, almost back to Sara's.

Owletta's new home would be at the glowing beechnut tree with Hool. She loved it there and had met with the vinetropes two more times after the initial meeting. Ekle and Apkin would live in the Glowing Tree too with Selena and Regata. But first they must bring the amazing news to Lucinda. A vinetrope city was waiting for their Master Rhymer. And then they must bring her back. They'd find a way; maybe they would have to use a human car idea after all.

The trip up had been fine. They had found a compartment to use and the ride had been fairly comfortable. Now they circled out over the tracks and Owletta got her bearings. The brown earth was covered in snow, like an endless layer of chocolate cake frosted in endless white frosting. The snow was light as they took to the air, but it began to fall harder and the flakes became large as they headed west, toward Pinewood.

How annoying, thought Owletta; her trip down had nearly killed her, but coming back had seemed a breeze till the last minute. Now they had to make the last miles in this cold and wet misery. She would be very happy to be living in a milder climate by next winter! Poor Hool wasn't used to this kind of weather at all.

"This is abominable, horrrendous!" said Hool, flying next to Owletta with difficulty in the cold gusty air. "How do you stand living like this?"

"Many owls do, my dear. You've just not had to, but you could. You'll see, once we settle in my old nest, you'll be fine. Anyway, it's only a temporary stay."

"I still say it's cold and miserrable."

"It is. I normally wouldn't be out in this weather. But we should just make the best of it, and I think we'll be there soon."

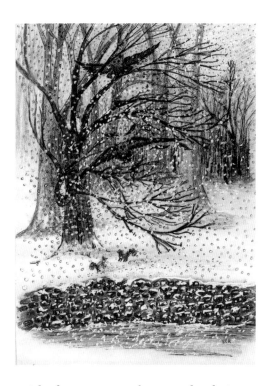

It was mid-afternoon as they made their way over the suburban landscape. The snow was really heavy now. They passed over a school sports field and a patch of woods. Owletta knew they were close. They had to be almost there. She just needed to get in closer for a better look, for the snow was obscuring her vision. She tipped her wing and they dived down. Before they knew it they were crashing through the top branches of a tree.

"Ouch," screeched Owletta, breaking through the top branches. She grabbed on to the first branch she could catch and came to a sudden stop. Hool kept scrambling and tumbling and grabbing, one branch and then another until he landed with a plop in a drift of snow.

"Oh my goodness, are you okay?" Owletta called down. She was fine and quickly made her way to Hool. He was up to his waist in a snowdrift, his wings sunken into the whiteness at each side, his talons sticking out in front.

"That *rr*eally hurt. This *rr*otten snow of yours b*rr*oke my fall, but I'm not happy, I can tell you that!"

"But you're okay? Let me see." She circled around him as he stood up, ruffled his feathers and grumbled and complained, flapping the snow off.

"Owletta! Is that you?" yelled a familiar voice.

"What?" She turned around. It was Lucinda, with Ekle and Apkin right behind. They had fallen right into Sara's backyard.

"Owletta, it *is* you!" Lucinda called out with excitement.

"Lucinda!" They embraced. Ekle and Apkin approached happily.

"You're back, you're alive, we were so worried," said Ekle.

"We were afraid you died," said Apkin, more bluntly. "Did you find our mates, and who's this owl?" Apkin never missed a thing.

"I've found your mates, I've found the vinetropes and this is my fiancé, Hool Beecham!"

"Yippee!" said Apkin.

"What?" asked Ekle.

"Oh my goodness," said Lucinda, dropping, with relief, to her knees in the snow. It reached her waist and Owletta helped her up.

"Better not do that again," warned Apkin, having some trouble in the snow himself.

"So much good news," said Ekle, wagging his tail like a dog and sinking and jumping in and out of a snow drift.

"It's all too much," said Apkin, getting dramatic once again. "My sweetheart, I'm coming!"

"There are other vinetropes, for real?" cried Lucinda.

"Yes, my dear, a whole city of them, two hundred and three to be exact, and they're all waiting for their missing member, their Historian, Glower and Master Rhymer—in a word, Lucinda, you."

"Oh Owletta, thank you, you've accomplished it all. Are you okay? Is your friend, your fiancé okay? Did I hear right?"

"I *rrealize* you are all very excited, and this is a wonderful *rreunion*, but would it be too much to ask to get out of this mise*rrable* mess?" were Hool's first words.

"Hool's a bit nicked and scratched and not too pleased," Owletta explained. "We kind of crashed through this tree. But yes, he is my fiancé. We took a train most of the way back, which was quite pleasant, but the flight from the station to back here got pretty rough." Owletta was rambling.

"A train?" said Lucinda. There was obviously a lot to learn.

"Please, eve*rry*one! I may not be dead," said Hool, still shaking the snow off, "but I'm wet, cold and tired. Hung*rry* too. And although I'm delighted to meet you, Lucinda, boys, could we please continue this conversation in drier and warmer su*rrr*oundings?"

"Yes, yes, of course," agreed Lucinda. "What is wrong with me? Let us head straight back to my place. You must be exhausted, flying in this weather, follow me."

They trudged and flew the short distance in the snow and arrived at Lucinda's home. Everyone eagerly entered. The room was nice and warm. Lucinda had kept the fire going all day. A pot of herbed broth was simmering and the room smelt wonderful. Everyone settled in: the boys went right to the table, hoping for food, and the owls perched on the water pipe in front of the crackling fire to warm their feathers.

"Welcome to my home, Mr. Hool Beecham," said Lucinda. "I am delighted to have you here. If Owletta loves you, I love you too."

"We need not go that fa*rr*!" said Hool, in his formal way, shivering a bit and still not that sociable. "I would never expect such total acceptance in such a sho*rr*t time."

"He's right," said Apkin. "What if Owletta has completely lost her head to love and he's really a rat!"

"Well, I wouldn't go that fa*rr* either," said Hool, a bit affronted.

Then everyone had a good laugh and that made them feel more relaxed, especially Apkin. If Hool could laugh like that, he was probably a good enough fellow.

"I can't wait to hear everything," Lucinda insisted. "Please tell me about my vinetrope people."

So while Lucinda ladled some nourishing broth into mugs for all her guests, Owletta and Hool told her as much as they could about the vinetropes and their beautiful city beneath the surface of the ground; how the ground itself was radiant with health; how their remarkable root system and nourishing water system seemed to heal the earth and even saved the beechnut tree in which Hool lived and where Owletta had found him. Owletta assured Apkin and Ekle of their mates' safety, health and loyalty and the joy they had in knowing that their boys would be with them soon. There was so much more to tell, but the owls were starting to fade.

"Tell me, Lucinda," Owletta asked, yawning wide and shifting her body at the table, her back to the fire. "I'm puzzled. How is it you were out in the snow as we arrived, as if you were waiting for us?"

"We were. We knew you were coming."

"You knew?"

Hool, who had begun to fall asleep, opened his eyes. "You knew we were coming at this very moment?"

"Yes, well, we knew it would be today some time, so we were keeping a lookout." Lucinda then told the owls about Jamuna and after that about Steven and Dr. Umberland.

"So they know? They know everything?" asked Owletta. So much had happened in her absence.

"This is all unne*rr*ving and unexpected," said Hool, getting irritable again. "I was just adapting to the *rrash* idea of meeting Sara and now I have to meet three more humans?" Then his eyes drooped shut.

"Four. You have to count Lynn," whispered Ekle, who had grown fond of her.

"My dear friends," said Owletta, "I can't keep my eyes open a moment longer. I'm actually feeling a bit dizzy." She turned to Hool to see how he was doing and he was already asleep.

"Sleep, Owletta," said Lucinda. "When you get some rest we will discuss more. Then I will explain to you all about my new friends and how they will help us. We will need to share everything with them as well. But for now, just sleep."

The two sleeping owls, nestled together, looked like a heap of breathing feathers.

Lucinda was ecstatic. A vinetrope city in the making and she was needed. She could hardly contain her excitement and curiosity, but she would have to. By now, Ekle and Apkin had curled up near the fire.

"Might as well take a nap," said Apkin. "It'll be boring until the owls wake up."

Ekle rolled his eyes at his brother's rude comment and then rolled them shut. The excitement and day's scouting had obviously tired them out too.

And Lucinda then realized, she hadn't even told Owletta about her baby, her baby Glower, almost ready to be born!

"Lucinda," called Sara, knocking on the slate door, her hat pulled over her ears and her gloves sprinkled with snow. It was still snowing. The afternoon session had been cancelled because of the weather and she was home early, but the school bus had taken forever getting everyone home safely and everyone, including the bus driver, was mad they hadn't just decided to cancel that morning.

Lucinda peeked out with a finger to her lips.

"They are here!" she whispered. "Owletta and her fiancé! I am not kidding, a fiancé. She has also found my people, Sara, and the boys' mates, and herself a Mr. Hool Beecham from Haw River."

"That's fantastic! Lucinda, she did it! And she's engaged to be married? Owls get married?"

"Yes, to everything, at least for these two owls. Take a peek, but let them sleep. They are exhausted; the boys too, they were out in the snow all day. I am just too wound up for sleep."

Sara poked her head in. She saw the pile of breathing feathers. Then Lucinda stepped out, with a blanket around her shoulders and gave Sara a quick breakdown of what the owls had conveyed.

"Okay, Lucinda, I'll let everyone know. When they wake up later, just come over."

Sara called her dad and Steven and Jam got permission for a sleepover. She got her stuff together right away and walked the block to Sara's in her new snow boots. Sara met her halfway. The two girls were excited and shared their enthusiasm.

"Your dream worked this time, Jam!" Sara congratulated her.

Jam's face lit up. "I know, it really did, didn't it!" She adjusted her duffel bag over her shoulder and grinned. "What do Steven and your dad think about it?"

"If any of us had doubts before, we don't now!" Sara assured her.

The girls hooked arms, crossed the street and trudged through Sara's yard.

By late afternoon the boys were up and kept themselves busy playing games like stack the acorn caps and guessing how many mixed nuts (from Sara) were in the jar. The reward, for whoever guessed the closest, was a fancy nut. It had been dark for a while when the owls woke up, stiff and hungry. Lucinda gave them each a bowl of thick soup and sprinkled ant eggs over the top.

"This is delicious," Hool acknowledged.

"Scrumptious," said Owletta. "I forgot what a good cook you are. You seem to know how to make food that appears human-like and yet is perfectly seasoned for owls."

"Vinet*rr*opes are good at that sort of thing," said Hool. "Just think of that Moonglad feast! But this is delicious," confirmed Hool.

"Thank you. Speaking of humans, we will head over to Sara's soon. But first, I have something else exciting to share. You see this pod, growing in my hair?"

"Yes!" said Owletta and Hool simultaneously, lifting their heads in unison.

"You're having a baby!" exclaimed Owletta.

"And it's a Glower, I can tell by the light glow," confirmed Hool. "I guess we were too tired to notice."

"Congratulations, my dear Lucinda!" And Owletta leaned over and gave Lucinda a gentle peck with her beak, an owl's kiss.

"I've learned a lot about vinetrope life," explained Owletta, "but I thought all Glowers were born full size."

Lucinda then explained the rare facts of tiny Glowers.

"Extraordina*rr*y!" said Hool. "That will be news to all the vinetropes in Vinet*rr*opland!"

"And good news!" said Owletta, tapping her Hool on his shoulder.

Apkin was trying to ladle some soup into his bowl and having trouble. Ekle was popping a walnut into his mouth. He had won the guessing contest. Then, noticing, Apkin helped himself to a walnut and threw it in his soup.

"Hey! That's not fair," said Ekle. "At least wait awhile so it feels special to have won it!"

"Let us stop all the arguing," Lucinda raised her arms in her gentle but commanding way, like a patient mother. "We need to gather ourselves together and head over to Sara's. There is a lot to talk about!"

It was dark and lightly snowing as the little group made its way to Sara's back door. The owls were apprehensive, but there was no choice. Meet humans, they must!

Lucinda rang the bell to announce their arrival, but then she showed her friends the door flap and they all filed in.

"Welcome!" the group heard on entering. Everyone was standing right there, anxious to meet Owletta and her soon-to-be husband, Hool.

In short, introductions were made and Ekle and Apkin ran around, excited and happy, making themselves at home as usual. Then, this most unusual crowd made its way into the living room where another much larger fire was burning in an even larger fireplace. The coffee table was already laid with refreshments and a little pillow for Lucinda. Everyone found a place to sit: Steven and Dr. Umberland on the two-seater, Sara, Jam and Lynn on the large couch, Ekle and Apkin took the velvet chair they admired so much and Lucinda sat on the pillow on the coffee table, between the biscuits and the teapot. Owletta and Hool perched on a small bench that stood in front of the fireplace, facing everyone, with their backs to the fire, a spot they seemed to favor.

Friendly introductions continued for a time and observations and compliments were made. There was a tinkling of china, the munching of biscuits, chocolate chip cookies and nuts and the sipping of tea. Then they began to really talk.

Everything had to be explained again, right from the beginning so that everyone was up to date on everything... nothing left out. And it had to be told from all sides. Owletta went first and told them about her near death from the cat bite and her rescue in the seagull ambulance.

"I might have been back here a month earlier, if that hadn't happened!"

She ended her story with a detailed description of Vine-tropeland. Hool helped with that, telling some of his own history and adding many more details about vinetrope life and what had been discussed at the Councils, including the last three that they both had attended.

Lucinda had to tell the owls about what had happened with Mr. Hawk, and that she had had two babies originally. The retelling of her loss caused her some sadness. This led to more discussions on vinetrope biology (well botany really) and Dr. Umberland had a number of more pointed questions. He explained the work he was already doing with the vinetrope water. He felt sure it would lead to a number of breakthroughs. Lucinda suggested she give him a sample of the liquid she would soon be feeding her baby with. It was even more potent, a purer form of the energy, and extremely nutritious as well.

"No wonder we feel so much better," said Hool. "I'm not even stiff after that nasty fall." The base ingredient in their soup was vinetrope water.

Apkin and Ekle added their notes to the history of what had happened, explaining how Lucinda's seed had been stuck in Ekle's paw for several days, on the way up and after they had escaped the barrel and made home here in Sara's backyard. And Jam had a chance to share about herself and her dreams. Steven told the tale of Halloween night and everyone had a laugh. Lynn was embarrassed at how much she had blanked out, but everyone made her feel comfortable. They all shared things about themselves, what they liked and what they hoped for and how they felt about this strange adventure they had all been thrust into.

Now that they all knew where they stood, they needed to discuss the chargons and vinkali.

"Therre has been no sign of them that we have seen," Hool assured his new friends.

"And we both asked a lot of questions," Owletta confirmed.

"Chantrroute has never told me the whole historry of how he and the others arrrived," Hool picked up, stopping a moment to wet his beak. "He said that therre was some kind of hollow stones that their seeds had been sealed in. That they had been tossed in someone's garrden and brroken open."

"Hmm, maybe a geode?" Dr. Umberland suggested.

"Yes, that is possible," Lucinda agreed. "My memory shows them sealed in an odd-shaped rock, like a stone egg. The seeds would last a long time with the right sealer in the right climate in a pod made of stone!"

"Yes, it would be a good choice," agreed Dr. Umberland.

Hool stretched his wings, carefully, and continued. "He told me he sprrouted, fully grrown like you Lucinda, and then he collected as many of the seeds as he could and brrought them to a safe place wherre he could plant them and take carre of them."

"And a city was begun!" Lucinda made her flourish with her arms.

"How many seeds did he have?" Dr. Umberland asked, beginning to yawn despite the importance of the conversation.

"Well, much of what was left was dust and damaged seeds. Chantrroute said that the drried out seeds and dust just blew away and many of the stones werre empty. But he saved more than 100 good seeds, taking his time. He was the only Glower, so you can imagine how much worrk it took."

"Yes, it is a credit to him that he succeeded all alone." Lucinda was impressed and thankful for his devotion.

"The babies grew way fasterr than he had expected, so in a few months he had help and together they planted morre

seeds. He said he had a chance for four la*rr*ge plantings over the two yea*rr*s since he first sp*rr*outed."

"I wonder if the whole process of vinetrope development has been sped up in some way?" Dr. Umberland thought out loud.

"It's possible," Lucinda was nodding. "This baby of mine is a rare footnote to our history. I only have one other example of it ever happening, back in the earliest records I can reach. Maybe something has allowed for us to finally return in full force. And it has sped up the process in the beginning to make it possible for us to return?"

"Because the world needs vinetropes!" Apkin concluded with certainty and cracked a pecan with his teeth.

Sara put down the cup of tea she had been holding. "But the world doesn't need chargons and vinkali!"

"That's for sure," said Jam, pulling all her shiny hair to one side.

"And they are plants too?" asked Sara, not sure if this had ever been discussed.

Lucinda got a puzzled look on her face. "Hmmm. I guess I assumed so. But as I think about it, go through my information files; they don't exactly fit the definition."

"They don't?" Dr. Umberland questioned. "Then what definition do they fit?"

"Let me think," Lucinda lifted her arms and then folded them across her chest.

Everyone put their teacups down and waited.

"I'm checking everything I have on file that I recently learned, studying on the computer." She got a surprised look on her face. "I know what they are. At least I am pretty sure. I believe they are a form of intelligent fungus!"

"What's a fungus?" asked Ekle.

"It doesn't sound good," added Apkin.

"A fungus comes from spores, not seeds," Dr. Umberland stated, his palms up. "Fungi are not plants. But actually, they are an important part of the botanical makeup of our world. They are as necessary to earth as plants."

"So they don't have to be bad?" questioned Steven.

"There is bad and good in all living beings," Lucinda reminded them. "But take my word for it, the chargons and vinkali were bad."

"They would likely need a moist environment to germinate, to grow successfully," Dr. Umberland was still adding to the facts about fungi. "Fungi have a complex network spread under the earth, just like the roots of plants. Plants and fungi actually have a joint relationship. In a sense they need each other. "

"Well, they certainly needed us. Or used us, I should say. I do not know anything about this useful relationship you speak of." Lucinda sounded annoyed at the idea. "I will need to study this. But what you say about *a moist environment* does make sense. The chargons always took us back to their homes and they always lived in a swamp."

"Well," said Hool, stretching his wings and yawning with his beak wide. "I think we will have to wait till Lucinda and Chantrroute meet and can talk to each other beforre we can get all the answers we want."

And that brought them to the final discussion of the evening. That they would leave for North Carolina—as they had already planned before Owletta had returned—over the winter break.

"That's wonderrful news!" Hool screeched. "I only have to stay in this miserrable climate for anotherr two weeks!"

"I'd love to come along, too," said Jam.

"You're more than welcome to come," said Dr. Umberland, "as long as you get your parents' permission."

"We don't have plans to go anywhere this year," said Jam, "we're Hindu so it's not really a religious time for us. But it is family time, and we have a family New Year's party. Still, my parents are really happy about my friendship with Sara, so I think they would be okay with me coming along. I'll try and convince them it's also educational. They're always obsessed with my education."

"Ask them!" Sara was excited at the prospect of her friend joining.

"But leave out the vinetrope part," Ekle added.

They laughed.

"Even though vinetropes are very educational," added Apkin.

They laughed again.

"And prrobably don't mention us talking owls either," added Hool.

They were all getting silly and exhausted and the evening had to come to an end soon.

"I know I won't be coming," said Lynn glumly. "My parents wouldn't let me go on a week's trip with my boyfriend and his family. I'm going to really hate to miss this."

"We'll tell you every detail," promised Jam.

"And none of us humans can go into the vinetrope city but Sara, anyway," reminded Jam.

"So we're *all* going to hear about what happens in Vinetropeland second-hand," noted Steven.

By now it was nearly midnight. They had covered a lot of material and the major decision had been made. They would leave on December 26th, the day after Christmas, early in the morning. With this decided, Steven had to take Lynn home. The snow had stopped and the snowploughs could be heard in the distance.

The next morning it was decided they would get a Christmas tree, and later Lynn would join them and they would make a gingerbread house.

Shopping for the tree was hysterically funny. Owletta and Hool followed the car overhead from tree to telephone pole until they reached the Christmas tree lot. The squirrels and Lucinda had their first ride in the car. Ekle and Apkin sat on the floor, in the back, at Jam and Sara's feet and Steven sat in front with his dad. Lucinda sat on Sara's lap, tucked under the safety strap.

When they arrived, Ekle and Apkin jumped out, ran into the lot and hid between the Christmas trees. They got out and Dr. Umberland said hello to Mr. Willard, who sold the trees, and chatted with him a bit. Lucinda was safe inside Jam's large and stylish tote bag. By the time they made it into the lot to look at the trees, Ekle and Apkin had picked out six.

"These are the only trees worth getting," said Ekle.

"My brother's right," Apkin confirmed. "These others are ready to fall apart! They're too old."

"Are you sure?" said Steven, skeptically. "This looks like a great one." He gave it a shake and a circle of needles appeared around the tree and on his boots.

"Well, only these six have passed our test!" Ekle was firm and Apkin backed him up.

"What's the test?" asked Dr. Umberland.

"We run up and down the trunks as fast as we can." Ekle pointed at the trunk of the Steven's chosen tree.

"And then we chase each other like mad," Apkin added.

"And bounce a lot," Ekle bobbed up and down on his hind feet.

Jam and Sara were laughing.

"It's a good test," Dr. Umberland had to admit.

But two of the six trees were perfect, the right size and height and a good shape, so a tree was chosen from the boys' selection. Owletta and Hool agreed it was a wonderful tree. Everyone was happy. This was another first—the Umberlands' tree had been chosen by two squirrels. Back home, Steven and Dr. Umberland got the tree in the house and into its stand. That's as far as they were going to get with the tree today if they also wanted to make a gingerbread house.

Steven and Dr. Umberland weren't that interested in building the gingerbread house, so the project fell to Sara, Jam, Lucinda and Lynn, who had just arrived. The squirrel boys said they would watch and offer advice, but they really didn't get the whole idea. Owletta and Hool were still recuperating and had decided to retire to their nest.

The "architects" gathered in the kitchen to make the gingerbread house. Three hours later, they had the fresh baked pieces ready to assemble. Sara used her mom's pattern to cut them out. They then made a gigantic bowl of egg white frosting to glue everything together, also a recipe from her mom. In her own handwriting her mom had noted that "the amount of egg whites and powdered sugar sometimes varied and you just needed to get a feel for the right stiffness each time". Lynn said she would start putting the chimney together, so that it would be ready to frost in place on top of the finished roof. Jam was getting candy, boxed cookies and ice-cream cones out of the pantry and into bowls in preparation for decorating the assembled house.

Sara noted that the gingerbread felt softer than she had remembered when she used to put the houses together with her mom.

"Don't worry," said Jam. "I've made a ton of frosting. It should hold everything together."

"I am so excited to be doing this," said Lucinda as she pranced around the bowls of decorating materials, the baby pod making her head tilt toward her right shoulder.

"This is a very clever idea. I can just imagine how it will look when it is done. I've seen pictures of gingerbread houses online. It is such a lovely idea. The decorating is going to be the most fun. Why, it makes me think of a poem," she said.

> *"We are making a house of*
> *Cookies and cream,*
> *We want it to look like a*
> *Lodge for a Queen.*
>
> *We'll use ice-cream cones*
> *To make shrubs in a scene*
> *And frost them points up*
> *With sugars bright green.*
>
> *We will whip up the cold*
> *With frosting so light*
> *It will be the North Pole*
> *With drifts high and white.*
>
> *Then on go the cookies*
> *The candies and chips*
> *Keep the squirrels away*
> *So they won't dip and nip.*
>
> *Or they'll eat the whole project*
> *And shock poor St. Nick!"*

Everyone laughed, even Ekle and Apkin.

"It's a good idea to keep an eye on us," agreed Apkin. "We

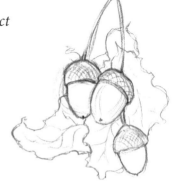

just might dip and nip." That comment made everyone laugh even harder.

"It would be even prettier if you used nuts and seeds for everything," said Ekle, "instead of these sharp candies." He pointed to the peppermint pillows and several looked sticky.

All the laughing and commotion brought Steven and Dr. Umberland back into the kitchen and they had to hear the poem again as well as what Apkin had said, so they could all laugh some more. Then it was time to assemble the house and everyone stood around while Sara and Lucinda attempted to put it together.

Lucinda leaned against one side of the house on her knees, with her arms stretching around to hold the three walls up. Sara frosted and placed the fourth wall into position and Lucinda continued to hold the three while Sara held the fourth.

"Okay, I think you can let go now," said Lynn.

Lucinda stood up on the table, her feet a gooey white mess. The cookie walls seemed to be holding.

"I hope the gingerbread isn't too fresh and soft," Sara repeated her concerns.

"Let's get the roof up now," instructed Jam.

The girls each frosted the edges of two large rectangular gingerbread pieces and put them in place on top of the house. It looked good for one second and then the two pieces of roof began to slide off, causing the walls to become unsteady.

"Yikes! Avalanche!" shouted Lucinda.

"This is getting more interesting," said Ekle.

"I can lie on the roof and hold the pieces together with my front feet and back feet," suggested Apkin. He got ready to climb on, stepping into the splattered frosting already spreading on the table.

"No, Apkin, get off, and get the roof off, the whole house is coming apart!" shouted Sara.

"This frosting is definitely not thick enough," said Lynn. "I'm having trouble getting this little chimney together. I think it needed more egg whites."

Dr. Umberland and Steven were laughing and very amused by the whole thing.

Jam had stopped what she was doing and had an odd look on her face.

Sara and Lucinda each pulled off their piece of roof and quickly pressed the walls together again. Lucinda took up her kneeling position on one side, and Sara held the fourth side firm with both hands. They held for about thirty seconds, then Lucinda carefully let go and stood up.

"The walls seem to be holding," said Sara, hopefully. On went the roof. Then, slowly but surely, the roof began to slide again and take down the house.

"It's happening!" said Jam.

"I know, it's so annoying, the frosting is too thin and the gingerbread too soft!" said Sara in frustration.

"No!" said Jam. " NOT the house. Look! I think Lucinda is having her baby!"

Lucinda sat down on the table with her back to the pile of gingerbread pieces, her feet straight out, and her hands in her hair. The baby-pod was huge, about the size of a large pea pod. Many additional vines had grown into the wobbly vegetable to give it support as it gained weight and gave the baby water and nourishment. As the family looked on, the pod began to tremble and give off a brightening glow.

"Get Owletta and Hool," shouted Apkin. So Ekle used the pet door and ran out back.

In no time the owls were gathered around the table as well.

"It *is* time!" Lucinda called out. "Jam is right. I can feel the baby kicking hard."

"Does it hurt?" worried Sara, who had heard stories about how painful the birthing process could be for women.

"Not at all, it just feels strange and exciting. Ouch! Well that hurt a little."

Then it happened. The pod began to split open as the baby's feet kicked against its walls, first at the top and then in the middle. There was a light ripping sound, like a piece of paper being torn in half, and then the pod gave way completely and split open down the middle. Lucinda reached up with both hands and grasped the tiny body firmly. It was wet and slippery inside the pod, and with a twist and a snap the baby came off her vine. In a moment Lucinda held her baby in her arms and it was a girl! A tiny Glower girl. She was damp, but sparkling clean, like she'd just had a bath and was not quite yet dry. Everyone gasped and said, "Aw!" and, "how cute!" and, "this is so amazing".

"What a sweet little perfect vinetrope you are!" said Lucinda to her daughter whom she examined from head to toe. "You are beautiful."

Her newborn answered her mother by sending out a pulsing glow.

"And you're a Glower for sure!" continued Lucinda.

"She's beautiful, Lucinda," said Sara. "And look at her teeny, tiny, minuscule dress! It's perfect."

The baby's dress resembled Lucinda's birth dress, but styled and proportioned for the tiny body.

"I love her!" said Apkin.

"Me too," added Ekle, not wanting to be outdone by his brother.

Steven and Lynn and Dr. Umberland bent in to get better looks and give their congratulations.

Lynn sighed, "She's so cute it's unbearable" and Steven smiled and nodded.

"What will you name her?" asked Jam.

"I will name her Saralinda Vinetrope after my best friend in the world."

"After me?" said Sara, exultant.

"Yes, of course."

Everyone applauded at the name and many more hugs and congratulations were said. Sara felt very emotional. Saralinda made a tiny squealing sound and Lucinda instinctively reached for her watering vine and placed the end of it in her newborn's mouth. The baby began to suck. Sara went to the coat closet and found a soft flannel scarf, blue plaid, and came back to the kitchen and cut it into a tiny square.

"Here, Lucinda, you can use this for a first blanket."

"Thank you, Sara." She carefully folded the baby in the scarf, papoose style, while she continued to nurse. Saralinda fed for a few more seconds and then fell asleep. Everyone watched with awe and affection.

"I will remember this for the rest of my life," said Lucinda. And everyone agreed.

"I want babies, too," acknowledged Apkin.

"We'll have families of our own when we reunite with our mates!" Ekle decided.

"I have a poem to share with everyone," Lucinda declared.

"Please, please!" said everyone in unison. "Tell us," encouraged Sara.

"Okay," said Lucinda.

"I've been tired and moody
And I think we know why,
One minute I'm happy,
The next I might cry.
Sometimes I don't know
Who it is I'm to be
Then I chuckle and laugh
Well of course, I'll be me!
All around I see change,
New events seem to burst,
For knowledge and answers
My mind has a thirst.
Then just when I have it
It speeds by way too fast,
Why can't the old ways
Continue and last?
Well, life makes us change
With the birth of a child, yet
We need to keep growing
And accept a new style.
But some things stay constant
Like my friendship with you,
Have faith in me friends
Let us always stay true.
Will you please stay yourselves
While you grow and you change?
And I promise you, friends,
I will do just the same."

Sara gave Lucinda a big gentle hug with tips of her hands.
"I feel just like that, just like the poem."
"I'm sure we all do," said Dr. Umberland.

"I am afraid of all the changes ahead," said Lucinda. "I cannot even bear the thought of saying goodbye to you, my human family, especially you Sara."

Sara felt the tears rise in her eyes.

"But when I am returned to my people, you must realize, we will have to part ways, at least for a time, while I establish myself with them and help them grow and succeed and defend themselves against any threats or dangers. It is also exciting, wondering what lies ahead, the mystery and adventure of all our lives, separately and together. And we will come together again. These new events in the world are a mystery but they will make themselves clearer as we live each day."

"It will be terribly sad when we part ways," said Sara.

Lucinda was teary-eyed too. Everyone looked sad and thoughtful in the middle of their happiness; a bit of grief mixed with the joy of new life.

"We will come together in the future to meet any challenges thrown at us." Lucinda rocked her baby and spoke to each of them.

"Dr. Umberland, you will have extremely important work ahead of you in your lab. You will begin the process of unraveling some of the mysteries of vinetrope energy. Jam, you must keep us informed of all your vivid dreams. You know we will believe you and take you seriously. Lynn and Steven, you must stay alert for any talk of odd environmental changes that may indicate vinetropes or other new kinds of beings are appearing in the world. Keep a lookout on the Internet and on TV. Vinetropes may be reappearing elsewhere. We do not really know. You can be like our intelligence team. Of course, Ekle and Apkin and Owletta and Hool will be coming with me, working with the vinetropes every day."

Owletta and Hool and the boys nodded in agreement.

"We're so lucky," said Ekle.

"I'm going home!" said Apkin. "That's not sad. But we'll be sad to say goodbye to our human friends," he added.

Lynn scratched Apkin's ears and Steven pet Ekle's back.

"Especially you, Sara," continued Ekle. Sara kissed the top of his head.

"And Sara," continued Lucinda, "your help may be the most demanding of all. You have the gift of understanding and you can bring that understanding to everyone, to all species, even those that seem the most unapproachable and threatening."

"But how can you know that?"

"I just do."

"I can't let my daughter become involved in anything that will be outright dangerous," spoke Dr. Umberland, showing alarm for the first time.

"We don't know what obstacles there may be," answered Lucinda. "My people may be able to develop unseen and while we do, we can secretly offer your people all kinds of useful tools. And we will learn so much from human creativity. I have already learned so much! I can lead my people into a technological future that will be fantastic and wonderful. It has the potential to keep us invisible from your world. I think we can program roots to send up a force field around our city! That will allow us to be safe and helpful." Lucinda was cradling Saralinda and watching her sleep while she finished what she wanted to say.

"Things could proceed smoothly and peacefully, but they may not. Other beings from our vinetrope past may emerge, like chargons. I cannot promise anything for sure, Dr. Umberland."

"I know you can't," said Dr. Umberland, "and I'll do every-

thing to protect you, to bring you to your people, but I can't allow my daughter to be put in harm's way. For some reason this is just sinking in."

"Let's not worry about this now," Lucinda backed off. "We have other things to achieve first and there have been no signs of chargons in two years."

Hool nodded. "That, as I've told you, is true."

"That's a good sign isn't it?," added Sara, pushing her hair back nervously.

"I agree," said Dr. Umberland. "Let's not spoil this lovely day."

All the while they spoke on these more serious matters, little Saralinda slept peacefully in Lucinda's arms. The December afternoon was pleasant, the temperature had risen to over freezing and the snow was melting.

"I think I'll return to my own home and take a little rest there, with my Saralinda," said Lucinda, rocking her baby softly to and fro. "We'll come back later, I promise, if the night turns cold, but it will be lovely to have her all to myself in a vinetrope home."

Sara understood and nodded with a wistful smile. Lucinda was not hers alone, not anymore, and soon she would belong to the whole vinetrope world.

"I'll walk you back," and Sara got up. Lucinda reached for her with her free arm and Sara lifted her and Saralinda into hers.

Once inside Lucinda's home, Lucinda handed Saralinda to Sara, still wrapped in the doll blanket and asked Sara to stay for a minute.

"I just want a few quiet moments with you, Sara."

Lucinda fussed with a few things while Sara sat at the table with Saralinda cradled in her arm.

"I need to make a bed for Saralinda. It will not take long."

By removing a few stones from her bed, she created a crib-like indentation in the stone mattress. She then placed some dried grass into the opening and, taking Saralinda from Sara, she tucked her baby safely into this vinetrope bassinet. Sara added a small log and some sticks to the pile in the fireplace and rekindled the fire, while Lucinda wrapped herself in a blanket. She was feeling very tired by now, so she curled up near her child. Saralinda woke hungry, making her tiny crying noises. This tiny being looked older already, more alert, and she reached right out with her hands for her mother. Lucinda lifted her into her arms and the baby grabbed the feeding vine and put it right into her mouth!

"She's older already!" Sara was alarmed, it seemed so impossible.

"She is," affirmed Lucinda, with a bit of sadness in her voice.

"And you look older too," observed Sara.

Lucinda no longer looked like a teenager. She looked and sounded like a young woman.

"Sara, will you stay," asked Lucinda, "just till I fall asleep?"

"Of course. I don't get you to myself much anymore."

Sara returned to her family. But she had new worries, ones she hadn't yet shared with Lucinda. Her father had changed his tone during that last conversation. He suddenly was fearful about everything, especially her involvement with Lucinda and the world of vinetropes. She hoped this change in his tone wouldn't be one of those unforeseen obstacles Lucinda had been talking about!

13

JOURNEY TO HAW RIVER

t was Christmas Eve. They would be leaving for the Haw River the day after Christmas, in two mornings! Jam was able to join them; her parents had agreed. Lynn was right about her parents, she wouldn't be coming. Her parents gave her an unequivocal "No!"

The Umberlands, Lucinda and Saralinda, the boys and the owls would share Christmas morning together. In the afternoon, Jam and Lynn would come over for a Christmas lunch and then Lynn would go home. Jam would bring her duffel bag packed for the trip and sleepover.

It was evening, the tree was lit, and everyone was settled comfortably in the living room. A warm bowl of spiced fruit punch was on the coffee table, mixed nuts and seeds sat in bowls, and grapes and sweet oranges lay invitingly in a wide dish. Of course there was a platter of chocolate chip cookies and also some shortbread. Sara had made it from her mom's book of family recipes. A lidded tub of dried fish food was included on the festive table for the owls' enjoyment. Lucinda had watered the fish food with her vinetrope water and then re-dried it to make it the perfect food for Owletta and Hool. Everyone had mugs of punch, in a variety of sizes to suit each member of the family.

Sara had hung stockings on the fireplace for Lucinda, Saralinda, the boys, Owletta and Hool. Stockings for her dad,

Steven and herself were up too. Her mom had made them for the family years ago with their names embroidered on them. Sara had a few surprises for those who would be staying at Haw River. Lucinda had a mysterious gift wrapped and ready for the Umberland family and it was already under the tree.

The boys had napped under the lit tree much of the day. They said it was "enchanting". They really liked that new word, after hearing it used in a fairy tale that Sara had read to them the day before. Everyone was finally comfortable and yet all that would change in two mornings. There was an unspoken understanding that this would be one of the very last gatherings in the Umberland home, maybe forever.

"This is so peaceful," Lucinda held Saralinda, and sighed.

"We're dreaming of our girls," said Apkin. Ekle nodded, confirming that his brother was right.

"But it's sad we're leaving," Ekle assured them.

"We feel sad and happy at the same time," explained Apkin. "But I do like it better where we used to live."

It was a confusing mixture of feelings for everyone. Success also meant a loss.

"But I won't ever go near any of those swampy areas," Apkin suddenly threw in. "They might be filled with those bad guys."

Dr. Umberland's tone immediately changed.

"It makes sense that the four of you stay with Lucinda near the vinetropes. That's where you come from anyway; it's your natural home. I mean, I know Owletta is from here, but now she has Hool."

He continued in a calm voice, as though what he said should be obvious to everyone. "Also it's much safer for the four of you to do this 'scouting' work. You blend right in. It's only logical that we humans stay out of the picture as much as possible. I know have a responsibility to return you to where you belong and then it's best that we leave."

There it was again, thought Sara. That tone. It wasn't that there was anything wrong with what her dad was saying, but there was something different with how he said it. It felt like he was putting distance between himself and what was happening, as though he wanted to be done with it and put it behind him, behind the whole Umberland family. She would need to discuss this with Lucinda.

Sara and Lucinda and the baby retired to Sara's room. Tonight would be their last chance to have a sleepover together. Christmas night Jam would be here and then they would leave. Lucinda fed Saralinda and tucked her into the doll cradle, retrieving an extra blanket for herself from the doll's bed that seemed to be stacked with extra bedding.

"Nite, nite," said the tiny vinetrope.

"She's talking?" Sara was astounded.

"Just a few words, but yes. It began just tonight. She is growing so fast. It is a bit sad. But if things were normal, she would have been born full size. So this whole experience is unusual."

Sara got into bed and Lucinda joined her on a second pillow, right next to Sara's head, and pulled the little blanket around her.

"It's so amazing," Sara reflected. "This has all happened in only three months, everything we've gone through. It's like there was my life before and now this new life, after meeting you. You are a mother now! It's still you, but you are changed at the same time."

"You too, Sara, are changed by what has happened, but still at heart the same Sara I met in the garden. Remember when I asked you what a year meant? You had to explain what the word 'year' meant by the earth's rotations!"

They both smiled wistfully with the memory of that first meeting, that first conversation.

"You may not know it yet," said Lucinda, looking at her hard, "but you are getting ready to handle a lot of new situations that will need to be faced, maybe not today, but one day."

"I know that." Sara's face was turned toward Lucinda who was resting propped up on her elbow on the pillow next to her. They were face to face. "And I know it might be dangerous. I'm not sure if my dad's ready for me to handle that."

"I sensed that too. That is only natural. He is your father and he is now taking that role very seriously. He finally understands that when his wife died, you lost your mother, so he is going to be very protective."

Lucinda sat up on the pillow. Her fingers fluttered. "But you should not have to worry about that now. He is bringing me home and I am so appreciative. When I am with my people other plans, ideas, and ways to solve this problem will present themselves. It will all work out. You will see. But things are going to get more complicated. That I know for a fact. This problem with your father will have to be dealt with eventually. We will figure it out."

"I know you're right. I believe you. And I'm scared myself. None of us really knows what's happening." Sara propped herself up on her elbow.

"That's why I am trying to get as prepared as possible," Lucinda fussed with the blanket. "Why I am studying so hard. I believe we vinetropes can build our own systems."

"Systems?"

"Yes, computers, networks, Internet." Lucinda sat up.

"Really?" Sara sat up too and turned toward Lucinda. "When did this happen?"

"It has been happening as I work. I think I have found a way to speed up our root growth. These roots will spread and grow rapidly, like my little daughter. And I have an idea that will allow me to program certain roots for specific purposes."

"That's really possible?"

"Yes, it is possible. But I still have to make it happen. If I can get the very first system up and running from a main control center, I know I can program the roots to make a vinetrope network. I will wait till I am with my vinetropes and we will all work on it together."

Lucinda was getting excited, as she shared her ideas with Sara. She stood up and began to pace back and forth on the bed as she spoke. Sara followed her with her eyes.

"This program would duplicate itself over and over, from root tip to root tip, spreading outward from the original system, moving in all directions, carrying the information along with it by vinetrope energy. It will be a root system meant just for this purpose—technological communication."

She stopped in front of Sara with her arms once again in the air and continued.

"I envisage a system for travel as well. But that I will need to work on much longer. But if vinetropes could travel and communicate around the world—just like humans—think of what we could do! Why we could send signals to clean up the earth! We could speed up the use of vinetrope energy to your scientists! And we could do it all secretly. We would have to."

"How? This is incredible. You mean these roots could connect to ours without us knowing?"

"That's right, in and out. We could control when we wanted to send messages to humans and when we didn't. These messages would carry a goal-specific code and then make that code a reality."

"How is this possible? You've learned that much? Is this even real?"

"Well, it is still a dream, true. But a beautiful one! It is a spiritual state in my mind and I will share it when I get home. Our vinetrope energy will absorb the dream and help us. It is all spiritual, really. It is about pure creation, after all."

"Spiritual? You mean vinetrope energy is spiritual?"

"Well, yes, of course. And so is yours. It is just that most of your people are not able to directly communicate with it."

"I never thought of it like that."

Lucinda sat down again on the pillow.

"You see, the spirit of vinetrope energy, and how it does all the other things it does, in its pure form, is still a mystery, even to me and my people. From what I have been studying, on the scientific side, it is something like cold fusion and photosynthesis combined . . . but it is also much more. It is alive!"

Her hands came forward and toward Sara, palms up. Sara touched them lightly with the forefinger of each of her hands. They smiled at each other.

"This process takes place in the water that circulates in our system, much like your blood. It is in us everywhere, moving around and enlightening us. So if I can communicate with this energy, and if the goal is a good one, I will be able to figure the rest out and build the dream."

She brought her arms back and folded her hands against her chest.

"I have all the information I need, here in my body."

"But how do you communicate? What does that mean?"

"It is a hard thing to explain, to find words for it. It is more like meditation or inspiration, or maybe like a prayer: sometimes all three at once. When we water the roots to make it keep our homes warm or cool, or to light our world, we are deeply engaged in a process of thinking about these things as we are watering them. This relationship developed ever so slowly over so many eons, and we vinetropes are in touch with this energy that is inside us and all around us. It is powerful, creative and good and it is more intelligent than anything else. And it loves us. It is the opposite of evil. It wants us to create. By understanding this, we dream our future into existence and we have faith that it will happen."

Lucinda was glowing and radiating beauty and to Sara she felt like the Wise One of all fairy tales. The fairy Sara had always wished to meet.

"But," Lucinda continued, unfolding her hands, "we must be willing to work, learn, study, do hard labor, sacrifice, whatever it takes to make the dream happen. We play an active role. We make choices. We make mistakes. But we make things happen. I am sure humans have the same ability deep inside them."

"I think we do, but I think it makes us scared to think about it. We like to feel everything has an explanation and has its place."

"Well, it does! This intelligence is what we call God. This intelligence is the greatest scientist in the universe, the first scientist! Where do you think the laws of physics come from? But these laws affect different parts of existence in different ways. We may not yet understand how it all works, maybe we never will, but we must keep communicating and trying."

"This adds a whole new understanding to what's happening, Lucinda. I didn't know that your abilities are a mystery to you too. In a few days, we won't be together anymore." Sara grew

sad and swiped at her eyes. "We may not see each other again for a very long time, and if we hadn't discussed this I would have been missing an important piece of the puzzle."

"The puzzle of vinetropes," said Lucinda, smiling.

"Not just that, Lucinda, the puzzle of everything."

"Well put!" and Lucinda reached over and dried Sara's cheek, the one tear, with her fingertips. "This is a unique moment in history, an unfolding of potentials, some wonderful and some not."

"And we'll have many decisions to make, some easy and some not."

"Exactly," Lucinda confirmed.

Jam had another dream. She was sitting on a small wooden box in a strange room facing a large door. It was, she realized on closer examination, a large center hall in some house she never remembered being in. She was facing the front door. On the front door there suddenly appeared a huge mirror with a golden frame. In the mirror she saw the reflection of a garden that lay behind her. It was a long, rectangular shaped garden with a fountain in the middle and dried flowerbeds all along the outer edges. The garden was completely enclosed by stone walls with a gateway at the far end.

She heard voices, but she didn't see anyone. Then there was the distant clatter of kitchen noises, someone working with pots and pans. These sounds gave her the odd sensation that there were people all around her, but she couldn't see them nor they her. It felt like she, or they, were in different dimensions.

She looked into the mirror again, and this time she noticed it was getting dark, but knew it was cold outside. The fountain was there; but there was no sound of water. A crow landed on the top tier and gave a loud cawing call. Then the crow lifted his left wing and seemed to point to the gravel path that ran around the four sides of the garden. The crow called out again. Her eyes followed the wing to where the bird pointed on the gravel. At first she saw nothing, but then she noticed a trail of nuts, scattered along the path going back to the distant gate at the end of the garden. Just then, the box she was sitting on began to rumble. Something was trying to get out.

She woke up.

It was Christmas morning and everyone was gathered to open gifts. Sara gave a miniature rattle and a tiny stuffed bear to Saralinda and she loved them, shaking the rattle in one hand and hugging the bear to her chest. She also gave a huge wardrobe of doll clothes to Lucinda for herself and Saralinda. Saralinda would be able to wear some of the pieces now, but she was growing fast and would outgrow the tiniest outfits very quickly. Lucinda could give the tiniest clothes to another mom with a slower growing baby. Sara also gave Lucinda the wooden doll cradle, stocked with a new mattress and several warm blankets and doll-sized pillows. That explained the extra bedding. Lucinda was delighted. She would supply her own stones. Lucinda's present to the family was an incredible collection of poems and stories that she had written, in between her studies, on the computer.

"The stories and poems are all about what it was like in vinetrope time, before the Ice Age. I thought you'd enjoy them."

"This is wonderful," said Sara. The book was 375 pages long and it was presented in a loose-leaf binder that Sara wasn't using. "That's what you wanted it for! This is great. Whenever we want to feel like you're here, we can take this out and read it."

"And we can learn about your ancient world," said Steven. It was just the kind of thing he loved!

Dr. Umberland seemed intrigued as well.

The squirrels didn't know what to bring, so they brought a lot of acorns and then ate them themselves. They were in a festive mood, excited about the trip and their humorous antics were gifts enough.

The owls each donated a "good-luck" feather to the family from their own wings. Sara's family gave the squirrels several bags of fancy mixed nuts in the shell to take with them, stuffed in their stockings. Then, for Owletta and Hool, there was a small hooked rug to make their new nest cozy.

"That is a t*rr*uly lovely *rr*ug!" said Hool. "Thank you."

Owletta patted Sara's arm and put her head on her shoulder. "Thank you, my dear!"

Dr. Umberland's gifts to Sara and Steven were new laptops for each of them; rather extravagant gifts and very much appreciated. This would be Sara's first and Steven would have a new one to take to college.

Sara and Steven had found an antique scientist's sample kit for their dad. It had old vials, collection tools and measurement scales that were used by scientists 100 years ago. It was in a really neat wooden box with two drawers that slid out and a secret drawer for valuable ingredients. They had found it together in a junk shop and surprisingly it wasn't that expensive. Sara donated what she had saved up, but Steven paid for most of it.

Their dad loved old science equipment, and he was delighted with his gift.

Saralinda, who had been napping, woke up and put the food vine in her mouth. She started to drink and then glowed very intensely.

"Wow!" said Apkin.

"She's dazzling," teased Ekle.

"Would you like to hold her, Sara?"

"I'd love to."

While everyone looked on, Lucinda undid her daughter from a tangle of hair and handed her up to Sara. She fitted in Sara's palm and she was about four inches long.

"She's so tiny and sweet."

The baby opened her eyes wide and looked up at Sara. Everyone was delighted.

Saralinda then smiled and said "Sara," as clear as a bell.

Everyone, especially Sara, was amazed. The baby's mini string-bean fingers tried to clamp around Sara's index finger, but were too tiny to make it all the way round. Sara stroked her little hand gently and then handed her back to her mom.

Then the Umberland family got dressed and ready and went to church to celebrate Christmas Day. They would be back by lunchtime. The others would stay in the house, visiting by the tree, until their human friends got back. It was just after noon when the Umberlands returned, and shortly thereafter the doorbell rang.

The squirrels and owls scampered and fluttered upstairs into Steven's bedroom closet. Jam had arrived with her parents. Dr. Umberland

invited her parents in, but they said they were going to Jam's aunt for dinner and had a bit of a drive. They thanked Dr. Umberland for inviting Jam on the trip and he gave them his cell phone number and promised them that Jam would give them periodic calls along the way. No sooner had they left than Lynn arrived at the back door. Sara yelled upstairs, " the coast is clear" and the boys and owls came down. It was time for Christmas lunch. Dr. Umberland had bought it all in the day before and everyone helped get it on the table. Soon they all had places at the table.

"I'm hungry!" announced Apkin, looking at the food on the table, especially the peanut butter, which was sending him a wonderful smell.

Here at this walnut dining-room table, the table on which Sara's mom had held so many happy family dinners, were gathered humans, squirrels, owls and a vinetrope, who sat perched on a pile of pillows with her baby in her hair. All were speaking, planning and sharing with each other.

To an outsider, who hadn't yet had exposure to a vinetrope, Owletta's voice and Hool's may have still sounded like a series of screeches and the squirrels' talk may have sounded like a frantic series of squeaks, but to everyone at this table, all conversation was clear and easily understood. These "beings" all looked very different from each other, as different as could be, but nonetheless, they all had intelligent minds and they all cared about each other, each in their own ways.

As they spoke, they graced the table top with wings, claws, hands and the elegant string-bean fingers of vinetropes; the sight was a marvel indeed. The room took on a soft glow and the mood of this special gathering felt both ancient and futuristic. It spoke of the past and things yet to come. This was definitely a first in history, at least on planet Earth.

After lunch, Lynn had to go home and then preparations for the trip moved into high gear. Ekle and Apkin didn't have anything to pack, but Steven put a litter box with sand in the back floor of the car, under Sara's feet, for an emergency.

"The owls can use it too," he commented.

The squirrels and owls were deeply offended by this. They said they were quite in control of the situation, no different than any human, and that an occasional stop by the side of the road would be sufficient.

"Frrankly," Hool said to Owletta, when they were alone for a moment, "I've neverr been so insulted."

"Let it go, my dear. He was only trying to be helpful."

So Hool let it drop.

The litter box was removed.

Lucinda was bringing the most. She had all her dishes and pots wrapped and ready and a small duffel bag of clothes for herself and the baby. There was also the laptop and cradle and bedding to fit in the trunk. They wrapped the laptop in a blanket and tucked it into the cradle. Each human had a duffel bag, soft and pliable, that could be pushed into corners easily. Owletta and Hool only had the new rug. They would be establishing a brand new home in the glowing beechnut tree.

Sara decided to bring several bags of chocolate chip cookies for Lucinda to have in her new home. She knew it was a favorite.

"Thank you so much for all these chocolate chip cookies," said Lucinda. "I must have done something wrong with the ones I planted. Maybe there was not enough energy yet to feed this kind of seed, but my cookie crop didn't grow at all!"

"What are you talking about?" asked Sara.

"Well, I planted quite a few of the chocolate seeds, but nothing seems to be sprouting."

"Lucinda, the chips aren't seeds," laughed Sara. "They're candy! They're made of processed plant life: sugar and cocoa."

"Well, that is a disappointment! I guess I never bothered to look that one up. I just assumed they were seeds!" She looked mildly irritated. "I guess that means the colored sprinkles on the gingerbread house will not be sprouting either?" She looked quite vexed.

"Nope, they won't." Sara held back her laughter. Then they both looked at each other and laughed hysterically.

The big problem was how to safely transport the animals and Lucinda and the baby. The solution took some thought. Everyone brainstormed. It was Steven and Dr. Umberland who came up with the first part of the answer. Working with large chunks of dense foam rubber, an old baby-seat that used to be Sara's, and some rope, they were able to rig up some clever travel arrangements for mother and child. They filled up the entire baby-seat with a huge chunk of foam rubber. They then tied and stitched it into place and, once secure, carved two compartments into the rubber. One was an indentation, just the right size for Lucinda. They left a sturdy strip of rubber intact across the compartment; like the guard bar you might find on a roller-coaster ride. All Lucinda had to do was climb in under the bar. The other smaller indentation was for Saralinda; a built-in bassinet with a mini strap and netting sewn across the opening that could be snapped into place for added security. Lucinda could reach her baby easily if she needed to. Now for the squirrels!

Apkin had an idea. "Look at these cardboard tubes," he called out, rummaging through stuff in the garage.

"Those were from posters I bought a couple years back," said Steven. "They were wider than the standard ones and I thought they might be useful someday."

"They're perfect!" said Apkin. "Help me get them up on the back window."

One long tube ran almost the length of the back window ledge, leaving just enough room for the boys to get in and out at the ends.

"I get it," said Sara and Steven at the same time.

Steven scratched his head. "We've got to make it secure on the window ledge. I'm going to get some strips of Velcro and Velcro it into place."

"Great idea," said Jam.

The boys ran in and out of the tubes, making a rumbling noise that suddenly reminded Jam of her dream. The rumbling was like a trapped animal in a box.

"Hey, everyone, I forgot to tell you my dream."

"Another one?" said Ekle.

"Yes."

So everyone stopped what they were doing and gathered around. Jam told them her dream and how it ended with her sitting on a box, with something trying to get out.

"The box kind of rumbled, like that."

"The tubes are kind of like boxes," noted Steven, "but not really."

"The present you gave me was in a wooden box," said Dr. Umberland, referring to the Christmas present from his kids.

"Well," said Lucinda, "we are not even bringing the antique box along." She looked thoughtful for a moment and fluffed her vines with her hands. "We'll just have to keep your dream in mind, Jam, and be ready to use it if we see the clues in time."

Everyone nodded.

"I think we should make a few extra holes in the tubes for air circulation," said Sara, getting back to the task.

"Perfect," said Ekle.

"And fill it with dried grass and some nuts," added Apkin.

"Okay," said Steven, "I can do that. I'll add two larger holes in the back as well, like small windows. You guys can ride along with your heads sticking out facing the back window." The boys seemed happy.

Now only the owls needed a safe way to travel.

Sara had the idea to hang a branch on a rope. The rope could hang over the back of both front seats, around the head rests, and the branch would then hang down over the back between Sara and Jam.

The owls thought that might work.

"But if the car jerks at all," said Jam, "you would fall off on top of us."

"Not a good thing," said Dr. Umberland. "We can't have you bouncing around like basketballs."

"Well, we'll have to come up with some kind of straps for them," said Sara.

"I'm not going to be chained to a perrch, for heaven's sake!" said Hool.

"Wait a minute. Eureka! A basketball net!" yelled Steven.

"Great idea," said Dr. Umberland, who got the idea immediately.

"What, may I ask, is a basketball net?" said Hool. "I'm not a ball, I'm an owl, and I have dignity."

"Wait and see, dear," said Owletta. "If it doesn't work, it doesn't work. We must find *some* way to travel safely, though I'm getting the impression that train travel is much more luxurious."

Dr. Umberland showed them the net. Tied into place, with the branch running through it, the owls could perch and be kept secure inside the net without feeling too restricted. Their heads would be above the net line.

"It will make me feel like one of those stuffed owls I saw once in a sto*rre* window," Hool complained. "It was ho*rrr*ible! But I guess it will do."

It had been a full and exceptionally rich and busy Christmas Day. The car was ready and all the duffel bags were packed except for last minute stuff. The cradle was in the trunk and all the things that Lucinda was bringing. They had one last job—to take down the Christmas tree before they left.

By 9:00 a.m. the next morning they were ready, including the drinks and snacks. The Umberlands left a couple of security lights on in their home and made sure the doors were locked. Sara went with Lucinda into the lower garden and Lucinda cranked the door open. They both looked in one last time.

"I'll keep your home clean and ready," said Sara, "just in case you come back for a visit."

"It will be nice to know that it is being looked after," said Lucinda wistfully, "though there is not much left. Of course, the root growth will die out."

"Your ceiling always reminded me of the Milky Way on a clear night," said Sara.

"Me too."

They both sighed and then Sara picked Lucinda up, with Saralinda in her arms and they went to the car.

"I feel sad," said Ekle.

Apkin nodded. "And happy."

"Everything will be different now," Sara added.

They took their places and secured their posts.

Steven would share the driving with his dad. They pulled out onto Rennselear, made a left down the hill and headed for the highway. Once on I-95 south, they picked up speed. Lucinda was thrilled and Owletta and Hool found it more comfortable than they had anticipated, but Ekle and Apkin felt a bit car sick. Also, it reminded them of their unpleasant trip north in the barrel.

"I'm seasick," said Ekle, not knowing how to describe it.

"How would you know?" questioned Hool. "You've neverr been on a boat. I think you should call it wind sick," he was quick to add.

"We call it car sick," added Jam. "People get it sometimes too."

"Will it stop?" asked Ekle.

"Hopefully," said Sara.

"I'm getting dizzy looking out this back window," continued Ekle.

"Shut your eyes," squeaked Apkin. "It's too much to take in. Don't look."

They ducked back in. After a bit, in the quiet of the tubes, the squirrels began to adjust. They ate a few nuts and kept them down. Finally they were able to look out the holes and watch the scenery as it went by without feeling disoriented.

Owletta and Hool made observations to each other on what they saw. Their perches were high enough for them to look out the side windows. Hool's dignity didn't seem to be suffering.

Lucinda could easily reach in and pat her baby. The feeding vine reached across into Saralinda's little mouth without having to lift her out of her seat. Furthermore, the driving seemed to make the baby drowsy and she slept a lot. Things were going well.

"It will be a *rr*elief," added Hool quietly, just before dozing off himself, "to get o*urr* sleeping patterns back in order. Working with humans and squirrels has really confused my lifestyle."

They drove most the day, with a lunch break and bathroom breaks and there were no "accidents". After a long day of driving, it was beginning to get dark and they would need to find a place to stop for the night. They were not too far from Richmond, Virginia, driving through beautiful rolling hills in every direction. The scenery was wintry but still lovely, as growing darkness began to cover the landscape with shadows. They hadn't booked rooms anywhere and Dr. Umberland thought they should begin to look for a bed and breakfast to spend the night before it got too late.

The late December sun quickly set. Now, as twilight deepened into night, and shadows masked everything, they still hadn't found a place to stay. The travelers stopped at a gas station for some suggestions. This took them off the main highway onto a smaller road that boasted some quaint and charming inns.

About fifteen minutes later, after passing a huge sycamore whose largest branch nearly stretched across the width of the road, they saw a sign for an inn. Set back from the road on a hill was a big old white colonial. They came to a stop in front of the open gate just past the sycamore. A sign was tacked on the gatepost.

"Sycamore Inn," read Sara out loud. "Vacancies."

The owls seemed to come out of a trance. "We're stopping here?" they both mumbled.

"We're not exactly sure," said Sara.

"I think we should give it a try," said Dr. Umberland.

"Good trees," said Apkin.

"No problem for us," said Owletta. "Just let us out here and we'll become part of the scenery in a flash."

"I could use a stretch," said Ekle. "We'll check out the outside while you check out the inside."

"Okay," said Dr. Umberland. "I will park the car up the hill in front of the house and see about checking in. If we're not, I'll drive back down here and we'll meet you here by the sycamore tree."

"Don't leave without us!" Ekle teased.

"They wouldn't," said Apkin.

Steven opened the back door and the owls and squirrels blended into the landscape in seconds. Then he got back in and they drove slowly up the gravel road to the parking lot in front of the Inn. The only other car there at the moment was a yellow Volkswagen. Dr. Umberland went inside to see what was available. Sara picked up the duffel bag from under her feet and put it on her lap. Inside were her clothes, a bag of toiletries, and a box of granola bars.

"Okay, get in," said Sara, helping Lucinda out of her seat. The sides of the bag were made of netting and there was a side pouch for Lucinda and Saralinda to ride in. Sara zipped the bag shut.

While Dr. Umberland checked on rooms, the kids stretched their legs outside on the circular driveway. Sara kept her bag with her. Steven went inside after a few minutes. The girls walked a bit around the side of the house down a smaller gravel path that led around back.

"Neat old house," said Sara.

"Yeah, looks like there might be a garden back here," said Jam.

"And an orchard of some kind," added Sara, "but it's too dark and I can't tell for sure."

"It looks pretty," said Jam.

Just then the garden lights came on, lighting the pathway and illuminating the garden. "Maybe we can take a walk back there if we stay. There seem to be some garden lights on," said Sara.

"You might as well take that walk," said Dr. Umberland, coming down the side path and overhearing her. "We're staying. It's quite charming. They had two rooms available with twin beds, so Steven and I will take one room and you and Jam can have the other."

"Great." The girls were happy.

"There's only one other room with guests right now. A mother and her daughter are staying in that room. That's their Volkswagen, with the Georgia license plate, parked next to us. They're doing renovation on the other four guest rooms, so it's a small group of guests. Dinner is at 7:00 p.m."

"Okay, Dad, Jam and I will do a little exploring out back, after we unload the car," said Sara. "Do you want to join us Steven?"

"No, I don't think so. I think I'll give Lynn a call and I want to take a shower before dinner. Why don't you two just go ahead and take a look around. I'll help Dad with the bags." He took Sara's bag.

"Be careful with this one," said Sara, pointing to her bag with Lucinda and Saralinda inside.

"I will. I'll park it gently on one of your beds and unzip it."

"Do you want to join us?" Sara asked Lucinda.

"No, girls, go ahead," Lucinda whispered. "I'll get Saralinda settled and explore the room. You go on."

So Sara and Jam darted down the gravel path that continued around back to a patio area with several tables and wicker chairs. Beyond the patio was the garden. The entrance was

through an arched arbor tangled with dried grapevines. The garden was long and rectangular in shape, walled in with a brick wall about six feet high. There was a tiered fountain in the middle that had been shut off for the winter and perennial beds ran the length, along the walls, with a gravel walking path around the entire perimeter. Floodlights and low-lying path lights lit the way. At the far end of the garden lay another arbor and a gate.

"This is it!" said Jam.

"What, the garden?"

"Yes! This is the garden in my dream! The one reflected in the mirror, right down to the gate at the far end."

"Really!" said Sara. "We'd better stay alert. Should we check out where the gate leads to?"

Jam felt a prickle up her spine. "Yes, let's have a look. This is eerie!"

The girls made their way down to the gate and found it led into a leafless orchard.

"We'll take a quick look. My dream seemed to focus on this gate," said Jam.

As they entered the orchard, they heard someone talking loudly.

"Ooh, you're so cute, aren't you, you little sweetie," a girl was crooning.

"Hello," Sara called out.

From out behind a wheelbarrow, a girl stood up. She looked to be about Sara and Jam's age. She had light brown hair, a petite body and a loud voice.

"Oh, hi," said the girl. "My name is Sandy. Sandy Williams. Are you staying here tonight, too?"

Then she turned and spoke to something in the bushes. "Don't run away you little cutie. You understand me, don't you?"

"My name is Sara and this is Jam. Yes, we're staying overnight, my dad and brother too."

"Hi," said Jam. "Who are you talking to?"

"Come and see. I've met the cutest little squirrel. He's so tame and smart and plump, he loves these peanuts I brought in my pocket. I've got breadcrumbs in the other. I love to feed animals.

Well, that was nice, thought Sara.

"He trailed behind me as I dropped them on the path... right out here into the orchard."

Sara and Jam looked at each other and then came around the other side of the wheelbarrow. Sure enough, it was Apkin, tempted by food once again. Apkin made a squeak when he saw Sara.

"Isn't he darling," Sandy continued. "I swear he'd make a great pet. He even let me pet him, but don't tell my mom, she'd be afraid I'd get bitten. She said maybe I could get a cat. I'm hoping for a dog."

Sara thought that despite Sandy's love of animals she sounded a bit spoilt. She suspected Sandy could wrap her mom around her finger.

"Oh, your mom would be right, you shouldn't keep a pet squirrel," said Sara. She didn't like the idea of Apkin and the word "pet" in the same sentence, especially in relationship to Jam's dream.

Jam was really upset and while Sandy was facing Sara, she tried to shoo Apkin away. She kept waving at him to go, wagging her finger, with a scolding look on her face. Apkin just sat there with an embarrassed look on his face.

"Nonsense, look." Sandy turned and reached out and gave Apkin a little ruffle on the top of his head. "I've never seen anything like this."

"He could have rabies," said Jam coming to stand next to Sara. She'd given up on chasing Apkin away.

"He's tame as can be," Sandy went on. "A rabid animal doesn't act like this! Do tricks for nuts! Here boy, fetch some more nuts," and she threw a few ahead of her onto the path. Naturally Apkin obeyed and gathered them in his cheeks.

Sara felt very angry with Apkin. How could he be so foolish as to draw so much attention to himself for a few peanuts? Just then, there was a scampering sound coming from the nearest fruit tree. The girls saw Ekle sitting in a branch. Apkin made another squeak and darted into the orchard and up the tree. Thank goodness for Ekle. At least Apkin listened to his brother.

"Oh, no, I wonder what scared him away?" Sandy was disappointed.

"Who knows," said Sara. "Maybe his mate called to him—doesn't like him talking to humans."

Sandy laughed at this.

"Could be right," said Jam.

"It's just as well," Sara tried to sound confident. "A wild squirrel could never get used to being locked up. It could rip up your whole house. Run up the drapes, scratch the furniture and make a mess."

"You might be right." Sandy shrugged her shoulders. "But he was awfully cute and tame. And cats scratch things up, too. But my mom wouldn't go for a squirrel anyway."

"And he'd probably never really be happy," added Jam, appealing to her love of animals.

"Well, we might as well head in," said Sara. "We'll have to get ready for dinner soon."

"Maybe we can play some board games tonight," suggested Sandy. "Where are you both from, anyway?"

They talked on the way back to the Inn. Maybe Sandy's not so bad, thought Sara. I mean, who wouldn't find Apkin adorable. It was Jam's dream that was making her jumpy. Jam seemed tense, which wasn't helping.

"Where are you from?" Sara asked Sandy.

"Oh, my parents are divorced and we're visiting my grandma in North Carolina, for the holidays. She's in a nursing home in Lumberton. We'll be out of here in the morning. We promised Grandma we'd be in Lumberton by lunchtime tomorrow."

So the conversation about Apkin ended. The girls went up the front steps across the wide old porch and into the front hall and Sandy headed straight upstairs. Jam spun around and took it all in.

"It's so much like the dream," she acknowledged out loud, "except there's no mirror on the front door."

They explored the main floor a bit and stepped into a parlor with comfortable chintz chairs and couches and many little tables. Jam noticed a table with games piled on it and another set up for chess. This is what Sandy must have been suggesting.

"Do you think we have to worry?" Sara turned and asked Jam.

"I'm feeling calmer now. She seemed to agree that a squirrel might not be such a good pet. And she said her mom would never go for it."

"I agree. I think we nipped her idea in the bud. By interfering just when she was having the idea, I think we've stopped it from happening."

"I guess you're right. It all fell into place so well. I guess my dream helped us out. I'm getting the hang of it!" said Jam.

"Me too! It's really amazing Jam. You dreamed the whole thing and we put a stop to it!"

"And Ekle saw what was going on. I bet he really scolded his brother."

Just then Steven came into the room.

"Nice old room, isn't it? Maybe we can play a few games after dinner."

"Yeah," said Sara, beginning to feel cheerful again, "We met a girl named Sandy and she suggested the same thing."

"Great, four is a better number for games."

Their room was charming, with a big bay window, much like the one Sara had in her room, but larger, with a thick green and white striped cushion on it, a ton of dainty little pillows and striped curtains to match. The two beds had matching fabric headboards as well and on the farthest one, closest to the window, sat Lucinda with Saralinda jumping up and down on the mattress, even though she was only four inches high.

"Hi Sara, hi Jam, jump, jump!" she called out in the tiniest voice imaginable.

The girls ran over and fussed with her. She was too cute to believe. She jumped into her mother's hair and sat in the leaves, grabbing at one light and then another as they blinked on and off. Lucinda had turned them on to amuse her daughter. Saralinda was squealing with delight. Jam and Sara took some pictures with their cell phones for memory's sake. They couldn't help themselves.

"We better be careful with these!" said Sara.

"That's for sure," said Jam.

"Let me get some snacks out for you, Lucinda," suggested Sara.

"Oh, I ate an inch of a granola bar, I'm fine for now. And Saralinda had a bite too."

"Solids, already?" asked Jam.

"Just a taste."

Jam and Sara showered and changed into the only dresses they'd brought with them and then they headed downstairs. The dining room was filled to capacity with local clientele. The restaurant obviously had a loyal following. The dining room was colonial, with pewter chargers on the tables, which were removed at the start of dinner. There was even a fire crackling in the fireplace and an oil painting of the Blue Ridge Mountains, which weren't that far from the inn. They said hello to Sandy and her mom as they passed their table and promised to play games after dinner.

The food turned out to be excellent. Sara brought a purse to the table, with a couple of zip-lock plastic bags in it, and as the meal progressed, she slipped morsels of food into the bags. These included a fabulous southern buttermilk biscuit, a piece of cornbread, three carrots sticks from the relish tray, and a piece of roasted potato. Dr. Umberland dropped a couple of mint chocolates in. "Some dessert."

"A feast for Lucinda," Sara whispered.

As they got up to leave, Sandy came over and they agreed to meet downstairs in the parlor in ten minutes.

Upstairs, Sara and Jam arranged the feast for Lucinda on the bed. They laid down a towel and placed the food on it, a vinetrope buffet. Saralinda was somersaulting across the bed. Lucinda laughed with pleasure at the feast and nibbled a little of this and that and Saralinda came over and sampled the biscuit and cornbread, taking sips in-between from her mom's vine. "Good food," she announced.

Sara and Jam laughed and then, leaving the Vinetropes with their picnic, went down to meet Sandy in the parlor. Steven and Dr. Umberland came too, had coffee with Sandy's mother and joined in a few games before calling it a night.

The trouble didn't make itself known till morning. They were already packed and ready to leave before breakfast. Steven headed to the garden where Owletta and Hool were roosting and the boys would be enjoying the fresh air.

It must have rained really hard in the night as everything was drenched and wet and pretty muddy out back. Steven's high tops squished in the mud. He found Owletta and Hool huddled under the eaves of the roofk.

"Well, the weather is still mise*rr*able," complained Hool. "I can't believe I'm saying it, but I'll be glad to get back into that car of you*rr*s."

Steven nodded in sympathy. "Sorry Hool. I wanted to let you both know we're leaving soon. We're just grabbing some breakfast and then you can meet us down at the sycamore tree. Be on the lookout. Where are the boys?"

"They took cove*rr* in the tool shed over the*rr*e," Hool pointed with his wing.

"We'll tell the boys," Owletta promised.

The Umberlands and Jam met in the dining room for some breakfast. Sandy and her mom weren't there and Sara, who was relaxed by now about Sandy's interest in Apkin, was sorry they couldn't say goodbye. They got their bags (with Lucinda and Saralinda safely stowed away) and Dr. Umberland paid the bill at the front desk.

Sara thought maybe Sandy and her mom hadn't come down yet for breakfast and spoke to the receptionist at the desk, a pretty young lady disguised in a lot of make-up.

"Excuse me, but do you know if the Williamses have been down for breakfast yet?"

"The mother and daughter? Yes, had breakfast early. They checked out maybe an hour ago?"

"Oh well," said Sara. "I guess Sandy didn't know how early her mom was planning on leaving or we would have said goodbye last night."

As they walked to the car, Jam admitted to Sara that she still felt tense. "I just feel off."

They got in and drove to the sycamore tree. Sara opened the door and in just moments, two owls and a frantic Ekle climbed into the car.

"They took him!" screamed Ekle, more upset than they had ever seen him. "He's gone! Follow their car!"

"You mean Apkin?" asked Sara, knowing that was exactly what he meant.

Jam gave her a look of horror. "I messed up again!"

"We messed up!"

"Stop it! No time for that. Let's get going!" said Apkin, in his tube with his face facing out back. "They got him!"

"Who's got him?" shouted Steven and Dr. Umberland.

Dr. Umberland was driving.

"Sandy," answered Jam and Sara in unison.

"Yes," said Ekle. "That horrible little girl! She put him in a box filled with nuts!" Jam nodded to Sara, affirming the box in her dream. It was instantly understood between them.

"She tricked him with a trail of nuts," Ekle continued. "That stupid brother of mine, I warned him last night in the orchard! I don't know why Regata wants that stupid squirrel back!"

"You're just verry upset," said Hool.

"You bet I am!"

"Where's Apkin?" asked Saralinda, starting to cry.

"Poor baby, no need to cry, hush, hush, we will find him," comforted Lucinda.

"Well, we know it's a yellow Volkswagen with a Georgia license plate," said Dr. Umberland.

"And they're going to Lumberton, here in North Carolina, somewhere," remembered Sara.

"That's right!" said Jam, unzipping her jean jacket and pulling her hair out of the back collar. "To her grandma's who is in a nursing home."

Steven got out his cell phone and searched Lumberton, N.C. "It's north of here, going back the way we came."

"We'll have to turn around," and Dr. Umberland did just that.

As they reached the north-bound highway, Sara and Jam quickly told everyone about the incident in the garden. How it was a lot like Jam's dream.

"Why didn't you tell us all this!" screamed Ekle, getting out of the tube and jumping onto the front seat console. "Has everyone gone stupid?"

"We thought we had it under control!" Jam whined in misery.

"We did!" said Sara, shoving furiously at her hair.

"I might just suggest, next time," Lucinda was firm but not as harsh as Ekle, "that if you see things happening that remind you of your dream, you simply share it with everyone. Then we can then all share the responsibility of figuring out what is happening."

"I will, I promise," said Jam and both girls nodded, looking miserable.

"Don't feel too bad, girls," Owletta reassured them, reaching out to each girl with a wing tip and patting their heads. Hool clucked soothingly to show his compassion.

"None of us might have been able to stop this," added Steven. "We're all new at this dream interpreting thing."

"I missed it too!" Ekle squealed, sounding desperate. "I'm the stupid one! I saw what he was doing with that girl, flirting with her for nuts! I should have kept a better eye on him!" He started to sob and his little shoulders shuddered.

Everyone began to comfort Ekle.

"I'm really mad at myself!" Ekle confessed. "I'm worried to death and I have a bad headache," he added.

"Squirrels get headaches?" asked Jam.

"Of course we do. Just because we couldn't tell you humans ever before, doesn't mean our heads don't hurt sometimes."

Lucinda managed to calm Saralinda, after all the yelling. She could explain enough for her to understand!

There were no longer any hard feelings. They just had to find Apkin.

An hour passed and still no luck—no yellow dot in front of them. But they had to make a stop at a bathroom facility and luckily they saw a sign that said "Rest Area and Restaurant—1 mile". As they pulled into the restaurant parking lot, they were welcomed by a beautiful sight—a bright yellow Volkswagen! And it was empty! That meant Sandy and her mom were still inside. They pulled in right alongside their yellow car and parked.

The Umberland family and Jam were out of the car in no time. Lucinda and Saralinda stayed behind with Ekle and the owls. The owls kept very still, pretending to be stuffed, and Ekle had a good view of the restaurant from the back window out of the hole in the cardboard tunnel, facing the front door. It was such a good view, Lucinda and Saralinda joined him and took a seat by the other hole, observing everything. Just as Sara, Steven, Jam and their dad approached the front door, Sandy and her mother walked out.

"Sara, what a surprise!" said Sandy. "Mom wanted to leave earlier than I realized."

"I thought you were headed towards Raleigh?" said Mrs. Williams.

"We were, but then we had to follow you," said Sara.

"Whatever for?" Mrs. Williams seemed genuinely surprised.

"Because you have my pet squirrel!" Sara blurted out, not able to hold in her feelings.

"She's not your pet!" said Sandy, getting angry. "How could you say such a thing?"

"He is," confirmed Dr. Umberland. "Sara has had him since he was almost a newborn." He was lying, true, but it gave the claim some sense and believability.

"That's ridiculous, Mom," said Sandy. "We both saw this squirrel in the garden last night. I was feeding him peanuts and Sara said squirrels didn't make good pets. She never said Little Missy was her pet. She just wants Missy for herself, because she saw how special she is! She's lying!"

"He *is* my pet, though he really belongs to himself and furthermore, he's not a she!" said Sara getting exasperated. "His name is Apkin."

"Can you prove it?" said Mrs. Williams. "My daughter is so fond of this little squirrel. I never thought I would have agreed to a pet squirrel, I'm not fond of pets, but Missy does seem so tame and smart. Sandy is so enthralled with her. I'm really quite impressed with her as well."

"Of course they can't prove it, Mom. The squirrel can't talk and I know they're lying. Let's just get in our car and drive away!"

"Now wait," interrupted Dr. Umberland. "Just hold on a minute and I think we can prove the squirrel belongs with us."

"Yes," added Steven, "Doesn't the fact that he's so tame with you show you that he probably grew up with people?"

"That is a reasonable point," responded Mrs. Williams, being reasonable herself. "He is exceptionally tame or I never would have considered this."

"If he's yours," Sandy said sarcastically to Sara, "why didn't you say anything to me last night out in the garden?"

Sara had to think on her feet. "We were going to sneak both squirrels into our rooms after dark. He has a brother. We knew the manager wouldn't allow squirrels in the rooms, so we let them run free for a while until we had a chance to sneak them in. We do it all the time when we travel."

"Oh, sure, sounds like what everyone does with their pet squirrels."

"Show them his brother," suggested Jam. "That will prove it."

"That's a great idea, Jam," said Dr. Umberland. "Sara, hon, why don't you go get Ekle."

Sara returned with Ekle in her arms and Mrs. Williams and Sandy gasped.

"You see," said Sara. "This is Ekle, Apkin's brother, and he misses Apkin very much."

Mrs. Williams finally nodded in acquiescence. "Yes, this certainly does seem to prove it. It looks as though the squirrel does belong to this family," she said to her daughter.

"I don't care if she has a brother. I want her, I mean him. She has one, and now I have one. You lied to me, Sara, and that's why all this happened. If you'd told me he was your pet, I would have understood. Let's just leave, Mom. What are they going to do? Chase us all the way to Grandma's and call the police?"

"We might very well have to do that if you don't see reason," added Dr. Umberland with authority.

"I'm really sorry," said Sara. "I didn't mean to lie. I didn't know you and it seemed the safest thing to do. I'm really sorry now."

"Me too," added Jam. Maybe the Williamses would see reason if they apologized. They did have some responsibility in this after all, and they hadn't used the clues of her dream very wisely.

"If you bring Apkin out," Sara continued, "you'll see how the brothers love each other and you won't want to separate them."

Mrs. Williams seemed torn. "Okay, let's see how Little Missy, Little Mister, responds to this other squirrel, Sandy. If they seem to know each other that well, we'll have to give him back to the Umberlands."

Sandy sulked as her mom unlocked her car and took out Apkin who was lying quietly in a big flowery hat box. When he saw Jam and Sara with Ekle, who was now on her shoulder, he leaped up and was out of the box and in Sara's arms in no time. Ekle and Apkin bumped noses in the joy of reunion. The girls fussed with them and they nuzzled the girls in return.

"Well I guess that says it all," concluded Steven.

"There's no choice," Mrs. Williams said with resolve to her daughter. "The squirrel is theirs. But that should teach you something about lying, young ladies," she addressed Sara and Jam. "I guess I couldn't offer to buy them both from you? she added.

"Not for a million dollars," said Sara.

"I didn't think so. Sandy, honey, let's go."

"Can I have a dog or a cat then?" asked Sandy, getting in the car without even saying goodbye.

"Well, I guess we'll have to get some kind of pet," they heard Mrs. Williams say as she got into the driver's seat. In a moment, the yellow Volkswagen pulled away and disappeared down the highway.

The Umberland family and Jam got back in their car with Ekle and Apkin. Everyone was overjoyed and Saralinda chanted in delight, "Apkin's back, Apkin's back!"

"I can't believe they thought you could be a pet!" said Ekle, patting his brother's back

"None of you are pets!" confirmed Jam.

"You're right," said Ekle. "We are our own free selves."

"And I'm sure glad of that!" said Apkin. "My life would have been awful. She was trying to tie a scarf around me! It hurt!"

"That's outrrrageous," piped up Hool. "You humans do the most affrronting things!"

Of course Lucinda had to invent a poem of joyous reunion as they made their way back toward Raleigh, so it would stay perfectly remembered in her storage of memories.

"We lost our dear friend,
We'll try to explain.
He was picked up
And boxed and
Completely renamed,
From a he to a she
The kidnapper
Had titled,
Our Apkin the squirrel
Was now Missy—
Her idol!

For the culprit, a girl,
Made Apkin her pet.
She lured like a spider,
Right into her net.
Then she loved him
And pet him
Till he let out a cry,
'If I don't get away
Then from love I will die.
I've been worshipped
Until I can't take it at all,
I feel so depressed
I'm curled into a ball.
She can woo me forever,
But my love she won't claim,
And I certainly won't answer
To 'Missy'—insane!'
So for Apkin our friend
We searched till we dropped,
In our car we pursued them
Till they came to a stop.
Then we pressed them and argued
Till our point was full won,
We were lucky that thief
Had forgotten her gun!
We claimed him for ours!
We proved him our own!
We freed him from worship
And brought him back home!"

The day had taken a strange turn, and they were way off schedule. But they all knew what the next stop was meant to be—the Haw River and Vinetropeland!

THE HOMECOMING

hey were closing in on their destination. Because of the "kidnapping" of Apkin, they would arrive later in the day than they had planned. Everything was wet and muddy from the night's heavy rain as they approached their goal. Their excitement grew and overpowered any sadness they would later feel when it was time to say goodbye. Right now they sang and were merry. They had made a plan, stuck to it and would now soon reap the reward. As the winter sun began to sink into the late afternoon landscape, they turned off the highway and onto back roads heading for a remote edge of the Haw River. They made a final turn, onto a muddy dirt road that seemed to go nowhere, and the GPS system no longer registered their cell phones. Steven was driving.

"Does any of this look familiar?" Sara's dad asked Owletta and Hool.

"Well, not yet," said Owletta. "But I didn't come by car."

"Doesn't look quite *r*right to me either," Hool added, "but we should be getting close. I can't tell from inside the *c*arr. It's not the way I normally *tr*ravel. I can't get my bearings in h*err*e!"

"Then, dear, what do you suggest?" asked Owletta.

"It feels to me like we are on the wrong side of the *rr*iver, but close. Flying is a lot different than *dr*riving." He shrugged and fluttered his wings a bit, blowing a breeze into Jam's face. "I would need to get out."

"Why don't we concentrate on getting down to the river first? It's got to be near," said Lucinda.

"Okay," said Steven, "let's make our way down. I'll get us as close as I can."

An opportunity arrived shortly thereafter and they made a turn onto an even smaller dirt road that cut between fields of tall grasses. There were many potholes and puddles and the muddy water splashed up onto the sides of the car and onto the windows. The road was a mess and it wasn't cold enough for the muddy slush to freeze. This was not a road meant for cars. Maybe locals used off-road vehicles or motorbikes down here, but obviously no one came this way much. The road led them to a dead end with nothing in front of them but more brush and weeds, no river in sight.

"Boy, this really feels off the beaten track," commented Dr. Umberland.

"It's not much more than a track," said Steven, his hands tense on the steering wheel.

"Maybe we should get out and look around now," said Ekle, his head out the window, peering all around.

"We will, boys," said Dr. Umberland, "but let's get out of this muddy dead end first."

"Nice and peaceful," said Hool, seeing it somewhat differently. "I'm su*rre* I can find my way to the vinet*rr*opes if I take to the air. Here is as good as anywhere."

"I don't know. It's getting dark," Dr. Umberland began to change his tune. "It might be fine for you owls, but it's getting kind of late for us humans to be tramping out in the mud. Maybe we should call it a day. We can come back early tomorrow and have all day to explore."

This suggestion did not go down well with most of the passengers. Ekle and Apkin complained mercilessly, and

Owletta and Hool insisted that they could find the way instantly, if they just got out and flew around for a few minutes. The girls were anxious to push on too.

Lucinda remained calm, but her heart was beating wildly. "I had so hoped to be there today, but I don't want to put anyone at risk." She was being considerate of Dr. Umberland's concerns and didn't want to aggravate them at the last minute. "It's getting dark. Maybe we should find a place to stay and come back in the morning."

That seemed to calm Dr. Umberland and make him more agreeable. "Okay, everyone, we'll give it one more shot, see if we can find the river, and if we don't have any luck on the next road, we'll call it a day."

They turned the car around carefully, avoiding the potholes as much as possible, and made their way back up the mile of bad road to the larger dirt road they had turned off. Five minutes later they came to another road that looked worth trying. Steven took the turn.

"Here we go," said Sara as the car went over a big bump and splashed some muddy water up onto the windshield. Saralinda laughed. "Weee! Fun. I like big bumps," she called, her little arms going up and down.

"What a mess!" observed Steven. "Keep the windows up, boys."

"Lots of mud," commented Apkin from the back window. He put his tongue on the glass and pretended to lick the mud.

"Let me try," said Ekle and started licking too.

The car went over another bump and now the road began to descend quickly, weaving to the right and left. The landscape opened into a field with some willow trees scattered about. After one more sweep to the right the river came into view. A cheer went up in the car.

"Thar she blows!" cried Sara dramatically.

"Open the window," urged Hool. "I want to get a sniff of the ai*rr*." Jam and Sara each opened a back window.

As Sara's opened, the car hit another puddle, splashing dirty water on her hair and face. She brushed the water off her cheek, as Hool and Owletta each leaned toward the incoming air.

"Smells like home," Hool announced.

Another shout of joy went up.

"Almost there," shouted Steven.

"Go carefully," said Lucinda, but you could hear the excitement in her voice. Saralinda kept lifting her arms up and down with the bumps.

The river was a wide belt of late afternoon shadows, a mixture of purples and smoky gray blues. It was often a soft and gentle river, but right then it flowed quickly, swollen with the heavy rains of the previous night. They reached the river's edge and Steven brought the car to a stop, right next to a lovely old willow that hung over the water's edge. They all got out and immediately their feet sank into the mud.

"Yuk," said Sara. "My sneakers are a wreck!"

"My socks are too!" said Jam.

"We should have brought wellies," acknowledged Dr. Umberland.

"I have boots in my duffel bag," said Sara. "I'm going to change into them and throw these sneakers into a trash bag in the trunk."

"I wish I'd brought some boots," said Jam.

"I'll circle around for a bit and get our location fixed," said Hool, ignoring the complaints. In a moment he was gliding over the river. Owletta watched him soar with pride. She loved that owl.

By now the daylight was waning fast.

Ekle, Apkin and Owletta didn't pay much attention to the mud. In a moment they were all in the upper branches of the willow tree, stretching their legs and wings and commenting on the tranquility of the spot.

Lucinda, with Saralinda, now in one of her mom's deep pockets, leaped onto the trunk of the willow and made her way up to the first branch, inchworm style, where she settled, feet dangling, and looked out over the water. She had worn her birth dress for the homecoming, not such a good idea in all this mud. But of course the dress would self-clean. Sara, boots on, made her way over to the tree and climbed and joined Lucinda on the branch. They sat side by side and gazed out over the water.

Jam, whose sneakers weren't going to get any cleaner till they reached a hotel, went down to the water's edge and looked up and down the river.

"It's moving pretty fast," she called and threw in a couple stones.

Steve joined her and tossed in some pebbles himself.

"We should have called it a day an hour ago," Dr. Umberland returned to his worries, calling up to the others in the tree.

"Well, we're here, Dad," said Sara. "We should make the best of it."

Dr. Umberland nodded. "I'll check the snack bag."

Hool didn't return for about an hour. They were just getting worried when he swooped in. He was excited, and took a moment to catch his breath. "We're prractically there, if only everryone could fly. The vinetrrope city is just across the rriver, but on the other side! I had to discuss the plans with Chantrrek."

Everyone gathered around him.

"That's annoying," said Jam, squishing up to them. "Wish we had a boat!"

"True, but vinetrope boats would be too small to carry you," Lucinda realized as she thought about it.

Hool was breathing calmly now. "Chantrrek is so thrrilled, they all are. You should see them! Well, you will. He said we should get back to the paved rroad drive north and take the turn that says Willow Brridge. It's about a mile from here. The bridge is a footbrridge, not for cars."

"So we'll have to get out and walk?" asked Sara.

"That's how it *should* be," said Lucinda, smiling.

Hool fluttered his wings. "There are no roads for cars on the other side of the rriver. Yes, you'll walk, cross over and make your way back down. But rremember, only those of us going to Vinetrropeland. Chantrrek wanted me to remind you, only Sarra can come."

There were some complaints and mutterings, but everyone knew the facts.

"We know Willow Bridge," said Ekle and Apkin nodded with excitement. "It's near our old tree."

"Yes," said Apkin, his tail whirling. "I didn't remember it was called Willow Bridge till now!"

"Wonderful, boys," said Lucinda. "So what are the plans?"

"Chantroute told me that Regata and Selena are at the Glowing Tree, not far from their old home, and will wait for their boys there. In fact, everyone will wait there. When we get to the bridge there will be two guides, one to the Glowing Tree and one to Vinetropeland.

"My Regata!"

"My Selena!"

"You can all visit at the Glowing Trree while you wait for Sara to rrreturn. Owletta and I will head back to the vinetropes

once we get to the Willow Bridge, and help with preparations." Hool turned to Owletta. "And, my dear, you will be happy to hear, Cobcaw and Skitter and his whole family are now living at the Glowing Tree too!"

"How wonderful!" Owletta beat her wings with joy.

"We're almost there!" said Lucinda, wistfully, like she still couldn't believe it.

Sara was feeling the same. She was thrilled and felt like crying at the same time. "Lucinda, we've done it, we've brought you home."

"So now what do we do?" asked Jam.

"Get in the car and drive to Willow Bridge," said Steven.

Dr. Umberland took the driver's seat and everyone scrambled back in. He turned on the ignition and put the car into reverse, but something was wrong. The wheels kept spinning uselessly and the car wouldn't budge. It was stuck in the mud.

"I was afraid this would happen!" he shouted. He put the car into drive to pull forward and the same thing happened. "I just knew it was a mistake to do this so late in this muddy mess." He got out of the car and slammed the door shut, angry.

"Steven, you take the driver's seat. I think I've got some kind of gizmo in the trunk to put under the wheels."

"Okay, Dad."

Steven sat behind the wheel while his dad went around to the trunk. He had to pile half the luggage out of the trunk onto the muddy grass in order to get to the supplies at the bottom. Along with a tool kit, a med-kit, a jack, a rope, a portable battery-operated lantern, a snow scraper and a couple of flashlights, he found the two plastic traction grids— devices meant to overcome skidding by giving the wheels some traction.

"I found them," he said holding them up. "Okay, Steven, I'm going to put these things in place and when I give the word, put the car in reverse and go for it. It looks worse up front, so we'll try reversing first."

"Okay, Dad."

Dr. Umberland piled the luggage back into the trunk, so they'd be ready to leave instantly if they got out. Then he opened the grids, which had hinges and placed them under the back wheels. "Okay. Give it a try!"

Steven turned on the motor, put the gears in reverse and drove it hard. For a moment, it looked like it was going to work, the wheels rising hopefully, but then the grids themselves slid sideways and sank into the mud.

"Okay, stop," called Steven's dad. "This mud is awful. The more you stir it up, the worse it gets."

"Shall we try again?" Steven suggested.

"Yes, I'll set them up in front this time. I wish I had a bag of sand. That would help."

"If we had the litter box with us, we would!" Steven laughed.

The owls rolled their eyes.

He placed the now very muddy grids in front, but the mud was so deep and slippery, it was hard to keep them in sight. The mud just rose up and covered them.

"Girls," said Dr. Umberland, "maybe you should get out."

They got out and stood on some flat rocks off to the side.

Dr. Umberland lifted up the grids, and placed some stones in the mud in front of the wheels first. Then he laid the tracks down on top of the stones. The squirrels and owls and Lucinda were looking out the windows. Saralinda was on Lucinda's head, tangled securely in her hair.

"Okay, hit the gas pedal!"

Steven gave it his best shot, the wheels spun, but they were not going anywhere. The mud had them trapped.

Lucinda opened the window. "I'm afraid it's not going to help."

"We'rre stuck!" Hool confirmed. "Thank goodness for wings!"

"I wonder how far we are from the nearest gas station?" asked Steven.

"Pretty far, I would say," said Dr. Umberland.

"Well, Hool, it seems we will all have to walk to Willow Bridge," Lucinda threw up her hands.

"Maybe the bridge gets some foot traffic and we'll meet someone who can help," said Dr. Umberland.

"Yeah," said Steven, "we have to get the car out eventually."

"I'm sure once we get to my people, they'll know what to do," said Lucinda, checking her vines as Saralinda moved about on her head.

"Where am I Mommy? I'm over here!" Saralinda teased, "Peek-a-boo!"

"I'll have someone from our city meet you at the bridge. We may be little, but as a group we can do a lot!"

"Well, I don't think we have a choice," said Dr. Umberland, throwing up his hands. "We're in the middle of nowhere on something that can barely be called a road. We could sit here till *next* December before anyone came along. We'll head for the bridge by foot and then you'll let them know the situation."

"And what about your supplies?" asked Sara, pushing her damp hair back, "the cradle and the clothing?"

"Or the stuff for you, Dad, the root samples from here and the vinetrope water?"

"We'll figure it all out," Lucinda said with assurance.

The car was locked, and everyone donned their jackets. Steven flung a backpack of water and snacks over his shoulders, and he and Dr. Umberland each grabbed a flashlight.

"We'll just follow this footpath along the *rr*iver," Hool instructed. "It *rr*uns the same way as the *rr*oad and it will end *rr*ight at Willow B*rr*idge."

"Perfect!" said Steven, adjusting his bag for the walk.

Ekle and Apkin kept running ahead and Owletta and Hool flew from tree to tree and came down once in a while to assure them they were going the right way. Lucinda sat on Sara's shoulder, so they could move at the same pace, and Saralinda was happily tucked in her mother's leafy hair, enjoying everything from her perch. Sara insisted it was no trouble to carry them—they weighed almost nothing, despite the fact that Saralinda had continued to grow. She was all of five inches high now!

The world around them was brown and black and through the brush they caught glimpses of rushing river, gurgling along swiftly, swollen from all the extra rain it had received during the night. Lucinda kept her glow up full force and it lit the way sufficiently with the addition of the two flashlights. The footpath was narrow and became less muddy once they left the car behind. They made a slow climb, until they were elevated above the river. The view was lovely and the ground was dry and it wasn't that cold. Everyone's spirits rose.

"You know," said Lucinda, from her perch on Sara's shoulder, "it's kind of fitting that we walk the last mile. In all the great legends of vinetropes, the heroes and heroines are always on foot making their way to their final destinations."

"Yes, just think of Bilbo in *The Hobbit*, or for that matter, anything in *Lord of the Rings*," said Steven, who loved those books.

"I don't know that story, but I will check it out when I have a chance," then Lucinda laughed, "though I cannot really say that I am actually walking!"

"I love carrying you. This might be the last time for a long time, Lucinda."

"Someday we'll walk together again on an even bigger adventure," Lucinda whispered in her hear, out of earshot of Dr. Umberland.

Ekle and Apkin kept darting back and forth and Owletta and Hool patiently waited for everyone.

"I know where we are!" Ekle called out excited.

"Yes, me too," said Apkin. "This is home. We're getting close. This is close to our old oak tree."

"Lucinda," Sara whispered sadly, "this will soon be goodbye. Somehow I didn't believe it was going to really happen."

"For me too, Sara; this is my greatest dream come true, except for not being able to live near you. But there will be a way for us to reach each other. That I promise!"

They came to a turn in the path and discovered a cluster of tiny pink flowers growing in a patch of bright green grass. The air smelled sweet, like springtime, despite the time of year.

"This must be the work of my people," said Lucinda.

"Sprinkling fairy dust?" Jam teased.

Maybe so, thought Sara. She was remembering the glowing dust that Lucinda's skirt had turned into inside her pocket.

The path came out alongside the river and they could see the bridge ahead of them.

"There it is!" cried Apkin.

"Let's hurry," said Ekle.

The boys were on the little bridge in no time. It was worn and old and in need of some repair, but looked safe enough for crossing. Sara, Jam, Steven and Dr. Umberland arrived soon

after and Owletta and Hool were waiting for them, perched on the railing. They all looked out at the water for a moment. Lucinda put her arms around Sara's neck and Saralinda tickled Sara's head with her feet. Some winter stars twinkled at them and the night sky was a deep navy-black.

Just then the party of friends heard the most beautiful music. It was the sound of a pipe, like something between a flute and a clarinet.

"What's that wonderful music?" asked Sara.

"That's a glintlight pipe," exclaimed Lucinda with delight. "I've dreamt of this music, but I never thought I'd actually hear it."

"Then it must be a vinetrope playing it!" said Jam.

They all turned and crossed the bridge.

Lucinda was so excited; she slid right off Sara's shoulder with baby Saralinda holding on and stood in front of the group on the other side of the bridge. The enchanted music came closer as they waited, and soon two young vinetropes came into view, one, a boy, playing an odd pipe that looked as though it were made of a dried pumpkin stem. The other was a girl. The musician was dressed in a pale yellow tunic with brown leggings, the girl in a long blue tunic with yellow leggings.

They stopped short in front of Lucinda.

"Lucinda Vinetrope, our Master Rhymer, is it you?" the boy spoke up.

"It is, it is, I am here!"

The three vinetropes smiled at each other and embraced while Saralinda dangled in her mother's hair, trying to reach the pipe. Both mother and daughter were glowing with both happiness and their golden/orange internal glow. Sara, in that moment, could see that as good-natured as Lucinda had always been, she was not truly happy till this very moment.

A fleeting stab of jealousy crossed her heart. Then it passed into joy for her friend and became that sweet-sadness that was by now so familiar to her.

"I am so happy to be home," were all the words Lucinda needed to say.

"Welcome! All of you—you don't know how excited we all are," said the vinetrope girl. "My name is Feylanda Fernroote and my brother here is Glintel."

"And you have a child, a Glower," the piper excitedly observed. "This is a double blessing to our city!" He bowed in greeting to the little child and she reached out and touched his cheek. "More music please!" she said and everyone was delighted.

He piped a couple notes. "This is such good news. But please, excuse me everyone. I am the head musician of our growing population, with a number of talented young students under my tutelage, I might boast, but today I've been sent to guide Lucinda, Sara and …"

"Saralinda!" Saralinda said for herself.

"Saralinda to our city, or what we like to call Vinetropeland."

"And I will guide the rest of you to the Glowing Tree," explained Feylanda.

"You must be Sara," Glintel nodded to her.

"Yes, and this is Jamuna and my dad, Dr. Umberland, and my brother Steven.

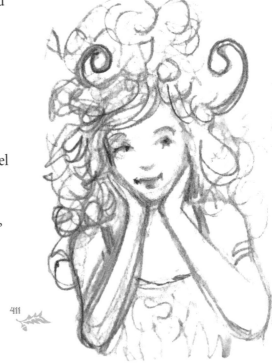

"Chantroute and our whole city is grateful to you all," Glintel made a little bow, "for bringing our missing member home to us. But you do all understand that we will be keeping the visit just to Sara today?"

Everyone acknowledged that they understood.

Ekle and Apkin jumped about, trying to get some attention, but not knowing what to do.

"This is Ekle and Apkin," said Owletta, "the squirrel brothers I've talked so much about."

"They will be living at the Glowing Tree, with *Rrregata* and Selena," said Hool.

"It is a pleasure to meet you," said Glintel.

Feylanda pet their heads.

The boys bobbed up and down.

"We're glad to meet you, too," said Ekle.

"Though we were scared the first time we saw a vinetrope," added Apkin.

"Before our barrel misfortune," finished Apkin.

"Yes we know the story well," Feylanda shared. "Owletta told us all about it. We vinetropes have a lot to thank you for, too."

"I bet, when the humans are gone," whispered Apkin, "we'll get to go to Vinetropeland."

"Shall we leave then?" asked Feylanda.

"Before we leave," said Lucinda, "we need to explain to you a bit of a complication to our arrival." She told Glintel and Feylanda about the car. Sara reminded Lucinda of her supplies in the trunk, which would also need to be transported.

"Not to worry," Glintel assured the group. "We will solve all this by the end of the night. We have rafts and boats and very sturdy mats that can be used for traction for those poor wheels. The car is right across the river from what Hool told us."

"Yes, that is *rr*ight," confirmed Hool.

"We will resolve everything. Leave it up to us," Glintel raised his hands in a gesture that meant it was as good as taken care of.

"And at the end of the evening," assured Feylanda, "I will guide Sara back to the Glowing Tree where you can say your goodbyes to Ekle and Apkin and Owletta and Hool."

"Yes," assured Owletta, putting a wing one wing around Sara's leg and the other around Jam's. "We will come back with you at the end of the evening and say our goodbyes.

"And you will see our home," Hool added with pride.

"May we leave now?" asked Ekle.

"We want to get home already and be with our sweethearts!" said Apkin.

"It's getting too hard to wait any longer," added Ekle.

"We plan to start a family," Apkin added.

"Yes, I can understand your hurry," laughed Glintel.

Everyone laughed.

"Of course, boys, we've kept you too long," said Feylanda. "Please, everyone, follow me."

"Wait!" Steven called out, suddenly seeming upset. "Lucinda, you're staying In Vinetropeland? You're not coming back to the tree? This means goodbye right now for the rest of us," he said solemnly.

"Steven, you are right. This is goodbye for now. I will miss you a lot. We have had some great times, Steven!"

"I'll never forget the night I met you, Lucinda, sitting in the trick-or-treat bag and ordering me around."

"You needed some direction. You were very confused."

"I was. But not as bad as Dad."

"That is very true. And I will never forget how you rescued me from the sewer."

Steven bent down and gave Lucinda a kiss on the forehead. "Take good care of that little girl of yours. She looks twice the size already."

"I will."

"Bye-bye, Stevie," Saralinda spoke right up, giving him a nickname.

Dr. Umberland bent down, his eyes were moist and he shook Lucinda's fuzzy hand and gave the baby a gentle hug with his thumb and forefinger.

"She's amazing, Lucinda, and so are you. But it is time we left you with your people."

"I will get you those supplies," said Lucinda to Dr. Umberland. "It will be arranged and brought to your car before you leave in the morning."

He nodded. "I'm very hopeful about the outcome. And it's a relief that you'll be with your people where you belong."

Jam stepped forward and looked heartbroken. "Lucinda, you were the first one to really believe in my dreams. You showed me and the others how to believe in them. I'll never forget you or what you did for me. Whenever you need me, let me know, I'll always be ready to help."

"I know that Jam. And I will call on you. And never stop believing in yourself."

"I won't."

"And share your dreams. Let the others know."

"I will."

Saralinda called out, "Jam, Jam, come visit me!" Jam started to cry a little. She gave Saralinda her finger to hug and then she kissed Lucinda good-bye.

Apkin started to cry too. All this emotion was too much for him. "I'll miss human fingers," he began to sob.

"No, don't cry *now*! We're all meeting at the Glowing Tree before they leave!" said Ekle. "You don't have to cry until later."

"That's right!" said Apkin joyously. "And you'll still get to meet Selena and Regata, later, Sara! It's all too much." He seemed to be laughing and crying.

Sara bent down and the boys bumped heads with her.

"Can we finally go?" asked Ekle.

"Yes," said Feylanda. "Follow me."

The boys scampered away at such a speed, it even surprised Glintel. Then they came right back.

"We don't know where we're going," said Apkin.

Feylanda laughed, and as the first group parted and made their way to the left, she told them of all the lovely preparations that had been planned for them on their arrival at the Glowing Tree.

There were heavenly refreshments and Selena and Regata had been decorating for days anticipating their arrival.

"Come," said Glintel, "we should get started too."

"We'll meet you therre," said Hool. "I would rrather fly than walk anytime." And the owls took to the sky.

Sara, Lucinda and Saralinda followed Glintel to the right.

"I hope my dad will be okay with my being gone so long," Sara called down to Lucinda who was walking at a fast clip in front of her on the path. Saralinda, on the top of her mother's head, kept waving up at Sara.

"Have no worries about your dad tonight. He will hardly know that you are gone. It seems my people have prepared a special evening for them at the Glowing Tree. I am not sure exactly what it is, but it will all go well. You will see in the morning."

"The morning!"

"Why yes, I am sure we will be busy all night."

So Sara relaxed and began to get excited about entering Vinetropeland. She had to walk quickly to keep up with Glintel, who walked twice the speed of the average human

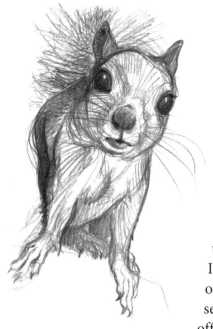

even though he was so much smaller. Was he flying a bit? Lucinda was walking very quickly too, faster and faster.

"Lucinda, I've never seen you walk so fast. How are you doing it?" asked Sara.

"I am not sure! This is a surprise to me. It is a bit like gliding on air. I think this is a new skill for vinetropes or I would have remembered it. There seems to be a kind of static coming off my feet and the ground; maybe the earth has changed? It is like I am in sync with some energy field, a rhythm of positive and negative charges between my feet and the ground. It helps me glide along!"

"It's like you're flying for short distances." Sara realized. "Maybe you will fly in time! Like in all the fairy tales."

Glintel looked puzzled. "This is how we all walk. I thought it was normal for vinetropes."

Lucinda looked puzzled too.

Now they took a path that made a sharp turn away from the river and entered a deeper thicket and then a wooded area. Lucinda turned up her glow, so they could see better into the darkness.

Glintel played his pipe and led them further into the wild.

"I have heard music like this a hundred times in my dreams and now I am actually hearing it," said Lucinda.

"Look, a light!" Saralinda called out, pointing up ahead.

"Just a short way to go," called Glintel over his shoulder.

The ground felt particularly soft and spongy under Sara's feet, and where the glow from Lucinda touched the ground, they could see that the grass was a brilliant green.

"This is it!" said Lucinda. "We are walking over the city right now!"

The back of Glintel's head bobbed up and down in answer.

Everything smelled clean and spicy.

"Yum! It smells like home." Lucinda skimmed along and flitted about, with Saralinda riding her mother like she was her pet horse.

Directly in front of them loomed the largest willow tree Sara had ever seen. There was a fabulous glow coming from the base of the tree. From where they were it looked like the moon was tangled in some vines. A few steps more and Glintel came to a stop. A mass of vines tumbled down from the tree right in front of the nearly round and brilliantly lit entrance into Vinetropeland. Owletta and Hool were waiting for them by the opened door. A tall male vinetrope, at least fifteen inches high, stood next to them.

"This is Klent Abo *Rrrootroupe*," Hool introduced Sara and Lucinda to Klent. The owls, of course, already knew him.

"Lucinda, I'm overjoyed to have you home with us!" said Klent to Lucinda, bowing and smiling. They both embraced. "And this is little Saralinda, I can see. Hool and Owletta just gave us the good news. And you must be Sara," he bowed to Sara as well. "Step inside and watch your head, it gets much higher soon."

Lucinda and Saralinda entered first, with Klent and Glintel on either side. Owletta and Hool were right behind.

"I'll be staying here for now," said Klent. "I'm on duty at the front entrance again."

The others moved quickly down a short incline and were then in a much larger glowing hallway. Sara heard the door shut behind her. The walls and ceiling seemed alive with light.

"It's beautiful!" said Sara.

"It's wonderful and beautiful and smells like home!" said Lucinda.

Saralinda sat in her mother's hair, clinging to her vines, her eyes wide open and she kept sniffing the air. "Smells like home," she repeated her mother's words.

"Follow me," said Glintel, heading onward, playing his pipe once again. They slowed their pace so Sara and the owls could keep up. Lucinda was looking everywhere, obviously overwhelmed by it all.

This gave Sara time to gaze about in wonder too. She took in all the same amazing details that Owletta had told them about. But seeing it was way beyond hearing about it. Now this was an adventure! She tried to notice all the details, the variety of colors that the roots glowed in, the intricate details and patterns the vinetropes were able to sculpt with the living roots, the fresh warmth of the air, the breezes that blew through the hall, keeping everything clean, the wonderful fresh smell. But It was impossible to absorb this much beauty in a single passing, a single visit. All of it delighted Sara, and delighted Lucinda even more.

"It is just right, it is just perfect," Lucinda kept saying. "It is truly home. It is what my memories have tried to show me."

Then they heard music up ahead.

"Something I composed in your honor, Lucinda," Glintel stopped and turned to say. Then he stepped forward and his piping blended with the music up ahead. The melody soared. It was a sound so moving and splendid that Lucinda began to cry with joy and Sara felt so much that she thought she would burst.

They arrived in the Great Hall, in a wave of music, with the whole town there to greet them. Chantroute came forward and Lucinda stepped up to greet him. He was glowing blue,

so she knew who he was: the Healer. They embraced, and the crowd gave a cheer of such welcome that Lucinda began to positively sob. The voice projection system that Owletta saw in use on her first visit was on, so that everyone could hear.

"My vinetropes, my vinetropes," spoke Lucinda. "There is no way I can begin to tell you how happy I am to be here. And I would not have had the courage or the ability to persist in my search for you, if it was not for my dear friend, Sara."

"To Sara, to Lucinda and her newborn daughter, Saralinda!" cheered the crowd. They had all been informed of the baby glower. They lifted glasses into the air while the musicians played. Sara and Lucinda were offered glasses filled with a pale green liquid. Sipping bowls made from hollowed gourds were provided for the owls.

"Our city is now complete! Vinetropeland is here! A nation in the making!" announced Chantroute Wayforth to his people.

"May we grow and find our place in this world," he continued. "Let us drink to our Master Rhymer, who will give us our history and shape all our legends so we can live with meaning. And let us also drink to our first human friend, the child, Sara."

A cheer went up and everyone toasted. The drink tasted at once cool, sweet, spicy and rich. Sara knew she would find it impossible to describe to her family and Jam afterwards, when they asked her about her experiences. It was not possible to explain any of it as it really was. It was its own reality.

"I want to make a special toast to Sara, my dear Sara," said Lucinda, lifting her arms high, her glass in one hand and the fingers of the other fluttering like little wings. "I believe, when the time is right, Sara will be the link between her world and ours. She will lead us into a safer future. But we will have to

fight hard for that future and we will not be able to succeed without Sara. I would like to make this toast a special naming ceremony for Sara. It is a name that means Sara the One Who Connects Worlds, in our language: Sara A Vittendo Krowenda!"

"To Sara A Vittendo Krowenda," the crowd cheered.

"Do you accept your name?" asked Chantroute the Healer.

"It is in Vinetropese," explained Lucinda,

"I accept," said Sara, overwhelmed, certain that this is what she must do, scared but certain. Her father would not like this!

"Yes, I accept," she said again firmly.

"To Sara A Vittendo Krowenda," cheered the crowd.

"This means we will call on your advice and your help when we need it," added Chantroute. "Can we count on you in the future? Do you still accept the challenge now that you understand it?"

"Definitely, absolutely, we're all in this together," announced Sara to the crowd.

"We are, Sara." Chantroute looked into Sara's eyes, his small face calm but serious. "And you can count on our world of vinetropes to be there for you." He then took out a pouch and removed a speck of dust, a particle so small and clear that you might hardly see it If it didn't catch a gleam of light. "This is an unfertilized seed of a vinetrope. If you swallow this, you will be connected to our world forever. You will be part of us."

Sara turned to Lucinda. She smiled, "It is completely safe. Any vinetrope can tell if you have this seed of vinetrope in you, and he or she will always be ready to help you."

Sara put the spark of light in her mouth and drank from her glass. She was now a part of the vinetrope world forever.

The crowd cheered even louder, if that were possible.

Owletta and Hool cooed and clucked. They were so proud of their two friends, Lucinda and Sara. They were proud to be part of this incredible change taking place on earth: the return of the vinetropes, the return of the little people who held so much wisdom of body and mind, of nature and soul. They were as proud of Sara and Lucinda as if they were their own two children. And this in and of itself was a miracle of feeling. For when had owls ever come to love and respect humans and beings called vinetropes? When had different creatures ever tried to unite in a new way of living? Well, never.

The fountain was splashing clean well water from its trumpet flower jets into its many elegant tiers and at the same time, mysterious globes of vinetrope light floated across the ceiling in a slow swirl of changing colors. Bouquets of dried and fresh flowers spilled out of vases on the walls that also looked like trumpet flowers. And in-between the vases, the roots on the walls had been designed to weave a pattern of flowers, vines, bees and butterflies. Among this beauty, Chantroute spoke.

"Will you recite your first rhyme to your people? he asked, smiling.

"Of course!" Lucinda handed Saralinda to Owletta who took her under her wing. Lucinda stood in front of her people, ready to recite her Homecoming Poem.

She closed her eyes, and lifted her arms.

> "Let there now come a sprouting
> To last through all time—
> So that old growth and new growth
> Will make a strong vine.

May this growth heal us all
As it spreads through our roots
May this vine touch our souls
And bring us the truth.

Let this growth keep on growing
And connect all with light
And give us the courage
To survive the Dark Night."

Many vinetropes started to cry. Their Master Rhymer was home. Lucinda was crying too, and smiling, and Sara hugged Lucinda. Everyone applauded.

"Bravo," called out Owletta and Hool.

Everyone toasted Lucinda and seemed excited to know that they all would play a role in this newly evolving world.

It was a good time for Lucinda to explain why she wanted to give Sara's father some samples of mature vinetrope roots and water. She explained that Dr. Umberland would not reveal where he got the original samples from.

"The samples can easily be arranged," said Chantroute. "Fantella and Jetro, would you collect samples tonight and have them ready for Sara to take to her father when she leaves?"

Fantella was a young female vinetrope with deep red hair and pumpkin-colored skin. She was a scientist and had taken it upon herself to study all the new and mysterious vegetation that surrounded them since their return to the world. Jetro was an engineer and he worked with Fantella, implementing new ways to grow and harvest these new food sources in their community.

"Yes," said Fantella. "I can pack samples in three or four root sacks and have them ready by the time Sara leaves."

"The liquid has to be free from contamination," said Chantroute. "It needs to be pure."

"No problem," said Jetro, whose short green hair looked like a crop of thick grass. His skin was a pale green and he was very animated. "I've engineered some of the roots to produce a thin, clear, strong fiber. It can be woven into a fabric or, when baked in a root oven, it hardens and can be shaped into tubes, cups and containers that are extremely strong and shatterproof. The drinking glasses at this celebration are made from it. I'll make sure my team sanitizes several tubes before filling them and we'll seal them with hot wax as soon as they're filled." Jetro was very efficient.

"That's wonderful," said Sara. "I can take them to my dad when I meet him at the Glowing Tree."

While they spoke and exchanged information, other vinetropes went into their homes and in short order the front doors opened and out came tables, chairs and then trays of delicious-smelling food, just as it had for Owletta's first visit. Everything was set up around the perimeter of the hall, leaving room for dancing. They had one extra-large table that was used in their market for nuts and vegetables; it was covered with a lacey root tablecloth and was the size of a long human table but on low legs so that everything would be reachable for vinetropes. Here Sara was asked to sit, but to do so she had to sit on the mossy floor with her legs crossed in front. It was fine. With her was Lucinda, Saralinda, the owls and the vinetrope council, which of course included Chantroute, Glintel and Fantella. Lucinda sat between Sara and Glintel and faced Chantroute across the table.

"Chantroute is quite handsome, isn't he?" Lucinda whispered to Sara. And as Sara observed him more closely, she saw him more clearly—not as a strange little being, but as

an individual. And when she did, it became apparent. He was indeed very handsome.

Soon platters of food were placed family-style on each table with serving spoons. Plates and spoons were given to each guest and root cloth napkins as well, trimmed with lace and very soft. The drinking glasses were as clear and delicate as cut glass, but, Jetro informed them, not breakable!

"Before we eat, let us open the sky windows overhead," suggested Chantroute. This was Jetro's grand accomplishment. The eighteen windows in the domed ceiling opened again like the inner lids of cats, but this time when they opened, they were filled with what looked just like glass!

"This is spectacula*rr*!" said Hool.

"They look like human windows," said Owletta, looking up at the stars.

"On a cool night like this we can keep them closed and still see the stars and in the fair weather we can open them all the way like we've always done," said Chantroute with pride. "Let us toast Jetro!"

And they all did.

"Now," he said, "let's eat and drink and enjoy each other's company. We have so much to discuss, but not on an empty stomach."

It would be impossible for Sara to describe the foods to anyone, but the flavors were sensational. It was a meal she would never forget and instead of feeling weighted down with having indulged in a feast, Sara felt enlivened and full of energy. She was sure vinetrope water was a regular ingredient.

Music accompanied their dinner and after a time the talk got serious again. Lucinda told the council everything that had happened as she remembered it, from the time she snapped off the vine till her arrival. Sara added information when it

seemed useful. Lucinda also went over much of what she remembered of vinetrope history and their great civilization. This included the relevance of chargons and vinkali to vinetrope history. She explained that she had used human learning methods to figure out that their enslavers were fungi, not plants. That meant they came from spores, not seeds. Her study methods led to some talk of human technology and her sessions on a computer. But most of that she would leave for other times at other meetings! This sharing led Lucinda and Sara into wanting to know the full story of Chantroute's birth, the birth of this small city and everything that had since happened in Vinetropeland.

"Chantroute, I know some of your history from Hool, but please tell me all the details. What did those stones look like? We think they might be geodes. How did this whole city come about?" asked Lucinda, rearranging her dress which had been caught under her legs on the chair. "Hool mentioned the human's garden you sprouted in and how you discovered the stone pods and took on the job of tending to them. We know how I came to be up north in Sara's yard, but we have no idea why I was not born already, two years ago, here with you."

"Yes," said Owletta, "Hool explained some of it to me and when we returned for Lucinda, we shared this with Sara and Lucinda.

Hool nodded and adjusted his feathers with a shake. "Yes, I told them that the maturrity and grrowth of your first vinetrropes was remarrkably fast, just days for the first thrree. But the pace, though still rrapid, has been slowing as your population grrows."

"This city looks years in the making," said Lucinda, the lights in her blinking with excitement. "There must be so much more to understand."

425

So Chantroute told his story, and they all listened with fascination.

"When I first sprouted I was extremely confused. I knew something was wrong. I had memories of a world of vine-tropes, but I couldn't place this memory in a specific time. I just knew that I was alone and it made no sense. I was a Healer but where were my people? I remembered some things as they related to healing, such as food sources to look for and cures for various ailments, but none of the plants I had in my mind were to be found anywhere. Nothing matched the limited memories that I had."

Here Chantroute placed his hands on the table and leaned forward. His skin pulsed a little, a blue glow.

"So I had to make a plan. I was fully grown and had good survival skills. In time I could determine what to eat from these new food sources and after calming down and using my natural investigative skills, which a good Healer must have, I began to examine and make sense of my immediate environment."

"So you looked for clues," added Lucinda.

"Yes. That's when I determined the stone pods all around the place where I grew contained seeds. As one who knows vinetrope botany innately and better than anyone, I recognized the seeds. They were vinetrope seeds. That was a good thing. I also soon learned that the land I was born into was a garden. I just saw it as plant life when I first stepped out, but then I encountered my first humans. I hid and watched them. They seemed unreal to me at first, they were so large and I was very frightened."

"I thought Sara was a giant from our ancient past," said Lucinda. "Giants were large creatures that seemed half plant and half animal, but were shaped a lot like us."

"Then I'm sure you understand just what I'm saying. Well, I observed them and realized this was a garden that they tended and cared for. They lived in a large dwelling on the property and the garden was behind this dwelling."

"A house," said Sara.

Saralinda climbed onto the table at this point and sat in front of Chantroute. She seemed to be listening intently!

"Yes, as I heard them talk, I began to understand their language. Soon I understood what they, and other animals, were saying. This was very fortunate! I had no idea at that time that it was actually a gift that vinetropes possess."

Chantroute held his hand palm up and Saralinda climbed on. He lifted her to his shoulder and she sat down. He continued, "So what I learned was that they had planted the garden themselves and took pride in it. They traveled a lot around the world and this was a home they lived in only half the year. The other half they lived somewhere else—I think, up north. Wherever they traveled, the man would collect interesting stones and rocks and shells and put them in this garden. Some were from a place called a desert, some were volcanic and some from a jungle. I didn't get many details as they spoke to each other about things they already knew and shared. I believe they were a mated pair."

"Married," interjected Sara.

"They mentioned a place called Arizona once, another time a trip to Africa. Not long before my birth they had come back from a trip to another place, I gathered it was very much north of here, called Alaska, to visit glaciers."

"Glaciers," said Sara and Lucinda at the same time.

"Yes, they talked of ice islands, strange life-forms, and many things I didn't understand. I came to realize it was their most recent trip because they talked about it like they had

just returned and at one point the man mentioned the new stones he had brought back with him for the garden; the odd black egg-shaped stones that he thought were most unusual and probably from before the last Ice Age."

Sara, Lucinda, Owletta and Hool all nodded at each other, knowing the direction this was going in.

"This is fitting into the puzzle," Sara commented, fussing with her hair and getting excited. "It's all making sense."

"Yes," said Chantroute, "I realize that now after what you've told me. Our civilization was from before what Sara calls the Ice Age and then we went extinct. But at that time, after just being born, I didn't know any of this. Anyway, this man mentioned how he scattered the stone pods into two matching flowerbeds that he had decorated with crushed red stones. He thought the 'black eggs', as he referred to them, looked pretty against the red pebbles."

Saralinda tried to slide off his shoulder, so Chantroute helped her back onto the table. She rolled across the table cloth to Sara and sat down.

"Continue," said Lucinda.

"This man had no idea that these 'black eggs' contained our seeds. Another time he came out with some other humans and showed them the 'black eggs' in both beds. That's when I realized I needed to collect as many as possible and move somewhere safe, where I could begin planting the seeds without being discovered."

"So you came here to start the nursery?" asked Sara.

"Not at first," said Chantroute, leaning forward again. "I planted three seeds at the edge of the woods, just outside the garden. As you know they grew extraordinarily quickly and were soon adults and able to help me. You've met Glintel and Klent and Fantella."

Glintel and Fantella nodded.

"They were the first three after me. We kept ourselves hidden. The humans often sat out on a flat stone surface, near the flowerbeds, so we checked on the pods at night. There were several more opened by this time, but they were mostly ruined and dried out with dust and debris. Only a couple of the opened pods seemed to have good seeds. We collected whatever good seeds we could. Some of the pods were still closed and still very well sealed. I knew they could probably be opened, but I wasn't sure how."

"About how many in all did you see?" asked Lucinda.

"I counted twenty-six between the two beds, but there might have been more since so many seem to have crumbled. This crumbling process must have just started at the time of my birth, and increased over the next few weeks. I was obviously a good seed that fell into the earth and grew. But most of what was inside had turned to dust.

"That's quite a few pods," noted Owletta.

"Yes," Glintel, joined in, "especially since the healthy pods contained about twenty seeds each. If they had all remained healthy, there would have been hundreds of seeds."

Chantroute took a sip from his glass. "So the four of us collected all the seeds that looked healthy. We needed to find a safer place to start our nursery and then we needed to come back for any of the pods that hadn't opened to rescue them as well."

"And that's when we found this place which is now Vinetropeland," said Glintel.

"We had to make baskets, and then we returned and collected all of the unopened pods and brought them here, where the land felt familiar to us, more like home," Chantroute concluded.

Fantella picked up where Chantroute had left off.

"That's when we started the nursery. Some of the stone pods *did* have good seeds. After examining them more closely, I noticed that many had splits in them. When I pried them open, I mostly found withered seeds, dried and useless. It was unfortunate. The tar glue used to seal them was rotting in this warmer climate. Most of the seeds wouldn't make it. We were lucky we got as many as we did."

'We did well!" Chantroute lifted his hands. "Didn't we?"

"You certainly did," said Lucinda smiling, the lights in her hair blinking like fireflies.

"And now we don't need those old seeds," said Fantella with pride. "We are doing so well, we producing our own new seeds!"

"We do have some stone pods left," said Jetro, "but they are completely falling apart, mostly dust; a gray dust that blows away. There may be a few, still unopened, I'm not even sure. We haven't had a reason to check on them in months."

"A gray dust?" asked Sara, thinking this through.

Lucinda and Sara looked at each other and they both grew alarmed at the same time.

"Could they be spores?" Lucinda spoke in almost a whisper. They were both having the same unpleasant thought.

"Spores," Chantroute picked right up on it. "That's what you said the chargons and vinkali come from, not seeds, but spores."

"What do spores look like?" asked Glintel.

"They might look like a small cloud of dust," answered Sara. "They're light and can be carried in the air till they reach a place that's good for them to grow."

"So they could be spo*rres*?" screeched Hool, his wings automatically lifting at the thought of danger.

"Quiet, my dear," said Owletta. "No need to alarm everyone yet."

"They could be spores, or nothing more than aged seeds. Seeds completely deteriorated," concluded Lucinda.

"You said there are still more pods?" asked Sara.

"Yes," said Jetro. "Probably a few. We haven't needed them in months."

"Where would we find them?"

"I put them out back, in a rain bucket by the back entrance," said Fantella. "I couldn't get the last few open, so thought if they weathered they might soften and open by themselves, just in case a few of the seeds were still usable."

"We had better check them out now," said Lucinda.

"Agreed, yes, let's go," everyone at the table was saying at once. Saralinda reached up and climbed back into Lucinda's vines.

The group then made their way across the Great Hall to a smaller hallway that led out back. It was more simply decorated with additional back doors. Chantroute explained that there were actually four entrances to the city. At this back entrance they met Dandor, who was guarding.

"Hi, Dandor," said Chantroute. "We need to check something out back."

"Yes, Chant, I'll get her opened right away." And the door cranked open.

"The bucket's right over here," said Fantella.

But it wasn't. They looked around and found it knocked over a few feet away. They sat it back up. Chantroute and Lucinda turned up their glow and they all looked in. There was a grayish layer of dust on the bottom of the pail, and one pod that was beginning to split. Lucinda picked it up to examine it closer.

"Look at this," she said, showing it to Sara.

Sara took it in her hand. "It is a geode," she said turning it over and seeing the split in the stone. "It was a great idea to put the seeds in one of these."

"Yes, sealed and frozen under the earth, our seeds had a real chance to survive," said Lucinda.

"And they did," smiled Chantroute.

Something caught Sara's eye on the ground. Sara handed the last unopened geode back to Lucinda. "Look, here are two more on the ground."

Sure enough, there were two broken stone pods on the ground. There didn't seem to be anything in them, just the four empty halves of two broken geodes.

"It looks like crystals in them," Sara observed, picking one up and looking more closely. "Geodes are made of minerals and the hollow part inside is often line with crystals. Steven taught me that. I broke some open with him once. I'm pretty sure these are amethyst crystals."

"They're pretty," said Owletta, taking a look.

"Well, I guess they've been opening out here all along," said Fantella.

"I'm afraid we haven't been that careful with these last pods," said Chantroute, upset that they'd been so neglectful of the ancient artifacts that had held their very life.

"I wonder if Ekle and Apkin passed right through here?" questioned Lucinda. "If they did, maybe that is when my seed got caught in Ekle's paw, one of the good seeds, left from one of these pods on the ground."

"That would explain everything," Sara continued the thought. "It explains why you didn't get planted till you fell off Ekle's paw and into my yard!"

"We will ask the boys later if they rremember anything," said Hool.

"Maybe they knocked over the bucket," laughed Sara. "It would be like them."

"And it enabled me to be born!" Lucinda finished with a flourish of her arms.

They all nodded. Here was another unanswered question now possibly answered.

Lucinda looked at the geode she still had in her hand. She applied a bit of pressure on the split with her two small thumbs. It broke open easily and a little cloud of gray dust released into the air and made her sneeze. A December gust stirred and carried the cloud away.

Everyone looked at each other.

"Do you think those were spores?" Sara asked the question everyone was thinking.

"I hope not!" said Lucinda.

"You'd better have some samples of what's left of this stuff put in with the other samples," said Sara. "Label it "SPORES?". My dad will be able to tell us for sure what this mess is."

"This dust was everywhere," said Chanroute, a bit frantically. "It was all over the ground from all the broken pods in the garden, the ones I didn't take. And we've let loose plenty of that dust here, while we gathered seeds."

"What's done is done," said Lucinda. "We can only hope that with no signs of chargons or vinkali, these are not their spores and if they are that they are damaged and useless."

"I'll get this packed up with the other stuff," said Jetro.

For now, there wasn't much else to say and nothing more to do.

So the group returned to the celebration. Chantroute said he would tell the community of the dust tomorrow. "Why let them worry about it now. Let them enjoy this wonderful night in which they were reunited with their Master Rhymer." Indeed, there might be no reason to worry at all. Time would tell.

There was more feasting, this time the equivalent of a dessert table, vinetrope style. Everything was fruity and creamy and there was even a flavor very much like chocolate. All took turns dancing, including the children, who were allowed to stay up late. Lucinda and Chantroute often danced together and seemed happy in each other's company and Saralinda and Sara liked watching them swirl about the room.

Later that night, Sara and Lucinda were given a tour of some of the homes. They were like apartments inside Vinetropland. These homes reminded both of them of Lucinda's home, but with three or four rooms in each apartment and a very mature root system in place. A few dwellings had beautiful paintings on the walls—fantastic landscapes of the surrounding area, some with vinetropes in them. Sara was very impressed. Her mom would have been too. They then went to see Lucinda's new living space. They had given her a very spacious four-room apartment. The root growth was mature, but nothing was yet designed.

"We thought we'd wait till you were here so it could be patterned to your liking," said Chantroute.

"Thank you, Chantroute. This is a most generous and spacious home."

Just then there was a happy commotion and a group of vinetropes came in, carrying Lucinda's cradle and clothing.

"Yippee!" said Lucinda. "You've been successful."

"You've got my dad's car out of the mud?" said Sara.

"Yes, indeed," said Tortlinde, a walnut-colored vinetrope, who seemed to be in charge. "When we left them, they were in the car on the way back to the bridge. I'm sure they're all back at the Glowing Tree by now, where they are being very much entertained. We'll get these supplies into your home, Lucinda," he concluded. "And then we'll join the party!"

The wonderful music continued into the night. The fountain gurgled and added its beauty to the music and seemed to blend in with it. The vinetrope light globes floated and glowed and cast their ever changing magical light on the company and the stars shone in through the eighteen majestic skylights. More toasts were made, more poetry recited and good conversation was had by all. Glintel joined his musicians and played like the musical genius he was.

Saralinda was put into a playgroup and was playing with a few children who were bigger than her in size, but whose maturity level she matched. She was having so much fun. The babies who were her age were still in bassinets! It gave Lucinda so much joy to know her daughter would never feel alone.

Toasts were made to Owletta and Hool on their engagement and there were many discussions about the wedding and who would do what and what the owls wanted and how soon the wedding would be. It was decided it would be held in two weeks' time. They were going to bead a wedding veil for Owletta, covered in finely stitched seeds on vinetrope lace.

Then all too quickly, it was time for Sara to leave.

"Come," said Owletta gently, "it's time for us to go. Hool and I will come with you to the Glowing Tree and say our farewells there. We're tired ourselves and want to go home."

"It's over?" said Sara. "It went so quickly."

"It's time. We have figured out quite a few things together, haven't we?" said Owletta.

"And there's more to come," assured Hool.

So Sara began her good-byes. She took Chantroute's hand and they bowed to each other.

"Take good care of yourself, Sara. You'll be in our thoughts and hearts and prayers always. We'll always remember that you brought Lucinda to us; you helped save our little nation.

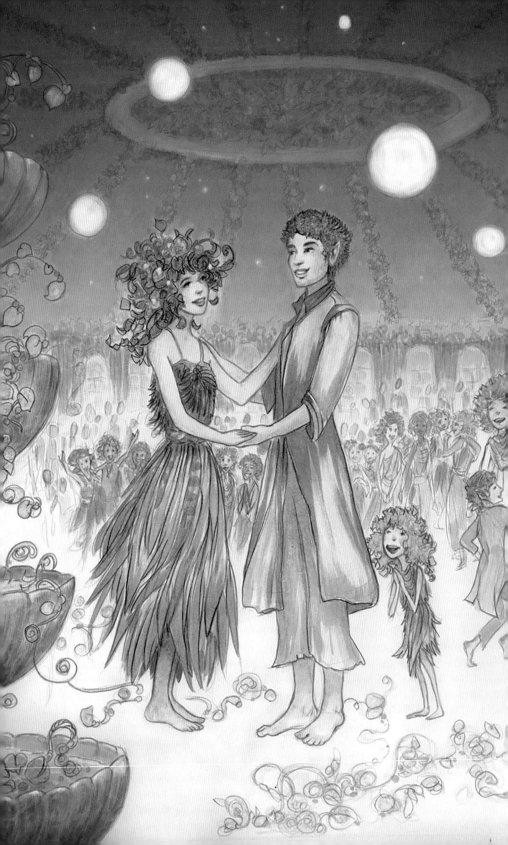

And remember, you have a vinetrope seed in your blood. You are one of us, forever."

Fantella arrived with three knapsacks made of root cloth filled with all the samples, including those that might be spores.

"Everything is labeled," she assured Sara.

The crowd then cheered and called out, "Sara the Connector of Worlds, Sara A Vittendo Krowenda! To the future, to the past, to the present—to our history!"

Lucinda approached with Saralinda once again in her hair. Sara dropped to her knees and gave Lucinda a big hug and baby Saralinda a little kiss on the cheek. Then she could contain her sadness no longer, nor could Lucinda and they both had a good cry.

"Bye-bye, Sara," said a tiny voice. Little Saralinda was crying too. "Come visit me soon!"

"This is really goodbye?" said Sara.

"For now my dear friend, my first friend, yes. Please be happy for me," said Lucinda. "I am home. I am where I am needed, where I am meant to be. And you made it all possible."

"I am happy for you," answered Sara. "It's just hard to talk right now."

"I know."

They hugged once more and then Sara hung two of the vinetrope knapsacks over her right shoulder and stood up. Fantella handed her the third and Feylanda arrived to help escort her back to the Glowing Tree. So she followed Feylanda, Owletta and Hool out of the Great Hall and into the large hallway that led to the front door of Vinetropeland. Sara turned one last time to see Lucinda and Chantroute dancing in a whirl of merriment.

WHAT'S NEXT?

S pring had arrived in this forlorn swamp, but it still wasn't a cheerful place. It was night, and the woods stood tall and branchless from the vantage point of her crouched position in the brush. She only saw dark trunks, like the legs on an army of giants, thick and well-spaced with nettle and soggy ground in-between. Here and there pools of water had formed and a warm fog drifted between the trees. The air smelt both sweet and moldy. There was the fresh scent of new ferns and the sprouting of woodland flora mixed with undernotes of rotting wood, leaves and forest floor decay.

Then she caught the sight of movement. She kept still, watching. Lights flickered. Something—no, some *things*— were drawing closer, coming through the trees, moving forward in a steady march through the dismal landscape. It was a small army in and of itself, one that was mobile and moved with a purpose. The creatures held swamp-gas lanterns that swung in rhythm to their forceful strides, adding an eerie glow, showing the floor of the swamp and casting a peculiar light into the fog.

She couldn't quite make them out yet, they were still far off, but it was obvious that some were tall, as tall as humans, and menacing, with alien-like legs. Their upper halves boasted the silhouettes of predatory animals, but below their narrow hips their legs were skinny poles that would have been comical if

they had not been insect-like, segmented and frightening. It was such a mismatched form of life, one totally unknown to her.

Now she saw that in between these larger creatures, small ones pranced about, frequently dropping their tiny lanterns, dancing around and then picking them up again. They seemed almost merry and weren't much larger than small cats. What was particularly odd was that from time to time one of the little ones would take the hand of a tall one, like a child holding the hand of a parent. No two silhouettes could have been more unalike. Even this tender demonstration of affection felt wrong.

They were close now. She could see the head of a tall one in better detail, enhanced by the light of his lantern. He looked like a wolf from the chest up, with a prickly kind of hair she had never seen before, brown and bristly like a porcupine's. On his head grew a horn, from which steam was shooting out, blending into the fog. Yes, the other tall ones had this horn too. What was she witnessing? Why was she crouching in these bushes, her feet shifting uncomfortably in the oozing mud? She tried to keep her balance, so that she wouldn't fall back into the thick slippery earth-paste. She knew she mustn't be seen. That was why she was here—to be a witness.

Jam woke and bolted upright, grabbing her phone. Sara answered on the second ring.

"Hey, Jam—"

"Sara!" Jam's voice was still hoarse from sleep.

"Jam... what is it? You sound—"

"It's happening, Sara. The chargons and vinkali. They're here."

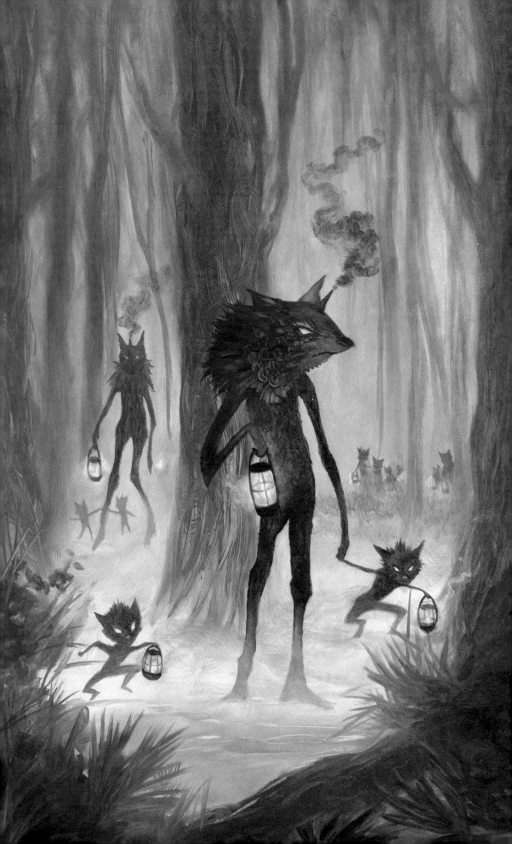